PALGRAVE STUDIES IN THEATRE AND PERFORMANCE HISTORY is a series devoted to the best of theatre/performance scholarship currently available, accessible, and free of jargon. It strives to include a wide range of topics, from the more traditional to those performance forms that in recent years have helped broaden the understanding of what theatre as a category might include (from variety forms as diverse as the circus and burlesque to street buskers, stage magic, and musical theatre, among many others). Although historical, critical, or analytical studies are of special interest, more theoretical projects, if not the dominant thrust of a study, but utilized as important underpinning or as a historiographical or analytical method of exploration, are also of interest. Textual studies of drama or other types of less traditional performance texts are also germane to the series if placed in their cultural, historical, social, or political and economic context. There is no geographical focus for this series and works of excellence of a diverse and international nature, including comparative studies, are sought.

The editor of the series is Don B. Wilmeth (EMERITUS, Brown University), PhD, University of Illinois, who brings to the series over a dozen years as editor of a book series on American theatre and drama, in addition to his own extensive experience as an editor of books and journals. He is the author of several award-winning books and has received numerous career achievement awards, including one for sustained excellence in editing from the Association for Theatre in Higher Education.

Also in the series:

Baggy Pants Comedy

Burlesque and the Oral Tradition

Andrew Davis

First published in hardcover in 2011 by PALGRAVE MACMILLAN® in the United States—a division of St. Martin's Press LLC, 175 Fifth Avenue, New York, NY 10010.

Where this book is distributed in the UK, Europe and the rest of the world, this is by Palgrave Macmillan, a division of Macmillan Publishers Limited, registered in England, company number 785998, of Houndmills, Basingstoke, Hampshire RG21 6XS.

Palgrave Macmillan is the global academic imprint of the above companies and has companies and representatives throughout the world.

Palgrave® and Macmillan® are registered trademarks in the United States, the United Kingdom, Europe and other countries.

ISBN: 978–1–137–37872–9

The Library of Congress has cataloged the hardcover edition as follows:

Davis, Andrew, 1952–
 Baggy pants comedy: burlesque and the oral tradition / Andrew Davis.
 p. cm.—(Palgrave studies in theatre and performance history)
 Includes bibliographical references.
 ISBN 978–0–230–11679–5
 1. Burlesque (Theater)—United States—History—20th century.
 2. Stand-up comedy—United States—History—20th century. 3. Comedy sketches—United States—History—20th century. I. Title.

PN1942.D275 2011
792.7'60973—dc23 2011017477

This book is printed on paper suitable for recycling and made from fully managed and sustained forest sources. Logging, pulping and manufacturing processes are expected to conform to the environmental regulations of the country of origin.

A catalogue record of the book is available from the British Library.

Design by Newgen Knowledge Works (P) Ltd., Chennai, India.

First PALGRAVE MACMILLAN paperback edition: January 2014

10 9 8 7 6 5 4 3 2 1

Contents ᴓ

Illustrations ❦

Preface ❧

With their trademark baggy pants, their seltzer bottles, and putty noses, burlesque comics offered a bawdy style of comedy that is usually dismissed as coarse and vulgar. Aimed at a largely uneducated male audience, burlesque relied heavily on sexual double entendre and broad physical comedy. If it is crude, burlesque represents a performance tradition quite distinct from more respected theatrical forms, one that addressed the concerns of its largely working-class audience. While the playwright was central to the legitimate theatre, burlesque was a performer-centered entertainment form, which relied on stock comedy routines that were preserved and passed on orally. Hundreds of these routines existed in the 1920s and 1930s, and a burlesque comic or straightman had to be familiar with most of them. Some of these scenes are familiar even today, having made their way into film or television. "Niagara Falls (Slowly I Turn)" was a standard burlesque routine that has been played on film by, among others, The Three Stooges, Lucille Ball, Danny Thomas, Sid Caeser and Imogene Coca, and Abbott & Costello. "Meet Me Round the Corner (In a Half an Hour)" is known to many from the film *The Night They Raided Minsky's*. This style of comedy is most familiar, however, through the work of Abbott & Costello. Bud Abbott and Lou Costello got their start in burlesque, and frequently used burlesque material in their films and television appearances. Their classic routine "Who's On First?" is said to be an old burlesque bit that had floated around for years.

This study examines the burlesque sketch, as a way of exploring the working methods and performance style of burlesque comics. Comedy on the burlesque stage was built around a five- to ten-minute scene, called a "bit," which alternated with the chorus line routines, variety acts, and, beginning in the late 1920s, striptease numbers. These bits were rarely set down on paper. Comics learned them by watching others perform them, or by talking through the scene before going onstage. The sketch was not a fixed text, but a point of departure for a comic's own inventiveness. As Ralph Allen, producer of the burlesque-inspired musical *Sugar Babies*, has observed, the sketch "is an outline of the action, a frame into which the comedian inserts his own eccentric character, his own pieces of business (his lazzi, if you will) and some of his own stock speeches."[1] Dialog was ad-libbed during the performance, and comics felt free to change, adapt, or steal material. Nobody "owned" these routines, although comics tried to make a scene their own by introducing their own jokes or pieces of comic business.

This method of working grew out of the specific demands of the burlesque stage. Burlesque was a poor theatre, which drew its audience of inner-city working men with low ticket prices and the spectacle of scantily clad women. The burlesque sketch was a feature of what was commonly known as "stock" burlesque. Like summer stock

theatres, these burlesque houses employed a company of performers who worked the same theatre for weeks, even months, on end. It was common practice to change the show every week. The comics who played these houses had to come up with several new routines each week. While some wrote their own material, more often they "remembered it up"—drawing on a corpus of comic bits and premises that had circulated for years.

Relatively few of these sketches ever made their way into print. Jess Mack published a number of them in the pages of *Cavalcade of Burlesque*, a quarterly magazine devoted to burlesque, which he edited between 1951 and 1954. Brooks McNamara included a number of burlesque sketches in his collection of *American Popular Entertainments*, along with similar material from other entertainment forms. Ralph Allen, who adapted traditional burlesque sketches for *Sugar Babies*, published some fifty of them in his collection *The Best Burlesque Sketches*. Several others were included in a revue published by Dick Poston titled *Burlesque Humor Revisited*. Many more exist only in manuscript form, written down and collected by burlesque comics and straightmen. I have drawn on a number of these in order to provide a comprehensive look at the style and subject matter of burlesque comedy. They include the Ken Murray Collection at the Magic Castle in Los Angeles, the Jess Mack Collection at the University of Nevada, Las Vegas, the Gypsy Rose Lee Collection at the New York Public Library, the Chuck Callahan Collection at the Players in New York City, the Steve Mills Collection at the Boston Public Library, and the Ralph Allen and the Anthony LoCicero Collections, both at the University of Pittsburgh.

This study was conducted with two main purposes in mind. First, to collect and document this material, bringing the scenes out of archives and making them available to both scholars and performers. Second, to show how these scenes facilitated a particular method of playing comedy—one that relied mostly on a remembered tradition. This study is informed by my background as a comedy performer, my training as a folklorist, and my ongoing work as a theatre historian, all of which have been connected with popular entertainments. This volume has been put together with the needs and interests of these three groups in mind.

My first goal is to get this material back into the hands of performers again and to expose them to an approach to performing and thinking about comedy that is somewhere between the scripted theatre and pure improvisation. It is a style of performance associated with *commedia dell'arte*, yet situated in modern urban setting. Although related to *commedia*, it draws on the methods and approaches of oral poets, singers, and storytellers. While this material can be treated as scripts to be acted out, performers are encouraged explore this material creatively, to adapt it to new performing situations, and update, fill out, and alter them as needed.

For folklorists, this collection opens up a new genre—one that has always been there, but was overlooked because it circulated among professional entertainers working in an urban environment. One of most important contribution folklorists have made—from the Grimm Brothers with their collection of German household tales to the relatively recent collections of urban legends by Jan Harold Brunvand—has been to bring this kind of material before the public, while organizing and classifying the stories in a way that allows for cross-cultural comparison and analysis. This kind of documentation has never been done on the comedy sketch. While this is not the comprehensive study

that it requires, it lays out the types of comedy sketches found in burlesque, and will, I hope, open up the exploration of sketch comedy material in other genres—circus clowning, for example—in other times—minstrelsy—and in other cultures—British pantomime.

Efforts such as these should open up new directions in theatre study. As an academic discipline, theatre grew out of the study of dramatic literature, and theatre scholarship and training remains decidedly text-based and playwright-oriented. While theatre historians have explored the impact of vaudeville, burlesque, and other forms of popular theatre, these forms have not left the kind of published records that provide the basis for understanding and appreciating the legitimate theatre. The texts that have circulated in the popular theatre and in street entertainments are smaller units that detach themselves from one performing environment and show up in the next. By applying some of the analytical tools of folkloristics, theatre scholars can open up our understanding of popular performance, and especially comedy performance. A study of an historical nature will undoubtedly impact the training of comedy performers.

This volume presents the most important of these burlesque sketches—or at least the most widespread. This study was purposely limited to collections that are presently available in public archives, to which other researchers will have access. I have chosen to focus on those scenes that are found in more than one collection, in more than one version. The fact that a scene exists in one or more of the collections indicates that it was relatively widespread. It also allows us to look at what remains stable and what varies from one version to another. It is this relationship between stable elements and variations that is most interesting and revealing about this material. It indicates that the material was circulating orally. Individual comics dropped in their own jokes and bits of business, altered endings to suit their own idea of what was funny, and often rearranged material.

I have grouped the scenes according to theme and subject matter. Although it is impossible to reproduce all of the sketches, I have generally synopsized one of the versions and then discussed important variants, and indicated where filmed and published versions can be found. I have chosen to present the scenes in synopsized form, including dialogue only when it seemed particularly important, or contained a joke that relied on specific phrasing. This seems to me to be in keeping with the material being presented. Certain lines of dialogue must be phrased a certain way for the joke to come across, but other lines of dialogue are not particularly important, and really have to do with communicating the action. I have also freely corrected spelling and standardized the punctuation as it appears in the manuscripts. Except in rare occasions, I have not indicated these corrections. These were working texts, typed up and passed on by the performers themselves. They were specifically meant to be read and performed, and no attempt was made to correct errors in spelling and punctuation. Often misspellings were simply XXed out on the manuscript. To allow the many misspellings or punctuation to appear in a published version would be distracting, as would any attempt to indicate every change.

I have used standardized abbreviations for the characters:

1st: First Comic
2nd: Second Comic

Com: Comic
Str: Straightman
Ing: Ingenue
Sou: Soubrette
Prim: Prima Donna
Wom: Woman
1st W: First Woman
Bus. Business

Occasionally, the scene title becomes a problem. There are no standard titles for most burlesque scenes. The same scene will appear under more than one title. I have tried to indicate variant titles, generally going with the title that appears most often. The scripts in several of the collections have a separate cover page, which lists the title of the piece, the cast members, the setting, and props needed for the scene. Sometimes the title page bears a different title from the one that appears on the first page of the actual script. For example, a scene titled "Golf Scene" in the Jess Mack Collection, on the following page bears the title, "Golf Bit." Steve Mills's scene "Packing the Trunk" bears a different title on the script, "Hiram and the Wedding Night." The "Spanish Bullfight—Balerio" in the Ralph Allen Collection has a title on the inside page, "Bullfight Scene—Balero." In each case, I have chosen to go with the cover on the title page, since this is the title a researcher will first encounter. When I have had reason to discuss the scene, however, I have tried to indicate the alternate title as well. The Ken Murray Collection does not have title pages; the scenes have been bound together into volumes with sequential numbers on the pages, and a table of contents at the front of the volume. In some cases the title that appears in the table of contents differs slightly from the title on the script itself. Since it is more important for researchers to be able to locate these scripts in the collections, I have elected to go with the title that appears in the table of contents

What is most interesting is what these scripts reveal about the performing methods of burlesque comics. As previous scholars have established, most scenes were passed on orally. Young comics learned them by watching more experienced performers at work. The scripts that exist were aids to the rehearsal process. Comics usually talked through the scenes before going onstage, then came up with their own lines of dialogue in performance. This method of "composition in performance" is associated in the theatre with the *commedia dell'arte*. But it is more useful to consider both burlesque and *commedia* in terms of the oral tradition most associated with "folk" cultures. If the routines are simple, the comedy broad, and the action repetitive or clichéd, it is because bits had to be easily remembered and passed on. The sketches that survive in manuscript form reflect the oral nature of the form in their use of simple structures, repeated actions, and stock characters. This flexible approach to performing is reflected in the manuscripts, for the scenes are not static, even on the typewritten page. Sketches exist in multiple versions. Jokes or bits of business show up in different scenes. A manuscript will sometimes suggest more than one possible ending for a scene. On some copies, there are handwritten changes in the margins. These suggest that the material was in process, constantly being reshaped and updated.

This study shows how burlesque comedy grew out of a particular social and historical context, as a response to a specific set of performance challenges. The

first three chapters set the scene for the rest of the book and present the theoretical approach that will be taken. The opening chapter establishes the influence of burlesque comedy by looking at the work of Abbott & Costello, and the source of their most famous routine, "Who's On First." Chapter two presents the central argument of the book—that burlesque comedy needs to be looked at and understood as an oral tradition, treated as a form of American folklore. Chapter three examines the history of American burlesque, tracing the development of "stock burlesque" from popular entertainments of the nineteenth century, and gives the reader a sense of what it was like to attend a burlesque show in the 1930s. Chapters four through seven look at the craft of burlesque comedy. Chapter four looks at the performers, detailing the various roles men and women played, and the types of characters they portrayed. Chapter five looks at how the comedians learned their craft, picking up material piecemeal that they could use in their scenes. Chapter six looks at the specific challenges of working in a multiplayer form, and the value of short, dialogic units that helped manage the give-and-take between the performers, also found in *commedia dell'arte*. Chapter seven looks at how stylistic features of the burlesque sketch worked as mnemonic devices, and what recent work in cognitive science reveals about them.

Beginning with chapter eight, we focus on the scenes themselves. Chapters eight and nine deal primarily with sexual humor. Chapter eight explores double entendre humor, while chapter nine discusses flirtation scenes, in which the comic tries to pick up a girl, with side-coaching from the straightman. Chapters ten and eleven are reversals of fortune. Chapter ten looks at scenes based on trickery—con games, betting, and practical jokes. Chapter eleven is concerned with brutality, in which a policeman or passerby begins pummeling the comic. Chapters twelve and thirteen deal with large-cast body scenes, looking at how the spirit of theatrical burlesque informs not just the comedy of theatrical travesty but other scenes as well. Finally, chapter fourteen concludes the study by looking the appeal of the burlesque show to working-class audiences, and what this study tells us about what makes people laugh.

This study could not have been done without the advice and support of a number of performers and scholars. There are, first off, the veterans of the burlesque stage, many of whom were associated with *This Was Burlesque*: the late Ann Corio, her husband Mike Iannucci, straightman Dexter Maitland, one-time dance captain Trish Sandberg, and Susan Mills, widow of funnyman Steve Mills. The people associated with Exotic World and its Burlesque Hall of Fame—notably Dixie Evans, Charlie Arroyo, and Bob "Rubberlegs" Tannenbaum—shared their knowledge and put me in touch with many of the old-timers, and with the young performers who are part of the burlesque revival. The people who most influenced me as a performer include Cindy Kamler, my cohorts at Improvisation, Inc. and Spaghetti Jam, as well as those from the Fools Guild—especially Jonnathon Cripple, Skip Blas, Greg Dean, and David Springhorn. There are my mentors in the university—folklorist Bob Georges, theatre historian Brooks McNamara, and circus scholar Hovey Burgess—as well as the many librarians, curators, and archivists who were so generous with their time and advice. On the editorial side, I could not have done this without the help of Carla Jablonski, who edited early versions of this study, and Don Wilmeth, who recognized the value of this material and shepherded me through the publishing process.

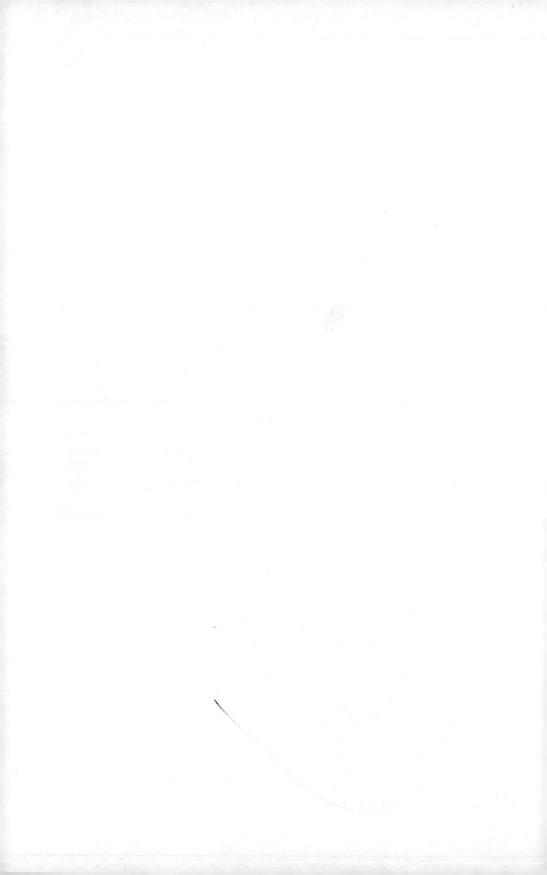

1. "Who's On First" and the Tradition of Burlesque Comedy ✑

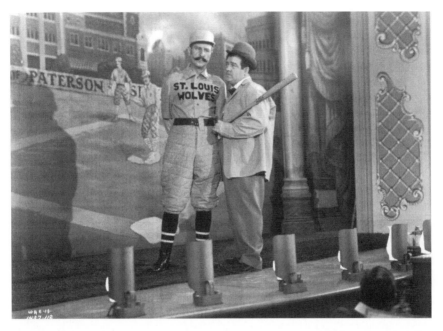

Figure 1.1 Bud Abbott and Lou Costello in their most renowned performance of "Who's On First" in the 1945 film *The Naughty Nineties*. Because they did not have the routine word-for-word memorized, each performance was unique. (Courtesy of Universal Pictures.)

If there were a Comedy Hall of Fame, Abbott & Costello's baseball routine, "Who's On First," would certainly have a place in it. Few, if any, comedy routines are as familiar to the American public as this classic piece of misunderstanding. More than half a century after it was first filmed, the routine is one of the most familiar and beloved comedy bits around. Though it may have stymied Lou Costello, nearly every kid growing up in America can recite the players in what is still the most famous infield in baseball: *who is on first base, what is on second, and on third base—I don't know.*

Given that there is no shrine (and little respect) for aged comedy routines, it is significant that the Abbott & Costello routine did find its way into a place of honor.

To mark the twentieth anniversary of their partnership, in 1956, "Who's On First" was given a place in the Baseball Hall of Fame in Cooperstown, New York. Abbott & Costello appeared on *The Steve Allen Show* to present a gold record to the museum. Today, a clip from their 1945 film *The Naughty Nineties* runs on a continuous loop in a theatre devoted exclusively to the routine—an appropriate sort of honor for a routine that also seems to run on an endless loop.

"Who's On First" is the most familiar example of a comic form that was widespread in the early part of the twentieth century, but has largely been forgotten today. The routine, like the comics who made it famous, came out of burlesque. Abbott & Costello were products of the burlesque stage, and their working methods, as well as many of their most famous comedy routines, came out of this tradition. It was a tradition that relied not on scripts or scriptwriters but on a remembered stockpile of comedy scenes, monologues, jokes, and bits of business that were passed on orally. This material circulated in a wide range of American popular entertainments, including circus, minstrelsy, medicine shows, tent shows, and vaudeville. But it was particularly important in burlesque.

Most people today associate burlesque with nudity and the striptease. The allure of scantily clad showgirls was certainly the primary draw for the mostly male audience. But burlesque was also an important venue for comedy, and the spectacle of striptease dancers and scantily clad chorus girls has overshadowed the comedic side of the performance. Before burlesque became associated with pasties and g-strings, it referred primarily to a form of theatrical comedy that ridiculed sentimental or heroic works through a grotesque or outlandish imitation. Comedy remained an important feature of the burlesque show, at least through the 1930s. Though a certain portion of the audience was not the least bit interested in what the comics were doing, pulling out their newspapers until the girls came back onstage, burlesque was a vital training ground for several generations of comedians. W. C. Fields, Fanny Brice, Eddie Cantor, Leon Errol, and Will Rogers all toured with burlesque shows before Flo Ziegfeld made them stars in the Ziegfeld Follies. A later generation made their mark in musical revues of the 1920s—including Bert Lahr, Joe Penner, and Bobby Clark. Yet another group of burlesque veterans worked in early television—Phil Silvers, Red Skelton, Pinky Lee, Jackie Gleason, and Red Buttons are among the most notable graduates of burlesque.

Nobody made more use of this tradition than Bud Abbott and Lou Costello. Many of their funniest moments onscreen were scenes that had had a long life on the burlesque stage—their crap shooting sequence on the troop train in *Buck Privates*, the three-card monte game featuring lemons in *In the Navy*, and the hat-breaking episode in *In Society*.[1] Bud Abbott is the quintessential burlesque straightman—a well-dressed, fast-talking schemer, who bullies and takes advantage of his partner at every opportunity. Lou Costello is the rumpled and frustrated innocent, forever struggling to make sense of the world, but never quite succeeding.

Comedy on the burlesque stage was built around a three- to ten-minute comedy scene called a "bit." These scenes were inserted between the striptease numbers and chorus line routines to give some variety to the show and to allow time for scene and costume changes. The term "bit" referred to everything from a one-joke blackout to a complex scene that involved the entire cast. Hundreds of these routines existed, and an accomplished comic or straightman could be expected to step in and perform any

one of a couple hundred or more at a moment's notice. A number of these scenes have been preserved on film, most notably in the work of Abbott & Costello. A few have seen print, but the vast majority exist only in manuscript form, in collections transcribed and passed around by burlesque performers. Several of these collections have been preserved, and they provide the most comprehensive (if incomplete) record of the work of comics who worked the burlesque houses of the 1920s and 1930s.

Although this study relies on these manuscripts, they will be analyzed in terms of the "oral tradition." The word "oral" can be a bit misleading in dealing with a theatrical tradition such as burlesque, since so much burlesque comedy relied on visual and physical humor—the baggy pants, the putty nose, the seltzer bottle, the pie in the face, and so on. The term "oral" is used in its more academic sense to distinguish burlesque comedy from a written or literary tradition. It is not to say that these scenes were not written down, for this study obviously relies on scripted versions. Most burlesque comics, however, never set their bits down on paper and rarely, if ever, referred to a script. The sketch was simply a comic premise, a scenario, a description of an action. Performers learned the gist of the scene, along with certain key jokes or lines of dialogue, but made up most of their lines as they went along. It is by thinking about burlesque as an oral form that modern readers can more fully appreciate this genre, and the skill and artistry of these comics who performed them.

It was not just the scenes that were being passed on, however. Burlesque comedy had an established method of performing, quite distinct from the scripted theatre, and this style of playing was being transmitted right along with the scenes. That is why the term "oral tradition" has more relevance to this project than, say, "oral literature." The term "tradition" has become problematic these days, with the concept of "invented" traditions, and the word can have many meanings, depending on who is using it. For this project, Ruth Finnegan's observations about the term "tradition" are particularly useful. According to Finnegan, "It is used, variously, of: 'culture' as a whole; an established way of doing things whether or not of any antiquity; the process of handing down practices, ideas or values; the products so handed down, sometimes with the connotation of being 'old' or having arisen in some 'natural' or non-polemical way."[2]

Finnegan's definition encompasses four important aspects that are appropriate to an understanding of burlesque comedy. Tradition covers (i) the products being handed down, in this case, the scenes; (ii) the process by which these scenes were passed on or handed down; (iii) the performance practices, or established way of "doing things," that the scenes were linked to and, ultimately; (iv) the cultural milieu in which these sketches circulated and which is reflected in their style and subject matter. This study will explore all four meanings of the term tradition, for they are not just interrelated, they are inextricably linked. The sketches take the particular form that they do because they had to be passed on orally. Burlesque comedy has often been dismissed as simple, crude, and hokey. But these are features that mark it as an oral tradition. If the form is simple and the action repetitive, it is because these scenes had to be easily remembered and passed on. In this it shares many of the features folklorists have observed in other traditional oral narrative forms—folktales, myths, and legends.

The scenes were linked to a method of performing that was distinctly different from traditional forms of scripted theatre. Burlesque comics came up with their own dialogue, and performances changed from one night to the next. In the theatre,

this tradition is primarily associated with the great *commedia dell'arte* troupes of the Renaissance, but in fact it was widespread in the popular theatre.

These sketches need to be understood in terms of the performance practices that produced them. This study concentrates primarily on the period of the 1920s and 1930s—the era when burlesque gained its greatest notoriety and the era most people think of when they hear the word "burlesque." It was an era when "stock" burlesque predominated. Stock burlesque operated much like summer stock theatres today. Theatre-owners employed a resident company of performers who were expected to put on a new show each week. This put considerable pressure on the performers. The chorus girls had to rehearse new production numbers and the principals had to come up with new singing and dancing specialties. The comics had to devise some six to eight new comedy scenes. In the 1930s, they did this *in addition* to performing some four shows a day, six days a week. With little time to rehearse, much less write new scenes, the comics accomplished the task by "remembering them up," drawing on scenes that had circulated in a wide range of popular entertainments, and updating or adapting them as needed.

Bud Abbott and Lou Costello are the most identifiable practitioners of this style of comedy, and their work is the best entrée modern audiences have to burlesque comedy. This chapter explores their comedy, examining their career and performing methods, concentrating on their most famous routine, "Who's On First," as a way of introducing the reader to this style of comedy. It attempts to get the reader to look more closely at a routine that is highly familiar, in order to undercut certain assumptions about the nature of comic performance and to understand the relation between text and performance and the role of originality and creativity.

It is often taken as a given that comedy works on the basis of surprise, since jokes are not as funny the second time around. But "Who's On First" has been repeated before audiences, and hardly ever fails to amuse. Abbott & Costello themselves played the routine for over twenty years, on the burlesque stage, on Broadway, on radio and television, and in the movies. They played it in front of presidents—FDR is said to have been a big fan. Whenever they made a public appearance, they were expected to do the routine. It's been claimed that they performed "Who's On First" fifteen thousand times.[3]

ABBOTT & COSTELLO IN BURLESQUE

Bud Abbott and Lou Costello teamed up relatively late in their careers. Abbott was over forty when he began working with Costello. Born William Alexander Abbott on October 2, 1895, Bud was raised in the entertainment business. His mother Rae had been a bareback rider with the circus and his father Harry was an advance man for Barnum & Bailey. Harry Abbott later went to work for the Columbia Wheel, the first burlesque circuit. Bud grew up in Coney Island, and took his first jobs at the rides and games there. At sixteen, he went to work at the box office of the Casino Theatre, a burlesque house in Brooklyn. Abbott worked as a treasurer and manager at a number of burlesque houses for over a decade before taking to the stage. He used the opportunity to interact with the performers backstage and study their routines. He married a chorus girl he met at the Casino, Betty Smith, and the

two of them worked together as a comedy team on the burlesque circuits, as Betty and Buddy Abbott. The couple was touring with *Harry Steppe's Own Show* on the Mutual Circuit, in 1929, when they received this review:

> Buddy Abbott, as the classy-clothed, clear-dictioned, aggressive straight man, was in every scene with Steppe, feeding him lines like a light comedian, thereby bringing out the best in Steppe.
>
> Buddy, by his natural talent and developed ability, has graduated from the ranks of singing and dancing juveniles, into an able straight man, with the versatility of an exceptional light comedian...
>
> Betty Abbott, a marcelled brunet, singing and dancing soubret, has mastered the art of versatile acting sufficiently well to be titled ingenue-soubret comediene, with the ability of a dramatic actress in lines and actions.[4]

Lou Costello did not come from a theatrical family. Born Louis Francis Cristillo on March 6, 1906, in Paterson, New Jersey, his father Sebastian Cristillo worked at an insurance company while his mother Helene raised the kids. Lou nurtured theatrical ambitions from a very early age and when he was twenty-one, he and a friend hitchhiked to Hollywood hoping to break into films. Things did not pan out there—he worked as a laborer on the MGM lot and occasionally as a stuntman—and about a year later, he headed back to New York. When his money ran out on the way, he heard about an opening for a comedian at a burlesque theatre in St. Joseph, Missouri. Although Costello had no previous experience in burlesque, he was hired, and stayed at the Empress for eight months, learning the bits and gaining confidence as a comic.

In 1929, Lou Costello was touring with *The Best Show in Town*, playing second banana to comic Bob Startzman.

> Lou Costello, a stranger to us, is co-comic to Startzman in their scenes together, and with other principals in other scenes. Costello effects little or no facial makeup and a sheik-like dressing of hair, apparently contenting himself with his comedy clothes; expressive mugging, humorous delivery of lines and funny falls, supplementing with singing and dancing. Costello has an easy manner of working, somewhat different from the usual run of burlesque comics and will stand watching.[5]

Although Abbott & Costello worked on the same bill as early as January of 1933, when they both appeared at Minsky's Brooklyn Theatre, they did not team up until 1936. The two men came to each other's notice in the spring of 1935 when they shared the same bill for several weeks at the Eltinge Theater on Forty-Second Street in New York City. By this time, Bud was working with a comic named Harry Evanson, while Lou was paired with straightman Joe Lyons. After their run at the Eltinge, both went their separate ways, but they were back together again, now working as a team, in January 1936. As a duo, they began getting more prestigious bookings, working the Minsky Theaters in New York City and Brooklyn, and touring with *Life Begins at Minsky's* in 1936 and 1937.[6]

By 1937, burlesque was on its last legs in New York City. In 1931, seeing that many of the theatres in the Times Square area were dark, Billy Minsky had turned

the Republic Theater into a burlesque house. Other burlesque producers followed suit. Prior to this, burlesque had been confined to working-class neighborhoods on the Lower East Side and in Harlem. The move to the heart of the Broadway theatre district scandalized the theatre community, already financially threatened by the depression. In 1934, Fiorello LaGuardia successfully campaigned for mayor of New York City by promising to clean up Broadway. He and his license commissioner, Paul Moss, launched efforts to control the burlesque interests. On May 1, 1937, he closed the burlesque theatres of New York. Though many of them eventually reopened, they were prevented from using the word "burlesque" on the marquees or in their advertising, and had to tone down much of the nudity.

Abbott & Costello, however, had been booked at the Steel Pier in Atlantic City. Although Abbott was content to stay in burlesque, Costello had bigger ambitions and they had acquired a new manager, Eddie Sherman, who was intent on getting them into legitimate theatres. Abbott & Costello were able to make the transition because, unlike most burlesque comics, they kept their material clean. Although they initially took a pay cut, under Sherman's management they were soon making better money, and were eventually booked onto the Loew's circuit of movie theatres. It was while working at Loew's State in New York City that they came to the attention of Ted Collins, the producer of the radio program *The Kate Smith Hour*. Collins needed a replacement for the regular comic Henny Youngman, who was going out to California for a screen test. Youngman recommended the burlesque team and Collins booked them for an appearance. Although "Who's On First" was already the team's most successful routine, they did not perform it because Collins thought it was too visual for radio. For their first appearance, they performed their race track routine, also known as "Mudder/Fodder," a bit that also depends on word play and misunderstanding:

> Bud: Didn't I see you at the race track yesterday?
>
> Lou: Yeah, I was there. I like to bet on the nags.
>
> Bud: *(Grabbing him.)* Don't talk like that about horses! Do you realize that I have one of the greatest mudders in the country?
>
> Lou: What has your mother got to do with horses?
>
> Bud: My mudder *is* a horse.
>
> Lou: What? I will admit there's a resemblance.[7]

Abbott & Costello were a hit, and they began to appear regularly on *The Kate Smith Hour*, performing routines from their burlesque days. Even so, Ted Collins resisted letting them perform "Who's On First." Abbott & Costello had to connive to get it on the air by pretending to have run out of material. On March 24, 1938, they premiered "Who's On First" on radio. The routine was immediately successful, and afterward they were asked to perform it once a month.

THE SOURCES OF "WHO'S ON FIRST"

Although "Who's On First" is forever identified with Abbott & Costello, the routine was not original with them. A number of burlesque comics recalled performing the

routine. Phil Silvers was one of them. "Nobody knows where 'Who's On First' came from," Silvers wrote. "Everybody used to do it. I did it myself with Rags Ragland. But Bud and Lou had the first crack at the big-time audiences with it, and nobody performed it quite like they did."[8] Just where the routine came from is uncertain, but even Bud's wife Betty acknowledged that it predates his partnership with Lou Costello. "Betty Abbott recalled that 'Bud had done the baseball bit a long time before he worked with Lou. That was public domain. He did it with some comic, I don't remember who it was. And it was a little different, because he and Lou put an awful lot of stuff in it, a lot of new material.'"[9]

It is extremely difficult to assign an origin to a scene like this one because it comes from the oral tradition. Performers learned a routine by watching other performers work or by talking through it before they went onstage. Once onstage they usually came up with their own dialogue. Even when scripts existed, they were used as scenarios, guides to performance rather than hard-and-fast scripts. Individual performers dropped in their favorite pieces of business. Bits were extremely malleable and most developed out of earlier ones. They were constantly being taken apart and recombined in different ways, as comics tried to come up with their own version of a particular piece. "There was nothing wrong with a new comedy scene," Rowland Barber pointed out in *The Night They Raided Minsky's*. "But it couldn't be *invented*. It had to be patched together out of bits of old bits from old burlesque shows."[10]

A scene like "Who's On First" is the result of this kind of collective authorship, with different performers contributing a particular piece of business or a comic idea that got picked up by others. A number of people have traced the origin of "Who's On First" to a Weber and Fields bit called "Watt Street."[11] According to Marc and Armond Fields, the famous German dialect comedians performed this routine as early as the 1880s.[12] In *Burlesque Humor Revisited*, Dick Poston published a version of the Weber and Fields routine:

Com: So tell me the street you work on, I'll come and pick you up.

Str: Watt Street.

Com: The street you work on. So I come pick you up, we go have lunch.

Str: Watt Street.

Com: The street you're working on.

Str: Watt Street.

Com: (*Nervously.*) Why don't you tell me what street you're working on?

Str: I'm telling you.

Com: You're not telling me, you're *asking* me!

Str: Oh, I see. Look, when I say "Watt Street," I don't mean "*What* street?" I mean, "Watt Street."

Com: Ohh-h-h—Look, when I say you're crazy, I don't mean you're insane, I mean you're *nuts!*—that's what you are.[13]

Another performer who was identified with the routine was comedienne Irene Franklin, a vaudevillian known mainly for her comic songs.[14] In the 1910s, she

performed a version that involved an interchange between a passenger on a street car and a conductor:

Pass: Let me know when we get to Watt Street.

Cond: What street?

Pass: Yes, Watt Street. That's where I'm going.

Cond: Where are you going?

Pass: Going to see my cousin. He lives there.

Cond: Lives where?

Pass: Watt Street.

Cond: How do I know what street he lives on?[15]

Modern audiences may recall the performance by Wheezer, Stymie, and Norma Jean in the Our Gang comedy, *Bargain Day*.

This kind of misunderstanding routine was quite popular around the turn of the twentieth century. It was a period of heavy immigration and most comics at the time did ethnic characterizations, working with Irish, German, or Yiddish dialects. These scenes reflected the difficulties these new immigrants had communicating and understanding the English language. A similar bit is "Izzy and Wuzzy," a vaudeville routine Brooks McNamara included in his anthology, *American Popular Entertainments*. In this scene, the Straightman inquires about the Comic's sister:

Com: Oh, she's fine: she's married and got twins…

Str: What are their names?

Com: Izzy and Wuzzy.

Str: Izzy and Wuzzy. Well, how are they?

Com: Well last week Izzy was sick. But he's all right now. But when I left the house this morning, Wuzzy was sick.

Str: Oh, Izzy?

Com: No, Wuzzy.

Str: That's what I said: Is he?

Com: No, Wuzzy. Izzy was sick last week.

Str: Oh, was he?

Com: No, Izzy.

Str: I thought you said, Wuzzy was sick.

Com: Wuzzy was sick. But now Izzy is sick.

Str: Oh, Wuzzy was sick? Izzy?

Com: *(Works this up big with Straight.)* Oh, they're both dead. *(They exit. Comic very disgusted.)*[16]

Several of these bits were combined in a scene called "Who and Die," a scene comic Steve Mills considered to be the source of "Who's On First."[17] The version in the

Ken Murray Collection shows how this routine brought together many of the earlier routines in a way that sounds very close to the baseball sketch:

<u>Who and Die</u>

Leem: I got a new job.

Yule: Yes, where?

Leem: Down at the nut and bolt works.

Yule: What do you do?

Leem: Nuttin'.

Yule: I thought you said you were working?

Leem: Sure. Down at the nut and bolt works.

Yule: And what do you do?

Leem: Nuttin', nuttin' down at the nut and bolt works.

Yule: Oh.

Leem: And I got a good boss too.

Yule: You have? What's his name?

Leem: Who?

Yule: Your boss.

Leem: Uh huh.

Yule: You say that you're working.

Leem: Sure.

Yule: And you got a good boss.

Leem: Sure. Fine fellow.

Yule: Well, I'm asking you what's his name?

Leem: It ain't what. What got fired. Now who took his job.

Yule: Who took who's job?

Leem: No—he couldn't take his own job, he took What's job.

Yule: Oh did he.

Leem: He. Oh, he's the salesman.

Yule: Who's the salesman?

Leem: No, who's the boss. He's the salesman.

Yule: You told me they fired him.

Leem: Him. Him's the office boy.

Yule: Who's the office boy.

Leem: No—Who's the boss. Him is the office boy.

Yule: Oh is he?

Leem: Izzy? That's the boss's son.

Yule: Who's son?

Leem: Yes.

Yule: Listen you say you're working.

Leem:	When I say Who I don't mean Who.
Yule:	What do you mean?
Leem:	Who.
Yule:	When you say What you mean Who.
Leem:	No—turn them around.
Yule:	Turn Who around?
Leem:	Yes—that's right. *(To audience.)* See he knows him.
Yule:	Listen, you got a boss—
Leem:	Oh, hell I don't work there anymore.[18]

Establishing a firm genealogy for these bits is difficult, perhaps impossible, because few burlesque bits were ever published or copyrighted. While manuscript copies do exist, there is no way to date them definitively. Even when there is a published version of a particular sketch, it does not mean that the author was necessarily the originator. As Brooks McNamara has pointed out, "most of those who claimed to have written a particular piece of material were…merely scribes who felt that there was some economic advantage in establishing authors hip."[19] There is every reason to suspect, for example, that "Watt Street" was circulating well before Weber and Fields began performing it.

In suggesting that Abbott & Costello did not originate "Who's On First," there is no intent to diminish the routine or Abbott & Costello's contribution, but to put their work in proper perspective. Burlesque, like many popular entertainments, was a performer's medium. Rather than relying on professional writers, the performers themselves were responsible for coming up with their own material. They did so by using the skills of the performer, recalling old comedy bits that had worked in the past, adding new jokes that happened to be circulating and slipping in a few local or topical references, then reshaping them in the rehearsal process, and letting audience response determine what to keep and what to throw out. A comic's originality lay not in coming up with a new scene, but in the way he put the scene over. Comics were expected to embellish the scene, dropping in their own jokes or bits of business, adapting the scene to their particular personality. In this way, a comic could make a scene his "own."

A PERFORMANCE TRADITION

"Who's On First" clearly bears the earmarks of this working method. What makes it such a successful piece of comedy is not the writing per se, but the acting. In contrast to a scene such as "Mudder/Fodder," which relies on a similar type of misunderstanding to set up a series of jokes comparing Abbott's mother to a horse, "Who's On First" contains no jokes as such. There is nothing in the routine that can be clearly identified as a set-up or a punch line. Rather than using a verbal joke structure to set up the laughs, it relies on pace, rhythm, and emotional dynamics to create the humor. The scene is almost musical in its structure. It uses repetition to create a series of builds that underscores Costello's increasing frustration as he and Abbott go round and round the infield, always winding up, somehow, on third base.

In the scripted theatre, performance elements are largely isolated from the text. The written word is not effective at conveying such things as inflection, pace, rhythm—all the elements that go into what is loosely called comedy timing. Comic actors, learning their lines from a script, have to invent or imagine the proper emphasis or timing. But in an oral tradition, these elements are typically picked up along with the words. Not only did a young comic learn the joke, he absorbed the pace and the rhythm of a line, and the inflection or emphasis to give key words or syllables. By watching others perform a particular scene, a burlesque comic could learn, for example, how certain facial expressions or body movement helped communicate the meaning of the joke. Young performers *still* learn comedy timing by watching and listening to and imitating other performers' inflections and emphasis. In fact, most jokes still circulate orally. In burlesque, and in other popular entertainment forms, entire scenes were passed on in this way.

Because it operated in the oral tradition, burlesque naturally stressed the performative aspects of the theatrical experience, in contrast to legitimate theatrical forms that privilege the written text. Scenes were freely revised in the rehearsal process to meet the needs of the performers. "The lines were reshaped by the comedians in rehearsal, altered, pirated, and copied, passing very quickly into the common storehouse from which every comedian felt free to draw," notes Ralph Allen. "Many bits were framed up in rehearsal by a group of performers during long stock engagements in which new scenes were required every week. The framed-up scene was subjected to an exacting trial-and-error test before the audience—pruned, revised, and frozen in to something approaching a final form."[20] Such adaptation was possible because this material was considered to be in the public domain, a heritage belonging to all, that every performer was free to draw on and reshape.

Once onstage, the performers were expected to improvise. Not every comic did so—some stayed very close to the way they had performed a sketch before. Rowland Barber distinguished between "'technicians,' actors who calculated every move onstage, and 'naturals,' who worked on impulse alone, adhering through a kind of instinct to what was right and funny and still in the burlesque tradition."[21] A straight-man had to be able to work with both types of comics. And audiences came to expect a certain spontaneity and immediacy in the performance. As Ralph Allen observed, "This dependence on stock material and on the actor's personal inventiveness became an important element in the burlesque show, which even in its most sophisticated guise always had a somewhat improvisatory air about it."[22]

Abbott & Costello brought this improvisatory quality to their film and television work. The people they worked with during their screen careers regularly remarked on their unusual approach to playing a scene. S. Sylvan Simon, director of their 1942 film *Rio Rita*, said in the film's press book, "It's always impossible to guess what they'll do next. Sometimes they follow the script, but they're just as likely to throw in their own stuff. More so, in fact. They may do something in a rehearsal that's funny enough, but when we're shooting they'll elaborate on it unexpectedly."[23] They needed very little rehearsal time. Charles Riesner, director of *Lost in a Harem*, said:

> They were known as the greatest non-rehearsers of all time; they hated to rehearse. They were both such quick studies that the director would walk them through the mechanics

of the scene and they'd always say, "Okay, let's go!" But in spite of the limited time that they would want to give to rehearsals, they'd have all the moves and all the lines down. It was just no big deal...[24]

In fact, Abbott & Costello could pick up a scene just from hearing it through. Tom Ewell, who costarred with them in their 1952 film *Lost in Alaska*, recalled a conversation in which Lou Costello told him:

> We never even read our scripts. We'll have them bound in leather, and some day when I'm old I'll sit down and read them. We don't even call each other by the names of the charac-ters. We call each other Bud or Lou. Because we have a way of working that we find works for us. That way is this. A dialogue director will come in before a scene and read the scene to us. Now, mind you, we've never read the script; we don't know what the hell the damn thing is about. He reads the scene to us once or twice and we think about it–but we don't rehearse. We go out and play the scene. We come from burlesque and vaudeville. That's the way we work. We take an idea and work it over. I know that's going to be difficult for you, because you don't work that way. But we can't change.[25]

One reason they could do this was that they did not memorize the scene in any conventional sense. Like most performers who were used to working within an oral rather than a scripted tradition, they were concerned with getting the gist of the scene rather than the precise words. As a result, they were able to pick up a scene very quickly. Once onstage or in front of the cameras, they would wing it, trusting their own skills as performers to put the scene over. Because they had an extensive fund of jokes and comic formulas, they could fit new material into structures with which they were already familiar. While Abbott & Costello's methods of working stood out in the film world, it was very much in keeping with the working meth-ods in burlesque. Rehearsals were often perfunctory affairs. Generally, the comics talked through the scenes that were being performed that night. Burlesque comic Rags Ragland reported that he had never rehearsed for more than three hours for any burlesque show.[26]

This is true even for an established piece such as "Who's On First." In the twenty-odd years that Abbott & Costello performed together, they never actually memorized the routine—at least in any conventional sense. In their book *Abbott and Costello in Hollywood*, Bob Furmanek and Ron Palumbo recount that

> Stan Irwin performed the routine twice at benefits with Lou after Abbott & Costello split up. Lou let him in on the secret. "I memorized the 'Who's on First' record, word for word, both parts," Stan explained. "When I met Lou backstage, I said, I'm all set, Lou, I've got it memorized." And he said, "You've got what memorized?" I said, "The record; I know it by heart." Lou said, "I don't even know the record. What Bud and I would do is, we'd go out there and try and catch each other. That way we'd keep it fresh." I said okay, and he said, "You just stay alert."[27]

This way of working seems extraordinary to an audience raised in the tradition of scripted theatre. That such a complex and convoluted routine could be recre-ated hundreds of times, without committing it to memory, is quite an accomplish-ment. But it is the very fact that the routine was *not* memorized that is the key to its

effectiveness and durability. Lou Costello's daughter Chris reports that the pair purposely tried to foul each other up. This kept them on their toes, forcing them to listen carefully to one another. It is easy to let a routine like this get stale, especially after it is performed for years. But by essentially re-creating it in each performance, Abbott & Costello kept "Who's On First" fresh and vital in spite of doing it thousands of times. Occasionally this could backfire. Chris Costello recalls attending a performance in Las Vegas when the team got lost in the middle of the routine, and couldn't find their way out for twenty minutes.[28]

This method of working gave them enormous flexibility. They could make the routine run anywhere from six to ten minutes, depending on the time they had available.[29] They could draw it out or shorten it by adding or dropping players. The version they performed in their first film, *One Night in the Tropics*, only covers the infield. Their more famous version, from *The Naughty Nineties*, includes the outfield.

"Who's On First" is just one of many of the scenes that Abbott & Costello originated on the burlesque stage. In *One Night in the Tropics*, they performed several routines from their burlesque and vaudeville days, including "Mustard," "Paid in Full," "Jonah and the Whale," "Two Tens For a Five," as well as an abbreviated version of "Who's On First." Lou Costello, especially, was most comfortable with material that they had had a chance to play in front of a live audience. Chris Costello noted,

> Dad absolutely refused to use material that had not been successful in vaudeville [and burlesque]. His theory was that a good joke is a good joke—and when updated to fit the times was an even better one. He stayed with that premise throughout his career. All new material had to have some basis in vaudeville (or at least he had to be convinced that it did).[30]

These scenes, in one way or another, had proven themselves in front of audiences.

Early in their film career, they hired another burlesque veteran, John O. Grant, to provide gag material. Grant, who had provided the "books" for a number of burlesque shows, was familiar with the routines that circulated in burlesque and laced Abbott & Costello's early films with well-known bits. Their films—the early ones in particular—were viewed as little more than vehicles for routines that they had honed on the burlesque stage. *Buck Privates*, their first starring feature, included the Drill Routine, the "Dice Game," "Go Ahead and Sing," and "You're 40, She's Ten." *In the Navy* offered another money-changing routine, in which Lou proves mathematically that "$7 \times 13 = 28$." The film also featured the "Lemon Table," a version of the old shell game, using lemons instead of a pea, and "Buzzing the Bee," a practical joke that was featured in burlesque and many other popular entertainments. *Hold That Ghost* introduced the "Moving Candle" bit, which has its roots in a minstrel show sketch called "Over the River, Charlie."[31] *Ride 'Em Cowboy* introduced a burlesque classic, "Crazy House," in which Costello is accosted by inmates of an insane asylum. These are just a few of the Abbott & Costello routines derived from burlesque.

After their first films, the team began to rely less on old burlesque bits, and more on narrative-driven comedy. In the early 1950s, however, Abbott & Costello made

the leap into television. They reprised many of these old bits in their appearances on *The Colgate Comedy Hour* and later *The Abbott and Costello Show*. In the case of their own show, Lou Costello, who owned the rights to the program, wanted a copyright on their routines. So each episode of the first year was built around one or more of their burlesque routines.

The bits that made it into these films represent only a small portion of the material that circulated in burlesque. Hundreds of these sketches existed. Brooks McNamara cites a medicine show comic who claimed to be able to perform three hundred scenes on the spot, and another three hundred on a day's notice.[32] Burlesque comic Rags Ragland once told reporters he knew some two thousand.[33] "A journeyman comic or straight," observed Rowland Barber in *The Night They Raided Minsky's*, "had to know at least a hundred sketches well enough to step onstage with no more notice than a jerk of the company manager's thumb."[34]

Many of these are variants of the same sketch, or alternative treatments of the same material. It is in these variants that we can see the oral tradition at work. Although it is tempting to think of Abbott & Costello's version of "Who's on First" (and in particular the version from *The Naughty Nineties*) as the definitive form of the routine, in fact it is simply one version—and incomplete at that. There are several versions of the routine in manuscript collections of other burlesque comedians, preserved under such titles as "The Baseball Rookie" and "Baseball Scene" as well as "Who's On First."[35] Not only do they offer slightly different treatments of the scene, they include players that Abbott & Costello never mention. In all of their performances of the routine, Abbott & Costello never identify the right fielder. In other versions it turns out to be an already familiar name—Izzy.[36]

Com: Well, suppose I get up to bat and hit the ball to center field. Why catches the ball—throws it to Is he—Is He throws it to Because—Because throws it to What. What throws it to Who—Who throws it to I Don't Know, and I Don't Give a Dam.

Str: What did you say?

Com: I Don't Give a Dam.

Str: He's the short stop.

Com: Oh—Nuts!

Str: He's the umpire.

Com: Oh, the Hell with you—Guum Bye. *(Both exit.)*[37]

Burlesque comics were constantly reworking this material, reshaping it according to their needs. Steve Mills had a variant titled "Who Plays First Sax" in which the baseball players are replaced by members of the band.

Com: Have you got a piano player?

Str: Yes.

Com: Will you tell me his name?

Str: Tomorrow.

Com: Can't you tell me now?

Str: I am telling you now—Tomorrow.

Com: Can't you tell me today?

Str: He's the drummer.

Com: Who's the drummer?

Str: Who plays first sax.[38]

Often a joke or comic premise would be taken out of initial context and reworked into an entirely new scene. Such seems to be the case with a scene titled "Jene Se Pas" [*sic*], from the Gypsy Rose Lee Collection, which takes the confusion over the answer "I don't know." In this scene, the Comic is in France, where he encounters the Straightman, who plays a Frenchman. The Comic wants to pick up one of the local girls. When he asks her a question, she replies:

Soub: Je ne sais pas.

Com: *(To Str.)* She says she is Jenny from St. Paul.

Str: No, no, she did not say Jenny from St. Paul.

Com: What did she say?

Str: I don't know.

Com: I'll go ask her. *(Starts.)*

Str: What you go ask her?

Com: What she said.

Str: But I told you what she said.

Com: What did she say?

Str: I don't know.

Com: I'll find out.

Str: What you go find out?

Com: What she said.

Str: But I just told you what she said.

Com: No, you didn't. I asked you what she said and you said I don't know. Now what did that Jane say?

Str: I don't know.

This kind of flexibility and creativity does not immediately come across when we view the screen work of Abbott & Costello. But it was very much a part of the experience of going to a burlesque show. Audiences for burlesque returned to the show week after week, and watched these scenes performed numerous times, by different comics. It was the rendition of a scene that became important. The comics responded by adding their own material, giving scenes a new twist, investing it with their personalities, making the scene their own. Some were more successful than others. Many burlesque comics were clearly second rate.

But comedians such as Phil Silvers and Abbott & Costello show what people with talent and imagination could achieve within this genre. "Paradoxically, burlesque gave me a lot of freedom," Silvers wrote,

> I could improvise anything I wished—a new bit here, a couple of lines there didn't matter to the others in the scene, as long as it got us all to the blackout. The only critic was the audience. If you failed, the show did not close. This was a big wide-open world for a young comedian. I had a stage, costumes, lights, music, a friendly company and a captive audience. The management gave me all this to play with—and even paid me.[39]

The following chapters attempt to bring this world back to life—the world of the baggy pants comedian.

2. The Oral Tradition and the Popular Stage ❧

Figure 2.1 Everybody performed the sketches, which were considered to be the property of all. Mandy Kay, Jimmie Cavanaugh, and Hank Henry pose with props for the "Lemon Bit" in a publicity shot from the 1950s. (From the author's collection.)

T he working methods of comics such as Abbott & Costello and the reliance on traditional comedy situations have been widespread in the popular theatre. Some of the routines can be traced to European originals, where many of the same comedy bits circulated in English music halls and seaside entertainments, in French clown entrées, and in Italian variety shows.[1] Certain stock routines can probably be traced back to the *commedia dell'arte*. The use of stock situations goes back to the earliest forms of Greek theatre as well as in oral storytelling traditions.[2] If the reliance on stock comedy material had a long history, it became especially important in burlesque in the 1920s and 1930s, when burlesque shifted from being primarily a touring show to a stock company.

As Brooks McNamara has shown in *American Popular Entertainments*, the popular theatre, from circus to medicine shows to vaudeville, has relied on traditional comedy material passed on from performer to performer. This material was considered old well before the 1930s. In *The American Burlesque Show*, Irving Zeidman noted that "*Variety*, in 1907, lamented that burlesque humor was precisely like that of 1900, with stolen lines and stale devices."[3] That same year, comic Roger Imhof observed:

> Much money is expended each season for new burlesque and first parts. After a short hearing they are finally consigned to the archives and a "bit" burlesque is produced. He says, "This was always a knockout. We did it with the Rentz-Santley show..."
>
> So the good material that has been paid for is cast out, for the "water in the hat," "siphon bottle" and "slap stick."
>
> In many instances where a really well-written piece lulls for a minute, someone injects one of those old time bits and makes the entire offering commonplace.[4]

While comments about the "oldness" of the bits were meant to disparage burlesque comedy, such remarks are an indication that we are looking at a traditional form that is being passed down from one performer to the next through generations.

It is my contention that these scenes are an American folk tradition and should be understood from that perspective. Various scholars have suggested that minstrelsy, vaudeville, and burlesque are America's folk theatre.[5] Folklorists, however, have generally resisted this comparison, insisting like Roger D. Abrahams, on the differences between folk and popular theatre. "Folk drama exists on a village or small-group level," Abrahams wrote in 1972. "The performers are members of the community and therefore known to most of the audience... Popular theatre often arises from folk theatre but the players are professional and the audience comes from places other than the community in which the players live."[6]

Although burlesque sketches circulated primarily among professional entertainers, they have all the hallmarks of a folk tradition—simply one that has been moved from a rural to an urban setting. In *The Study of American Folklore*, Jan Harold Brunvand writes, "Folklorists generally associate five qualities with true folklore: (1) its content is oral (usually verbal), or custom-related or material; (2) it is traditional in form and transmission; (3) it exists in different versions; (4) it is usually anonymous; (5) it tends to become formularized."[7] Of these, the first three qualities—orality, traditionality, and variability—are most significant, and Brunvand concludes that "folklore may be defined as *those materials in culture that circulate traditionally among members*

of any group in different versions, whether in oral form or by means of customary example, as well as the processes of traditional performance and communication."[8]

By all these measures, burlesque comedy meets the criteria of a folk tradition. Burlesque comedy is, first of all, "oral or custom-related, that is, it passes by word of mouth and informal demonstration from one person to another and from one generation to the next."[9] While scripts certainly exist, they existed alongside and largely supported an oral method of transmission. Burlesque comics largely worked without scripts, learning the scenes by watching others perform them, and by talking through the scenes before going onstage. Second, these scenes are *traditional* insofar as they are "passed on repeatedly in a relatively fixed or standard form, and circulate among members of a particular group."[10] The fact that they circulate among a professional class of entertainers in no way lessens the traditional nature of the material, for folklore circulates among all levels of society, not just an unlettered minority. While only a handful of these scenes can be tracked back to earlier times with any degree of certainty, contemporary accounts indicate that this kind of material was old. Third, these scenes exist in multiple versions. "Oral transmission invariably creates different versions of the same text, and these versions or 'variants' are the third defining characteristic of folklore," Brunvand observes.[11] This *variability* is one of the most recognizable features of oral narratives and, as Ruth Finnegan has noted, "folklore scholarship is based almost entirely on variation."[12] "Variation in the particular appearance of one item is probably the most reliable hallmark of live folklore available to the student," notes Barre Tolken in *The Dynamics of Folklore*.[13] He observes that "It is axiomatic that we need more than one instance of a tale or motif or ballad or popular belief even to know whether in fact we are dealing with an expression shaped by tradition."[14]

Although orality, traditionality, and variability are the defining features of folklore, two other qualities also come into play. Like other folklore forms, burlesque is *anonymous*. "Folklore," Brunvand writes, "is usually anonymous simply because authors' names are seldom part of texts that are orally transmitted, and folk artifacts are seldom signed."[15] Even legitimate claims of authorship are difficult to establish, in large part because burlesque comics were reworking and adapting well-known and well-established comic motifs. Lastly, burlesque is *formularized*, "that is, it is expressed partly in clichés."[16] Folklorists have recognized that folk narratives rely on verbal clichés and formulas, which "may range in complexity from simple set phrases and patterns of repetition to elaborate opening and closing devices or whole passages of traditional verbal stereotypes."[17] Burlesque, while it makes use of verbal structures, relies more heavily on theatrical clichés—on character types and situations that regularly repeat themselves. Both folk narrative and folk drama create images that communicate a story to the audience. On stage those *images* are largely acted out rather than described.

The idea that folklore can circulate among any group, not just an illiterate peasantry, is a relatively recent development. Prior to the 1970s, when the dean of American folklore scholarship, Richard Dorson, posed the question "Is There a Folk in the City?" in an article for the *Journal of American Folklore*, folklorists were concerned almost exclusively with rural populations.[18] Folklore continues to be associated with the past and with rural life, but in recent decades much of the focus in folklore study

has gone into living folklore. It is now understood that folklore circulates among all levels of society and every social group and persists in a primarily literate society.

It is largely because burlesque sketches circulated among professional entertainers that these scenes were never collected by folklorists or analyzed from a folkloristic perspective. Although folklorists have collected and documented many narrative traditions, folk drama remained something of a backwater in folklore study, allowing a scholar such as Brunvand to assert as recently as 1986 that "some types of folklore (such as folk drama) are nearly extinct in the United States."[19] But if we recognize comedy skits and sketches as a legitimate form of folk expression, as Anne C. Burson argued, then folk drama is very much alive.[20] One of the principal aims of this study is to address this situation, to bring these scenes once again to the attention of scholars and performers.

Folklore is often viewed as static and unchanging—a product handed down intact from generation to generation. In fact, folklore is a dynamic form that draws on materials handed down from earlier generations, but constantly reshapes this material to current needs. Though much of the material is traditional, new material is always coming in and is being combined with older material. It is very much the case with burlesque.

SOURCES AND FEATURES OF THE BURLESQUE SKETCH

Like narratives that survive in oral tradition, burlesque scenes are basically simple in form. Most scenes ran somewhere between three and fifteen minutes. Comic Joey Faye insisted that no scene should go longer than eight minutes. Those that exist in manuscript form mostly run two to three single-spaced typewritten pages. Some of the sketches can be defined as routines—a series of unrelated gags, usually in question-or-answer form played by the comic and the straightman. Most scenes, however, are built around a situation. "The typical bit," wrote burlesque historian Bernard Sobel, "always contains a menacing situation—like a man caught with another man's wife. The situation, because of its universal applicability, is open to innumerable deviations. The second man can kill the first, all three can commit suicide, or turn the whole incident into a joke."[21] Endings often circulated independently of the rest of the scene and it is not unusual to see several resolutions to a particular scene or to find the same ending or "tag" on different scenes.

Most burlesque scenes are versions of a relatively small handful of comic situations—comics' attempts to seduce a girl, getting caught with another man's wife, getting fleeced by a conman, or being brutalized by a cop, a domineering wife, or another authority figure. There were innumerable variations on these standard comic premises, and burlesque comics were always on the lookout for a new angle.

Scenes generally fall into three categories: "body scenes," scenes played "in one," and blackouts. A *body scene*, to cite Ralph Allen, was "the name given by burlesque people to bits that use a full stage set, special costumes and properties, and a cast that includes at least two comedians, a straight man, a character man, perhaps a juvenile...and several talking women."[22] These are usually identified by location—restaurant, schoolroom, or courtroom scenes. A second category of scenes were meant

to be played *in one*. Allen has used the term "flirtation scene" to refer to these scenes, although there is strong indication that the term referred only to pick-up scenes between a man and a woman.[23] These scenes, usually called "acts in one" or "scenes in one" or simply "in one," featured two or three people and were played on the apron of the stage, in front of the olio curtain, which was hung a few feet behind the front curtain.[24] The last category is *blackouts*. Blackouts are short scenes, constructed along the lines of a joke, which lead up to a single punch line at the end. These are relatively short scenes, running a minute or so. They can either be played "in one" or using an entire set. They could also be strung together for a longer scene.

Most of the scenes that became standard in burlesque already circulated on a more or less casual basis in a variety of popular entertainments. Longer and more involved "body" scenes originated as afterpieces. It was common practice in the nineteenth century to conclude a theatrical performance with a one-act farce or comedy. The afterpiece brought all the performers onstage for the finale. "The afterpieces were fashioned about stock situations, invariably ad-libbed or improvised and exist now only as vague and scattered dialogue in the minds of the oldest troupers," Douglas Gilbert wrote in *American Vaudeville*.[25]

A number of these afterpieces were published, primarily as blackface sketches.[26] A few burlesque sketches can be directly traced to these published versions. In the early 1950s, comic Bob Ferguson and his wife Mary Murray were performing "Who Died First?"—a scene originally published in 1874 as a Negro sketch.[27] "The Theatrical Agency" (Jess Mack Collection) appears to be a revised version of the popular nineteenth-century afterpiece "Razor Jim."[28] The courtroom sketch is said to have originated with a minstrel show afterpiece titled "Irish Justice." The term "Irish Justice" is really a category, for, as Joe Laurie points out, "If the judge was played by an Irish comedian, it was called, 'Irish Justice'; if a Dutch comedian played the lead, it was called, 'Dutch Justice'; and if a blackface comedian played the judge, it was called, 'Colored Justice.'"[29]

Although a number of sketches can be traced to published versions, this does not solve the origin of these scenes. Many of these scenes circulated in the oral tradition before being set down on paper. Some of these scenes derive from European originals. The scene published as *Black Justice*, which is supposed to take place in a "Kentucky Courtroom" shows evidence of being an English farce, as characters repeatedly address the Judge as "m'lord." Joe Laurie's version of "Irish Justice" contains a ruse that goes back to a medieval French farce, *Maitre Pierre Pathelin*.[30] The play concerns a shepherd who is accused of stealing the sheep belonging to a draper. He is represented by Pierre Pathelin, a roguish lawyer, who advises him that no matter what question he is asked he should answer by bleating. In Laurie's version, the defense lawyer Guggenheim advises his client, "Now when anyone says anything to you, don't say a word, just make a sound like a nanny goat."

> Judge: To this terrible charge do you plead guilty? *(Hooligan imitates nanny goat.)* I say do you plead guilty or not guilty? *(Hooligan repeats nanny goat imitation.)* Officer, remove him, he's a nut.
>
> Gugg: *(Goes to Hooligan.)* I got you out all right. Where's my ten dollars? *(Hooligan imitates goat and Exits. Gugg appeals to the Policeman, Cop, and Judge and they all imitate nanny goat.)*[31]

Burlesque sketches are closely related to humorous anecdotes known as *schwank*, which circulate as folktales. According to folklorist Stith Thompson, these are "short anecdotes told for humorous purposes [and] are found everywhere. They are variously referred to as *jest, humorous anecdote, merry tale,* and (German) *Schwank.* Important themes producing these popular jests are the absurd acts of foolish persons (the *numskull tale*), deceptions of all kinds, and obscene situations."[32] These are the same themes that predominate in burlesque comedy. Although burlesque is primarily known for risqué or obscene comedy, the sexual scene is only part of the repertoire. Many scenes are essentially trickster tales, which involve deceptions carried out by one character on another. *Schwank* are different from the "regular" folk or fairy tales, which usually have a magical or fantastic component. The *schwank,* Linda Degh writes,

> is a relatively long, well-structured, realistic narrative without fantastic or miraculous motifs. Its humor is obvious and easy to comprehend and the action is funny in itself without a punch line. The themes, though universal, are always localized in villages and small towns, the actors being peasants, small craftsmen, soldiers, itinerants, and members of religious orders.[33]

The burlesque sketch involves many of the same types—doctors, policemen, judges, lawyers—but they are moved to an *urban* setting.[34]

Shorter bits are much less easy to trace, for they were less likely to have been published. Some originated as interludes or "stalls in one," which were performed between the acts of a stage show while scenery was being moved around. These were similar to the afterpiece, but required a smaller cast and minimal props. "One of the most popular was 'Sim Dimpsey.' It was not strictly an afterpiece but a 'stall,'" Douglas Gilbert reported. "Yet it followed the afterpiece formula nearly enough and could run, according to the ad-libbing abilities of the performers, as long as fifteen minutes."[35] "Doing a Sim Dimpsey" became a theatrical expression referring to scenes in which the "comic garbles the speech that the straight man has taught him in a progressively more bizarre way each time he repeats it."[36]

In vaudeville, this kind of talking act was incorporated into the body of the show, and became known as a "two-act." It could be presented by two men, two women (often performing as sisters), or a male-female comedy team doing a "flirtation act." "A pure vaudeville two-act," wrote Brett Page in *How to Write for Vaudeville,* "is a humorous talking act performed by two persons. It possesses unity of characters, is not combined with songs, tricks or any other entertainment form, is marked by compression, follows a definite form of construction, and usually requires from ten to fifteen minutes for delivery."[37] These acts often incorporated song, dance, or parody into the act as insurance, but largely depended on talking.

If many of the scenes and bits had been handed down from the mid-nineteenth century or earlier, the tradition was by no means static. Complaints about the repetitiveness of burlesque bits have led to the assumption that all of the material was ancient. A lawyer for burlesque interests declared, in 1937, that "not one new burlesque skit has been written in the last twenty years."[38] But in fact, new material *was* coming in, new scenes *were* being created. Prohibition produced a number of scenes on the subject of bootlegging and poisoned alcohol. Current theatrical productions

were often parodied on the burlesque stage—Eugene O'Neill's works were especially popular. In some cases, these parodies outlasted the original. The burlesque of a 1923 potboiler *White Cargo* became a standard, and was being performed into the 1960s.[39] What happened was that new material was combined with older bits so that in the end, it seemed unchanging.

Comics lifted material from vaudeville and Broadway revues, as well. In this they were not unique. Pirating material was (and is) an ongoing problem in the entertainment business. "As soon as a 'blue' gag is new, all the comedians copy it, and spring it in each succeeding show, so the muggs know all," *Variety* complained in 1930.[40] Joey Faye learned his craft by watching and taking notes at vaudeville houses, then trying the material out at amateur shows.[41] The Minskys regularly sent staff members to check out Broadway shows. Morton Minsky writes that "Billy [Minsky] got himself and Maisie [Harris, a Minsky's choreographer,] one of those little notebooks that school kids use. They went uptown and watched the shows, writing down all of the song lyrics, the blackout punch lines, and the details of the costumes and dance routines."[42] Later on, Minsky writes,

> I used to go to the Broadway theaters, especially to the revues, the Earl Carroll, George White, and Oscar Hammerstein shows, and pretty soon I was contributing bits that finally appeared on the stage. When I came back from a show, I would tell about a certain scene that I found amusing, and before you knew it, they would send in an assistant manager to steal the scene.[43]

Scenes that originated in a Broadway revue often had a second life in burlesque. Billy K. Wells's "Pay the Two Dollars," written for the 1931 edition of *George White's Scandals*, quickly made its way into burlesque.[44] But not all the material worked, as the Minskys discovered. "We had already found out that you can't tamper that much with burlesque humor. There were an estimated 400 to 600 bits that the comics and most of the audiences knew. They did not like too much in the way of revision. It made them uncomfortable."[45] "There was nothing wrong with a new comedy scene," observed Rowland Barber in *The Night They Raided Minsky's*. "But it couldn't be *invented*. It had to be patched together out of bits of old bits from old burlesque shows. A comic once said: 'If you want a new bit you don't write it. You just remember it up.'"[46]

To be fair, this pirating of material was widespread in the entertainment business and Broadway producers also took material and performers from burlesque. Comics who had gotten their start in burlesque continued to do the bits they learned there after they went to work for Ziegfeld, the Shubert Brothers, George White, or one of the other producers of musical revues. "There are more time-worn bits of burlesque now being shown in Broadway shows than new bits and far more than in burlesque," a *Billboard* reviewer noted in 1930. "These time-worn bits are acceptable to Broadway theater patrons for several reasons; that is, costly scenic productions, colorful lighting effects, efficient stage direction and far more talented and able players than burlesque warrants."[47]

In 1926, the Shuberts brought suit against burlesque comic Harry Steppe for copyright infringement, claiming that the "lemon bit" he was using in a show was lifted

from their revue, *A Night in Paris*. The scene referred to was built around the old shell game played with lemons and is familiar to modern audiences from Abbott & Costello's *In the Navy*.[48] Performers of the 1920s immediately recognized the scene as an old burlesque bit that had been around for over twenty years and "got the laugh of their life," *Billboard* reported. The manager of a burlesque theatre in Providence, Rhode Island, Sam Rice claimed that he had originated the scene in 1907 when working as a comic with the Merry Maidens Company.[49] It appeared that Harry O'Neill, one of the comics hired by the Shuberts for their revue, had worked with Harry Steppe in burlesque and, like many performers, he continued to use his old scenes after moving on.[50]

REMEMBERING UP "FLUGEL STREET"

New gags or comic premises were usually combined with older material so that the tradition seemed unchanging. Such seems to be the case with the burlesque classic "Flugel Street." The scene is most identified with Abbott & Costello, who performed it in the 1944 film *In Society* and reprised it for their 1950s television show. Joey Faye insisted to the end of his life that he wrote "Flugel Street," and went so far as to copyright the scene (as "Floogle Street") in 1942—two years before the Abbott & Costello version was filmed.[51] Faye claimed to have written the scene several years before, sometime around 1934. His claim has been disputed by, among others, John Lahr, who argues that the scene was originally written by Billy K. Wells and that his father, Bert Lahr, played in it on the Columbia wheel during his burlesque days. Indeed, a review in *Billboard* for the 1918–19 edition of *Maids of America* indicates that in a scene played "Somewhere Near Fleugel Street," the "Sweatband Hat Company's hats came in for the usual comedy destruction."[52]

In the appendix to *Notes on a Cowardly Lion*, Lahr reprints a copy of a script identified as "Flugel Street."[53] This script, however, bears little resemblance to the version made famous by Abbott & Costello. In fact, Joey Faye's claim to have created the version most familiar today is probably justified. It is certainly bolstered by a review that appeared in *Zit's Review* of a Minsky show at the Werba Theater in Brooklyn in 1934. The reviewer, Sid Rankin, writes that

> The "Flugel Street" scene was one of the big comedy hits of the first part. It is the first time the writer has seen this scene in about fifteen years. It was written by Billy K. Wells for the "Maids of America." Al Hall did it and how. [Jack] Diamond and [Joey] Faye did the comedy and they sure put it over in a big way. The scene has been changed around somewhat from the original script.[54]

How Faye "changed it around" is instructive for it shows how burlesque comics worked—creating new scenes by piecing together material from a variety of sources. The Bert Lahr/Billy K. Wells version is built around a conflict between Lahr and the bandleader, who takes offense when Lahr disparages unions, and breaks the straw boater Lahr is wearing. Faye's version is set on a street, where the comic is trying to

return some straw hats to the Pascunyak Hat Company located on Flugel Street. Uncertain of where Flugel Street is located, the comic approaches several people for directions.

The first person he encounters is a policeman. The cop is argumentative, taking everything the comic says as an affront. At a 1977 Conference on the History of American Popular Entertainment, Faye explained that it was "a scene which we stole from a vaudeville act called 'Moss and Frye.' The actors were two black boys, and the routine was: One says 'You know nothing, you don't know a thing. I'll show you how dumb you are. Suppose you were standing on the corner with a handful of nickels, how much money have you got?"[55] The scene he is referring to is the venerable "Handful of Nickels," and though it was identified with the comedy team of Arthur Moss and Edward Frye, it became a standard in burlesque. When the comic mentions the Pascunyak Hat Company, the cop takes off the comic's hat. After making an impassioned speech against child labor, he tears the hat to shreds.

The second person the comic encounters is a widow. As Faye recalled it, "Minsky says, 'What is this, four men? Get some sex in there.' Now where are we gonna get the woman? Well, from St. James Infirmary…that was a vaudeville act. Jans and Whalen did it."[56] The original—attributed to Billy K. Wells—features a sexy widow who accentuates her grief over the recent death of her husband with suggestive bumps and grinds. Faye explained that "we took that widow character…and when the guy leaves the cop, the comic says, 'I'll ask this lady.'" On hearing he's returning the hats to Flugel Street, the woman lets out a piercing scream.

> Wom: Floogle Street! Don't you know my husband died on Floogle Street? He was so good, and so kind…and now he's dead…dead. *[At this point she would execute a bump and grind.]*
>
> Com: Lady, lady—your husband ain't dead…he's hiding.[57]

She too takes his hat, tears it up, and smashes the remains on the messenger.

The last character to enter was Faye himself. "Now I come on as a comic stutterer. I say, Oh, the fa…the first thing you do…you do…*(He says)*: is get away from you. *(I say)*: Hey hipatippy, hippatippy." The comic gets so confused by Faye's stuttering double-talk, he begins stammering himself. In the end, Faye frustrates him so much with his answers that he removes the hat from his own head, rips it apart, throwing it to the ground with a triumphant, "There!"[58]

Although Faye fails to acknowledge any debt to Billy K. Wells, his explanation reveals how burlesque comics worked, piecing together new scenes out of older material. The technique, which is common in folk forms, has been dubbed (by Claude Levi-Strauss) as *bricolage*.[59] The term comes from the French term for a "handyman" (*bricoleur*) who uses whatever materials he has at hand to perform a large number of diverse tasks—usually bits and pieces left over from previous projects. The term *motley*, however, is more evocative and certainly more appropriate to a comic form like burlesque, with its connection with clowns and court jesters. Motley refers to a parti-colored or multicolored fabric, and there is a

pieced-together quality, that one finds in quilts, in which a new fabric is constructed from bits of older fabric.[60] Comedy scenes have a similar patched-together quality. Often the ending of one scene is attached to the beginning of another. Others are pieced together from several scenes.

A STANDARD REPERTOIRE DEVELOPS

By the 1930s, burlesque had evolved a fairly extensive repertoire of scenes. Any comic working in burlesque was expected to know these standards, and to be able to step into them with little or no rehearsal. An experienced performer could walk into any burlesque theatre in the country, and put up a scene with people he had never met. Phil Silvers talked about how it worked for a touring comic:

> You had to appear in at least three sketches. They were all traditional, in the public domain, handed down by generations of unnamed, underpaid comics. The title gave you the entire routine. When you walked into a theatre, the manager asked, "What do you want to do?"

> "*Pick Up My Old Hat?*"
> "Did it last week."
> "*Pullman Scene?*"
> "Red is doing that."
> "*The Schoolroom?*"
> "Did it four weeks ago."
> "*Fireman, Save My Wife?*"
> "Ecch..."
> "*The Courtroom?*"
> "Maybe."
> "*Crazy House?*"
> "Now you're talkin'."

> I often ran through twenty titles before I got one into the show.[61]

The precise number of these scenes is uncertain. Rags Ragland claimed to know some two thousand, while Joey Faye reported that he had a collection of eighteen thousand.[62] A more reliable figure is Morton Minsky's estimate of four hundred to six hundred scenes.[63] A typewritten list prepared by Jess Mack includes roughly fifteen hundred titles, but many of these are undoubtedly alternate titles of the same scene. Getting a precise count is difficult, for many (if not most) of these scenes are "variants" of one another—another characteristic of oral traditions. To complicate matters even further, the same scene often circulated under more than one title.

In its June 28, 1930, issue, *Billboard* printed a "dictionary" of burlesque bits sent in by Eddie Welch, an "old-time character-comedian" who was working for the Minsky Brothers at the National Winter Garden. Welch's list contains 150 titles, most of them alternate versions of roughly 50 basic scenes. The list is by no means complete, for many well-known scene titles are missing, but it can be taken as a fairly reliable list of the most well-known bits circulating at the time.

AT THE RACES—The Last Race, So Long, See You Later, The Derby, Boat Races, Put the Saddle on the Horse.

BARNUM WAS RIGHT—Sucker Born Every Minute, Little Daughter Rosie, Hello, Sucker, I'll Do Well Here, Turning the Tables.

CASEY THE FIREMAN—Little Simmy Dempsey, What Did the Jailer Do, Pie in the Face.

CIRCUMSTANTIAL EVIDENCE—Third Degree, The Inspector, The Reformers, The Judge, The Westerner.

ENCHANTED LILY—The Enchanted Rose, The Poppy Scene, Turn to Nance Scene, Rose in a Garden Grew, Stick It In Your Album.

GARTER BIT—Getting Gertie's Garter, See A Little Higher, Three Garters on Leg.

GRAVEYARD MYSTERY—Dissection, Over the River Charlie, Take the Bag, At Midnight, Fluey Fluey.

HAUNTED HOUSE—Oh, Charlie, Spirit Rappings, At Midnight, Near Hour One, Ghost in the Pawn Shop.

HIGHNESS TO THRONE—King for a Day, Auction of Wives, To the Throne, The Rajah.

IN SOCIETY—Dance Your Way Over, Give Her the Card, Meet Me on the Corner, Something You Don't Expect.

INDIAN LOVE—Tomahawk Scene, Play on His Tom-Tom, Her Tepee.

INSPECTOR—Killem Harry, Third Degree, Apartment 44, Can't Make a Case With One Quart, You Refuse To Answer.

JANITOR—Hunting Apartments, The Janitor, You Must Come Up.

KISSING SCENE—Art of Kissing, Blindfolded Kisser, Interrupted Kissing, Kissing Bee.

LAVALLIERE BIT—Tie My Shoe, Brother-in-Law, The Badger Game, Missing Lavalliere, Shooting Backwards.

LEMON BIT—Waiting at the Church.

LEMON GAME—Three-Shell Game, Lemon Bit.

LOVE SCENE—Love From a Book, Love on a Bench, Love for 10 Cents, Love and a Cookbook, Love-Making Clock.

MATCH PEDDLER—Ten Matches for a Penny, How Old Is Your Father?, Lead Pencil Vender.

MOVABLE BAR—Bootleg Cop, Street Cleaner Bootlegger, Rolling Chair Bootlegger, How Many, Brother, Police Club Bootlegger.

NECKLACE—Diamond Necklace, Missing Lavalliere, Stolen Pearl Necklace.

NUMBER BIT—One to 10.

NO CLUBS—He Reniged, You Do Love Me.

PERFUME SCENE—Ottar of Roses, The Dummy, Oh Yes You Will (Nance Cop).

PINOCHLE—Pinochle Fiends.

POLICE HOLDUP—I Got a Story Too, The Holdup, Come to Jail, An Accommodating Cop, A Nice Policeman, Holdup for Convenience, A Polite Burglar.

RESTAURANT SCENE—Pousse Cafe, White Seal, 16 Straws, One Sarsaparilla, All Cut Up and Bleeding, Ordering Bill of Fare, Syncopated Menu.

REFORM—We'll Reform You, Bootlegging Deacon, We'll Reform the World.

REST—A Quiet Night's Rest, Room 44–45, Good Night, Landlady, Oh, Sarah, Ala Gazam, The Quiet Hospital.

ROSE—Rose in My Garden Grew, Fanny Herring Bit, Stick It in Your Album, The Rose Bit.

SAUSAGE BIT—No I Haven't Heard This Story Before, Have the Sausage or the Money, Can't Ask Three Questions.

SAVE YOU—Smith Family, Blind Man Bit, Tincup Bit, Too Good to Live (Shoot Woman).

THE SLAP BIT—Do It Again, The Choking Bit, Slap Him the Hardest, Choke Him the Hardest.

SOMNAMBULIST—The Sleep Walker, She'll Bring It Back.

SULTAN'S GARTER—Three-Garter Bit.

THREE BOMBS—Three Keys, Three Bracelets, Three Grips, Three Garters.

THREE CIGARS—One Banana Have You, Do You Smoke, Here's a Pipe.

THREE COLOR LIGHTS—Three Bells, Three Auto Horns.

THREE TIMES THREE—Three Hats, Three Dusters, Any Three Counting Bits (Add More Each Count).

TOUGH BARTENDER—Come in, I'm Tending Bar, Throw Out Scene.

UNION BIT—Straw Hat Bit, Flugel Street, Union Employees.

UNION MAN—The Socialist, The Democrat, The Republican, Would You Be a Thief Too?, His Ancestors Were Socialists, Eight Hours a Union Day.

THE VAMPIRE—Pantomime Drinking Bit, A Fool There Was, Kipling's Vampire.

WAHOO—Wahoo Bitters, The Trimmers, Go to Hell, Go to Hell, Go to Hell, Not Worth the Paper It's Printed On, Wahoo, My Boy, It's Wahoo.

WINE BIT—Whisky Taster, Gin Tasters, Rat Poison, Port Wine Scene.

WIDOW—Waiting To Hear the Shot, The Widow, No Now, No Next Week.

WOMAN HATER'S UNION—Remember the Union, Stick to the Union, To Hell With the Union.

THE WRONG ONE—His Wife, Do It All Over Again, Yes, That's the Right One.

The article explains that "Welch has taken the original titles a la Webster … and given their definition or aliases."[64] It is not that simple. While burlesque comics often ran standard scenes under new titles, the alternate title might indicate some kind of variant scene. Burlesque bits often went by different names.

This is the case with the "banana bit" that Phil Silvers suggests was the source of the term "second banana." The title "One Banana Have You" appears as an alternative title to the sketch called "Three Cigars." The other titles listed—"Do You Smoke, Here's a Pipe," "You Drink the Third," "You Smoke the Third One," and "Three Glasses of Wine"—show that the scene could be performed with cigars, pipes, glasses of wine or another alcohol. Simply shifting the object created a different version of the scene. Given their work pressures, comics had an incentive to do so.

Welch's listing demonstrates the complexities that arise in classifying these bits. In some cases, these are alternate titles of the same bit, but in other cases they indicate quite different scenes. The haunted house sketches indicate some of the difficulties. Welch provides alternate titles for the "Haunted House" sketch.

HAUNTED HOUSE—Oh, Charlie; Spirit Rappings, At Midnight, Near Hour One, Ghost in the Pawn Shop.[65]

He also classifies "At Midnight" among scenes labeled "Graveyard Mystery."

GRAVEYARD MYSTERY—Dissection, Over the River Charley, Take the Bag, At Midnight, Love-Making Clock.[66]

One of the difficulties with these bits, however, is that the same bit often circulated under more than one name. And a title might apply to more than one bit. "The Lemon Bit" applied both to a version of the old shell game using lemons instead of peas, and to a scene in the Gypsy Rose Lee Collection where the comics, expecting to see the soubrette dance a cooch dance for them, get stuck with bags of lemons.

Although a scene might go by more than one title, the situations themselves were so familiar, experienced burlesque performers could put a scene on its feet with little or no rehearsal. Rags Ragland claimed that he had never rehearsed longer than three hours in burlesque.[67] Most rehearsals were much more perfunctory than that. Comics, who were familiar with the basic outline of the scene, simply talked through the scenes before going onstage. Often they would be familiar with slightly different versions of the scene and had to compare notes before going onstage.

In her autobiography, Gypsy Rose Lee gives an account of one of these run-downs, recalling the first time she stepped onstage in a burlesque bit.

> "Ever done the 'Illusion' scene before?" [Herbie] asked me.
> I shook my head.
> "Well, it don't matter," he replied. "I do a rehash on it, anyway. I don't use none of that Tondelayo dialogue. I go right inta the switch on the Joe the bartender bit only I use a ukulele instead of a bull fiddle. And after the yok yok with Stinky, the second banana, the lights come up and you're lying stage left in front of a grass hut. I give you a skull, then a slow triple, and you get up and start giving me the business. You do about four bars a bumps and grinds while I chew a hunk outa the grass hut, then you read your lines, 'I'm not illusion,' you say. 'I'm real—here, take my hand—touch me, feel me...' You scram on the blackout and I finish the scene with Stinky."
> "What finish?" I asked faintly.
> "Him and me clinching—the old tried and true.[68]

The scene Gypsy is describing is a blackout that survives in several collections, including one in the Ken Murray Collection titled "Shipwrecked Sailor's Illusion."[69] It recalls the scene in *The Gold Rush* in which Mack Swain hallucinates that Charlie Chaplin is a giant chicken. Here the dream sequence replaces the male Comic with a sexy island beauty, only to discover, when the lights turn up, that he is embracing the Second Comic.

Shipwrecked Sailor's Illusion

AT RISE both comics on grass mats asleep at R of Stage.

1st: Wake up, all you do is sleep.

2nd: Oh shut up and go to sleep.

1st: How can I go to sleep? I tell you I can't stand it on this island much longer.

2nd: Will you keep quiet and don't worry so much. Some day a boat will come along and pick us up. Now come on and get some sleep.

1st: That's all you've been saying for the past six months, a boat will pick us up. I tell you man this place is driving me crazy. Oh gee, if I was only home

now instead of looking at these trees from morning till night. Gee, ain't you got any feeling at all? I want to go to dances again—I want to see my friends. I want to laugh. I want to see those that I love. My sweetheart. My mother. I tell you I can't stand it any longer.

2nd: Oh go to sleep. Go to sleep. *(1st Comic sinks to floor still raving about wanting to go home—LIGHTS OUT—2nd Comic exits—Girl enters and takes 2nd Comic's place on grass mats—LIGHTS UP.)*

Girl: Hello!

1st: Who are you? *(Rises and backs away with Girl following.)*

Girl: Why don't you know me? Everyone knows me. I am known all over the world. I am Illusion.

1st: Go away from me.

Girl: Don't be afraid, I will not hurt you.

1st: I know, but I'm liable to hurt myself. Leave me alone.

Girl: Feel me. Feel me. I am real.

1st: No, I'm too young. *(Girl vamps 1st Comic over to mat again and draws him to the floor—LIGHTS OUT—Girl exits—2nd Comic reenters and takes original position—LIGHTS UP—1st Comic is trying to get on top of 2nd Comic.)*

2nd: Here what the hell are you trying to do?

1st: Why, I must have been dreaming.

2nd: Well, if you are going to have any more dreams like that, get the hell on the other side of the island.

BLACKOUT

In this episode, Gypsy has only a small part, but the comic gives a run down of the action as he would with an experienced burlesque performer. She only needs to know one line of dialogue. The rest is just an outline of the action that will take place, and Gypsy needs to get a gist of what is supposed to take place in order to play the scene. "Herbie" uses references to other well-known bits and employs theatrical jargon that describes specific actions. Experienced performers could run down much more complicated scenes in much the same way. The explanation contains references to other well-known bits. "Tondelayo" refers to the beautiful native girl in "White Cargo" who seduces and destroys white men.[70] "Joe the Bartender" is a classic "rave" scene in which the straightman plays out a scene in fantasy in which he murders a bartender and is hanged for the crime.[71]

"Herbie's" run-down also contains terminology and jargon that Gypsy, having grown up in vaudeville, would be expected to know. To do a "switch" on a bit is to create an alternate or topical version of the joke, writing a new set-up or punch line for the joke. The meaning of the term "ukulele" in this context is uncertain, but it was frequently used as a phallic reference, noting its small size in comparison with a "bull fiddle." A "yock" was a loud laugh or a belly laugh. The "second banana" refers to the number two comic in the cast. A "skull" was the burlesque term for a "take," as in the expression "double take," while a "slow triple" is a delayed reaction or take, often involving more than one turn of the head, like a "double take." "Chewing a hunk

outa the grass hut" is a switch on the phrase "chewing up the scenery," a theatrical term for zealous overacting.

One of the things the comics would talk through is which ending to use. A scene might have a number of alternate resolutions. In an adultery scene, for instance, where the straightman discovers the comic in his wife's bedroom, there would be a number of ways to end the scene. The finer points would be worked out in performance. With four shows a day, the comics essentially rehearsed the scene in front of the audience. "Week after week a new afterpiece was presented, little better than a dress rehearsal at the Monday matinee, but going full swing toward the middle of the week, when half-forgotten bits were recalled and inserted,"[72] recalled Joe Laurie, Jr. In this way, burlesque comics could put together a new show with little or no rehearsal. This method of working became especially important in the 1920s, when burlesque shifted from being a touring show to a stock company.

3. The Pressures of Stock Burlesque ✧

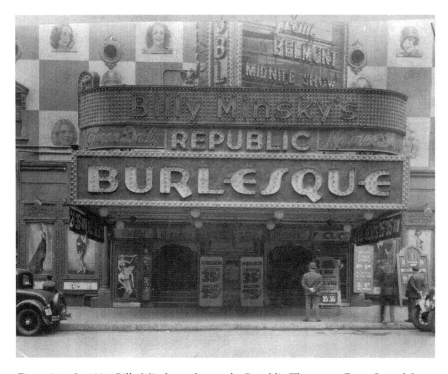

Figure 3.1 In 1931, Billy Minsky took over the Republic Theatre on Forty-Second Street prompting a backlash from Times Square business interests, which eventually led to the ban on burlesque and even the Minsky name in New York City. (Courtesy of Photofest.)

Prior to the 1920s, most burlesque shows operated as touring companies. Performers were hired for an entire season, averaging forty weeks, and they rehearsed and played essentially the same show for the entire season, performing in a different city each week. In the first two decades of the twentieth century, the business was controlled by two circuits, called "wheels," that booked shows into participating theatres, rotating the shows from one city to the next like spokes on a wheel. The wheels, particularly the more powerful Columbia Wheel, were concerned with "improving" burlesque, making it respectable. In the atmosphere of

the Jazz Age, this approved form of burlesque began to look dated, and many of the houses that once booked touring shows found it more profitable to hire their own companies and stage their own productions. Without the interference of the circuit managers, stock burlesque houses could offer a rawer form of entertainment featuring erotic cooch dancers, double entendre humor, and, eventually, the striptease.

By the 1930s, stock burlesque came to dominate the business. In stock burlesque, the performers themselves were responsible for putting the show together. Comics began collecting material for use. Steve Mills, who got his start on the Columbia Wheel and made the transition into stock burlesque, explained how it affected the comics.

> Now if you're doing a book show, as on Columbia, they put it on for you; but in stock there was no book, you're doing a new show every week, you've got to be ready with three scenes at least. Once in a while you'd get away with two. So you build up, you start collecting these scenes, from watching and listening, and you put it on paper somehow, because next time you play it—it may be five years later—there may be a different angle you find.[1]

It is the stock burlesque of the 1920s and 1930s that most people envision when they hear the word "burlesque." This is the period when the striptease was introduced and came to dominate the form, when such stars as Gypsy Rose Lee and Ann Corio became big box-office draws, and when the Minsky brothers moved burlesque out of the Lower East Side into the heart of New York City's entertainment district on Forty-Second Street.

STOCK BURLESQUE

Although burlesque is associated with the 1920s and 1930s, the American burlesque show dates back to the Civil War era, when an English burlesque troupe—Lydia Thompson and Her British Blondes—arrived in New York City, presenting a three-act extravaganza titled *Ixion, or the Man at the Wheel*. A rather ordinary send-up of a Roman tragedy, it was written in verse and relied heavily on punning humor. What set this production apart from earlier burlesques was that it featured cross-dressed women in most of the major roles. Outfitted in short Roman togas, the costumes revealed the actresses' legs, at a time when respectable ladies kept their lower limbs hidden beneath full-length skirts. The spectacle of seeing women onstage exposing their legs was both scandalous and alluring, guaranteeing the success of the production and spawning a host of imitators.[2]

The burlesque show, as it evolved in America, combined English burlesque with variety entertainment and blackface minstrelsy. A number of burlesque shows toured the country in the last decades of the nineteenth century, booked into variety halls primarily in the northeast and upper midwest. As burlesque troupes proliferated, efforts were made to systematize bookings and improve its reputation. Shortly after the turn of the century, the Columbia Amusement Company, better known as the Columbia Wheel, was organized in an effort to consolidate the business.

Stock burlesque emerged as an identifiable form in the early part of the twentieth century, when many of the wheel houses, desiring to keep their doors open during

the summer months, put together stock companies to perform in their theatres.[3] Instead of relying on a new show to come in each week, the performers themselves were responsible for coming up with a new lineup every week. This formula was not new; it just had a new name. The roots of this form of entertainment go back to the Gold Rush era, when the first variety shows began to be staged in saloons and honky-tonks. Bernard Sobel states that the first honky-tonks started on the Barbary Coast, and identifies a place called The Comique, in Seattle, as the first.[4] Although concert saloons are associated with the frontier, as a result of movie westerns, they flourished in many communities across the United States, particularly in those with large, single-male populations. In New York City, they emerged in the 1850s.[5] The concert saloons advertised "pretty waiter girls" who were available to serve customers and to drink with them. In many cases, these women performed onstage, in the *corps de ballet* or early chorus line.

These early variety shows drew heavily on the minstrel show, which had been the leading form of popular entertainment in the years preceding the Civil War, but offered the added attraction of putting women up on stage. Most of the comics who performed in the early variety houses were former minstrel men, who continued to work in blackface. "Bills averaged from twelve to fifteen numbers and lasted longer than an English week end," Douglas Gilbert reports in *American Vaudeville: Its Life and Times*. "The 'first part' usually ran forty-five minutes. Next came the olio, that is, the variety acts of song and dance, comic skits, acrobats, afterpieces, closing dramas, and what not."[6] The bill concluded with an afterpiece, "in which all the performers in the olio appeared."[7] The lineup, with its reliance on song and dance acts, comedy sketches, and a *corps de ballet*, bears a strong resemblance to the burlesque program of the early twentieth century.

Variety entertainment was a male-only preserve and remained so into the 1880s, when a number of producers, notably New York City's Tony Pastor, made an effort to clean up the variety show and make it acceptable for a general audience. Pastor began to attract women to his shows by offering product giveaways and banning suggestive material from his theatre, located on Union Square, near the fashionable shopping district. Although Pastor continued to use the term "variety" to describe his shows, other producers appropriated the term "vaudeville" to give their shows a European refinement and to distinguish them from the disreputable variety entertainments of earlier decades.

Stock variety thrived in the areas that the touring shows did not visit. They were more likely to be in small towns. Since the burlesque circuits extended no farther west than Kansas City, stock houses flourished on the Western frontier. One could also find them in seedier bars in those cities where burlesque did play. Coney Island was one place where stock variety operated freely. "By the mid-1910s, a few enterprising producers organized what were called "stock" burlesque troupes to play wheel houses during the summer. Other show business entrepreneurs took over theaters in run-down areas of big cities and installed stock burlesque without affiliating with either wheel."[8]

The managers of the wheels were concerned with improving the respectability of burlesque, putting burlesque's reputation as indecent entertainment behind them. They were largely successful when it came to their own shows, but they had little influence over the stock houses, which were wide open. In the anything-goes

atmosphere of the Roaring Twenties, audiences showed a marked preference for the more risqué entertainment available in stock burlesque.

Stock burlesque houses discarded the three-act structure of the traveling burlesque shows, in favor of the "bit-and-number" format of variety. The stock houses offered a rawer form of entertainment that featured "cooch" dancers. Cooch dancing derives from the "hootchie-cootchie," the colloquial term for the Middle Eastern *danse du ventre* that was introduced at the 1893 World's Fair and quickly became *the* "scandalous" dance. Employing the shaking movements of what we know as belly dancing, by the 1920s it was being performed to a jazz beat. The dance was normally performed by the soubrette, costumed in an outfit vaguely reminiscent of Middle Eastern dancers. It "usually consisted of a semitransparent brassiere and short skin tights, open at the hip."[9] The cooch dancer did not remove her garments. The eroticism of the dance had to do with shaking the hips and breasts in movements that became known as "bump and grind." In rougher houses, the entire chorus line would participate. "The chorus girls on the runway, yelling, shimmying directly at and over the men, the music blatant, jangling and dissonant, the audience alternately hooting or derisively encouraging—it was a demoniacal, orgiastic spectacle," Irving Zeidman writes in *The American Burlesque Show*. "Hands upraised to a merciful heaven, the girls would sprawl out on the runway, twist, writhe, squirm and shake, each to her own inventive, obscene devices."[10]

Although burlesque is now identified with the striptease, it was unknown before the mid-1920s. Ann Corio puts it specifically in 1928.[11] About that time, *Billboard* began to identify striptease dancers in their reviews.[12] Just who originated the striptease is uncertain. Morton Minsky claims that it was invented at the National Winter Garden by Mae Dix.[13] Rowland Barber suggests that it happened in 1925, but the story in *The Night They Raided Minsky's* is certainly apocryphal.[14] Most accounts have it coming out of Chicago, attributed to an early striptease star Hinda Wassau. The most frequently told story is that her bra-strap broke as she was leaving the stage. The audience went wild. After that she arranged to have the bra-strap break every night.

The most famous of these stock burlesque producers were the Minsky Brothers in New York City.[15] The Minskys—Abe, Billy, Herbert (known as H. K.), and, later, their younger brother, Morton—got their start in a Lower East Side theatre owned by their father, Louis. The ground floor of the building, which was located on the corner of Houston Street and Second Avenue, housed a well-known Yiddish theatre, the Tomashevsky. The top floor held another theatre—dubbed the National Winter Garden—which had never been particularly profitable. So in 1913, Louis Minsky turned it over to his sons to run. After first trying their luck operating the theatre as a movie house, they turned to burlesque. For a few years, they ran the house as a wheel operation, booking shows of the Empire circuit. But by 1920, they had turned to burlesque, organizing their own companies and putting together their own shows.

The showman of the clan and the person largely responsible for the success of the Minskys in burlesque was Billy Minsky. Billy had been a society reporter for one of the New York City newspapers, and he had a particularly keen sense of generating publicity. He began attracting prettier chorus girls by paying them thirty dollars a week, at a time when most were getting fifteen. He drew a largely neighborhood

crowd, according to Irving Zeidman, because he "emphasized neighborhood camaraderie and good fellowship."[16] But Minsky also made efforts to bring in a more upscale crowd. Prohibition was luring uptown drinkers to Lower East Side speakeasies, and Minsky's burlesque became a regular stopping place for slumming parties. One of Billy Minsky's publicity stunts was to send season passes to professors at nearby New York University. Soon the uptown literary set began frequenting the theatre; e. e. cummings was a frequent visitor, as was Edmund Wilson, who reviewed a Minsky's show for *The New Republic*.[17] "The great thing about the National Winter Garden show," Wilson wrote,

> is that though admittedly as vulgar as possible, it has nothing of the peculiar smartness and hardness that one is accustomed to elsewhere in New York. Though more ribald, it is more honest and less self-conscious than the ordinary risqué farce, and though crude, on the whole more attractive than most of the hideous comic-supplement humor of uptown revue and vaudeville.[18]

DEPRESSION-ERA BURLESQUE

In 1933, there were some fifty burlesque theatres scattered across the country.[19] The count is an approximation, since many theatres, struggling through the Depression, experimented with different entertainment policies, shifting from burlesque to variety to film and back again, in an often unsuccessful effort to attract an audience. Most burlesque theatres were located in the northeast and the upper mid-west, along the routes where the Columbia and Mutual shows toured. New York City had the heaviest concentration of burlesque houses with fourteen in all: eleven in Manhattan and three in Brooklyn. Two others—the Empire and the Hudson—were located across the river in New Jersey. Detroit came in second with five theatres running burlesque. Chicago had four burlesque houses. Boston had three. California was another center for burlesque, with the Follies and the Burbank in Los Angeles, the President in San Francisco, the El Rey in Oakland, and the Hollywood in San Diego. Most good-sized cities had burlesque theatres of some note—the State in Seattle, the Gayety in Minneapolis, the Empress in Kansas City, the Garrick in St. Louis, and the Trocadero in Philadelphia. One could find burlesque playing in a number of smaller cities in New York State, New Jersey, Pennsylvania, and Ohio, including in such factory towns as Wilkes-Barre, Allentown, Trenton, Rochester, and Schenectady.

Most burlesque houses were located in run-down commercial or industrial neighborhoods, where rents were cheap. One could often find several burlesque houses clustered together in neighborhoods marked by low rents, deteriorating buildings, and transient populations.[20] In Boston, several burlesque houses, including the venerable Old Howard, were located in Scollay Square, across the river from the navy yard. In Chicago, three burlesque houses were located in the area near the intersection of State and Madison Streets, a district of saloons and flophouses. In Los Angeles, the Follies and the Burbank were located directly across Main Street from each other in the downtown area of the city. These neighborhoods also housed pool halls, speakeasies, taxi-dance halls, small-time vaudeville houses, and other lower-class amusements.

In New York City, the Bowery had historically been the center for this kind of entertainment. In the early nineteenth century, the Bowery and lower Broadway were the hearts of the entertainment district. As the population of Manhattan moved north, the theatre district also moved, leaving a number of empty theatre buildings in lower Manhattan—buildings that were taken over by a variety of low-priced entertainments. The association of burlesque with the Bowery goes back to the nineteenth century when Miner's Bowery and the London Theater were located there. By the 1930s, the Bowery was a depressed area. "The Bowery, in Southern Manhattan, is a quarter virtually without women," Geoffrey Gorer observed in 1937. "The long, wide and desolately empty street, with the 'El' running down the middle, is almost entirely made up of rooming houses and hotels For Men Only, with beds at 15 to 35 cents, and rooms from 30 cents to a dollar."[21]

The Minsky's original burlesque house, the National Winter Garden, was located one block east of the Bowery. At the upper end of the Bowery, just north of Union Square was another important stock burlesque house, the Irving Place Theater. The Irving Place was considered a "class" house, and was the only theatre in the city to maintain a policy of two shows a day when most burlesque houses began offering continuous entertainment. At the other extreme was the Peoples Theater, located at Bowery and Delancy, in the vicinity of Chinatown. The Peoples was known as a "scratch" house, one that offered low prices and drew a particularly seedy clientele. Another such house was the Fifth Avenue Theater located at Broadway and Twenty-Eighth Street. A *Variety* reviewer, in 1937, panned it as "the worst burlesk in N.Y." The owner promptly used it in his advertising, and claimed that it boosted his business by 30 percent.[22]

The other center for burlesque in New York City was Harlem. The famed Apollo Theater on 125th Street was built as a burlesque house in 1913 and was operated as one until 1934, when new owners made it famous as a variety house for the African American community. Also on 125th Street was the New Gotham Theater, located several blocks east of the Apollo. A 1935 *Fortune* Magazine article mentioned an unnamed Spanish-language burlesque house on 116th Street and 5th Avenue, probably the Teatro Hispano.[23]

TIMES SQUARE BURLESQUE

In the 1930s, the center for burlesque in New York City shifted to the Times Square area. Broadway had been declining for several years before the 1929 stock market crash, as motion pictures and, later, radio drew the audience for live entertainment. Theatres in the more desirable locations along Broadway had been converted to movie palaces. The remaining theatres, mostly located on side streets, struggled to draw an audience. Feeling the pinch of the Depression, and taking advantage of empty houses in and around Times Square, Billy Minsky took over the lease on the Republic Theater on Forty-Second Street and brought burlesque to Broadway. Other burlesque producers followed suit. A month after the Republic opened, Max Rudnick leased the Eltinge Theatre across the street and instituted a policy of continuous entertainment. H. K. Minsky took over the Central Theater at Forty-Eighth

and Broadway that fall, while Abe Minsky moved into the Gaiety Theater right next door. In the fall of 1934, Max Wilner took over the Apollo Theatre two doors down from the Republic on Forty-Second Street. At the height of the Depression there were five burlesque theatres operating in the Times Square area.

The move to Broadway represented the height of stock burlesque, and simultaneously heralded its demise. So long as such risqué entertainment was confined to lower-class districts, it could be tolerated. But its arrival on Broadway shocked and threatened the business community, already reeling from the Depression. They were joined by the local tabloids, most notably the *Daily Mirror,* which expressed outrage at what was taking place in Times Square, while providing titillating reports on the dialogue and methods of disrobing. In the spring of 1932, the Forty-Second Street Property Owners and Merchants Association launched a publicity campaign to drive out the burlesque theatres, on the grounds that they represented a menace to morality. They were joined in their efforts by the Society for the Suppression of Vice and a number of clergymen. Mayor Fiorello La Guardia, elected on a reform platform in 1934, joined the efforts, and was eventually successful in closing New York City's burlesque theatres.

Although much of the public blamed the decline of Times Square on the arrival of burlesque, in fact, the presence of burlesque houses was an indication of changes that were already going on. The Great White Way was turning into a low-priced amusement center. As stores and restaurants that depended on the theatre trade closed their doors, their storefronts were taken over by contract bridge games, chess tournaments, chop suey parlors, and side shows, and Times Square increasingly took on the feel of a carnival midway. A guide to the city from 1939 described the area: "Adjoining elaborate hotel and theater entrances and wide-windowed clothing shops are scores of typical midway enterprises: fruit juice stands garlanded with artificial palm leaves, theater ticket offices, cheap lunch counters, cut-rate haberdasheries, burlesque houses, and novelty concessions."[24]

The burlesque houses contributed to the midway quality of the area. Theatres employed barkers to call out to people on the street, describing the attractions that were available inside. Men wearing sandwich boards—some on stilts—paraded up and down the street. Large neon signs advertised "Continuous Entertainment" inside, and posters of showgirls decorated the outside walls. "Each makes a bid for patronage by the display of huge pastel posters showing the blond and brunette sirens in every stage of provocative undress, and promises even further adventures in nudity in the dimly-lighted interior," the *Daily Mirror* trumpeted.[25] The walls of the lobby were covered with the same sort of pictures that graced the exterior of the theatre—images of "beautiful girls, skirts gayly raised to reveal stockings and garters to the goggle-eyes of a bald-headed man."[26] There were photographs and drawings of performers, past and present, some of which were identified by name. "There are invitations to see '40 Bewitching Damsels 40,' in 'Burlesque As You Like It.' One is told this is 'the hottest show in town.' '20 Red Hot Mammas,' 'Madame Kishka Dances,' are signs often seen."[27]

The price of admission depended very much on the theatre, and on whether it was a "two-a-day" or a "grind" house. Until the 1930s, burlesque houses ran two shows a day: a matinee at 2:30 in the afternoon and an evening show that normally started at 8:30. On Saturday nights, most theatres added a midnight show. Prices ranged from

twenty-five cents to a dollar ten. Seats were reserved, and those closest to the stage were the most expensive.[28] The best seats were sold out well in advance, reserved for the regulars who attended the show each week.

During the 1930s, most burlesque houses shifted over to a grind policy. The term "grind" had nothing to do with the bump and grind, but referred to a policy of continuous entertainments. Admission to a grind house ranged from ten to fifty cents, depending on the house and time of day. Seats in the grind house were not reserved, and members of the audience could stay as long as they wished, so a number of transients and unemployed used them as flop houses. Even some of the Broadway houses depended on this trade. Harold Minsky recalled that

> at one of the family's theaters, the Gaiety, we charged only a quarter admission before one p.m. every day, and we got a great play from the unemployed. Wives would turn their husbands out into the streets in the mornings to look for work. The husbands knew there was no point in looking for jobs that didn't exist, so they passed their time as best they could. Before one p.m., there was always a big line waiting to get into our Gaiety. Inside, they could see a show and a movie, and sleep.[29]

A VISIT TO A BURLESQUE HOUSE

The makeup of the audience depended on the theatre. Those located in the Bowery, as well as those outside of Manhattan, largely drew a neighborhood crowd, which was decidedly working class. "Weed out the regular patrons of long-established houses, weed out slumming socialites, rowdy collegians, and honest seamen ashore, and where once the bloods of the town sat now sit the backwash of a depressed industrial civilization, their eyes alight and most of their mouths open."[30] The Broadway houses made a special appeal to tourists "eager to savor the wicked delights of the big city."[31] On a Saturday night, particularly at the midnight show, you could expect to find slumming parties, young men with their dates, and groups of college boys. But during the week, especially in the daytime hours, shows served as a refuge for the unemployed.

Before the show got underway, the candy butcher would take the stage and deliver a harangue about the candy available. The candy butcher had the candy concession at the theatre, and his spiel became one of the traditional features of the burlesque show. "I have here a box of chewy, delicious chocolates, manufactured especially for the patrons of this theatre by the Lofty Candy Company of St. Louis," one spieler promised. "Now a box of chocolates such as this would cost a dollar in any confectionery establishment—and you would consider those chocolates cheap at that price."[32]

Several young assistants would be working the aisles, hawking candy to the members of the audience while the candy butcher kept up his spiel from the stage. "Concealed in some of the boxes of chewy delicious chocolates is a selection of big bonus gifts. You buy the candy and may receive either a twenty-dollar bill, the key to a Ford automobile, a season pass to this theatre, a lady's alligator-style wallet, a gold-plated pen and pencil set, or a deluxe smoking article," the spieler would announce.[33] The customer, of course, never actually received these articles and most of the audience was well aware of this.

When the candy pitch was finished, the candy butcher trotted out an old edition of a sex magazine. "The magazine, we are told, 'contains ten sensational and daring stories of the kind you like to read,' about places 'where men are men and women accept tips.' Added feature, we will be reminded, are twenty beautiful girls 'posed just the way that nature made them, and if you can't get a kick out of those, you'd better see your doctor.'"[34] Before concluding the sale, the candy butcher might offer a novelty like a peep show device.

Once the candy butcher had moved all the merchandise he could, the lights dimmed, the band played an overture and the curtain would come up on the opening production number. The stage was usually decorated to suggest some far-off land or exotic environment.

> Against a spangled background, a chorus of 18 or 20 girls is revealed, three rows deep, graded according to size, figure and avoirdupois. The girls are "modestly" clad in girdles and brassieres. Keeping time as best they know how (which is pitiably little, for their instruction in terpsichorean art is as brief as it is inept) to the cacophony produced by the orchestra, they lift their powdered legs, bend, wiggle, grunt and pirouette around.[35]

Chorus girls were typically divided into two "lines." The shorter girls, known as "ponies," would execute most of the dance maneuvers, while those over 5'7", called "showgirls" or "parade girls," would be posed on risers in feathered and sequined costumes. As the band played, the ponies would perform a simple dance routine to a popular tune. The movements were neither sophisticated nor well-executed, since few chorus girls had dance training prior to joining the show.

The opening production number also offered the opportunity to introduce the principal performers in the show. After the opening dance number, the prima donna or a singing straightman would step to the front of the stage. The prima donna was the principal singer in the show. Usually tall and statuesque, she dressed in lavish costumes and had a strong voice. This was often a slower, sentimental song to accompany the showgirls as they moved gracefully around the front of the stage, displaying "every stitch of finery they can pack on their willowy backs—furs, diamonds, brooches, silks and satins."[36] This would usually be followed up by a high-energy dance number by one of the soubrettes, or by a specialty dance team. Soubrettes were the principal dancers in the show and most burlesque troupes had two or more soubrettes. The ponies would be brought on to back her for the grand finale.[37]

Sometimes the comics would be introduced in the opening production number, but they usually played their first scene "in one," in front of the curtain on the lip of the stage. The opening scene was usually a "flirtation scene," in which the comic tried to pick up the ingenue, while the straightman coached him through it.

> In a typical flirtation scene, the straight man (an immaculately dressed authority figure) has a secret method for succeeding with women. He may own a manual of seduction ("The Love Book") or a magic peanut which emits stimulating vapors ("The Tweeter or King Tut's Nut"). Or he may simply be such a smooth talker that women find him irresistible ("The Ukulele Scene"). He promises to teach his technique to the comic whose approaches to the opposite sex have not been notable.[38]

It invariably worked for the straightman, but usually backfired on the comic.

When the comics left the stage, the band would strike up, and the first strip of the evening took place. This act was usually one of the striptease dancers associated with the house, and the opening strip might just be a "tease" number. In the early 1930s, there was still a distinction between "stripping" and "teasing." Teasers never removed their brassieres, while the strippers revealed their breasts at the end of their routine. Only later would they become known as "strip-teasers." Most striptease numbers were also performed "in one," making use of the runway.

> She is fully clad to all appearances, in sheer but complete wardrobe—hat, shoes, parasol. She sings, shouts, or indifferently talks off a song while playing with some article of dress, an article which she finally, after seeming compunction, removes only to replace it a moment later while removing something else. They are artists in undressing; this is the superlative contribution of today's burlesque, the only contribution. They have a routine, with technical terms like "teasing." But they don't give in easily. For every piece they take off or put on they must get applause. And thus the time of performance is consumed, with perpetual encores, posing, simpering, brief moments of cootching, and disrobing.[39]

This arrangement of musical numbers alternating with comedy scenes and strip-tease numbers was the basic formula for the entire show, with an occasional vaudeville act thrown into the mix. The acts had "little or no thematic or plot relationship to one another."[40] In order to keep the show moving, acts that required a full-stage set alternated with those that could be played in front of the curtain so that scenery could be changed behind. But that did not mean the acts were thrown together haphazardly. They were simply organized, as McNamara notes, "by practical considerations about balancing the elements of a show, by traditions about the location of certain kinds of material within the show's framework, and by the attempt to create a 'rising action' as the evening progressed, building toward a climactic act at or near the end of the show."[41] The headliner—a well-known stripper such as Gypsy Rose Lee, Ann Corio, Georgia Sothern, or Carrie Finnell—had the feature spot just before the close of the show. Shows in the 1920s featured one stripper, who appeared in this spot, but gradually the number of strip routines increased so that they took over the show.

THE TWO-A-DAY AND THE GRIND HOUSE

Within this formula, burlesque producers could achieve markedly different effects. Some producers emphasized the comedy. The Minskys had a reputation for hiring the best comedians available. At the Irving Place Theater, however, the emphasis was on the strippers and on lavish production numbers. The type of show was different depending on whether you were attending a class or a "scratch" house. At the high end, they resembled expensive musical revues; on the low end, the shows could be listless and dull. The length of the show varied depending on whether it was a grind house or a two-a-day. A two-a-day show lasted roughly two and a half hours and included an intermission, while a grind show lasted roughly an hour and a half, with no intermission.

The lineup from Billy Minsky's Republic Theater from first week in January 1932 (figure 3.2) is characteristic of shows in a prestige house in the early 1930s.[42] Although several striptease numbers are included in the show, the strippers had not taken over, as they would later in the decade. The show features a number of singing and dancing specialties performed by the principal women in the cast. The star of the show was Gypsy Rose Lee, who appears in the featured spots just before intermission and the close of the show.

Billy Minsky's Republic Follies Program
Week of january 4th
Hedda Hangover From Rye

ACT ONE

Broadway to Paris (Opening)	*Gould, Kellar, Carol Gale and Ensemble*
Specialty	
Going Some	*Ethel DeVoe, Radiana, Walent and Happy "Pep" Pearce*
That American Tune	*Ethel DeVoe and Republic Steppers*
Specialty	*Gould and Kellar*
A Hotel Episode	*Golden, Kane, Harris, Elinor Walent and Lola Pierce*
Sooner or Later	*Peggy Wilson and Republic Steppers*
Dance	*Dolores Leland*
The Holdup	*Jules Howard, Mrs. Howard, Charles Harris and Don Trent*
Red Headed Baby	*Elinor Walent and Republic Beauties*
Family Troubles	*Bert Carr, Al Golden, Harris, Lola Pierce and Ina Howard*
La Belle Moscow	*Carol Gale, Gould and Kellar and Republic Ballet*
Specialty—The Interview	*Golden, Eddie Collins, Ina Hayward, Charlie Harris and Ethel DeVoe*
Georgia Brown	*Lola Pierce and Republic Steppers*
Fireman Save My Life	*Jules Howard, Charlie Harris and Mrs. Howard*
Specialty	*Happy "Pep" Pearce*
You're the One Baby	*Radiana and Republic Babies*
Husband and Wife	*Bert Carr, Al Golden, Charles Harris and Lola Pierce*
Specialty	*Gypsy Rose Lee*
Carnival Nights (Finale)	*Entire Company*

ACT TWO

Soldiers on Parade (Opening)	*Gould and Kellar and Carol Gale and Ensemble*
Specialty	*Lola Pierce*
The Postman	*Jules Howard, Charles Harris and Ethel DeVoe*
Chances Are	*Elinor Walent and Republic Steppers*
A Friendly Game	*Bert Carr, Al Golden and Co.*
Falling in Love	*Radiana and Republic Steppers*
The Bell	*Johnny Kane and Happy Pearce*
In My Mind	*Peggy Wilson and Steppers*
Specialty	*Gypsy Rose Lee*
Finale	*Entire Company*

Figure 3.2 Billy Minsky's Republic Follies program.

Each act opened and closed with a production number involving all or most of the members of the cast. How these numbers were staged can only be surmised. The title of the opening production, "Broadway to Paris," suggests that this might have been set aboard a cruise ship, as the cast sets sail for Europe. The opening incorporates several specialty numbers. Three soubrettes—Ethel DeVoe, Radiana, Elinor Walent—are introduced by Happy "Pep" Pearce, an eccentric comic, in "Going Some." Ethel DeVoe fronts the Republic Steppers—undoubtedly the pony line—singing a number titled "That American Tune." The song may well be "American Tune," a song by Henderson, Brown, and DeSylva, written for the 1928 edition of *George White's Scandals*. A vaudeville team, Gould and Kellar, are brought to do their specialty, probably a dance number.

Unlike the shows of later years, the Republic show makes considerable use of singing and dancing numbers, which probably did not culminate in a striptease. Most of these musical numbers were set to and identified by popular tunes of the day. "Red Headed Baby" is a 1931 song by J. Fred Coots, and was performed by Radiana, herself a petite redhead. "Chances Are" by Barris, Freed, and Arnheim and "Falling In Love Again" by Henry Sullivan and Earle Crocker were also copyrighted in 1931. "Georgia Brown" is undoubtedly the 1925 song "Sweet Georgia Brown" by Bernie, Pinker, and Casey, while "You're the One Baby" may be the 1930 song "You're the One" by Youmans, Robinson, and Waggner.

It is not so easy to identify the comedy bits. The titles given in the program are not, for the most part, standard ones. There are two comedy teams—comic Bert Carr is paired with straightman Al Golden, while Jules Howard, a German dialect comic, works primarily with his wife Helen. Charles Harris appears as the second comic in most of the scenes, while Don Trent, the stage manager for the show, filled in as a supporting straightman. Each of the comedy teams is responsible for three sketches—two in the first half and one in the second. Jules Howard works opposite his wife in "The Holdup" and "Fireman Save My Life," then appears in the second act in "The Postman" opposite Charles Harris. Bert Carr and Al Golden perform "Family Troubles," "Husband and Wife," and "A Friendly Game." Golden also works as the straightman in "A Hotel Episode" and "The Interview." The only scene that can be positively identified is "Fireman Save My Life," in which the comic is called away to a fire only to have the fire chief step out of the closet.[43]

Each of the principal women had a distinctive look and style. Lola Pierce, who was the principal talking woman, does a striptease in the second half of the show. Irving Zeidman writes that "Lola Pierce, who learned to play the violin while with Columbia, played it on Mutual runways. At the conclusion of a soft lullaby, she would turn round, slap her buttocks resoundingly and shake them vigorously."[44] Ethel DeVoe (or DeVeaux) was a veteran Minsky's soubrette, and had been in the business at least fifteen years. Delores (or Deloris) Leland was a striking brunette who had worked regularly in Minsky houses since arriving from the west coast a year and a half before. Her "Egyptian dance"—probably a traditional "cooch" dance based on belly dancing movements—regularly won encores. Gypsy Rose Lee has the feature spot on the bill, immediately before the finale of each act. Gypsy (only twenty at the time) had made her New York debut less than a year before.[45] She was set to appear in the new edition of the Ziegfeld Follies in February. She probably performed "in

one" interacting with the audience from the runway as she stripped. The rest of the company would join her for another production number "Carnival Nights," which closed the act.

The second act follows much the same pattern as the first, although it was typically shorter. Intermission allowed the stagehands to reset the stage. The "Soldiers on Parade" opening was an excuse for putting the girls in uniform to execute military drills. Such "Amazon marches" had been standard in burlesque since the Civil War era. Lola Pierce followed with a striptease act, and the comics are brought out again for two more scenes. "A Friendly Game" may be a version of the "Dice Game" made famous by Abbott & Costello in which the straightman tries to teach the comic how to shoot craps, and finds himself swindled. These are interspersed with several other song and dance numbers. Gypsy Rose Lee closes the show, and the entire cast comes out onstage to take their bows during the finale.

Although there are no reviews of this particular show, *Billboard* reviewed the same cast two weeks later.

> The Minskys are endeavoring to shape their stock projects into something better than the usual fare, and in this particular case they seem to have succeeded to some extent. Big numbers are more flashy and better dressed than ever, altho [*sic*] there was a tendency to use the same costume in more than one number. This was especially true of the gaudy feathered headgear and costumes...
>
> No less than 30-odd girls clutter up the stage, there not being room enough for the entire line to straighten out. There are many good dancers among the ponies and they do very well at all times.
>
> The principals are all sure-fire, each having a distinctive style. Miss Leland is famed for her ability to adapt her Oriental dances to many different scenes, and also offers standout strips and costumes. Miss Pierce is musical as well and talks in her scenes like nobody's business. Gould and Keller, vaudeville act, are also present to further strengthen the show.[46]

Very few burlesque houses could afford the kind of quality or spectacle offered by Billy Minsky at the Republic Theater. Most were shoestring operations that operated on a grind policy of continuous entertainment.

Shows at the grind houses were rarely reviewed and never in much detail. Even programs are difficult to come by, since most burlesque houses simply did not print them. Instead, a lineup would be typed up and posted backstage. Steve Mills saved a number of show lineups from a nine-week booking at New York's Gaiety Theatre from the week of January 20, 1939, through the week of March 17, 1939.[47] Sharing the bill with Mills during this run were comics Herbie Faye and Bert Grant and straightman Milt Bronson.[48] The striptease dancers included Margie Hart and Betty Rowland, both rated among the top stripteasers of the time.[49] On the last week that Mills appeared at the Gaiety, Carrie Finnell replaced Margie Hart in the featured spot.[50] Several less-renowned strippers also appeared.

The format for the shows are identical from week to week. Each show was made up of sixteen bits and numbers, including five comedy scenes and four striptease acts. The order of the acts did not change from week to week. The performers simply

plugged in new comedy routines, juggled the order of the strippers, and changed the music used for the production numbers.

The lineup for the week of February 17, 1939, is typical (figure 3.3). The show opens with a production number featuring Kane and the Girls. Kane, who is otherwise unidentified, may well be Johnny Kane, a juvenile in the 1932 Republic show, who is the principal singer in the show at the Gaiety.[51] The opening number is followed by a comedy scene, with comics Herbie Faye and Bert Grant, straightman Milt Bronson, and Jean Mode, a striptease dancer who doubled as a talking woman in the scene. The scene is "Hello Bill," a well-known bit in which the comics try to extricate themselves from a difficult situation by claiming to be members of the Elks Club. This is the first of five comedy scenes in the show, which includes the classic "Slowly I Turned." Comics Herbie Faye and Steve Mills alternate scenes, while Bert Grant works as the second comic for each of them. The last scene, "Chinese," includes a large cast.[52]

The label "Specialty" indicates a striptease number. There are four strips during the show, leading up to Margie Hart, who is the headliner. Betty Rowland, a petite blonde whose energetic stripping style earned her the nickname "The Ball of Fire," was also a leading stripper, and is used primarily as a dancer in the Novelty Number (#5) and in the Ballet (#12). The show ends with a finale in which each of the featured strippers appears to take a curtain call, while Johnny Kane sings a closing number. Unfortunately, there is no indication anywhere as to what music was used or what the production numbers looked like.

Gaiety Theatre…Week of February 17, 1939		
1. Opening		Kane, Girls
2. Scene	Hello Bill	Faye, Grant, Bronson, Mode
3. Jazz Number		June March, All Girls
4. Scene	Baseball Bar	Mills, Grant, Bronson
5. Novelty Number		Kane, Rowland, Girls
6. Specialty		June March
7. Scene	Slowly I Turned	Faye, Grant
8. Jazz Number		Girls
9. Number		Kane, Parade Girls
10. Specialty		Jeane Mode
11. Scene	No I Haven't	Mills, Grant, March
12. Ballet		Kane, Rowland, Girls
13. Specialty		Margie Kelley
14. Scene	Chinese	Mills, Faye, Grant, Bronson, 2 Chorus Girls
15. Specialty		Margie Hart
16. Finale		Kane, All Women

Figure 3.3 The Gaiety Theatre lineup for the week of February 17, 1939.

THE AUDIENCE

Such synopses give only a general sense of what was taking place, for they tell us very little about the audience's response. The reaction of the audience was a large part of the experience of going to a burlesque show. The most successful producers were well aware of this fact and sought to create an atmosphere of sociability and camaraderie. The better houses had a celebratory carnival atmosphere. The Irving Place, according to one observer, had "a free-and-easy, everybody-in-on-the party attitude of the house and the performers that makes their shows consistent smashes."[53] William Green reports that

> at the National Winter Garden, the Minskys had developed a regular clientele from among the local residents. Since there were no reserved seats, the audiences came early and made themselves comfortable with "newspaper, cushions, house slippers... extra cigars," and snacks. Billy Minsky boasted, "Our patrons know each and every performer by their first names."[54]

"It is quite within the custom for [a man] to show his excitement," David Dressler reported. "He may yell, 'Take it off!' to the stripper; he may whistle and call at the girls; he may laugh fully and uproariously at the lewdest jokes."[55] At the Star Theatre in Brooklyn, this anything-goes atmosphere got completely out of control. "It was a heckling, sarcastic, filthy mob that barely permitted the performances to proceed. Epithets so vile and obscene were thrust at the performers, particularly the women," writes Irving Zeidman.[56] Eventually management brought in bouncers to maintain order, and hecklers were taken into custody and turned over to the police.

If heckling in some houses got out of hand, a far more persistent problem for the performers was the lack of any response whatsoever. Edmund Wilson's 1926 review of a show at the Olympic, a scratch house on Fourteenth Street, describes a problem that eventually became all too common in burlesque.

> The audience do not even applaud when the girls have gone back to the stage; and you think that the act has flopped. But as soon as the girls have disappeared behind the scenes and the comedians come on for the next skit, the men begin to clap, on an accent which represents less a tribute of enthusiasm than a diffident conventional summons for the girls to appear again.[57]

This indifference became a particular problem as most houses shifted from a two-a-day to a grind policy. Although the theatres ran travelogues and second-rate comedy shorts as "chasers" to clear the house, a large portion of the audience stayed all day. H. M. Alexander reported that

> they work their way down to the first row in slow advances, seeing one show after another until hunger or other necessities force a temporary retreat. When one gets up (and this only happens during a comedy bit), forty men will rush down the aisle for his seat, completely disrupting the scene on stage."[58]
>
> The fact that there was practically no audience turnover—in the orchestra at any rate—makes it tough as hell for comedians who are playing a grind house. When they

try to speed up the performance by "scissoring a bit" the jerks remind them in loud voices that they've left out a line or a piece of business.

"You've forgot the one about the bear and the traveling saleswoman," someone will jeer from the second row.

Or a jerk will deliver a punch line before the comic gets to it: "Yeah, we know all about it. Time's a wastin', balls of fire."

"You *ought* to know," he'll say. "You've been here since eleven this morning."

A frequent reply to this squelcher from the stage is the flatulent bird or "Bronx-cheer." It usually draws a laugh form the audience, which is always on the jerk's side.[59]

The shift to a grind policy worked against the burlesque comics, and the decline of burlesque can probably be traced to this change. Individuals entered the theatre with little regard to opening time, so there was no way for the comics to build a sense of cohesion or camaraderie. Audiences during the daytime were sparse, and this sense of isolation did not help. As humor theorist John Morreall notes, "comedians and theater owners have long been aware that it is much easier to get a full house laughing than just half a house, especially if the smaller crowd is spread out so that they don't reinforce one another's laughter."[60] Trish Sandberg, who worked as the chorus captain in the 1960s retrospective *This Was Burlesque*, and later wrote her doctoral dissertation on the comedy of Steve Mills, observed that burlesque comedy worked best in an atmosphere of communality and sociability.

> I came to see that *This Was Burlesque* always played better in areas with a well-developed sense of community. It worked best with audiences not too theatrically sophisticated: the kind who infrequently see live theatre, come to it prepared to have a wonderful time and generally do, as much because they enjoy the pure sociability of the occasion as because of what transpires on the stage. A well-filled auditorium was requisite. Sparse houses precluded sociability and generally spelled disaster. Large and imposing auditoriums also inhibited audience response. The occasions upon which *This Was Burlesque* exercised its most effective appeal invariably took place in theatre plants which encouraged an informal, neighborly atmosphere.[61]

Increasingly, however, the grind houses began to draw an audience that specifically *sought* isolation—largely for the purposes of masturbating. The presence of someone sitting close by would naturally discourage such activity. But at those houses, or in those parts of the house, where attendance was spotty, some men felt free to satisfy themselves. Burlesque performers referred to audience members as "jerks" and David Dressler states that this referred to their masturbatory practices. Some men brought newspapers into the theatre that they spread across their laps to disguise what they were doing. Nevertheless, performers could see them from the stage. "Numerous girls bear testimony that they get so they can detect masturbators in the audience, but they soon take this as a matter of course and pretend not to notice," David Dressler reported.[62] In some cases, "an entire row of poorly riveted seats will vibrate with the masturbatory movement."[63]

In such an environment the comedians were simply an intrusion. While there were undoubtedly some people who came to the show to enjoy the comics as well as the strippers, they, along with the comics, were inhibited by the silence of the house.

"If we are in a group and find that we are the only one laughing at something, we will usually cover our mouth and stifle our laughter, at least until others join in," Morreall writes.[64] At the Friday and Saturday night shows, when the house might be filled to 75 percent of its capacity, the comics could still generate laughs. But the economics of the business worked against them. Friday and Saturday night audiences were largely composed of one-time visitors—it was the regulars who covered the operating costs. The matinee and mid-week audience, though sparse, contributed heavily to the profits of the burlesque theatre. Since even the best comics had trouble getting laughs, theatre owners hired the cheapest comics available, simply to fill in between the strip acts. In the years following World War II, chorus lines were cut back and eventually eliminated, while comedy teams were often replaced by stand-up comedians.

Burlesque depended on a balance between eroticism and comedy, and it is in the relationship between titillation and laughter that we get to an understanding of the form. Each was enhanced by the other. The erotic dancing of the striptease artists naturally builds up excitement and arousal, which requires some outlet or expression. The comedy provided a release, through laughter, for those feelings. Thus released, the audience could then be rearoused by the next dancer. It is the bringing together of sexuality and laughter that defined the burlesque show and is what differentiated it from the adult entertainment forms that replaced it. The burlesque show was not about satisfying sexual desire. Rather it was about dissipating those feelings through laughter.

4. The Cast and Characters ⟶

Figure 4.1 Lew Fields and Joe Weber performed as typical "Dutch" comics in the late 1890s and early 1900s. Early straightmen such as Fields wore the eccentric costumes and makeup of ethnic comics. (From the author's collection.)

Figure 4.2 "Hebrew" comics such as Harry "Watch the Slide" Welsh were popular in the early decades of the twentieth century. Protests from the Jewish community prompted comedians to tone down or eliminate ethnic stereotypes. (From the author's collection.)

Figure 4.3 Dewey "Pigmeat" Markham was one of the few African American comedians to work in burlesque. Even he performed in blackface makeup. (Courtesy of Photofest.)

Montage 2: Boobs, Tramps, and Eccentrics

Figure 4.4 Chuck Callahan wore the round glasses identified with "boob" comics. (Courtesy of Peter Genovese.)

Figure 4.5 Comedian Billy Fields appeared in a toned-down version of "tramp" makeup in the 1920s. (From the author's collection.)

Figure 4.6 Later burlesque comics, such as Lou Ascol, chose to go with a more individualized "eccentric" look featuring mismatched clothing and little to no makeup. (From the author's collection.)

Figure 4.7 Jess Mack wears typical straightman's attire in this publicity photo from the late 1920s. (From the author's collection.)

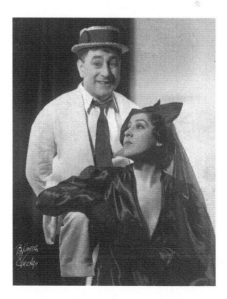

Figure 4.8 Talking women were often married to burlesque comics and straightmen and toured with their spouses. Alice Kennedy worked opposite her husband, Mike Sachs, and the couple performed together even after he went blind. Audiences never knew. (From the author's collection.)

ketch comedy of the 1930s differs from the sketch comedy of today in one important respect. Whereas the comedians trained in improvisational comedy, who appear on such shows as *Saturday Night Live*, are adept at creating a number of characters, comedians trained in burlesque developed a single comic persona, appearing in a variety of circumstances. "Comedians like Chaplin, [Bobby] Clark, [Jack] Benny, Ed Wynn, and others have one thing in common," theater historian Garff B. Wilson explains, "they do not create a variety of roles or appear in different guises from show to show. Each has built up a single comic character which is engaging enough to be continuously appealing. The character does not change; only the actions and situations change."[1]

This approach to the comic role is characteristic of the clown tradition to which burlesque comedy really belongs. In America today, clowns are primarily associated with the circus and with children's entertainment, but in the European tradition and on the stage, they are principally sketch performers. A vibrant tradition of clowning in America once existed on the stage and in early film comedy. At the heart of this tradition is the clown duo. John Towsen, writing about circus clowns, observed that

> the clown as a stupid buffoon is just one ingredient in an ancient comic formula. Comedy traditionally has depended upon two zanies, the first a scheming rogue and the second his less clever butt—the stooge, "he who gets slapped." Today we can see this comic opposition in the films of Abbott and Costello or Laurel and Hardy, but they were certainly not the first.[2]

This partnering of a crafty and a stupid clown can be seen repeatedly in the history of comedy, in the relation between the *eiron* and the *alazon* in ancient Greek tradition, the first and second *zanni* in the *commedia dell'arte*, and the white-faced clown and *auguste* in modern circus clowning.

This pairing of clever and stupid characters is widespread in folk traditions as well, where many comic tales relate the misadventures of "numskulls" or the crafty deceptions of trickster figures.[3] A similar pairing persists into the present day, where they are the basis of most ethnic jokes. Christie Davies, who has written extensively on ethnic joking across cultures, observes that

> the stereotypes that underpin ethnic jokes tend to occur not singly but in pairs of opposites. Thus in most western industrial societies the most popular ethnic jokes are those about groups supposed to be stupid and (in opposition to this) jokes about groups supposed to be canny (i.e., crafty and stingy). These two kinds of ethnic joke are far more numerous, widespread, durable and popular than any other type of ethnic joke.[4]

These figures are not static. While the role or function remains constant, new figures arise to fulfill these functions. Clown figures undergo a certain maturation or evolutionary process over time. According to M. Willson Disher, the clown originates as a rustic outsider. Over time, the character undergoes a transformation, evolving from dummy to knave, eventually to an idealized or romantic figure.

> Thus Arlecchino, the butt, changed to Arlequin, the knave, then to Arlequin, the parodist in every shape imaginable, to Arlequin the swain of Marivaux, to Harlequin the magician, adventurer and dancer, and finally to a symbolic character. Pierrot, before he

became mystic and pale as the moon, was a butt or knave. Clown, who also began as a butt, changed to knave, then to bully, and then to a symbol of pathos.[5]

Once such a transformation takes place, a new "dummy" character has to be created, a new yokel is needed, and this character usually comes from marginal groups in the society. In the United States, these new yokel types have been provided by racial and ethnic outsiders.

THE COMICS

The central figure in burlesque comedy was the comic. Immediately identifiable by his baggy pants and ragged coat, he made a comic appearance as soon as he walked on stage. "Nearly all the comics wore ragged clothes, ill-fitting and grotesque," burlesque historian Bernard Sobel writes.

> Certain ones wore enormous shoes, sometimes with enormous protruding papier-mâché toes. A favorite device was to use trousers too large for the body and let them drop down unexpectedly. Most of them wore an alcoholic red putty nose which made their normal proboscis twice the size, completely out of proportion with their normal features. Some wore flesh-colored skullcaps which created the impression of an extremely bald pate. Others wore "scare" wigs, so constructed that the false hair stood on end, as if in a continuous state of fright. Certain comics, imitating strong men, padded their muscles and biceps and wore huge codpieces.[6]

Burlesque comics trained through a system of apprenticeship, which allowed young performers to work alongside more experienced professionals. Many comics got their start as "candy butchers" hawking merchandise before the show and during intermission. Since there was little to do once the show was going on, they could observe the comedians at work. Some picked up their skills in traveling "tab" or tabloid shows, "condensed versions of successful musical comedies" that generally toured rural areas, while in the New York City area they often got their first real jobs in the Catskill resorts.[7]

A young comic just starting out would be hired on as the "bit man" or "character man," sometimes referred to as the third comic. As a bit man, the comic appeared in brief walk-on roles. Joey Faye talked about working in these roles:

> I had very little to do. I said a few lines or made some sounds, like screaming, in a scene, like the "Crazy House" scene. In another scene, I'd be the customer getting a haircut in a barber shop. The barber suddenly poured the illegal booze on my head when the cop entered. Then I'd run out in a frenzy. In another scene, I'd come out in a sheet playing an inmate in a mental institution.[8]

Generally it required very little in the way of talent or experience, but it allowed a young comic to learn the ropes.

After gaining some experience and having a chance to observe most of the standard sketches, he could then move up to second comic. The second comic had to be familiar with the standard burlesque scenes and be able to step right into them. He

also took responsibility for being the principal comic in many of the scenes, alternating scenes with the first comic, and often supporting him in his scenes. In some cases, the second comic was a "house comic" affiliated with the theatre, while the first comic was a headliner brought in for a week or two.

With enough talent, a comedian might work his way up to the first, or principal comic. The first comic had the primary responsibility for the show's lineup and generally had the first choice of scenes. He was generally understood to be the most talented performer, but this was not necessarily the case, for the second comic might be a talented young performer just coming up.

One often hears the principal comic in a burlesque show referred to as the "top banana." There is no evidence that the term was in widespread use in burlesque before the 1950s. Steve Mills insisted the term "banana" was strictly a derogatory term. "You never called a top comedian a banana. Top comic, you know, or first comedian. A banana was something you slip on. You might talk about a mediocre comedian, 'Aw, he's just a second banana.' But 'top banana,' never."[9] The phrase "top banana" actually dates from the 1950s, and the Hy Heath/Johnny Mercer musical *Top Banana*. According to Phil Silvers, who was a veteran Minsky's comic before starring in the 1953 musical, the term was the invention of show's lyricist, Johnny Mercer. "'Top banana' was never used in burlesque to my knowledge. Johnny Mercer thought it sounded better in his lyric than 'first banana,' and that is how the words entered the English lexicon."[10] Silvers claims that "in the early burlesque era, before my time, the comics referred to themselves as First Banana, Second and Third Banana."[11] Silvers believed the term "second banana" came from an old sketch popular with Dutch dialect comics.

Three comics. One holds up two bananas.

First Man: "I have three bananas here, and I will give you one."

Second Man: "You only have two bananas."

First Man: "I have three bananas. Look, I'll show you. (*Holds up one banana in his right hand.*) One banana have I. (*Holds up one in his left hand.*) Two bananas have I now. One banana and two bananas makes three bananas."

Second Man: "I only see two bananas. In your own words, I will show you, you are wrong. (*He takes the bananas.*) One banana have I. Two bananas have I. One banana and two bananas...by golly! he's right. (*To Third Man.*) Would you like a banana? (*Third Man nods.*) Okay, one banana for you. A banana for me—"

First Man: "How about me?"

Second Man: "You eat the third banana."[12]

The comics tried to differentiate themselves from one another by the characters they played. These characters were based on traditional comic types that circulated in the culture, and once they had developed a character, they played the same figure through much or all of their careers. A comedian might choose an ethnic character—a Tad, a Dutch or Hebrew type, based on widespread stereotypes of immigrant Irish, Germans, and Eastern European Jews. Alternatively, a comic might select one of the more generic outsider types—a rube, a boob, a tramp, or an eccentric comic. These

characters were all traditional comic figures, immediately recognizable from their outlandish costumes, grotesque makeup, and stereotypical character traits.

ETHNIC TYPES

In the nineteenth century and early part of the twentieth century, ethnic characters predominated. As each wave of immigrants sought to establish themselves in this country, they became the object of ridicule. Their old world values, their unfamiliarity with American customs, and their peculiar style of dress were ridiculed in the theatre and the popular press. Once they became established, they underwent a transformation, whereupon a new outsider group took over the dummy role. Irish immigration in the 1840s produced the "Tad" comics. German immigrants gave rise to the "Dutch" comics—the name came from a corruption of *Deutsche*. Jews immigrating from Eastern European at the turn of the century produced the "Hebrew" comics, who exaggerated their noses with putty, added a crepe-hair beard, and wore a derby over their ears to simulate a *yarmulke*. Each of these were highly stylized and stereotypical portrayals that were immediately recognizable by their dialects, makeup, and costuming. These are comic archetypes from which the burlesque show drew.

A Tad comic was immediately identifiable by a distinctive fringe of whiskers along his jaw. There was no moustache attached to the beard, and the upper lip remained bare, even whitened with greasepaint. The hair and beard were usually red, although they might be dyed green, and the hairline was often receding. Clothing tended to be rustic. "The shirt had no collar; the vest, most likely, was either too big or too small; the pants, tied about the waist with a piece of rope, were old and roomy; and a battered hat topped off the outfit. Green was used as a dominant color in the costume."[13] As time went on, the rustic outfit became more elaborate and stylized. In 1908, Robert Lynne Hartt observed an Irish comic whose costume was wildly exaggerated.

> What with crimson face, whited upper lip, green Galway whiskers, a tiny mirror adhering to the end of his nose and scintillating as he moves; what with an alarm clock doing duty as a shirt stud, a cabbage as boutonniere, and a shillelagh stout enough for a newel post, there's not an inch of him, from infinitesimal stovepipe to fantastically elongated feet, but screams with absurdity,—plaided coat seven sizes too big, trousers cut from a horse-blanket, waistcoat an Irish flag. Indeed, he is so terrifically funny that you gaze upon him with mute solemnity.[14]

The comic Irishman played on the stereotypes of the Irish character that still circulate. He was seen as a heavy drinker and a fighter. "Because of his supposed love of the bottle, the stage Irishman was often depicted as a rough, crude, loud individual; there was a swagger to his walk, a cocksure tilt to his head."[15] Important to the characterization was the dialect. The Tad comic spoke in a singsong stage Irish associated with Pat O'Brien in his Irish cop roles, and frequently utilized Irish slang and epithets. Irish comics were popular in the 1910s, and were usually paired with a Hebrew comic. By the 1930s, however, the Tad comic had all but disappeared from the burlesque stage.[16]

The Jewish or "Hebe" comic was often paired with the Tad comic and was frequently the victim of the Irishman's abuse. Hebrew comics had a closely trimmed beard and a derby hat, pulled down over the ears. In the early part of the century, they dressed in black frock coats, imitating the stark outfits seen in European ghettoes and still worn by men in certain Orthodox sects. Often, they wore diamond studs. Nose putty exaggerated the nose and crepe hair was applied to the face like a week's growth of beard. Rollin Hartt suggested that "the close-cropped beard suggests the flowing ornament so grand in Waltner's etchings; the loathly pallor of the face and the melancholy hollowness of eye bespeak ages on ages of hunger; and you know that the Jewish nose, here exaggerated almost beyond credence..."[17] Like other ethnic comics, the Hebrew comics used a distinctive dialect based on Yiddish, that replaced "w's" with "v's." Later Jewish comics continued to work with a Yiddish accent, while eliminating the stereotypical costuming of the early part of the century.

Dutch comics exaggerated the characteristics of German immigrants. Their hair, often blonde, was cropped in a bowl shape, and they wore a characteristic square-cut beard that came off the end of the chin. They dressed in the middle-class fashions of the day, but the patterns and cut of the clothing was exaggerated and ostentatious. "The lapels were too wide, the checkered patterns too garish, and the ties and vests are too showy."[18] The vests were often flowered, with a double row of pearl buttons.[19] "The German immigrant seemed to project the image of a slow-thinking person...This was, of course, further complicated by his inability to express himself in his new language."[20] Dutch comics played with a thick German accent, and mangled the language by applying German syntax to English, reversing word order and combining words in ridiculous ways. "In any case, a state of befuddlement was added to the generally accepted image of the sturdy, reliable and industrious middle class citizen, to produce a stage figure who was genuinely friendly and trustworthy, but who got himself entangled in language mazes to the point of exasperation."[21] The popularity of Dutch comics fell during World War I, when hostilities undermined the comic image of the German. It was later revived by radio comics such as burlesque veteran Jack Pearl, who performed as Baron Munchausen. In the late 1920s and 1930s, a fair number of Dutch comedians worked in burlesque, but like the Jewish comics, they had toned down the stereotypical wardrobe.

Other ethnic groups were also represented on the burlesque stage, but are found less frequently. Italians were represented in the "Wop" character, in an outfit associated with Chico Marx—a short conical hat with a narrow brim. Eyebrows were heavy and dark, and many sported a small black moustache. Wop characters often wore a colored handkerchief around the neck, and corduroy pants that were short in the legs. The Chinese were portrayed in pigtails speaking in gibberish singsong, but only appeared in minor roles. The French were burlesqued as sophisticated but somewhat effeminate, and were typically played by the straightman. Mexicans and Spaniards also reflected stereotypical images in their occasional appearances.

A few burlesque comics worked in blackface, but it was rare. Although blackface was common in vaudeville during this period, it was unusual in burlesque. This is not due to any enlightened attitude on the part of burlesque performers—rather, the sexual content of burlesque raised troublesome issues for white audiences seeing a

black comic make suggestive remarks to white showgirls.[22] The two most prominent blackface comedians in burlesque were themselves African American. Eddie "Coffee" Green played the Minsky houses off and on for fifteen years in the 1920s and 1930s. He starred in a number of black-and-tan revues that featured an African American cast, such as *Blackberries of 1932*, for which he wrote the book. Green later worked in radio as a regular on *Duffy's Tavern*.[23] Dewey "Pigmeat" Markham worked on the Supreme Circuit in the mid-1930s, performing alongside Bud Abbott before he teamed up with Lou Costello. Like Green, "Pigmeat" Markham worked on the black vaudeville circuit, TOBA. Many of the sketches *did* cross over, as anyone acquainted with his comedy albums can attest. His classic "Here Come De Judge" is a version of the courtroom sketch. A number of other burlesque scenes made their way onto Markham's comedy albums as well.

While each of these ethnic types is founded on stereotypes, they were frequently performed by and for members of the immigrant group being depicted. Although Irish comedians often performed in blackface, and Jews took the stage as Dutch comics, comedians of Irish descent performed as Tad comics and Jews performed as Hebrew types. Ned Harrigan built his career on depicting Irish immigrants in a series of musical comedies about the Mulligan Guards. David Warfield, who performed as a Hebrew comic alongside Weber and Fields, was Jewish, as were brothers Ben and Joe Welch, two leading Hebrew comics in the early twentieth century.[24] Most African American comedians were expected to work in blackface. Those working within the stereotype regularly tried to give a sensitive and nuanced portrayal, moving the characters from one of reproach to one of pride, who became a wise, penetrating, and observant commentator on society. The person best remembered for this was Bert Williams. Williams, a light-skinned black who worked in blackface, portrayed the stereotypical slow-moving, slow-witted darkie character. But like others before him, Williams utilized the stereotype to create a sensitive portrait of a man forever marginalized by society.

By the turn of the twentieth century, antidefamation groups began to criticize comedians who were relying on ethnic stereotypes. "Jewish and Irish societies—composed of first and second generation offspring of immigrants—centered their protests on the comics' burlesquing of the clothes, facial characteristics, accents and supposed ethnic traits of their ancestor."[25] By World War I, the worst of the ethnic stereotypes had disappeared from vaudeville. "The old 'tad' of forty years ago passed on," Maurice Drew observed in the pages of *Billboard*.

> His grandson is the character now. Where we roared at the old man's dialect, comic walk and ignorance, we are now interested in the grandson when he displays brightness and knowledge. Instead of the bald head, "Galways," and monkey face of the grandfather, we have the sparkling eyes, pearly teeth, "smile that won't come off," and handsome appearance of the grandson. He is your Irishman of today, and the one that fits in a playlet.[26]

The traditional ethnic representations persisted longer in burlesque than in vaudeville and the legitimate theatre, in large part because of the social class of its audience. Most burlesque houses were located in or near working-class neighborhoods, where there was a large number of foreign-born living nearby and in the audience.[27]

However, as Steve Mills noted, even in burlesque, "it came to the point where the German population said, we don't want them to do German…Hebrew, we don't want that man to do Hebrew. This is what it is. So you all went to just nondescript characters."[28] As the ethnic representations became less acceptable, other character types became more prominent.

TRAMPS, BOOBS, AND ECCENTRICS

In the 1920s, we see a more generic image of the comic outsider with the spread of the "tramp" and "boob" comics. The comic tramp figure goes back to the late nineteenth century, but became especially popular just after the turn of the century.[29] "In the first decade of the 1900's, tramp comics swarmed through vaudeville almost as a national symbol; legit musical stages were heavy with them; and joke magazines and newspaper strips (a few are left) detailed their haphazard lives with jesting abandon," Douglas Gilbert writes.[30] The tramp character sported a putty nose, often reddened to signify drunkenness, and a heavy beard, either made with crepe hair, tobacco, or burnt cork makeup. Usually an area around the lips was left white. This makeup was essentially half of the blackface minstrel.

There is a tendency to equate the tramp clown with the sentimentalized portrayals by Charlie Chaplin and Emmett Kelley. The tramp figure, in burlesque, was a much more disreputable figure. Ralph Allen writes that

> the comic, despite his putty-nose and baggy-pants, is never a pathetic figure in Burlesque. He is not in any sense the tearful tramp of Chaplin. In most bits he is represented as a child of nature—the slave of stimulus and response. A girl with obvious attractions appears. He is obviously attracted…The Burlesque show tramp represents man stripped of his inhibitions, stripped of restraints of all kinds—free of moral pretense, innocent of education and, above all, lazy and selfish. He frequently appears to be a victim, but never a pathetic one, because in nine bits out of ten he blunders at the end into some kind of dubious success.[31]

The other character that figures prominently in burlesque in the 1920s and 1930s is the boob comic. The term derives from the English term "booby," referring to a rustic fool. Boob comics emerged around the turn of the twentieth century. They were an adaptation of the "silly kid" figure, and are loosely related to the Toby character that was popular in rural tent shows. As William Slout writes in *Theatre in a Tent,*

> The Toby character typically wore a red fright wig and freckles. As a stock character, he was subject to the style and comic eccentricities of the individual actors who portrayed him. He took on manners of the regions in which he appeared; with some companies he was a mid-western farm boy, with others he was a western cow-hand or lackadaisical hill-billy.[32]

The boob was essentially the Toby character adapted to an urban environment. The boob is often outfitted in glasses, particularly large round glasses. Chuck Callahan was one of the comics who worked within this characterization.

By the 1930s, an increasing number of burlesque comics were identified merely as "eccentrics." These were more individualized comic portrayals. The 1932 edition of *Dennison's Make-Up Guide* suggests how actors developed an eccentric make-up: "Watch the make-up of some of the moving-picture comedians, and you can get good ideas. You will find they use a straight make-up and depend upon a comedy mustache and a slight change of the eyebrows, to get their effects."[33] In addition to the eyebrows and mustache, they often wore (or painted on) comedy glasses, and added a ridiculous or ill-fitting hat. In addition to physical attributes, they often worked with vocal inflections, using lisps, letting the voice crack, and other comic effects. Many of the leading comics of the era, from Ed Wynn to Bobby Clark, worked eccentric characterizations. Some toned down their look even further. Lou Costello adopted what the theatrical trades called a "sheik" look, slicking his hair back and going without makeup.

It is tempting to view these ethnic stereotypes in a purely negative light, but the situation is more complicated. The burlesque comic is a comic outsider—a disreputable or despised figure, which reflected societal attitudes toward the urban poor. But he also aroused the sympathy of the audience. Bert Lahr stressed the importance of gaining that sympathy.

> You will find that a comedian—a good comedian—has to be a good actor. And the reason for a comedian being a good comedian, he creates sympathy. He immediately creates a warmth in his audience, so once you do that, and the audience roots for you, it's a very simple matter to make them cry. I think you laugh at a great comedian because you want to cry. Laughter is never too far from tears.

Pushed to explain how he got the sympathy of the audience, Lahr said, "I think it's a physical and chemical thing, the same as if you go to a party and somebody comes in a room and immediately attracts you. So a person comes out with a manner on stage that makes you say 'Aha, he's such a sweet guy'—do you see?"[34] Joey Faye reaffirmed this need to gain the sympathy of the audience, remarking that "To get the audience's attention, you make the character specific—for example, crazy, or a little nuts, simple-minded, or some other definite characterization. You do things to get the sympathy of the audience. After you have made the character specific, you must present yourself in the most believable way."[35]

Many comics projected a childlike quality, gaining the sympathy of the crowd by drawing on a natural human tendency to protect and nurture children.

> "I use psychology on the audience to make them laugh," Harry Conley explained. "It's as though I am a child, a naughty boy, and the audience is put in the naughty-children frame of mine. They become children emotionally and laugh as children. As grownups, their laughter might be inhibited. Fanny Brice used that technique as Baby Snooks."[36]

Lou Costello also projected a little boy quality, which was reflected in his catch phrase "I'm a baaaaad boy."

If the comic is the central figure in burlesque comedy, he was by no means alone. Burlesque comedy was very much a collective production. The comedy depended on the give-and-take between the comic and the "feeder." The feeder could be either a straightman or a talking woman.

THE STRAIGHTMAN

The straightman has always been the underappreciated member of the team. Usually paid less than the comic, his responsibility was to set up the comic.[37] "On the stage his work was to 'feed' his partner, to make his acting bear toward one end, which was that his partner could 'get over' the point of the jest to best advantage."[38] Although Jill Dolan has suggested that the audience identified with the straightman over the comic, the straightman is not someone to root for.[39] He functioned as the antagonist in the scenes, filled the authority figure role, criticizing the comic and often brutalizing him. "In the burlesque ritual the straight man was the universal fast-talking sharpie, swindler and con man who, in at least two bits out of three, had to be outsharped, swindled and conned by his victim," Rowland Barber writes.[40] His presence functioned as a "superego," allowing the comic to go farther out on a limb. When the comic got too far off-track in his improvisations, the straightman was there to pull him back to the script.

Before the turn of the century, many straightmen also played in ethnic garb. Lew Fields, the straightman of comedy team of Weber and Fields, wore outrageous clothes and spoke in the thick German dialect used by his partner. Fields found that when he began working in front of more middle-class audiences, he had to put on evening attire. Beginning in the early 1900s, the style of the two-man act changed. Instead of both members of the team dressing outrageously, a distinct line was drawn between the comic and straightman. "The straight man began to dress in street clothes, if you can call a flashy suit, gray derby, two-toned button shoes, and stock tie 'street clothes!' The comic would wear 'funny' misfit suits, etc. so you couldn't mistake him being the comic."[41]

The burlesque straightman played the "high" culture to the comic's "low." He was generally well-dressed, even something of a fashion plate, sometimes making costume changes between each scene. The straightman always wore a hat onstage, at a time when well-dressed men never went outside without one. There may be some sense in which the straightman is *above* the audience, while the comic is *below*. He often contrasted physically from the comic. Bud Abbott is tall and slender, while Lou Costello was short and fat. "A good straight man had to make a good appearance, dress well, have sex appeal, and have a good speaking and singing voice. They were usually fairly well-educated guys who had a good vocabulary (for an actor) and handled the business for the act," Joe Laurie, Jr. wrote.[42] They also reproduced relations between the Anglo and immigrant cultures. Although Bud Abbott was Jewish, his name and image comes across as Anglo. Costello, on the other hand, is clearly ethnic.

There were two types of straightmen—aggressive and suave. The aggressive straightman was an authority figure, who browbeat and brutalized the comic. Joe Laurie Jr. described the straightman as "the scolder" because "he scolded the comics with such lines as 'I'm ashamed of you—what you did when I introduced you to that lovely lady...'" The suave type was more low-key, more along the lines of a light comedian in a drawing-room comedy. This type of straightman "knew his way around women, and was easily exasperated with the comic's ineptitude."[43] In actual practice, the straightman often combined qualities of both the aggressive and suave

types, as different scenes called for different approaches. The straightman was something of a con man, taking advantage of the comic with fast talk and glib promises.

> As straight man, Bud Abbott evinced the manners and morals of a carnival grifter. He was the swift-talking, brass-hearted rogue, often the victim of his own chicanery. Lou Costello, the comic, portrayed the victimized Everyman, an innocent in a mendacious world. Together they worked with the harmony of a Heifetz-Pitaigorsky duet.[44]

The contribution of the straightman is frequently, undervalued by the public, but there was a definite art in performing the role effectively. He had to be able to work with a variety of comics and size them up and play to their strengths. Describing Bud Abbott's work, Bob Thomas writes,

> He learned to read the moods and movements of the comic he worked with. Some were dullards who repeated the funny stuff by rote, never experiencing the thrill of lifting an audience to a new level of enjoyment. Some were inspired improvisationists, sensing an audience's mood and playing it with variations, like a Bach fugue. Some were manic, performing three feet off the stage floor with a holiday crowd; others were depressive, sparse audiences sending them into fits of unfunniness.[45]

Timing and pacing was largely the straightman's responsibility. He had to sense where the laugh was coming (or not) and when to jump in with the next line, without stepping on the laugh. It was often the straightman who set the rhythm of the dialogue, while the comic reacted to what was going on. The straightman also furthered the plot of the scene. Playing a trickster and a rascal, he often motivated the scene with some scheme to take advantage of the comic. He also had to let the comic go with his improvisations, but be there with the next set-up line if his partner's creativity began to flag. The tendency of the straightman to repeat the comic's lines helped to make sure that important information was repeated, so that audience members got what was going on. And he had to do so while keeping the scene and the relationship believable.

THE JUVENILE

Like the comic, the straightman served an apprenticeship, starting out as a "juvenile straightman" or juvenile. Like many straightmen, the juvenile often doubled as a singer or a dancer in the shows. He would often be cast in bit parts that required a second straightman, frequently appearing as a cuckolded husband or a suitor. The juvenile was most identified, however, with the "nance" role. The nance was the effeminate or gay character and the juvenile, with his youth and good looks, was frequently called on to play the part.

While gayness and effeminacy were generally excluded from films and other "respectable" forms of entertainment in the 1920s and 1930s, the nance character was a regular figure in burlesque, as one might expect where so much of the discourse revolved around sex. Geoffrey Gorer, a British writer, remarked that "homosexuality plays an astoundingly large role in burlesque humor." Unlike British comedy, which mimicked and made fun of effeminate behavior, Gorer asserts that "in burlesque

homosexuality is completely divorced from physical stigmata; the humour is in the homosexual situation." One character will misunderstand the situation "reading into the innocent words and actions an attack on his person."[46] The role of homosexuality on the burlesque stage is more complicated than Gorer posits, for comics did mimic and make fun of effeminate behavior.

Gay men were a very real presence in and around burlesque theatres. The entertainment districts in which burlesque thrived were also neighborhoods where gay men openly congregated. The Bowery, Harlem, and later Forty-Second Street were places where "fairies" were open about their sexuality. David Dressler found that they were a presence in burlesque theatres as well. "Here and there a homosexual will make stealthy advances to a likely neighbor," he wrote. "One will touch the genitals of the other. Another will try to 'date up' a young man through the preliminaries of a casual conversation."[47] As in most areas of the performing arts, gay men were well-represented among the performers. According to straightman Dexter Maitland, a good number of singers and dancers with the shows he worked on were openly gay.[48]

The nance figure was clearly an object of ridicule and condescension, and sometimes outright cruelty. To be identified as a fairy was a mark of shame. Even the implication that a man had fathered an effeminate son was a mark on his own masculinity. To be accused of being effeminate was an insult and burlesque comics delighted in portraying professional men, figures of authority, and the well-to-do as sissies. Such representations probably reflected widespread attitudes in working-class culture. However, there was a good deal more acceptance of homosexuality than one might expect. While the nance was ridiculed for effeminacy, he could also be the object of desire and was treated as a perfectly acceptable sexual partner for the comic when no woman would have him. In his study *Gay New York*, George Chauncey has observed that in working-class circles prior to World War II, sexual encounters with gay men did not carry the stigma that it did among the more privileged classes. It was effeminacy that was considered perverted. Men who had sexual encounters with "fairies," but were otherwise masculine in their behavior, were not marginalized or labeled as queer. "Indeed," writes Chauncey, "the centrality of effeminacy to the representation of 'fairy' allowed many conventionally masculine men, especially unmarried men living in sex-segregated immigrant communities to engage in extensive sexual activity with other men without risking stigmatization and the loss of their status as 'normal men.'"[49] In fact it is often a measure of the comic's insatiable sexual appetite, and meager opportunities that he engages in sexual relations with the nance. Whether this reflects any kind of enlightened attitude is moot for, as the comic sighs as he walks off-stage with the nance, "any old port in a storm."[50]

TALKING LADIES

A woman who worked in the scenes was referred to as the "Talking Lady" or the "Talking Woman."[51] The term could apply to a chorus girl picked for a brief walk-on or to an experienced sketch performer. Most women in burlesque got their start in the chorus. Chorus girls in the 1930s tended to be quite young. Most were in

their teens, David Dressler found, and had little in the way of skills or education.[52] Theatres regularly advertised for showgirls, "no experience necessary." Burlesque shows always had difficulty recruiting and holding on to chorus girls. Hours were long, the pay was low, and working in burlesque carried a stigma. The most attractive girls were usually picked up for Broadway revues, while those with some degree of talent moved into one of the principal roles.

While many scripts refer to female characters simply as "Girl" or "Woman," most distinguish between three different female roles—the ingenue, the soubrette, and the prima donna. The ingenue functioned as the main object of lust for the male characters. In some cases the ingenue was a young chorus girl playing a walk-on part. "The ingenue was generally a young, pretty thing, unschooled in worldly ways," Jill Dolan noted. "She often wandered on the stage asking to be taught the best way to kiss. Frequently called 'jail bait' because of her youth and virginity, the ingenue was the comic's ideal conquest—a beautiful, brainless, sexually naive victim."[53] More accurately, the ingenue was a parody or over-the-top depiction of the naive young girl. Rowland Barber noted that she was "given to 'cute' faces and baby talk. She stepped tiptoe-toe up the runway while singing 'Oh, Johnny!' or strewing daisy petals as she recited 'He loves me, he loves me not.'"[54]

The ingenue came to refer to the principal talking woman in a show. She was the woman in the show who really knew the scenes, and was the equal of the comic and straightman. In such cases, she might have a very different sort of stage persona than the traditional innocent. "Some like Hallie Dean and Bobby Pegrim, had all the prerequisites of soubrettes except the brassy voice to belt across a jazzy number. Hallie and Bobby had Principal Woman stature and often played character parts in comedy scenes," Rowland Barber writes.[55] It was not unusual for a comic to team up with a talking woman—often his wife or girlfriend. Comic Maxie Furman worked with his wife for much of his career—playing scenes specifically geared for a man and woman. "At the Eltinge, I met this chorus girl," Furman told an interviewer.

> She was seventeen. Everybody gave it six months . . . A couple of years later, we got married, and for thirty years we worked together, doing scenes like "After My Money," "French Maid," "Dressing and Undressing," "Stage Door," "Automobile," "Hit and Run Hotel," "Crazy House," "Westfall Murder," "Irish Justice," "The Celery Scene," "Flugel Street," "The Wise Child Court."[56]

A number of other husband-and-wife teams toured burlesque, most notably Mike Sachs and Alice Kennedy, and Bob Ferguson and Mary Murray. Generally, the talking woman played straight for the comic, but Bud Abbott partnered with his wife, Betty, for a several years before teaming up with Lou Costello.

When not working opposite the comic, the ingenue often appeared with the soubrette. The soubrette was the featured dancer in the show, and many shows carried two or more soubrettes. Rowland Barber characterized them as "semicoquette-semitomboy free spirits who whooped out blues and 'pep' songs, and twitted the men along the ramp about their baldness and virility."[57] Most got their start in the pony line of the chorus. "Soubrette is generally a little squat," Steve Mills observes. "Heavier girl, you know. Jazzy, snappy kid. Soubrette didn't have to be a great singer,

if she was a good rugged girl, good hoofer."[58] In the scenes, the soubrette was a party girl, who used her sexuality to get what she wanted. "The soubrettes were usually older, wiser women, sexual teases even more inaccessible than the ingenues. In later, more explicit burlesque, these 'sex-teases' became strip teases," Jill Dolan writes.[59] Paired with the ingenue, the soubrette was the more experienced woman of the world advising the inexperienced youngster. This reproduces the relationship between the knave and dummy characters found between the straightman and the comic or the whiteface and *auguste* clowns.

The third female role was the prima donna. Typically tall and statuesque, the prima donna was the principal singer in the show. "[The] prima donna is really a woman with a good soprano voice, the big-voiced woman," Steve Mills pointed out.[60] She was inevitably well-dressed, modeling high fashion. In the scenes, the prima donna usually played figures of authority, appearing as the comic's domineering wife. In her function within the show, she corresponded to the straightman, as the well-dressed embodiment of the social order. Margaret Dumont, in the Marx Brothers films, was a classic prima donna figure. Jill Dolan describes the prima donna as "the soubrette's straight, morally pure counterparts, usually correlated with the mother-in-law types found in many bits."[61] While the characterization of the mother-in-law *type* is apt, it is quite misleading. In fact, the mother-in-law figure is almost entirely absent from burlesque bits. The authority figure in burlesque scenes is the wife.

During the course of the 1930s, the principal women roles were taken over by striptease dancers. It was a gradual process. At first, a show might feature a single stripper, who invariably got the next-to-closing spot in the show. But their popularity soon forced out other female roles.

BURLESQUE CHARACTERS

Burlesque characters do not necessarily come across on the written page, for they are based on a tradition that circulated quite independently of the scripts. On the page, they appear flat and undeveloped. There is little attempt at characterization. The characters, except in rare occasions, are identified by their roles in the show—first comic, second comic, straightman, juvenile, ingenue, prima donna, and soubrette. They are defined by the function they fill in the scene—the comic as dupe, the straightman as hustler or con man, the woman as the object of desire.

It is a mistake to think that simply because they are sketchy and undeveloped on the page this is the case in performance. "This is a problem for the reader, not one for the member of the audience during the actual production," Harold Scheub points out in a discussion of African oral narratives. "The performer is himself the characters, he gives them life and fullness, and his *body* gives them dimension."[62] The characters are only sketched in because the performers themselves would fill them in with their own personalities and comic personas. "Characterization," Ruth Finnegan points out, "need not be expressed directly in words when it can be as clearly and as subtly portrayed through the performer's face and gestures."[63]

Unlike the legitimate theatre, for which the actor creates a new character for each part that he plays, the burlesque comic created a character that he played through

much or all of his career. The best comedians work on this character, deepening it, bringing humanity to the type by infusing it with their own personality, their own outlooks and concerns. Such characters go far beyond the stereotype. As Garff Wilson points out, "the created character is complex and many-sided and becomes involved in situations demanding great imaginative and emotional output, the player who successfully projects such a characterization has achieved acting on the highest level."[64] One important reason for this is that the comic actor "is also the author and creator of the part, he is apt to embellish it with more artifice and to develop more facts of the character than the tragedian who brings to life a dramatic character conceived by someone else."[65] They utilized recognizable stereotypes, but the best comics moved beyond the stereotypes, infusing them with their own personality and humanity. They were not simply two-dimensional buffoons, but fully realized comic characters, whose inner life contrasts and deepens their outward appearance as ludicrous outsiders.

5. Learning the Business ᴄᴏ

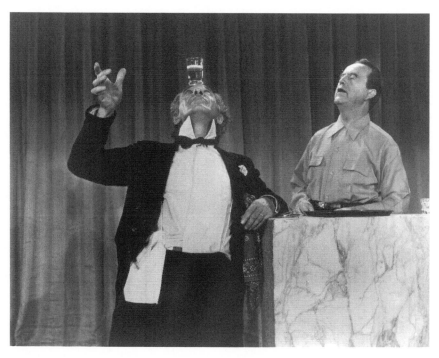

Figure 5.1 Harry Arnie successfully balances a glass of beer on his forehead to win a bar bet against straightman Charlie Crafts. (From the author's collection.)

The particular pressures in burlesque made it a valuable training ground for young performers ambitious for a career in comedy. Working in a burlesque house gave them an opportunity to be in the business, to observe more experienced performers at work, and to try out what they saw. By watching other comics work, seeing how they dealt with different audiences and situations, listening to the stories and advice that they had to offer, then stepping into scenes in which they were given larger and larger responsibilities, young comics not only learned the repertoire but how to put them over.

Burlesque valued the performance aspects of comedy over the written text. The script was secondary to performance—in burlesque the attitude was "anything for a

laugh." Burlesque comics were expected and encouraged to go beyond the text, to embellish the scene with their own comic business, personal mannerisms, and jokes. An early burlesque star Al B. Reeves compared burlesque with musical comedy:

> In burlesque...there is much more freedom. You are not compelled to stick to your lines at the sacrifice of laughs or amusement for the audience. For instance, a comedian finds a situation, discovers how to obtain a laugh; he "gets it over," as Mr. Broadway Producer would put it.
>
> And the comedian is not obliged to cut it out because it is not in the manuscript or interferes with someone else.
>
> That is why we have so many successful burlesque shows; that's why we have advanced. The public wants to laugh; we want to make them and when we give a comedian a part it's understood he or she is to get all possible out of it, and to "fatten" it up to the best of his or her ability; not to stick to lines.[1]

Most actors today are trained to analyze a script and there is an assumption by many in the theatrical profession that the ability to interpret a script is what the actor's job is all about. This was not the skill that was either necessary or useful in burlesque, since the bits were passed on orally. Many highly accomplished comedians did not learn and were not comfortable with reading and interpreting a script. As noted earlier, Abbott & Costello preferred to have their lines read aloud to them. This was not unusual—Rags Ragland, a top Minsky's comic, was another who could only learn his lines by hearing them read.

> "I was doing a burlesque routine on Main Street in Los Angeles," [Ragland] explained, "and this talent scout Bill Grady, took me out to MGM for a screen test. They threw a script at me, and told me to memorize it."
>
> That did it, Ragland told them.
>
> "I said I couldn't learn off paper. Had to get somebody to read it to me. I always learn my lines that way. So they say, 'we can't use this bum. He can't even read.' So I went back to Minsky in New York."[2]

TIMING AND DELIVERY

The real strength of the oral tradition is that much more is passed on than words. When jokes and routines are transmitted face-to-face, facial expressions, movement, pacing, rhythm, and emphasis are all part of the communication. Putting over a joke or physical bit requires a lot more than simply repeating the words or the actions. Delivery is as important, if not more important, in the success of the joke. In stock burlesque, a young comic not only learned jokes and comic business, but by observing the scenes, rather than interpreting them from a written page, he was able to see how a particular line should be delivered or how a particular facial expression could heighten the laughter. These are all the features that fall under the loose category called "comedy timing."

A good deal has been said about comedy timing, but most of what has been said is vague. To a large extent this is because the word "timing" has come to be applied

to all aspects of joke-telling that are not directly related to the text of the joke itself—including such elements as pacing, rhythm, inflection, and other aspects of vocal delivery. In the 1930s, "timing" had a more restricted meaning. As Morton Minsky pointed out: "Another important talent for any comic, and this is something that is hard to teach, is timing. Now, I'm talking not only about timing in delivering the punch line, but knowing how to wait for the laughs, how not to step on your own line just when the laugh is building."[3]

At its most basic, timing is simply about "waiting for the laugh," pausing long enough for the laughs to start to die down before going on to the next joke or set-up line. Generally this meant waiting for the laugh to crescendo and start to die down before delivering the next line. "There is a psychological moment for beginning your next gag," observes gag-writer Robert Orben. "This occurs at a point just following the peak of your audience's laughter. The laughs haven't stopped as yet, but they're diminishing in volume. When this moment is reached, go into your next line. If you start too soon, you'll cut off the audience's full enjoyment of the line. If you wait too long, there'll be a moment of awkward silence that'll give your audience a chance to cool off."[4] The responsibility for this usually fell to the straightman, who had to know when to come in after the laugh. It also involves the confidence or resolve to wait for the laugh to happen, letting the audience respond, rather than rushing through to the next line.[5]

Awareness of the audience is crucial in comedy. A scene between a comic and straightman is not so much a two-way communication, as a three-way interchange, in which the audience plays a role. "In serious plays good timing maintains or modulates suspense and assumes audience involvement in the dramatic situation," Terry Hodgson observes. "Comic timing seems to appeal to an audience more aware that it is an accomplice in the dramatic illusion."[6] Sigmund Freud noted the same thing when he observed that a "joke calls for three people: in addition to the one who makes the joke, there must be a second who is taken as the object of the hostile or sexual aggressiveness, and a third in whom the joke's aim of producing pleasure is fulfilled."[7] Timing has a lot to do with including the audience as a part of this communication, as essentially a third character in the scene, and playing to them, giving them a role in the scene and leaving room for their reactions.

Timing is often used to talk about delivery. But in the 1930s comics made a distinction between timing and "pointing." "'Pointing' a joke," Morton Minsky wrote,

> means emphasizing the right word by giving a certain inflection so that it becomes funny—much in the way that I sometimes will emphasize a word in the text here by italicizing it. You can point a line by shrugging your shoulders or by using your voice. You can also take the heat off the joke, for instance, one with a salacious intonation, by more or less "depointing" it.[8]

That is, "there must be a dramatic pause (actually, of course, it is no more than a breath) *before* the line which is intended to get the laugh, followed by another and longer pause *after* the line…"[9] In addition to pausing just before the punch line, techniques for pointing a joke include emphasizing a key word by raising the voice or pitch, or pronouncing specific words in a slightly distorted way. Comic dialects or lisps were useful ways of pointing a joke. As one commentator observed about Eddie Green, "He spoke genuinely entertaining lines and used his dialect and vocal tricks to

point them."[10] Often this involves distorting the words in a way that emphasizes the key word. John Fernald suggests that "comedy points are just like any other important effect upon the stage; they require emphasis in precisely the same way; and the principles behind their emphasis are simply those of clarity and suspense."[11]

Just as important as the joke delivery—in some ways more important—is the reaction to it. The laugh often comes on the comic's response to a line, a sudden realization, or a take to the audience. In some cases it was appropriate to reveal an emotion—of shock or delight or embarrassment—but it was often a deadpan look at the audience. In burlesque, the term for a reaction was "skull." "Part of [the comic's] training, in addition to the obvious—learning to tell a gag—was learning how to point and how to skull it," Morton Minsky wrote. "A skull is a mug or a double take. The gag is told and the comic leers to the audience or registers pain or looks around him, pretending to be innocent. The joke must be emphasized so that the audience, which is not *entirely* made up of intellectuals, gets the point."[12]

According to Don Wilmeth,

a skull or (to) skull a line meant a slow reaction to a line, with the skull being the face or facial expression. To be effective, the skull was done as a carefully timed delayed reaction, and if the face did much of the work, this was called *to skull a line*. Give him a skull, then, was the process used by the comic in reaction to a straight man or vice versa.[13]

The term "skull" suggests that these takes should generally be underplayed. Sherman Siegel emphasizes this in *The Language of Show Biz*:

Takes and skulls can be done crudely or subtly, depending on the taste, skill and soul of the performer. In the more elevated forms of the take, hardly a single overt change in the actor's body occurs, yet the audience has read his mind and has seen him smacked over the brain with a new awareness.[14]

Timing and delivery are ultimately very subjective and very personal things. What worked for one comic might not work for another. "Timing cannot be measured in seconds or milliseconds, since it is organic to what the performer is doing."[15] There are no hard-and-fast rules on timing and burlesque comics found what worked for them—through trial and error—rather than by absorbing any principles of comedy. "You tighten your timing by performing," Robert Orben advises. "You try a joke one way, then another, then a third way. You work it over until you reach the point where no further variations are possible. Then you use the delivery that was most effective."[16] By performing in four shows a day, six days a week, comics had an opportunity to try different approaches, keeping techniques that worked for them and discarding those that did not.

John Lahr observed of his father, Bert:

He worked hard on stage, trying out many different comedy gestures, eliminating ones that did not get good laughs or which, in certain situations, killed a bigger one to come. He had already acquired, along with his distinctive delivery, a catch phrase. All the great comedians used some such phrase or action not only as a trademark but also as a psychological gimmick to elicit the audience's response at the right moment. Will Rogers

lowered his head and twirled his lariat after he told a joke. George M. Cohan glanced sideways toward the boxes and pretended he was cleaning his molars. Lahr did a double take toward the audience after the punch line and then growled his "gnong, gnong, gnong." The audience was led to the joke, cued to laugh, and then, with an effective comic phrase, the basic joke was expanded far beyond its original proportions.[17]

VERBAL WITTICISMS

A young comic collected verbal jokes in much the same way that stand-up comedians assemble gag files. Most did so in a haphazard way, trusting their memories, while some amassed extensive joke files. Stealing jokes was the way that the business worked. "Performers had no way to protect their gags, business, or parodies. Nobody paid any attention to the copyright law. Good gags spread like gossip. If a team at the Palace in New York introduced a new gag or bit of comedy, it reached San Francisco the next day via wire, or vice versa," Douglas Gilbert noted in *American Vaudeville: Its Life and Times*.[18] If a particular bit were clearly identified as belonging to a specific performer, burlesque performers generally tried to prevent others from using it.[19] Many of the jokes that circulated were solidly in the public domain, and had been around for decades.

In a theatrical center such as New York, the trade in jokes was a local industry. Joey Adams wrote that in New York City,

> there were three supermarkets for gags and social directors' materials. Kellog's Cafeteria on 49th Street just off Seventh Avenue and the Palace Cafeteria and Theatrical Drugstore just across the street from each other on 46th Street west of Sixth Avenue. Together they constituted a Corn Exchange. There you could swap two Berle black-outs for one Red Skelton Guzzler Gin routine or twelve Bob Hope's jokes for a Willie Howard sketch.[20]

In the late 1930s, white performers went uptown to Harlem's Apollo Theater, where "Pigmeat" Markham watched them taking notes on his performance.

> Those were the days when all the gang from downtown used to come up and sit "on the front seat" as we used to call it. I mean comics like Milton Berle, Jack Carter, Henny Youngman, Joey Adams and Molasses and January (who were white in spite of those names) and a whole lot of others would come to see our Saturday midnight shows, and they'd bring their girls along with them—the girls had notebooks and took shorthand awful fast—and they'd sit in the front seats and copy down our jokes.[21]

Joey Faye admitted that he did impersonations of the comics he saw at leading vaudeville theatres when he was starting out.[22]

Most jokes circulated more informally, much as they do today. New jokes tended to make the rounds of the theatres, and often spread across the country on the stages and in the green rooms of vaudeville and burlesque houses. A *Billboard* reporter found one such joke making the rounds in February 1931:

> Here's a comedy bit of dialog you ought to get acquainted with, if you aren't already:
> The boy asks the girl:

"Do you drink?" "No."

"Do you smoke?" "No."

"Do you pet?" "No."

"Then you must be a very nice girl."

And the girl asks the boy:

"Do you drink?" "No."

"Do you smoke?" "No."

"Do you pet?" "No."

"Then you must be a very nice girl, too."

This gag was caught, word for word, by a *Billboard* reviewer at three houses in different acts this week.

Looks like an epidemic.[23]

Joke books provided a reliable source of gag material. "Printed collections of jokes, monologues, sketches, recitations, and songs circulated widely among both professionals and amateurs from the middle of the nineteenth century through the 1930s," Brooks McNamara observed.[24] Gypsy Rose Lee's collection of burlesque scripts includes a number of blackout bits clipped from *Madison's Budget*, a gag book that regularly advertised in the theatrical papers. Performers often put together their own gag books. "Typically, these books were anthologies tailored to the interests of a particular performer," McNamara explained. "They tended to be made up of clippings from published gag books and more general joke books, together with manuscripts contributed by other entertainers, and material written by the owner of the book."[25] Often these were indexed by theme or subject matter.

Jess Mack saved a large number of gags, which he grouped according to theme. Some are classified by subject matter and arranged alphabetically, from "Absent-Minded" through "Xmas." Some are identified by title—"Dream Gag," "Father Has Red Hair Gag," and others. Others are classified by function. Many of these are bits you would expect to belong to a standup comedian. Some are specifically for emcees. There are a number of "Heckler Gags."

Another set of jokes were meant for ad-libbing and padding. Many of these were risqué or suggestive.

> Com: Remember when we used to go out in the woods and pick wild flowers and your little brother used to hang around and we really had to pick flowers?
>
> Com: My wife threw my pants up in a tree. I threw her dress down in the well. She pulled my pants down and I pull her dress up. Now everything is okay.
>
> Com: Did you hear about the Scotsman that stuck his finger in gold paint so he could give his wife the golden goose?[26]

While Mack set many of these down on paper, others collected them on a more informal basis, relying on their memories and a sense of what remarks had garnered

laughs in the past. The ability to quickly come up with comic material was a central part of the burlesque comic's job.

PHYSICAL BUSINESS

Young comics also picked up "bits of business"—comic actions and mannerisms—that they could drop into any scene. "These 'bits of business,'" Irving Zeidman observed, "were unrelated to anything in the show or in the bit itself. They could vary in nature from pawing at the women in the act to spitting in the straight man's eye. In this manner, a basically clean bit could be roughed up or dirtied at will, as circumstances dictated."[27] Not all of these bits of business were suggestive or obscene. Although burlesque had a preference for risqué or off-color remarks, any line or gesture that could garner a laugh soon became part of the burlesque comic's arsenal.

These bits of business were an important way of embellishing a scene. Some of the bits were tied to a specific type of scene—a restaurant scene or a schoolroom sketch. Others were general and could be used as entrance gags or as padding when the performers had to stretch a scene. A bit might be as simple as a shrug of the shoulders or as complicated as a routine. Some were incorporated into the comic's character, with catch-phrases such as Lou Costello's "Heyyyy, Abbott," Billy Hagan's "Cheese and Crackers," or Joey Faye's stutter. While some bits were personal to one particular performer, many were standard routines that had been around the business for years. They are related to the *lazzi*, the physical shticks, of the *commedia dell'arte*.

Comics kept their eye out for interesting comic mannerisms, in much the same way that a dancer looks for interesting steps. Harland Dixon was an eccentric dancer who worked in burlesque and other popular entertainments who made a concerted effort to collect such moves.[28] "Dixon has a keen eye for characteristic gestures he can use," Marshall and Jean Stearns noted in their history of jazz dance.

> One day he saw Lew Dockstader, who was a monologist not a dancer, unconsciously doing a tight little strut during rehearsals. "It was a gem, and I adopted it then and there." Another time he was fascinated by "a little body twist" that Billy Rock employed. "He was famous for doing something with nothing. If he knew two more steps, he would have had six more routines." Dixon still treasures it. He learned something from everybody, including hand gestures from the vaudeville orator Henry E. Dixey.[29]

Much more elaborate physical bits could be built around props. Every burlesque house was well-equipped with objects that had proven comic potential. "Stage properties which had a great part in the fun included the slapstick, bladders, bottles, rolled-up newspapers and phallic symbols," Bernard Sobel wrote.

> Two other important properties were the revolver and stage money. The revolver and the blank cartridge appear most importantly in the infidelity scene. Betting scenes were popular, with the dumb comic, always the dupe of the occasion, losing every cent he had. While the betting is in progress, scores of bills are flashed, wallets displayed and dozens of worthless paper, colored with numerals and green ink, scattered over the bar and stage.[30]

One of the standard comic props was the bladder. Ann Corio wrote that

> in the old days burlesque comics would go to the neighborhood slaughterhouse and buy
> a pig's bladder. This would then be dried and inflated. The bladder was needed because
> the running motif of the Courtroom [Scene] was the Judge flailing away at the heads of
> the prosecuting attorney, the defense counsel, and the crazy cop in attendance. What the
> bladder did was make a terrific crack, without hurting anyone.[31]

When the company needed one, a prop man would soak it in water over night to soften it, coat it with Vaseline, inflate it, and tie it off with a string to be used.[32] The bladder has been used as comic prop since at least medieval times when it was carried by court fools.

A bed was an obvious and frequently used property. If a comic were presented with a bed onstage, he could build the anticipation with a number of physical bits. "There will be endless oiling of the springs with a locomotive engineer's squirter, examining of the sheets, puffing up pillows and placing them in the center of the bed with sudden anticipatory bursts of noise, whistling, shouted snatches of love phrases from popular songs."[33]

The baggy pants that burlesque comics always wore functioned as a comic prop as well. Too large around the waist, they were held up by suspenders, so the comic could pull them up or down, twist the fabric in front, peer down the front. The straightman might grab him by the seat of the pants. As H. M. Alexander wrote:

> A bottle of seltzer squirted down a trouser leg is good for an indefinite period of wry faces,
> stiff walking and leg shaking. A little home-made dialogue that the straight man will pick
> up very easily conveys the idea that the comic has just had an "accident" in school, has
> been sent home. He looks down at his trousers and then a wry embarrassed expression
> creeps over his face; he blushes. The audience roars.[34]

"STRETCHING A BIT"

Physical business was especially useful for "stretching a bit" when there were problems backstage, covering for an accident backstage or a missed cue. H. M. Alexander describes such a scene:

> The comic and his straight man are out there, pacing their way to the inevitable gag finish and blackout. Just as the straight man is about to deliver the cue for the punch line, the stage manager waves frantically from the wings to get their attention. They look at him. He lays the palms of his hands together and separates them widely. "Stretch the bit." Something's gone wrong. The comic has to keep it going until everything's been straightened out for the next number.[35]

Another way of stretching a bit was termed "lecturing on a skull." In this, the comic or the straightman did all the talking, while his partner simply registered reactions. It was often done when one of the performers was too drunk to function onstage.[36] The sober partner would fire off a series of insults or impossible questions,

while the partner reacted to the onslaught. "It's the guy that's doing the lecturing that has the whole creative burden, and most of them have a bagful of these lectures in their repertoire. Sometimes the silent partner can make the joke funnier simply by his reactions," Morton Minsky writes.[37]

One of the classic lectures is "Handful of Nickels," which Joey Faye claimed was one of the sources of "Flugel Street."[38] This interchange is taken from the Jess Mack Collection:

> Str: I'll prove how dumb you are...suppose you walked into a railroad station and bought a ticket. Where would you be going?
>
> Com: Well...
>
> Str: See you don't know. What are you buying the ticket for? You walk up in front of the window and stand there like a big jerk with hundreds of people standing in line behind you and you don't know where you're going. Now when you bought your ticket, how much change did you get?
>
> Com: Well...
>
> Str: See, you don't know. You just walked up, reached in your pocket and handed the man a pile of money. You don't know how much change you got and you don't even know where you're going. Now here is another question. Suppose you went to a baseball game? The grandstands are packed. It's a beautiful day. Who's playing?
>
> Com: Well...
>
> Str: See you don't know. Why in the devil do you go to a ball game, sit in the hot sun for nine innings, yell yourself hoarse if you don't know who's playing. Now another thing. How high is up? How long is a piece of string? What color is red? Suppose I came along and gave you a handful of nickels. How many nickels would you have? See you don't know. Now supposing you and I... *(Tries to keep talking.)*[39]

The straightman could lengthen this scene at will, by adding more insults and impossible questions.

The mark of a good burlesque performer, one comic told H. M. Alexander, was how well he could stretch a bit. "He has to be bearable if not funny without the faintest notion of what he's going to do. If his impromptu stuff is no good, the bit becomes a 'stage-wait' and the strip-minded jerks 'ain't waitin' for nobody. 'Off! Off!' they'll yell."[40] In creating their own dialogue on the spur of the moment, burlesque comics did not depend entirely on their own inventiveness. They had at their disposal prepatterned routines and formulaic expressions that they could draw on. As Richard Andrews points out in his study of the *commedia dell'arte*,

> A performer whose living depends on making people laugh collects jokes, and stores them either on paper or, if illiterate, in his memory. His collection will range from one-line responses through simple question-and-answer routines to quite complex verbal and physical sequences. Jokes, gags, routines, are needed in their own right, and they are more important basic tools than plots or situations. They are the life blood of the strolling comic actor—each joke raises a laugh from the audience and the more often they laugh the more money they will pay.[41]

FORMULAS

Like performers working in other oral traditions, burlesque comics commonly relied on what are termed *formulas*. The term was originally applied to Yugoslavian epic singers, who create lengthy narratives in verse, and is the basis of what is known as *oral-formulaic theory*. Homeric scholars Milman Parry and Albert Lord found that these illiterate poets are able to create lengthy poetic works in performance, determining that, as with shorter forms, the text of the story is not memorized, but is created anew in each performance. Even lengthy epics like the *Iliad* and the *Odyssey* are the result of "'composition-in-performance,' by which singing, performing and composing are facets of the same act."[42]

Such a feat is possible because an epic singer "has in readiness entire sets of 'recitation-parts' [that] consist of descriptions of certain occurrences and situations like the birth of a hero, his coming of age, praise of weapons..." and so on.[43] These recitation-parts or *formulas* are defined as "a group of words which is regularly employed under the same metrical conditions to express a given essential idea."[44] They are essentially stock phrases or expressions of varying length, used to complete a metrical line. Formulas are tied to specific *themes*, which are "groups of ideas regularly used in telling a tale in the formulaic style of traditional song."[45]

Such formulas are necessary in a nonliterate culture. "In a literate culture verbatim memorization is commonly done from a text, to which the memorizer returns as often as necessary to perfect and test verbatim memory," Walter Ong observes in *Orality and Literacy*.[46] But in a nonliterate culture, this is not possible. "In a primary oral culture, to solve effectively the problem of retaining and retrieving carefully articulated thought, you have to do your thinking in mnemonic patterns shaped for ready oral recurrence," Ong writes.[47] These formulas are repeated constantly so that "they come to mind readily and which, themselves, are patterned for retention and ready recall."[48]

In such cultures verbatim repetition is neither possible nor the absolute goal. "We must remember that the oral poet has no idea of a fixed text to serve as his guide," Albert Lord points out. "He has models enough, but they are not fixed and he has no idea of memorizing them in a fixed form."[49] Epic singers absorb material by listening repeatedly to a story or song, under a variety of circumstances over an extended period of time. Among the Yugoslavian epic singers studied by Parry and Lord, the bards learned "by listening for months and years to other bards who never sing a narrative the same way twice but who use over and over again the standard formulas in connection with the standard themes."[50]

Other scholars have found that the use of formulas and a formulaic style of composition is widespread in oral narrative traditions, and is not limited to purely oral cultures. Walter Ong points out that "to varying degrees many cultures and subcultures even in a high-technology ambiance preserve much of the mind-set of primary orality."[51] Citing the work of John Miles Foley, Ong observes that "what an oral formula is and how it works depends on the tradition in which it is used."[52] He expands the definition of formula to be a "more or less exactly repeated set phrases or set expressions...in verse or prose."[53] D. Gary Miller also characterizes formulas

in a way that applies to a variety of genres, calling them "prefabricated utterances—expressions stored for some mental content," noting that "information is packaged, stored, uttered and processed in 'chunks.'"[54]

Burlesque comics, of course, had little use for the kinds of descriptive passages used by epic singers, since the action is acted out and the setting suggested through props and scenery. Their primary goal was to get laughs, so they would need formulas with a joke structure. A joke can be said to be a formula in that it, too, is a "prefabricated utterance"—one specifically designed to elicit laughter from a listener or an audience. Jokes are tied to certain "themes"—subject matters that have proven humorous potential. Some of these themes are timeless; others go in and out of style.

The formulas that we find in burlesque comedy are much more closely related to the kinds of formulaic expressions found in conversation rather than in narrative forms. Clichés, proverbs, metaphors, and parables are all traditional formulas that occur in everyday exchanges. Jokes, too, are traditional expressions, a formula that specifically fits in a comic situation or conversation.

In *Conversational Joking: Humor in Everyday Talk*, linguist Neil Norrick has shown how such formulaic humorous utterances appear in everyday conversation, noting that "joking allows us to manipulate talk and participants in various ways, by presenting a self, probing for information about the attitudes and affiliations of our interlocutors, realigning ourselves with respect to them, and, of course, injecting humor into a situation."[55] Norrick shows how participants in conversation use both original and recycled humor in everyday conversations. There is not always a clear distinction between canned and spontaneous jokes, as people introduce jokes or comic sayings where they are topically relevant.[56] Joking material is often used for the most formulaic portions of conversation—greetings, leave-takings, topic-changes, and so on. People store and recycle humorous phrases tailored to bridge segues in conversation.[57] These seem to be the same instances when jokes occur onstage, at the beginning and ending of scenes or to mark a transition between one action or subject matter and another. Once such formulas are memorized they can be used creatively in a number of situations. "The more sophisticated orally patterned thought is, the more it is likely to be marked by set expressions skillfully used," Walter Ong writes.[58]

EMBELLISHMENT

Comics were expected to embellish scenes with their own jokes and bits of comic business. To some extent this is true of any theatrical script, which requires the actor to draw on his or her own personality and affective memory when enacting a scene. But in burlesque, this happened to a far greater extent. The script merely laid out the main line of action, suggesting certain jokes or bits of comic business. This becomes quite apparent when we compare a scene in written form and the same scene as it is actually played by an experienced comic. A very clear example is a bit I have dubbed the "Upside-Down Beer Bit," as it appears in a scene titled "Louie the Bartender" in the Ken Murray Collection.

<u>Upside-Down Beer Bit</u>

The Straightman goes offstage and returns with a glass of beer on a tray.

Str: I'm going to bet you that you can't drink that beer there with one hand behind your back without spilling it.

2nd: What the hell, it's nailed.

Str: Of course not, try it if you like.

[The Comic tests the glass, which is not fastened to the tray, by lifting it slightly.] While the Comic is betting money, the Straightman turns the glass upside down on the tray. [He does so by removing the glass from the tray, placing the tray upside down on top of the glass, then turning both tray and glass upside down so that the glass is upside down on the tray. The liquid is trapped inside.]

Str: There you are go ahead.

2nd Comic rushes up to drink glass of beer and sees it.

2nd: That's a dirty trick.

Str: That's all right.

The Straightman takes the money and exits. At that point, the 1st Comic enters.

2nd: You're just in time.

1st: What's the matter?

2nd: I'm going to get you some real beer.

1st: Hell with you.

The Straightman enters with tray with a glass of beer on it.

1st: Let me at that.

Str: I'm going to give you a chance to make ten dollars. I'm going to bet you ten dollars that you can't drink that glass of beer with one hand behind your back.

1st: Can I try it?

Str: Sure go ahead.

[The 1st Comic tests the glass, lifting it off the tray.]

1st: That's a bet.

Ad-lib betting. Straight turns glass of beer upside down.

Str: Go ahead.

1st: That's a dirty trick.

2nd: You can't do it.

1st: I'll bet you ten.

Betting. 1st Comic goes back to glass and looks it over. Picks up tray in hand. Head down puts glass up against forehead, straightens back up. Balances it. Throws tray on floor. Reaches up and gets beer, drinks it, picks up money.

BLACKOUT

Despite the fact that this appears in script form, it is really just an outline of the scene. An experienced comedy team would be expected to elaborate on it, introducing their own jokes, adding bits of business, and infusing the characters with their own charm and personality. We can see how this was done with this particular scene in a video feature filmed in the 1980s with Lou Ascol as the Comic and Sandy O'Hara as the Talking Woman. The video was released under the title *The Best of Burlesque*.[59] It gives a good idea of how elaborate such a scene can be when a comic adds his own jokes and bits of business. This premise is worked into an eight-minute routine, and is one of the best examples of what burlesque comedy could be in the hands of accomplished performers. Ascol, admirably assisted by O'Hara as the feeder, turns the scene into a comic *tour de force*.[60]

The scene opens with O'Hara standing behind a makeshift bar. She sets up the premise to the audience in a brief opening monologue.

> O'Hara:　I just opened this bar about a month ago and business has been so bad I have to come up with a little scheme to get some money into this place. Now when a customer comes in, I'll offer him a drink on the house. But…when he goes to pick up the drink, I'll bet him ten dollars he can't put his left hand behind his back and with his right hand pick up that drink and drink it. Oh, it sounds easy, but when I take the glass like this … *(Raises glass off bar.)* and place the tray like this… *(Places the tray upside down on the glass, then turns them both over.)* the trick becomes impossible. He'll lose and I'll win the money. Now I just need a few customers in here.

Ascol enters quickly from stage right, crossing in front of the bar, trilling "She didn't know my gun was loaded." O'Hara stops him, asking where he's going. He answers with a well-known entrance gag: "You see my wife told me to go to hell twenty minutes ago. I'm half an hour late." When he tries to leave, she calls out, "Come back here, you jerk." Ascol takes this as a challenge, assumes a fighting pose, and warns her not to mess with him, since "I come from a fighting family." "Yeah, who's *your* father?" O'Hara demands to know. "That's what they're fighting about," he replies. This sets up another joke on prize-fighting: "I used to be a prize-fighter. Kid Underwear, they called me." "Kid Underwear?" "All my fights were drawers [draws]." He gives a quick aside to the audience, "That's the way they write 'em, that's the way you gotta read 'em." Ascol tries to leave again, explaining that "I heard a woman opened up a bar. She's giving away free beers to the first twelve customers." This sets up a series of jokes on beer as Ascol explains how beer caused the breakup of his marriage. His wife used to drink canned beer in bed, and leave the cans under the sheets. "I couldn't tell one can from another," he quips, topping that remark with "I reached for a Pabst and got Schlitz." The audience laughs at the scatological double entendre.

While O'Hara sets up the premise of the scene at the very opening, the actual bet is delayed and instead we get a series of jokes. The jokes are not extraneous to the scene, but serve to define the themes of the scene, establishing, first, that Ascol is fond of beer; second, he has a lot of money; and, third, he is a gambling man. This information is presented in a series of one-liners that are linked by subject matter. These

jokes, then, are a way of conveying information, building character, and advancing the action as well as setting up laughs. Important information must be emphasized through repetition—a series of jokes on key topics serves that purpose.

Once it has been established that he likes beer, Ascol tries to get O'Hara to give him a "pick me up." She refuses, so he insults her. "Ah, your sister goes under the bridge with pygmies." How does he know? His brother is a pygmy—"about this high," Ascol says, holding his hand at thigh height. She explains that he is not going to get any because he has "no lettuce, no tomato, no cabbage." This serves as a transition to series of jokes on money.

"Money never bothers me, just the lack of it," Ascol announces, as he pulls out a huge wad of stage money. He licks his thumb to begin counting the money, then looks at the thumb and comments, "I remember eating there last night." There follow other gags on money, as he counts out tens, twenties, fifties, seventy-fives...nineties. "I call them twenty dollar Williams. I don't have them long enough to call them Bills," rescuing this pun with another aside, "Now you know why burlesque is dead."

This leads in to the "two tens for a five" bit that was outlined earlier, as Ascol asks O'Hara to change his five-dollar bill. But the bit is interrupted half-way through for a couple of jokes and side comments. When she demands her money back and threatens him, we get a couple of jokes about his size. "Just because you're bigger than I am don't mean I'm smaller than you." Both look quizzical. He claims to have a longer reach than she does, anyway. He demonstrates by having her hold her hands down at her side as he does the same—"See? Ten inches anyway." After this interruption, he offers her back a five, and gets two more tens in return.

O'Hara asks him how he got all this money, and Ascol admits "I'm a gambling fool, I'll bet on anything." This leads into a series of whoppers about betting on the horses.

> I bet fifteen cents on a fourteen horse parley, and the whoooole fourteen of 'em come in. Even the horse plowing up rutabagas in a field, he came in, too. I collected on the whole damn bunch of them...I'm so lucky, I got two dollars on a horse's nose, two dollars on her tail, and be damned if she didn't come in sideways.

With O'Hara prompting him, he keeps going: "Fast? They had to run her sideways to keep her from flying. That horse was so fast, half way around the track she gave birth to a colt, and would you believe it, the colt finished second?" Turning quickly to audience, he says, "And if she believe that, I'll tell her twelve more." Turning back to O'Hara, he says, "And that ain't all...I had second money on the colt, too." Several more jokes follow and the sequence finishes off with Ascol claiming to have gotten inside information from a talking horse. This strains even O'Hara's credulity. "Who ever heard of a talking horse?" she demands. "You never heard tell of a talking horse?" Ascol responds. "Well I'll give a for instance. Just the other day, I walked over to the paddock, looked around, made sure none of the trainers were there, walked over to the talking horse...what do you think he did?" "What?" "Lifted up his tail and said, 'A f-f-f-f-few.' If that ain't inside information I don't know what is."

It is only at this point, some five minutes into the scene, that the performers get around to the actual bet. O'Hara offers him a drink on the house, pouring him a glass

of beer that is mostly foam. "Just what I always wanted, a beer float," Ascol quips. Taking the glass, he makes sure the drink is for him. Assured that it is, he pulls an imaginary bug out of the glass. "Get the hell out of there." After a pause, he turns to the audience and says, "Don't drink much, but no sense letting him flounder." As he raises the glass to his lips, O'Hara interrupts him, proposing to bet that he cannot drink the glass of beer with one hand behind his back. As this is important information, Ascol repeats the proposal, ostensibly to make sure he understands the bet, but ensuring the audience got it. Satisfied, he lays ten dollars down on the bar, and O'Hara matches it. He continues laying down and picking up the same ten dollar bill, as he rattles off "ten more—ten more—ten more—ten more" as O'Hara lays down a new ten dollar bill each time. She catches him, prompting him to protest, "It's not my fault. Sometimes the damn thing sticks."

The bet is drawn out with a number of interruptions. While he is downstage talking to the audience, O'Hara turns the glass upside down on the tray. Ascol notices that "the head is smaller" and O'Hara announces "You lose, I win the money." "Just a moment," Ascol replies. "Maybe I can do it, maybe I can't, but to show you I'm a gambler, I'll bet you ten more, ten more, ten more, ten more, and that's all. Gotta keep the game honest, here, you know what I mean?" Then, relenting, he proposes they each bet their whole bankroll. Laying down his own, he declares, "Why there's enough money to finish the freeway all the way to Fresno, sixteen lanes with Big Boys every twenty-five feet." She lays down her much smaller bankroll, and he notices, "There's not enough money here to build an outhouse in Fallon." Pausing a second, he adds "Not that they need another one."

Ascol keeps up a steady line of patter as he takes the tray with the glass on it. "All I got to do is one hand behind my back, the other hand I gotta drink it. This is a good trick if I can do it. This is a damn good trick even if I can't do it." He leans over, pressing his forehead onto the bottom of the glass. "Well, as they say in Puerto Rican, 'Nostrovia.'" "Nostrovia?" "That's the Polish section of San Juan." He straightens up with his head tipped back so that the glass is turned right-side-up on his forehead. Taking a moment to balance the glass, he asks, "Hey, Red, did a tall dog, just walk by here?" "No, why?" "Must've been an inside job." He removes the tray and lets it drop, takes the glass with the now-freed hand and takes a swig of the beer to the applause of the audience. Taking the money from the bar, Ascol tells his partner, "I got all-l-l-l this crazy money and guess what?" "What?" "This is for you—" He thumbs his nose at O'Hara and exits, as the scene blacks out.

While this scene shows how a burlesque comic could embellish and extend a scene with patter, a written account captures only a part of the performance. Much of the humor comes out of the unique charm and appealing personality of Lou Ascol. He directs much of his performance directly toward the audience, making frequent asides to them, taking them into his confidence as he comments on the quality of the material, and after he has delivered a truly atrocious pun, crowing about how easily he has taken advantage of O'Hara with his money-changing bits. Ascol has several comic mannerisms that he uses to punctuate his jokes. He shows his assertiveness by moving his head forward and back, much like a pigeon, and periodically tips his hat to O'Hara to emphasize a point. When he pauses for laughter, he often cues it with a silly expression in which he sticks his tongue out of the side of his mouth. The

scene itself is played at lightning speed, but the action is punctuated with pauses for laughter and frequent asides to the audience.

O'Hara does excellent work in the role of the feeder. She is a buxom woman, several inches taller than Ascol, and she projects a no-nonsense quality, assertive but affectionate. O'Hara's job is to move the action along. She establishes the premise of the bet, right at the top of the scene, stops Ascol from dashing offstage, proposes the bet, turns the glass over, and keeps bringing Ascol back to the subject at hand. This is an important part of the straightman's role, and O'Hara plays it with verve.

What we see is a well-defined division of responsibilities between the comic and the straightman. The comic introduces a variety of jokes and bits that are extraneous to the plot, although thematically tied to the action that is taking place. The straightman is mainly concerned with the plot, introducing most of the plot points, and interrupting the comic's reverie to get the scene back to the matter at hand. The straightman regularly jumps into the comic's monologue, taking advantage of natural pauses to move things along. All of the comic's commentary helps to keep the audience in suspense as to how he is going to win a seemingly unwinnable bet, so that when the trick is finally revealed, the audience responds with laughter and applause, bringing the scene to a quick conclusion.

This is clearly a signature piece for Lou Ascol, one that he performed for much of his career. In that time he has embellished it greatly, adding his own jokes and bits of business, introducing certain mannerisms that help to "point" the joke and making the scene uniquely his own. There is an immediacy to the performance that comes across even on film. Ascol has good rapport with the audience and makes direct contact with them. The audience's appreciation of the scene ultimately has little to do with winning or losing the bet, although the audience is pleased by the way that Ascol wins, which provides a satisfying payoff to the scene. The strength of the scene, and the premise, is the opportunity it presents to hang a variety of jokes and bits onto while allowing Ascol to establish an intimate relationship with the audience. This is not to say that the premise or plot is unimportant, for that is what sets up the comedy and brings the scene to its satisfying conclusion. But it is the convoluted way that a skilled comic like Lou Ascol gets us there that makes these scenes such a pleasure in performance.

Comics needed at least three types of bits: physical bits and business, which were useful for developing character, pointing the jokes and stretching a scene; jokes or one-liners, which they could use as commentary anytime during the scene; and dialogues, which required the give-and-take between two performers. The best comics always added their own material, filling it out with their own personalities and adding their own comic turns. Willie Howard, a leading star of musical revues in the 1920s and 1930s and a graduate of burlesque, acknowledged the importance of these bits. One interviewer got the following quote:

> The success or failure of a scene is dependent on what tricks a comedian can bring to it. First he must believe in the scene. Intuition tells him more than audience appreciation. His next step is to analyze not only the scene but the construction. To succeed, comedy must be tricked. Mugging, gestures, tempo, and vocal pyrotechnics play important roles.

When you cannot get over with a line, you must trick with an absurd facial expression or a burlesque movement of some part of the anatomy, or by a surprise pitch of the voice either up or down the register. The veteran stage comic knows these tricks and uses them every second of the time he is in front of an audience. Not for an instant does he relax from the broad caricature he has drawn. If he does, the illusion is gone.[61]

Comics trained on the burlesque stage acquired a bag of tricks that served them well throughout their careers, both in burlesque and beyond.

6. Bits and Blackouts ⨍

Burlesque is distinct from other oral forms, including most comic traditions, in that it was a multiperformer genre. The presence of more than one actor on the stage adds a level of complexity not found in other narrative forms, observes Tim Fitzpatrick, who has analyzed performance practices in *commedia dell'arte*. In a multiplayer form, the individual "performer is not completely free to inflect the performance to suit his or her individual reading of the performance," Fitzpatrick writes. Instead, "each performer needs to sustain and enhance, by the choices he or she makes, the choices of the other performers."[1] While a one-liner or humorous anecdote will serve the needs of a stand-up comedian or a nonprofessional telling jokes in a social setting, the burlesque comic—in fact any performer working in a dramatic form—is best served by a *dialogue*. Formulas used in a stage situation "would have been dialogic in structure," Fitzpatrick notes, "requiring a continuity of personnel in the fixed roles to ensure that one performer provides recognizable cues to the other to achieve smooth turn-taking."[2]

Richard Andrews has also written about the dialogic structures in the *commedia dell'arte*. He notes that in addition to their individual *lazzi*, "these actors would need a technique for creating and memorizing material which actually led somewhere, dialogue which was capable of building narrative and therefore of contributing to the plot."[3] They would have employed *dialogic units*, he concludes, constructing lengthy dialogues out of "small manageable units, not so very different from the autonomous so-called lazzi."[4]

Such dialogic units are *modular*, Andrews has found. That is, they can be taken out of one context and put into another. "Dramatic texts fall into a characteristic pattern—one whereby dialogue is built out of short units, many of which are interchangeable, or removable, or indeed recyclable into a different narrative context," he writes.[5] Andrews has found that such "modular components are a sign of improvisation technique, of a mode of performance in which an actor's existing repertoire of jokes, long and short, can be adapted and inserted into any plot with which they do not actually clash."[6]

It is a method, he argues, that allows oral performers to memorize complicated scenes with relative ease. "In my mind," Andrews writes, "the scene will be chopped into small units, each one simple and self-explanatory, each one relatively undemanding to the memory; and all I have to do is remember the units in the right order."[7] Individual units will be identified by a title—"the lemon bit," "the zoop bit"—or by the punch line, or some similar notation. Each bit can be rehearsed independently and dropped into an order that the comedians determined. "Such techniques could have been developed first of all by illiterate performers, who needed them to help build their mental catalogue of material," Andrews tells us. But performers did not give up this approach

because they could read. "When the acting profession ceased to be illiterate…then the mental memory bank was replaced by the personal *libri generici* (commonplace books), written collections of useful and transposable material which we know actors kept right down to the time of Goldoni."[8] Such commonplace books are identical to the joke files that professional comedians have kept to the present day.

DIALOGS AND BLACKOUTS

We find these dialogic units repeatedly in the burlesque collections, and in the joke books of the era. Comedy writer Art Henley calls them *two-ways*. A two-way is a "gag told in dialogue between two performers, one taking the straight-line, the other the punchline."[9] Robert Orben refers to them as *double* or *dialogue jokes*. "Double jokes are delivered by two or more people. Usually one of them sets up the straight line while the other comes through with the gag line," Orben observes. "The basic double joke is a question followed by a snappy answer: 'Why does a chicken cross the road?' 'That was no chicken—that was my wife.'" "Double jokes," he explains, "range all the way from this simple specimen to ones involving complex combination of questions, statements, and answers."[10]

A substantial portion of the gag files of burlesque comics is given over to dialogue jokes. Comedian Billy Foster organized his gag files thematically in a tabbed binder.[11] The following are some of the dialogue jokes appearing under the topic "Court."

Judge: Have you ever earned a dollar in your life?

Prisoner: Yes, your honor, I voted for you at last election.

* * *

Judge: You are fined $25 and costs.

Woman Shopper: I'm sorry judge—but that's a little more than I care to pay.

* * *

Wife: My husband beats me every day, Judge.

Husband: Don't pay any attention to her your honor…she's punch drunk.

The speakers are not always identified:

Young lady—how do you plead?

Pitty pwease—judgie wudgie.

* * *

I couldn't serve as a juror, judge. One look at that fellow convinces me he's guilty.

Shh-h—that's the District Attorney.

* * *

You admit that you drove over this man with a loaded truck?

Yes your honor.

What have you to say in your defense?

I didn't know it was loaded.

These dialogue jokes are identified primarily by their function. When presented on their own, they are identified as *blackouts*. "A black-out is a term used on the professional stage for a short, comical dramatic situation, the climax of which is followed by a killed spot-light and a swift curtain," writes Charles F. Wright in a 1934 collection of *1001 One Minute Black-Outs*.[12] Sometimes called "illustrated anecdotes," they are often jokes that have been adapted for the stage. Chuck Callahan's script for "Drunk" is a case in point. The scene opens on the street where the Comic is coming home late and encounters a policeman who doesn't believe that he lives in the neighborhood. To prove it, the inebriated Comic takes him home to meet his wife. The scene shifts to a bedroom, and the Comic points out the woman in the bed as his wife. "Then who's the man beside her?" the policeman demands to know. "That's me," replies the Comic. Here's how the gag appears in *Playboy's Complete Book of Party Jokes*:

> "Are you sure this is your house?" the cop asked the thoroughly sizzled gentleman.
>
> "Shertainly," said the drunk, "and if you'll just open the door f'me, I'll prove it to you.
>
> "You shee that piano?" the drunk began. "Thash mine. You shee that television set? Thash mine, too. Follow me, follow me."
>
> The police officer followed as he shakily negotiated the stairs to the second floor. The drunk pushed open the first door they came to.
>
> "Thish ish my bedroom," he announced. "Shee that bed? Thash my bed. Shee that woman lying in the bed? Thash my wife. An' shee that guy lying next to her?"
>
> "Yeah," said the cop suspiciously.
>
> "Thash *me*!"[13]

Some trace their way back to known folktales. Such is the case with "Ding Dong." A version in the Ken Murray Collection has the Comic and Straightman arguing over which of them has slept with more women in the neighborhood. The Comic proposes that they make a wager.

> Com: You and I will stand right here and watch the women go by. Every woman that goes by that you have been with, you say "Ding" and every woman that goes by that I have been with, I will say "Dong."

The Straightman agrees and as several women pass by, he calls out "Ding!" Each time, the Comic replies "Dong!" Looking offstage, the Straightman spots two more women coming their way. "Now I've got you," he says, "here comes my wife and daughter." As the two women enter and cross past, the Straightman greets them, then says, "Ding!" to which the Comic responds, "Dong! Dong!" Comic Eddie Ware worked the scene with straightman Charley Crafts in the 1950 burlesque feature *A Night at the Follies*. Ware adds an extra tag. As Crafts is paying him off on the bet, George Rose walks by in an obviously effeminate way, and Ware calls out "Dong" yet another time.

Versions of the scene also circulates as a folktale, and folklorists have identified it as Tale Type 1781, "Sexton's Own Wife Brings her Offering." Vance Randolph collected a version in the Ozarks in 1941 featuring two parsons who say "Amen"

whenever a woman they had seduced passes by.[14] Gershon Legman also collected a variant of the routine set on a golf course.

> A lawyer and a doctor are bragging about the advantages of their respective professions, ending with the ease with which their professional entrée allows them to seduce the wives of all the other club members. They finally bet on this, and sit down at the tavern on the green to count members' wives they have seduced, as they appear on the green. To their surprise they keep singing out the numbers together: "Four…five…six…" and so forth. Eventually the doctor's wife and daughter appear, and he turns triumphantly to the layer. "See those two women?" "Sure, says the lawyer—"forty-nine, fifty!"[15]

ENTRANCE GAGS AND CLOSING TAGS

While some of these dialogues were able to stand on their own, they were much more useful in building up the comedy in longer scenes. One interesting group of them is identified as "entrance gags." These are three- or four-line interchanges between the comic and the straightman, usually in question-and-answer form, leading to a punch line. They were meant to be dropped in at the beginning of the scene when the comic and straightman first encounter each other. Such gags were a useful, even necessary, way of getting the audience's attention before setting up a scene. Whenever the comics came onstage, they would naturally be following either a chorus line number or a striptease act. Inevitably, the audience would be focused on the women, and the comics needed to grab their attention back before launching into the scene. If the audience was not listening, they would miss key information and the scene would likely fall flat. A laugh-line from an entrance gag would draw their attention to what was happening onstage before the situation was set up.

Coffee

Com: How did you like that cup of coffee my wife made?

Str: Terrible. It tasted just like water.

Com: Hey, let me tell you something. When my wife makes coffee, she makes coffee and when she makes water, she makes…

Stepped on Back

Com: While I was walking through the park the other night, I stepped on a man's back.

Str: I'll bet he was mad wasn't he?

Com: No, he didn't say a word, but I heard a woman's voice say, "Thank you."

Scar

Str: How did you get that scar on your nose?

Com: You know that woman that lives around the corner from me?

Str: Yes.

Com: Well her husband went to Chicago last night on the midnight train.

Str: What has that got to do with the scar?

Com: He missed the train.

<u>Twin Sisters</u>

Com: My brother and I married twin sisters and we both live in the same flat.

Str: You mean to say that you and your brother are married to twin sisters and you all live in the same flat?

Com: Yes.

Str: Well how do you tell them apart?

Com: You damn fool, we don't even try to.[16]

Others show up principally as *tags* or *cappers*, providing a resolution and a closing laugh for a scene. Tags, too, circulated independently of the scene, and one finds the same tag on quite different scenes. "At Last We're Alone," a blackout in the Chuck Callahan Collection, is a bit that is usually used as a capper to a longer scene involving adultery. Two men argue over which of them the woman really loves. They pretend to shoot themselves to see which one the wife will respond to first. The wife enters with the butler, and seeing that they are alone, they embrace.

Another common tag has the soubrette or ingénue showing her disdain to the men by flipping up her skirt. Here's how it appears in Ralph Allen's "Scrutinizing Scene":

Girl: Oh this is for you, and that for you *(Bends over with pratt up.)* and that for your old man.

Com: Hey boss, my old man gets the best of everything. *(Shoves broom handle at her pratt or seltzer finish can be added in girl's pratt.)* B.O.

The seltzer finish merely involves the comic squirting seltzer at her exposed rear end.

ROUTINES

An entire routine could be built around these comic dialogues, in much the same way that a standup comedian will put together a monologue with a series of loosely connected jokes and one-liners. Such routines are commonly referred to as "sidewalk conversations" in joke books of the era. "A 'sidewalk conversation' was ordinarily nothing more than a couple of dozen two- or three-line jokes designed to be presented by 'He and She' or 'Pat and Mike' or 'Comic and Straight,'" Brooks McNamara explains. "An old advertisement defines it as 'a string of funny questions and funny answers to be "done" in quick succession.'"[17] Meant to be performed "in one," most were set in a vaguely described public space. "In a somewhat more structured approach the performers might develop a single theme, as was often the case with the 'crossfire' between the Interlocutor and the minstrel endmen, Tambo and Bones," McNamara adds.[18]

Burlesque scenes usually set up a loose premise, in which the comic is being questioned by an authority figure, often a traffic cop or a doctor, and provides snappy or nonsensical answers to the questions. The humor comes from frustrating the intentions of the straightman, as the comic offers incongruous answers to his questions. Jess Mack preserved a routine involving an army doctor, which he reworked for different shows during World War II.

Army Induction

Mack is on the telephone, getting the information that they are sending another patient over by the name of Charles Kemper for an examination. As he hangs up the telephone, the comic appears.

Com: Is this the selective service office?

Str: Yes.

Com: Well I received a card saying: will you call at our office or shall we come and get you.

Str: Well?

Com: Well after they came and got me...here I am.

Str: Okay, I'm going to ask you a few questions and give you an examination [...]

Str: What's your name?

Com: Charles G. Kemper.[19]

Str: What does the G stand for?

Com: Gwendolyn.

Str: Gwendolyn?

Com: You see my mother wanted a girl.

Str: What's the name of your parents?

Com: Poppa and Momma [...]

Str: Born?

Com: Yes sir.

Str: Were you born?

Com: You don't see no feathers on me.

Str: I mean where were you born?

Com: There's been some discussion about that.

Str: Discussion?

Com: They don't know whether it was in the front room or the kitchen.

Str: What state?

Com: State of excitement [...]

Str: What state of the union?

Com: Oh, union. Pennsylvania.

Str: Pennsylvania. How do you spell Pennsylvania?

Com: [...] Put down Ohio. O-H-one-O. Dot the one.

Str: What city?

Com: Pittsburg.

Str: And when did you first see the light of day?

Com: When we moved to Cincinnati.

Str: Have you any dependents?

Com: Yeah, I got two brothers.

Str: What are they?

Com: Boys.

Str: Yes, I know they're boys. But what's their names?

Com: Izzie and Wazzie.

They go into the Izzie and Wazzie routine discussed in the opening chapter.

Str: Why were you born in Pittsburg?

Com: Because I wanted to be near my Mother.

Str: What time were you born?

Com: Six o'clock in the morning.

Str: How do you know it was six o'clock in the morning?

Com: Didn't I get up and shut the alarm off?

Str: Oh, you're impossible!

<div align="center">BLACKOUT</div>

ELASTIC GAGS

Thus far, we have talked about dialogues that have a clear joke structure—with a distinct set-up and punch line. A dialogue could be a more open-ended interchange, in which the humor comes out of absurd, outrageous, or confused behavior on the part of the characters. These open-ended dialogues are different from gags in that they do not rely on a single punch line, but on absurd conflict or outrageous behavior. Unlike jokes and witticisms, they do not depend on brevity. The longer these routines could be drawn out, the greater the potential for laughter.

One well-known example is the "Mustard Bit," which Abbott & Costello used in several film and television appearances. It is a short interchange in which a waiter or food vendor tries to browbeat the customer into putting mustard on his sandwich or hot dog. This version is excerpted from a script in the Jess Mack Collection titled "Café."

<div align="center">Mustard Bit</div>

1st: Do you want mustard?

Str: No I don't want any mustard.

1st: Well give me a reason why you don't want mustard?

Str: Why should I give you a reason?

1st: Because it's good mustard.

Str: I don't care how good it is. I don't want any mustard.

1st: Do you realize that the mustard industry spends millions of dollars every year to manufacture and put better mustard on the market? Do you realize that they employ thousands of people to make mustard. And you, one lousy customer, don't want any mustard. You're a Communist.

Like most burlesque bits, this is presented in shorthand version, and the performers would be free to embellish it. Abbott & Costello extended the bit to roughly two-and-a-half minutes in *One Night in the Tropics*. Such bits are *elastic*, in the view of Richard Andrews, who has analyzed such dialogic units in the *commedia dell'arte*. "Each little exchange, each gag, can be elastic: it can be made longer or shorter in any given performance just by varying the number of times the routine is repeated," he writes.[20] Through improvisation, by playing variants and inserting new minor inventions, a comedian could make a particular unit as long as necessary. If the bit was not working, it could be cut short, and the performers would move onto the next bit, hoping it might generate laughs. The actors only need to memorize cue lines and climaxes to each unit, and improvise the dialogue in between.

RESTAURANT SCENE

"Restaurant Scene" is pieced together from a series of dialogue jokes and the more open-ended elastic gags involving a waiter and a customer. The premise of the scene is that the First and Second Comics are the waiter and cook operating a low-class eatery. The Straightman brings his date into the restaurant. The scene is built around a series of loosely connected modular bits, mostly between the First Comic and the Straightman. Different versions of the scene arrange these bits in different orders. They are only loosely connected, but create a rising action as the behavior of the Comic gets more and more outrageous. All of the scenes finish with a slapstick bit as the Comic prepares an egg nog or milk punch, creating a huge mess on the stage.

"Restaurant Scene for Martha Raye" is typical of scenes that link a series of restaurant jokes. It is a piece that Jess Mack prepared for the comedienne for the Minsky Show (probably in Las Vegas in the 1950s). It is unusual for a burlesque bit in that it features a woman as the principal comic, but the scene utilizes Raye's gender to set up a strong closing gag. The scene opens between Raye and a Second Comic. Raye tells him that he will act as the chef and she will be the waitress. Whenever anyone orders anything, she will call out the order and he is to repeat it. At this point, the Straightman and a Girl enter. The Straightman gushes about the excellent Chinese food they serve there, prompting a quizzical take from Raye—"Chinese food?" The Second Comic exits into the kitchen as the Straightman hands Raye his hat and tells her to hang it up. Rather than hang the hat, she impales it on the hall tree so the hook sticks through the top of the hat—although the script does not indicate it, straw boaters were used for this bit.

Raye comes over to the table to take the couple's order. The dialogue between Raye and her customers is simply a series of jokes built around the question-and-answer formula of traditional cross-fire jokes and sidewalk patter. There is no attempt at a transition between one bit and the next, but this does not come across as particularly

unusual, since we are accustomed to abrupt changes in subject matter when ordering food in a restaurant. The following reproduces the text of the scene just as it appears in the manuscript, but the bits have been identified by a title to show how they have been strung together. The scene picks up from the point when Raye arrives at the table to take the order:

You Know What I Want

Str: *(To Girl.)* Dear, what do you want?

Girl: Oh sweetheart, you know what I want.

Raye: You'd better eat first.

Some Eggs

Str: Maybe you can suggest something?

Raye: [...] How about some nice lamb's tongue?

Str: I'll give you to understand that I never eat anything that comes out of an animal's mouth.

Raye: How about some eggs?

Zoop

Raye: Maybe you'd like to have some "Zoop"?

Str: Some what?

Raye: Some zoop... *(Spells.)* Z... You double P... Zoop... *(In eye.)*

Hold the Chicken

Str: What kind of soup do you have?

Raye: We have chicken and pea soup.

Str: Okay... I'll have a bowl of chicken soup.

Raye: *(Calls off stage.)* One bowl of chicken soup.

2nd: *(Off stage... repeats.)* One bowl of chicken soup.

Str: I've changed my mind miss... instead of chicken soup... I'll have pea.

Raye: *(Calls off stage.)* Hold the chicken and make it... *(pea.)*...!!!

Garbage Delivery

2nd: *(Enters.)* Hey Martha, the garbage man is here.

Raye: Tell him we don't want any.

2nd: Better take two cans!!

Raye: What for?

2nd: For the soup. *(Exits.)*

With or Without?

Str: Cancel the soup. I think I'll have a ham sandwich.

Raye: With or without?

Str: With or without what?

Raye: Ham.

Str: I want a ham sandwich...with ham.

Raye: Do you want bread with it?

Str: Certainly. How can you make a ham sandwich without bread?

Raye: You could put it on a piece of Matzo, or on a bagel.

Str: Forget the ham sandwich.

Beans a la Tot

Str: Do you have any specials?

Raye: You lucky people...today is Tuesday and every Tuesday we have a blue plate special...beans a la tot!

Str: Never heard of it...what's beans ala tot???

Raye: First you eat the beans...then ta tata tata ta tot.

Str: No I don't think I want that.

Raye: How 'bout some macaroni and beans???

Str: What's the macaroni for?

Raye: Gives it that pipe organ effect...

At this point in the action, the scene shifts from a verbal exchange between the waiter and customers to comic business between the two comics, as the zaniness begins to escalate.

Two Eggs—Fry One on One Side

Str: I think I'll have two eggs.

Raye: *(Calls off stage.)* Two eggs...

2nd: *(Off stage.)* Two eggs.

Raye: How do you want them?

Str: Fry one on one side...and...fry one on the other...

Raye: *(Calls off stage.)* Fry one on one side...

2nd: *(Off stage.)* Fry one on one side.

Raye: And fry one on the other.

2nd: *(Enters.)* What the hell is this...fry one on one side and the other?

Raye: Don't you know how to do it? I'll show you...First you take one egg and fry it...Okay? That's fried...Put it on the side and forget it...Now you take the other egg and you flip it...

2nd: Flip it???

Raye: Yes you flip it *(Business of hands and arm ala Italian.)*

2nd: It can't be done...Tell him to order zoop or get the hell out of here. *(Exits.)*

Raye: Sorry we're all out of eggs.

A slapstick bit provides the climax for the scene, as the waitress prepares an "egg nog" for the Girl, creating a huge mess at their table.

<u>Egg Nog Bit</u>

Raye: How about something to drink?

Girl: A good idea. I'll have an egg nog

Raye: *(Calls off stage.)* One egg nog.

2nd: *(Off stage.)* Fry one on one side... *(Enters.)*

Raye: You don't fry an egg nog. You've got to mix it. Come over here and I'll show you.

Business of mixing drink, with tall glass...mixer...saw dustegg...a couple of bottlesgin and whiskey color... bottle of seltzer when she gets to seltzer...

Raye: This is what they call go-zint-ta water.

2nd: Go zint ta???

Raye: Yes...this goes into that... *(Squirts seltzer into tall glass till it runs over... and then squirts Comic in fly of pants.)*

2nd: *(Pants and leg bus.)* Did you see a tall dog pass by?

Raye: No.

2nd: Must have been an inside job.

Raye: *(Continues with drink...uses bar rag...wrings same into glass. Takes small red flag, puts it into glass, walks to table...sets in on table with hand in it.)*

Girl: You don't expect me to drink that do you?

Raye: Not if you have good sense.

Girl: You've got your fingers and everything in it!!!

Raye: Not everything.

Like many scenes, the script offers two possible payoffs to the scene. One, a more-or-less standard burlesque tag in which the Girl flips up the back of her skirt as a show of disdain, and Raye squirts her in the "pratt" with a seltzer bottle. The more effective blackout is one that utilizes her gender:

Girl: I have never been so insulted. I'm leaving. *(Exits.)*

Str: I'll pay you for the drink. How much do I owe you?

Raye: Thirty-five cents.

Str: Thirty-five cents??? That's cheap. How do you make any profit?

Raye: Well, to tell the truth, I'm not really a waitress. The real waitress is upstairs with my cheating husband. And what my husband is doing to her upstairs, I'm doing to his business downstairs.

BLACKOUT

"Restaurant Scene for Martha Raye" shows just one possible arrangement of these bits.[21] Different comics created their own version of the scene by adding different

bits or arranging them in a slightly different order. The strength of the scene is that bits could be rearranged without hurting the flow of the scene. The flexibility of these sketches does not immediately come across in print, for readers are used to treating printed material as though it were the definitive script. But burlesque scenes were enormously flexible, and individual routines could be lengthened or shortened according to the show or the comedian. This is the case with the "Zoop" bit, which takes up only three lines in the sketch for Martha Raye. In "Restaurant (Zoop)," also from the Jess Mack Collection, this routine expanded considerably as the Waiter tries to force his customers to take the soup.

> Com: Well we got what you want if you want what we got.
>
> Str: What have you got?
>
> Com: Zupp.
>
> Str: What?
>
> Com: Zupp.
>
> Str: Zupp?
>
> Com: Yes zupp.
>
> Str: Spell it.
>
> Com: Z-u-pup-zupp
>
> Str: I don't know what you are talking about
>
> Com: *(Mad)* Zupp. *(Str. gets up and backs away as Com. follows him.)* Zupp, zupp, you cockeyed polock zupp.
>
> Str: I don't get you, I don't get you.
>
> Com: I don't want you. I don't want you. Look. *(Str. sits down. Bus. by first of sipping zupp. Illustration making noise then pointing down his throat.)* Ah, ah, aha, ah *(Str. looks in his throat.)*
>
> Str: Ah tonsillitis.
>
> Com: Tonsillitis hell. I got zupp, zupp, you put on your vest.

Interactions between the characters could also be turned into running gags. One bit that Jess Mack used in "Café Scene" involves calling the order into the kitchen. The Girl orders a fruit cocktail. The waiter yells "Fruit cocktail." The order is repeated over the loudspeaker by four voices, as it disappears into the distance. The straightman wonders. "Where's your kitchen—in Philadelphia?" This sets up a running gag. Whenever the waiter calls an order into the kitchen, voices from the kitchen respond, "Fruit cocktail." Although the scripts make no indication there is probably a homosexual connotation in the choice of "fruit cocktail," with offstage voices camping it up outrageously.

It is only by comparing different versions of these routines that one gets a sense of the flexibility of the form. Scripts of these scenes are essentially shorthand versions of what actually takes place onstage. It was what the comic brought to the scene and his creative use of prepatterned routines that was the mark of a good burlesque comic. Like stand-up comedians, burlesque comics collected as many bits as they could—both physical and verbal—to add to the scene. They used these bits creatively, working them into the give-and-take of onstage conversation.

MANAGING LARGE-CAST SCENES

Similar techniques are also used to manage scenes involving more than two people. "With two performers, 'improvisation'...is still possible," Tim Fitzpatrick writes, "provided the actors have a sufficiently well-developed sense of each others' patterns and instincts. But with three performers, no matter how attuned to each other they are, even this 'improvisation' is impossible, the complexity of turn-taking among three performers being such that only chaos will ensue."[22] The solution is to reduce every interchange to a two-person dialogue. In burlesque scenes involving three or more people, all the characters interact with one central figure. In the typical "flirtation scene," the straightman and the girl will interact only with the comic, as the straightman coaches the comic on how to court her. If there is more than one girl in the scene, they invariably come on one at a time, with each girl leaving the stage before the next one enters. This reliance of two characters is a recognized feature of oral traditions, identified by folklorist Axel Olrik as the "Law of Two to a Scene."[23]

In large-cast scenes—which required the use of less-experienced and less-able cast members—each bit is given to a separate actor, who comes onstage, interacts with the central figure (usually the comic), and exits before the next character comes onstage. These are known as "interruption scenes," and each entrance is a "crossover." In the typical interruption scene, Ralph Allen writes, "a pretentious artist is performing an ostensibly serious act—reciting poetry, playing a musical instrument, or more commonly, singing operatic arias. Meanwhile the comics interrupt her (or him) with outrageous questions and impertinent gags."[24] Allen featured an interruption scene in *Sugar Babies*. The prima donna, appearing as Madame Gazaza, attempts to sing an aria only to have her performance interrupted by a pair of stagehands who are making repairs. The scene segues into a series of crossovers as various members of the company come onstage, interact with the character, and exit just as quickly.

Often these crossovers involve props. In one classic interruption featured in the film *Top Banana*, the Comic crosses the stage, carrying a case of soda or beer. The Straightman asks what he is doing. "I'm taking my case to court," he replies, not even breaking stride. Later in the routine, he crosses the other way, this time with a stepladder. "I'm taking my case to a higher court," he explains. On the third crossover, he carries an empty coathanger. "I lost my suit," he moans. These jokes are quite simple to put over, and could be handed off to a beginner.

A manuscript in the Ken Murray Collection titled "Insane Asylum" is merely a compilation of crossovers gags. Most of them are essentially visual puns, several of which are reproduced here:

Enter Girl with a stove pipe behind her back.

Girl: Do you smoke?

Com: I never get that hot. But I smoke once in a while.

Girl: Good here's a pipe. *(Hands stove pipe to Comic and exits.)*

<div align="center">* * *</div>

Girl enters with a heavy chain behind her back.

Girl: Have you a watch?

Com: Yes.

Girl: Here's a chain.

<div align="center">* * *</div>

2nd Comic enters carrying two carpenter's vices

1st: What are you doing now?

2nd: I just got a job as a detective. I'm on the vice squad.

<div align="center">* * *</div>

2nd Comic enters with bird cage with cat in it.

1st: Where are you going?

2nd: I'm taking my bird out for air.

1st: Where's the bird?

2nd: In the cat.

These are all simple bits that any member of the cast could do. Many performers got their start in the scenes doing one of these visual puns.

CRAZY HOUSE

The classic interruption scene is "Crazy House." The premise is that the Comic must spend the night in a lunatic asylum. In most versions, he is hired on as a night watchman to make sure that none of the patients escape. The scene is a fast-paced hodgepodge of entrances and exits, as various lunatics enter, interact with the Comic, and exit quickly. Individual versions differ markedly, for comics were free to drop in their own material. The scene usually featured a well-endowed nurse in a tight-fitting dress who ran on whenever the Comic called for help. The scene could be changed every night depending on who was in the show. Typically, a lineup would be posted backstage identifying entrances and exits and the performer doing the bit.

Jess Mack's version of "Crazy House" is particularly revealing, for the typewritten manuscript contains extensive handwritten notes in the margins that spell out in more detail the business that is to be done, or to clarify a bit. These handwritten additions to the scene are indicated in boldface.

Crazy House

At the opening, a Nurse is seated at desk using a phone. She explains that their night watchman just quit. There is a knock on the door, and the Comic enters. He is looking for a job. She tells him they need a night watchman. All he has to do is guard the door and make sure none of the patients escape. When he discovers it is an insane asylum, he hurries to leave, but the Nurse restrains him.

Nur: The patients won't hurt you. All you have to do is humor them. They are all perfectly harmless.

Com: There's always one you got to watch.

Nur: That's right. He's an old sea captain. You see a man ran away from his wife and went to Hoboken to take a boat to Europe, and the mention of the word "Hoboken" drives him mad.

The Doctor enters, in scary makeup, and the Nurse introduces the Comic. The Doctor engages in business of fondling the Comic's butt. He talks to the nurse in sign language.

Com: What did he say?

Nur: He said that you look alright and he hopes that you will last longer than the last one. *(Laughs.)* He died last night.

Com: What the hell. *(Starts to exit. Nurse grabs him.)* So he's the doctor. I'd hate like hell to see the rest of the nuts.

Doctor does goodbye business with Comic and exits.

Com: Hey, you look like a nice kid...

Nur: I am his secretary. *(Nudges Comic.)* Get it? He gives me everything—get it? And I gave him... *(Whispers in Comic's ear.)* Get it?

Com: I just got rid of it.

Nur: Now go to bed, and be sure and guard that door.

Nurse sits down at desk R. Comic starts to undress. Does goodnight business.

Com: **You don't understand. I want to take off my pants.**

Nur: **That's alright, I'm used to those little things.**

Comic grabs hat and coat and starts to exit R.

Com: **I didn't come in here to be insulted.**

Nur: **I didn't mean to insult you. I'm sorry if I touched a soft spot.**

Com: **Get the hell out of here.**

Nur: **If you want anything during the night, call on me. *(Exits L.)***

Com: **(Starts to undress.) Little things? I haven't had a complaint in years. (Gets into bed.)**

The Nurse exits and the Comic begins to remove his pants, when two men enter right, one in front and one behind.

1st M: Take it back I say.

2nd M: I won't. *(They repeat these lines three times. Man behind shoots him. He falls in his arms and 1st man drags him off.)*

Com: *(Does moan.)* It's starting already. *(Gets in bed.)*

Can Call Nurse—Optional.

A Salome dancer enters to Oriental music.

Sal: Oh john, lay it on the floor. Oh john, put your head on the floor.

Com: You got to humor these nuts. *(Lays on floor. Girl dances around him. Comic gets up.)* Now you lay down. *(Girl screams and exits right.)*

Nurse enters left.

Nur: Now go to bed and get some sleep.

Com: I can't. I got ideas on my mind.

Nur: She can't hurt you.

Com: No, but she can make me hurt myself.

Nur: Come now, get to bed and be a nice little boy. **Put your head on the pil-
 low. Now close your eyes.** Put your hands under the covers. Now enjoy
 yourself.

The Nurse exits and a Girl enters carrying a watering can.

Girl: Sweet violets, all covered with roses. *(Bus. explained. Exits.)*[25]

The Two Men re-enter and repeat the shooting business, and exit.

Com: He killed the same guy twice.

*Girl enters, carrying a basket and singing "In the Shade of the Old Apple Tree." She
stops center stage and begins picking apples from an imaginary tree.*

Com: What are you doing, my screwy little maiden?

Girl: Picking apples on the watermelon vine. *(Bus.)* Now my basket is full, I'll
 go. *(Exit R.)*

Com: *(Looks up.)* I don't think there's an apple up there, but I'm just curious to
 find out.

He takes hold of the imaginary tree and shakes it. Real apples fall on him.

Com: What the hell's going on here?

*After apples fall down, 2 men in audience. B.O. change to green spot D.L. Enter
char. as Sea Captain.*

Char: Ah. Come with me little girl.

Com: I'm no girl.

Char: Come with me little *girl*.

Com: I told you, I ain't no girl.

Char: *(Grabs him below.)* Come with me little boy. Do you know who I am?

Com: Yes, you're the old sea captain.

Char: Yes, you know where my wife is. Where is she?

Com: I ain't gonna mention that town.

Char: Where is she?

Com: Over in New Jersey.

Char: What part?

Com: *(Mentions several different towns.)* If you think I'm going to say Hoboken,
 you're crazy.

Character throws him on bed, pummels him and exits.

Lights up. White pin spot on Comic. Starts to put on pants.

Man: *(L to R.)* I'm a pump. Pump me. *(Arm straight out. Repeat line till off.
 Gets water.)*

Man and girl enter R. She leads him around Com.

Girl: He's a pump, pump him. He's a pump, pump him. *(Both stop in front of Comic, Man's arm still outstretched.)*

Com: Alright, I'll pump him. *(He does so. Man spits in face.)*

Man and Girl exit R. saying: "He's a bum pumper." (Repeat.)

The Two Men re-enter, doing the same business.

Com: That guy's got nine lives. That's the toughest guy to kill I ever saw.

Two men enter as soldiers with seltzer bottles. Business.

Men: Alakazam. Alakazam. *(They march to the bed. Comic looks at them.)* Hands up. Ready, aim, fire.

They squirt seltzer on Comic's crotch and both turn around and exit right.

Com: Oh nurse, oh nurse.

Nur: *(Enters.)* Why didn't you call me before.[26]

Com: I didn't do anything. Two guys just came in here and Alakazamed all over me. *(Comic repeats things that happened excitedly, finish with: I will, I won't, etc.)*

Nur: Why your nerves are getting the best of you. *(Feels his head and pulse.)* Why your fever is rising. You have a fever of one hundred and your pulse is going up.

Com: Stick around till it busts.

Nur: Now go to bed and get some sleep. *(Exits left.)*

Two men come back and do same bus. Shot and exit right. Comic screams. Doctor enters with chamber pot. Comic sees same and yells:

Com: It's too late now.

<div align="center">BLACKOUT</div>

Variants of "Crazy House" go by a variety of titles, sometimes indicating that the scene sets up in a different way. In "Nick the Greek" (Jess Mack Collection), the Comic and Straightman are two cops who pursue an escaped criminal into the asylum. In "Nervous Wreck" (Gypsy Rose Lee Collection) and "Peace and Quiet" (Ken Murray Collection), the Comic is a patient who has been checked in for a badly needed rest. This is the premise that Abbott & Costello used in their film and television appearances, including their 1941 feature *Ride 'Em Cowboy*.

JOKE SWITCHING

Once learned, these comic dialogues became a permanent part of a comic's repertoire and could be used in a variety of scenes and stage situations. They served as self-contained blackouts that could cover a stage wait. More likely, they would be used in larger scenes, as an entrance gag opening up the scene, as padding to beef up

the scene, or as a payoff at the end. They could be used as "interruptions," delivered by a stooge who comes onstage to interrupt someone's performance. A series of them could be cobbled together to make a lengthy scene.

Such bits have a different value for a performer just starting out and a more experienced comedian. For the novice, they provided more or less verbatim material for generating laughs. As he became more comfortable with these routines, the comic would use them more creatively. As Fitzpatrick notes that "the more often a speech program is run, the less shifting among phases is necessary, and greater effort can be expended on variations and embellishments…the very fixity of the roles and repetitiveness of the situations enables (rather than disables) the creativity of the performer to assert itself in variations."[27] These memorized routines become the basis by which experienced burlesque comics created original material, either by adapting a set joke or expression to a new situation, or creating new jokes based on the underlying structure.

Most people learn to be funny on a more-or-less informal basis, listening to jokes over many years, memorizing and retelling them throughout their lives. Professional comics do the same thing, but on a more organized basis. One of the important benefits of assembling a joke file, Robert Orben advises,

> is that in the process of reading, clipping, pasting and filing—you are absorbing the basic thought processes that go into the creation of humor. By reading the tens of thousands of jokes available to you in printed form, you will be sharpening your own perception of what is funny and what is commercial. You will draw into yourself the essence of comedy construction, economy or wording, and an appreciation of flow and continuity.[28]

The process is formalized in the technique of *joke switching*. "'Switching' is the gag writer's alchemy by which he takes the essence of old jokes from old settings and dresses them up in new clothes so they appear fresh," Sidney Reznick explains in *How to Write Jokes*, one of the many books on comedy writing to recommend the technique. "The reasons for switching is simple: Very few writers can pound out a huge batch of jokes week after week relying solely on sheer inspiration. They need the help of some mechanical process."[29] Reznick identifies several types of switches—*substitution*, whereby a few words are changed, but the basic structure of the sentence is retained; *changing its buildup*, but leaving the punch line intact or almost so; *changing the punch line*, but leaving the buildup as it is; or using the *same thought* as the original joke, but using it to create a new set-up and punch line. With practice, this process becomes internalized so that "once a humor formula has been identified and understood it can be used repeatedly to produce original humor without recourse to [formal] switching."[30]

Substitution is obviously the simplest way to switch a joke. It's often used to localize a joke to a particular city, as in the opening to "The Bull Fight" (Chuck Callahan Collection), which finds the Comic and Straightman in sunny Spain, causing the Straightman to wax poetic.

Str: Spain. That's where the señoritas sit on the verandas. Smoke cigarettes. Flirt with men. Ah, that's Spain. Spain. That's where the whiskey flows

freely through the streets. That's Spain. Spain, where the policemen sleep on their beats all night. That's Spain, boy. That's Spain.

Com: Now let me understand this right. You say Spain is where the señoritas flirt with men?

Str: Yes.

Com: Spain is where the whiskey flows freely?

Str: That's Spain.

Com: Spain is where the policemen sleep on their beats all night?

Str: That's Spain.

Com: You're crazy as hell, boy, that ain't Spain. That's (local).

Another alternative is *changing the buildup*. The following joke appears in the Jess Mack Collection:

Com: My father and mother and one of the boarders are having terrible fight.

Str: *(Repeats what Comic has said.)* By the way, who is your father?

Com: That's what they're fighting about.[31]

It has a slightly different buildup from the version of the joke used by Lou Ascol and Sandy O'Hara.

Ascol: I come from a fighting family.

O'Hara: Yeah, who's *your* father?

Ascol: That's what they're fighting about.

Somewhat more challenging is *changing the punch line*. One of the jokes that comes up in a number of restaurant scenes in the Jess Mack Collection involves one of the characters ordering "cod fish balls." In "Peach Melba Café," the bit goes like this:

Str: I say waiter, have you cod fish balls?

Com: I didn't know cod fish had b——. No we ain't got cod fish balls.

In "Café Scene," the line gets a slightly different response:

1st: Have you cod fish balls?

Wait: Now don't get personal.

1st: Why that's the best part of the fish. Bring me an order.

In "Cut Up and Bleeding," a slight change in the buildup generates yet another punch line.

2nd: I want some cod fish balls.

Str: Oh a wise guy, eh? We ain't got any. Do you think we're going to ruin a poor cod fish every time a customer comes in?

A pair of jokes that Jess Mack collected show how you can use the *same thought* to create both a new set-up and a punch line. The first goes by the title "Toothache":

Com: I've got a toothache.

Str: That's too bad. Why don't you use my method when you get a toothache. I go home and my little wife meets me at the door. She places her arms around my neck, she kisses me, we go into the parlor, turn down the lights, and she loves and hugs and kisses me and then...well, why don't you try that?

Com: I will. When will your wife be home?[32]

This joke is closely related to the following, titled "Rosie."

Str: You are certainly looking bad and thin. Not a bit well. Why you're all run down. Why don't you try my system. I get up early in the morning, take setting up exercises for about fifteen minutes, then a cold shower and a rub down, and I feel rosy all day long. Now why don't you try that?

Com: That's a good idea. Where does Rosie live?[33]

There is more to joke writing than simply repeating formulas. Playwright and comedy writer Abe Burrows insisted,

There's a writer still around who, when he thinks of a joke, writes it in a book and saves it for his second act curtain. Real writers don't do it that way. It comes when you need it. We know it and we trust it as a way of life. It's like throwing a forward pass. You don't decide to learn how to throw a forward pass. You find you can throw a pass and you learn how to do it well, and then instinctively do it when you have to. I am still able to come up with a punch line when I need it.[34]

Burrows acknowledged that formulas exist; like most great creators of comedy, he had internalized them. Most comedy writers understand the presence and usefulness of humor formulas, for the craft of comedy—like other arts—is acquired by copying the techniques of others.

It is not necessary to know every joke formula. People tend to prefer certain types of jokes—puns, insult humor, nonsense—that they use repeatedly. In his book *How Speakers Make People Laugh*, Bob Bassindale advises speakers to concentrate on the jokes they like or feel most comfortable with, and study the formulas for those jokes. He points out that

It is far better for a speaker to master a few of the easier [techniques], for [m]astery of even a few humor formulas and techniques gives a speaker confidence...After gaining this confidence a speaker can then proceed to the other formulas that appeal to him most. He can begin breaking down some of his favorite borrowed jokes and extracting the basic formula or blueprint that makes them work. Eventually, formulas and techniques submerge into the subconscious, and the speaker discovers he has managed to develop that most elusive talent, the one many people think you have to be born with, the talent for "thinking funny."[35]

7. Scenarios, Scripts, and Schemas ॰∾॰

Figure 7.1 The cast of the sitcom *Happy Days* perform "Under the Bed," filling in for stranded members of a burlesque troupe. From left to right, Ron Howard, Juanita Merritt, Henry Winkler, Donny Most, Anson Williams, and Scott Baio. (From the author's collection.)

The most common complaint about burlesque comedy was not the sexuality, but the sameness of the bits. Reviewers regularly bemoaned the lack of originality. Often this was attributed to simple laziness on the part of the performers. One fan wrote to *Billboard* in 1929 that "the comedians won't learn new lines because it is simpler to use the old stuff that is so familiar and monotonous that it is really criminal to offer it up as 'comedy.'"[1] The fact that these routines were often very familiar to the audience should not automatically be seen as a negative quality. Audiences expect popular singers to perform standard pieces and are disappointed when they fail to perform certain favorites. Similarly, one would be disappointed to attend a live appearance of Abbott & Costello and not see them perform "Who's On First."

Elements that made these scenes easy for the performers to remember and pass on would also make them seem repetitive, even clichéd to audience members. Yet repetition is a necessary feature of oral narratives, for what is not repeated will be forgotten. Oral narratives have built-in mnemonic devices, and utilize striking or memorable images called "motifs," which are interwoven with familiar stories or schemas drawn from everyday life, and utilizing story patterns that are commonplace within a culture. In comedy, these often set up expectations in the minds of audience members that are shattered by the payoff or punch line, for comic effect. This chapter looks at some of the stylistic features of burlesque comedy and how those features allowed the scenes to survive in an oral tradition.

STRUCTURAL ELEMENTS IN BURLESQUE

Stories that survive purely in the oral tradition are necessarily simple. There is a stylistic similarity shared by myths, folktales, and legends that folklorist Axel Olrik described as the "epic laws" of oral narrative composition. Characters are simply drawn. There are generally no more than two persons in a scene at a time, and these characters are contrasting—hero and villain, knave and dummy, male and female. The weakest or worst in a group turns out to be the best, with the youngest brother or sister triumphing in the end. The plot is simple; one story is told at a time, and characters exhibit only those qualities that directly affect the story. There is repetition throughout, usually in groups of three, sometimes four, and suspense is built through repetitions.

What is stable and memorable in an oral narrative is not on the level of word, but on that of image. An oral performer "remembers the essential ideas rather than the exact verbal expression," John Miles Foley explains.[2] Harold Scheub prefers to use the term *images*, observing that "the fundamental narrative unit is a sensually experienced image and not a word rote-memorized."[3] This is how people memorize jokes. Whereas the punch line will likely be remembered word-for-word, the set-up will be loosely indicated. In *How to Remember Jokes*, Philip Van Munching advises, "To learn to remember jokes, you have to retrain your brain to absorb them as if they were true stories."[4] There are

> at least four distinctive mental cues that you can easily build into every joke you hear: categorization (what kind of joke is it?), casting (who's in it?), location (where does it take place?) and action (what happens?). Once you practice using these elements as memory cues, you'll see how little effort it takes to remember jokes.[5]

There are two categories of imagery, Scheub notes. "One contains the images commonly called motifs, often fantasy, usually old, always capable of eliciting strong emotional responses from members of the audience."[6] "A motif is the smallest unit in a tale having the power to persist in tradition," Stith Thompson writes in *The Folktale*.

> In order to have this power it must have something unusual or striking about it. Most motifs fall into three classes. First are the actors in a tale—gods, or unusual animals, or marvelous creatures like witches, ogres, or fairies, or even conventionalized human characters like the favorite youngest child or the cruel stepmother. Second come certain

items in the background of the action—magic objects, unusual customs, strange beliefs and the like. In the third place there are single incidents—and these comprise the great majority of motifs.[7]

Folklorists have identified and collected narrative elements from around the world, which have been catalogued in a six-volume *Motif-Index of Folk Literature*. They have been grouped thematically, and each motif has been assigned an alphanumeric code from A0-A2700, "Mythological Motifs," through Z0-Z399, "Miscellaneous Groups of Motifs."

These memorable motifs are combined with contemporary images, typically realistic and drawn from everyday life. "It is the function of the storyteller to weave these two kinds of imagery—the ancient images that encapsulate the deepest dreams, hopes, fears, and nightmares of a society, and the contemporary images that record the evanescent world of experience—into a single strand," Scheub asserts.[8] "Story," he goes on to say, "is the artful mixing of images by means of pattern, drawing on and working within two contexts, the past and the present."[9]

ADULTERY MOTIFS

Burlesque relied on the same types of images we find in traditional tales—perhaps not the identical images, but certainly falling in the same general categories. Some of these images have a magical quality associated with folk and fairy tales—the ghost who creeps up behind the comic and plays tricks on him, or the "essence of poppy" that the straightman promises will cause any woman to fall in love with him. Generally, the comic tradition relies on more prosaic images, which fall into one of three categories: Chapter J—"Wise and Foolish," Chapter K—"Deceptions," and Chapter X—"Humor."

While a premise, image, or motif—in order for it to be memorable—need not have a magical or supernatural quality, it must have a strong emotional content. The threat of getting caught with another man's wife has that kind of emotional resonance. It evokes strong conflicting emotions: there is the anticipation and delight of an erotic scene being enacted, then there is the threat posed by the cuckolded husband should he walk in. The adultery motif is well-known one in traditional tales, and is found under motifs K1500–K1599, "Deceptions Connected with Adultery."

K1500. Deception connected with adultery
K1510. Adulteress outwits husband
K1550. Husband outwits adulteress and paramour
K1570. Trickster outwits adulteress and paramour
K1580. Other deceits connected with adultery

Such scenes are quite common in burlesque—mostly as blackouts—which rely on the sudden or accidental revelation of marital infidelity. Sometimes the woman gives herself away. In "No Ice Today" (Chuck Callahan Collection), the husband

sneaks up behind his wife as she is looking in the ice box, and gives her a big hug. Not even bothering to look around, she responds, "No ice today." In "Fell Out of Bed" (Gypsy Rose Lee Collection), the First Comic tells the Second Comic that he kept his wife entertained while he was away, per his instructions, taking her to shows and cabarets and dances. "Did you tell her any funny stories," the Second Comic asks, "You know she loves to hear funny stories." "I told her a dirty story last night," the First Comic replies, "and she laughed so hard she almost fell out of bed."

The setting for these blackouts is often the bedroom, where the lover is found hiding somewhere. In "Brown Scene" (Gypsy Rose Lee Collection), the Comic, whose name is Brown, has accompanied the Prima Donna to her bedroom. She warns him that her husband could be home at any time. He replies that he has his chauffeur looking out for him. The Chauffeur enters and tells Brown that the husband is on the way home. The Comic hides just as the husband enters. The Husband is arguing with a Friend about what color his wife's eyes are. "Just as I told you, brown!" he declares triumphantly. Believing he has been found out, Brown comes out of hiding pleading that he'll confess everything. In "Shower Bath Scene" (Chuck Callahan Collection), the wife is entertaining her lover when the husband's voice is heard offstage. She quickly hides him in the shower. When the husband inevitably discovers him, he claims to be waiting for a taxi.

The husband may not catch on at all, as in "Thash Me" discussed earlier. In "Six Feet in Bed" (Ralph Allen Collection), the Comic comes home drunk and climbs into bed with his wife. As he does so, he pulls up the covers to reveal *three* pairs of feet sticking up at the foot of the bed. He points this out to his wife who tells him it is not possible. He should get out of bed and count them again. He does so and is forced to admit there are only four feet in the bed.

These blackouts rely on the audience's understanding that there is about to be hell to pay, and that the aggrieved husband will have his revenge. The audience has certain expectations as to the outcome of the confrontation, based on previous experience. If the husband catches the couple *in flagrante delicto*, he is entitled to kill the paramour, and get off scot-free, at least according to tradition. Such images have an element of fantasy about them, but they are the fantasies of an adult male audience— hopes of a sexual encounter, but the fear of being discovered.

These scenes black out before this takes place, and we are left to enjoy the situation. The story is likely to continue, and we are fully aware of what might transpire. The husband will likely pull out a gun and shoot the lover (or the wife). This scenario is so familiar that there are more extended scenes in which this is played out, as in "Two Word Drama," in the Ken Murray Collection.

<u>Two Word Drama</u>

Wife:　*(Discovered. Phone rings.)* My number. My sweetheart. My flat. *(Hangs up phone fixes hair etc. and turns L.)*

Lover:　*(Lover enters L.)*

Wife:　My sweetheart. *(Embrace.)*

Lover: My honey.

Wife: My sweetheart.

Lover: My baby. *(Shows some string of pearls.)*

Wife: My time.

Lover: *(Giving pearls.)* My money.

Wife: *(At phone.)* My husband.

Lover: My God.

Hus: *(Enters.)* My home.

Wife: *(Pleading.)* My dear.

Hus: *(To lover.)* My rat.

Lover: My get away. *(Starts to exit R.)*

Hus: My revenge. *(Shoots.)*

Lover: *(Staggers off.)* My finish.

Wife: My God.

Com: *(Raises up from behind screen.)* My pants. *(Takes pants.)*

BLACKOUT

REPETITION AND STORY PATTERNING

Traditional motifs and contemporary images are organized into certain patterns that are themselves traditional within a society or social group. It is through repetition and patterning that a story is developed. "Against a regular rhythmic background of repeated image, the narrative plotting of events is developed," Scheub writes.[10] Storytelling "achieves its aesthetics through pattern, which has to do with color, with music, and with emotion."[11] This holds true for an acted-out story as much as one that is narrated.

One very important pattern is what Scheub terms the *expansible image*, which he defines as "the recurrence of image-sequences consisting of a central action which is similar if not identical with each repetition." Information important to the story is repeated for emphasis. A storyteller can create a dramatic build by repeating actions or images, with slight variation. "The artist fashions a work of art around the repeated action, moving the characters towards a climax, succeeding repetitions adding further 'new information' to the accumulated experience."[12] In such a case,

> a basic image set is established (a combination of remembered image and associated details), and then it is repeated. The image is thereby etched into the imaginations of the actively involved members of the audience, and the plot is thus moved along, steadily, toward the point at which the performer will slightly alter the image set in order to bring the performance to a resolution, or to move it into another narrative image.[13]

In addition to emphasizing important images, actions or lines of dialogue may also be repeated within the story. The information that is most important to

remember is built into the story; this repetition creates a pattern and expectation that the narrator can use creatively to build tension and create suspense. "Friction is introduced as the artist purposely neglects to fulfill the audience's expectations by refusing to complete a pattern," Scheub observes. "The audience, now full in harmony with the movement of the patterns, becomes uncomfortable, anxious, and this contributes to its aesthetic experience as new relationships are forced upon it."[14]

This kind of patterning occurs frequently in burlesque comedy. One of the best examples is "Under the Bed," a scene that appears under a number of titles such as "The Bed Room" (Callahan Collection), "House of Dave" (LoCicero and Steve Mills collections), "The Wrong Apartment" (Gypsy Rose Lee Collection), and variants of those titles. The scene is a standard situation in which the husband returns home unexpectedly, when his wife is entertaining a lover. To avoid detection, the lover hides under the bed. The scene takes this familiar image and repeats it, creating a dramatic build through this repetition. One version, from the Callahan Collection, titled "Come Under the Bed" is preserved in scenario form. The scene is reproduced just as it appears in the manuscript, except that paragraph breaks have been added to help clarify the action.

Come Under the Bed

Bedroom set, vanity table, hat rack, telephone on table near bed. Woman lying in bed. Man in lounging robe walking floor complaining about the bottom falling out of the stock market. Girl asks him to come to bed. He starts to bed. Phone rings. Woman answers, says, "My god, it's my husband." Man runs and gets under bed.

2nd Comic enters, bawls woman out for lying in bed all the time and eating candy, then she tells him to come to bed. Phone rings, she answers it. "My God, it's my husband." 2nd Comic mugs. His hat and coat are already on the rack. He gets under bed, sees Str. man. Woman introduces them. "Mr. Smith meet Mr. Brown." 2nd Comic says "Didn't I see you under a bed in Hollywood last week?"

They talk a little, third man enters. Bus. argument about fur coat. Sees hat and coat, asks whose it is. 2nd Comic under bed says "It's mine you fool." Girl tells him it belongs to the plumber. Finally she asks him to come to bed. He starts, telephone rings. "My God, it's my husband." Third man gets under bed, all make themselves acquainted.

Fourth man enters, argument about how tired he is and nothing to eat while he works all day long. Steps on Comic's hand. Comic says "I want to use that." Discovers comic under bed. Makes him come out. Comic says "He was here ahead of me." Fourth Man says, "Bring them all out."

Asks First Man who he is. "I'm the landlord, I came to collect the rent." Tells him that night is a fine time to collect the rent.

Asks next man who he is. "I'm the plumber, I came to fix her leaks."

Asks the next man who he is. "I'm the butcher, I came to deliver the bologna."

Then fourth man says to all, "I could kill you but I'm not going to do that. (To woman) You are to blame for all this, I'll kill you."

Telephone rings. Woman answers it. "My God, it's my husband."

All scramble to get out or hide some where. Comic tries to get in vanity table drawer. Finally they all get under the bed. Woman gets out of bed in scramble and says "My God, what will I do? Comic or all say "Come under the bed with us." Or man comes out of bathroom and says, "Come in the bathroom with me."

BLACKOUT

This scene creates its dramatic build by taking the action of hiding under the bed and repeating it, building a sense of anticipation on the part of the audience, but pushing it to the point of ludicrousness. The tension or complication is developed through the repetition of a single action. This is underscored by the woman's line upon answering the phone, "My god, it's my husband." One might expect, given Olrik's "Law of Threes," that the third man who enters would be the one to pull a gun and kill the others. In at least one version of the scene this is the case. But in most scenes, it is the fourth man who enters who pulls a gun. The pattern of three is completed, and the appearance of the fourth man creates a new line of action based on the threat of the gun.

The fourth man orders the others out from under the bed, demanding to know who they are. There is another repetition of threes, as each responds with a different occupation. Because the precise wording is important to the jokes, the line is included in the text. There is parallelism, as each man answers with his version of the line. Again there is a build, as they become more overtly sexual.

While certain lines are spelled out, much of the dialogue is left up to the actors. Each of the men, when they enter, complains about something different—the bottom falling out of the stock market, the way the woman lies around all day eating candy, the argument about the fur coat, the fourth complains how tired he is. The men are also allowed to engage in banter underneath the bed. Here too, it is only loosely indicated. For example, the Second Comic, after being introduced to the first man, asks him, "Didn't I see you under a bed in Hollywood last week?" However, it does not indicate the expected response, "Never been in Hollywood. Must've been two other guys." Because the response appears in other versions of the scene, experienced performers would be expected to know it.

"Come Under the Bed" is unusual in that it is preserved in an obvious scenario form, which merely outlines the action. Most burlesque sketches are preserved in script form, which lay out the scene through dialogue. This creates the expectation on the part of most readers that they are looking at a finished script, when in fact they are not. The scripts would be used by the producing comic or straight-man to talk through the scene, setting out specific lines, detailing the action, and working out specific business. It was a loose system and the performers needed to have a rough indication of the action rather than specific lines to memorize. Brooks McNamara observed this in scripts belonging to Mae Noell, a veteran medicine show performer.

I came to see that the references in Mae's texts to "Business," "Lots of funny business here," "the Straight fusses," and so on, were not products of a faulty memory or merely bad writing, but were conventional instructions to the actors to improvise, using some traditional speech or business, in order to create a bridge to the next set piece of dialogue.[15]

Different versions of the same scene will provide more or less detail on the action that takes place. What appears confusing in one text is sometimes made clear in another. By comparing these different versions, we can get an idea of how a particular scene or bit was played.

This method of improvising within a scenario is generally associated with *commedia dell'arte*, but this approach to theatre did not begin or end with the great Italian troupes of the sixteenth and seventeenth centuries. It was an approach evidently borrowed from illiterate street entertainers who performed on mountebank stages at fairs and marketplaces, as several works on *commedia dell'arte* have argued.[16] When the Italian comedians were banned from the theatres of Paris in the late seventeenth century, they returned to these same streets and fairgrounds. It is from these fairground entertainments that later forms such as circus, music-hall, and variety developed. Far from being unique to *commedia*, the method of improvising within a scenario has been commonplace in the popular theatre and may even be said to be the primary method of performing in popular entertainments.[17] Burlesque is one of the more recent manifestations of this tradition, one that was adapted to the culture of urban America and to the working conditions of mass entertainment.

SCHEMA THEORY

Burlesque comics, like the Italian improvisators before them, could put up a scene with little or no rehearsal, even with people they had not worked with before, so long as all of them were familiar with the material. They were able to do so because the scenes were built around a limited number of situations, which allowed bits used in one situation to be reused in another. Because they came up with their own dialogue, performers often gave more spontaneous and honest performances than those delivering memorized lines and created an immediacy and intimacy with the audience that is a critical part of comedy performance. Recent work in cognitive science helps us understand why.

Human beings naturally process new information by fitting it into preexisting knowledge structures termed *schemas*. According to what is known as the "schema theory" of cognition, people are able to remember and to understand new situations on the basis of memory structures built from previous experiences. "People record in memory a generalized representation of events they have experienced, and this representation is *invoked*... retrieved when a new experience matches an old script," observes Mark Ashcraft.[18] Gillian Cohen writes that

> schema theory emphasises the role of prior knowledge and past experience, claiming that what we remember is influenced by what we already know. According to this theory, the knowledge we have stored in memory is organised as a set of schemas, or knowledge structures, which represent generic knowledge about objects, situations, events, or actions that has been acquired from past experience.[19]

A *schema* is defined as "a structured cluster of knowledge that represents a particular concept."[20] Each schema is a prototypical abstraction of an entity or an event

against which all similar transactions are interpreted and evaluated. Rather than being a precise outline, it is a series of slots. These slots "may be filled with fixed compulsory values, or with variable optional values," Cohen points out. "A schema for a boat would have 'floats' as a fixed value, but has 'oars' and 'engine' as variable values."[21] Schemas permit reasoning, particularly from incomplete information, and allow us to comprehend both fictional stories and actual events.

More specific versions of mental schemas are called *scripts* (although in a discussion about the theatre, the term "scenario" is more appropriate). These consist of general knowledge about particular kinds of events. Scripts are sequentially ordered and are goal-directed. They are an outline or plan of action for familiar situations. People have scripts for familiar experiences such as going shopping, eating in a restaurant, or attending a birthday party. These scripts are abstracted from previous experiences, and individuals have hundreds of these scripts. Your mental script tells you what to expect in a given situation, what order the events will take, who the central characters are, and what each person is supposed to do in a given situation. "Scripts allow us to supply missing elements and infer what is not explicitly stated. As well as guiding and enriching our understanding of events, scripts also provide an organising framework for remembering events," Cohen writes. "They explain the common observation that in remembering routine, familiar, often-repeated events we seem to have generic memory in which individual occasions, or episodes, have fused into a composite."[22]

Elements of a situation will trigger or activate the appropriate script. A suggestion of food or the appearance of a maitre d' will activate a script about a restaurant. The script outlines actions that are expected to take place and defines the various roles. It enables a person to predict what will occur, while being flexible enough to allow for unexpected or unforeseen events to take place.

Similar schemas allow us to understand and process stories. D. Gary Miller observes that "the *story schema*, being constructed from listening to stories...embodies knowledge about how stories begin and end, how events are structured and how causal relationships and action sequences are handled."[23] These schemas or story structures then aid in understanding and recalling other stories. We match new stories to old schemas, then rationalize or reconcile any discrepant parts, based on real world experience. "An orally transmitted story will survive only if it conforms to an ideal schema in the first place or has gradually attained such a structure through repeated retellings," write J. M. Mandler and N. S. Johnson.[24]

THE STRUCTURE OF ORAL NARRATIVES

This slotting of information into a preexisting schema is a feature that is well documented in stories that circulate orally. Russian folklorist Vladimir Propp analyzed Russian folktales in terms of a series of "functions" that every folktale will contain. Each function is "an act of dramatis personae" and represents a particular point or development in the plot. Propp identified thirty-one functions that all (or most) folktales share. An individual folktale will often include only some of the functions, but they will always appear in a standard order, as he outlined in his book

The Morphology of the Folktale. Each function is a slot into which particular "function-fillers" can be dropped.

According to Propp's model, all folktales proceed from either "villainy" or "lack" and the villain must be defeated or the lack liquidated. In the "villainy" scenario, a character causes harm to a member of the hero's family, and the villainy must be avenged. Function-filling actions of the villain may be a murder, abduction, some sort of bodily injury, stealing a magical agent, casting a spell on someone, or performing a similar misdeed. In the "lack" scenario, the hero or someone close to him lacks something or desires to have something. This may include the lack of a bride, a magical agent, a wondrous object, a physical abstraction of some kind, or a rationalized form like money. The story proceeds to avenge the villainy or satisfy the lack. The functions that follow are optional and may or may not appear in a particular story. Each act of villainy or each new lack, in Propp's model, is the basis of what he terms a "move." A tale can consist of a single move, or a number of moves, that may either directly follow each other, or interweave in some way.[25]

Propp's morphology is especially geared to a certain type of folktale—what is commonly known as a fairy tale and is classified as a "regular folk tale." They do not necessarily apply to folktales outside the European tradition or to humorous tales, which are typically much simpler in structure. Heda Jason, in a report for the RAND Corporation, analyzed the structure of what she termed "swindler tales," which have a particular applicability to burlesque and to many humorous tales. Jason found that there were five function-slots and two role-slots in the stories she investigated. She defines the two role-slots as the "dupe" and the "rascal," and they correspond closely to the roles of the comic and straightman. In burlesque, however, the comic can often play the rascal deceiving (or trying to deceive) the straightman or one of the other characters. Jason's characters of "dupe" and "rascal" are roles that remain constant no matter what character is filling them.

The outline for a "move" in a typical swindler tale, according the Jason, involves the following events or functions:

1. (a) A situation evolves that enables Rascal to play a trick on Dupe;
 (b) Dupe reveals his foolishness so that Rascal can utilize it.
2. Rascal plans a trick.
3. Rascal plays the trick.
4. Dupe reacts as Rascal wished him to do.
5. Dupe has lost; Rascal has won.[26]

Jason notes that the "move can stand as an independent story or can enter into various combinations with other moves to form a whole tale."[27] Several moves can be combined in different ways each time the tale is performed.

One combination of "moves" that crops up quite often in folktales and in burlesque sketches is a structure that Alan Dundes termed "unsuccessful repetition."[28] In this, the comic, after being duped by the straightman, tries to pull the same trick on another character, but it backfires. The scene is a combination of two moves, but in the second move, when the comic attempts to turn the tables on the straightman,

he is unsuccessful, thereby losing twice. An illustration of this is a money-changing bit called "Two Tens for a Five," which appears in the Ken Murray Collection.

<u>Two Tens for a Five</u>

Str: Can you give me two tens for a five?

Com: Sure. *(Counts two bills to him—stops suddenly.)* Just a minute—I've been gypped.

Str: Gypped?

Com: Yes, I gave you two tens for a five.

Str: Well here's your five. Give me back my two tens. *(Comic counts out two tens to Straight. Straight exits. Comic scratches head—then figures it's right— smiles.)*

Com: Can't gyp me. *(Exits.)*

The bit should be familiar to Abbott & Costello fans, for the pair performed it in their first film appearance, *One Night in the Tropics*, and frequently revived it. Lou Costello generally added a third "move." Realizing he has been taken advantage of, Costello tries to pull the con on a third person, but gets it fouled up, offering the stranger "two tens for a five" so that he winds up losing yet a third time. The swindle is the basis for a great many scenes in burlesque.

Another sequence seems to be at work in scenes involving adultery, which follow a sequence identified by Alan Dundes: *interdiction, violation, consequence,* and *attempted escape.*[29] In this scenario, the character is given an interdiction or a warning, which he breaks resulting in negative consequences. The interdiction can be explicitly stated or, as in the adultery scenario, implicit—a taboo form of sex with another man's wife.[30] We know the consequence—the cuckolded husband will likely pull out a gun and shoot the paramour, and the person attempts to hide someplace—in a closet, under the bed, even under the covers. In some cases, the paramour escapes notice; in "Come Under the Bed," he faces justice.

SCRIPTS AND HUMOR THEORY

Schema theory also goes a long way in explaining why we laugh. Linguist Victor Raskin has applied schema theory to the study of jokes and joke structure. Writing about the verbal mechanisms of humor, he concluded that in any joke there are two scripts, and the punch line shifts from one script to the next. Raskin means something very specific by his use of the word "script." A script is defined as a "large chunk of semantic information surrounding a word or evoked by it. The script is a cognitive structure internalized by the native speaker and it represents the native speaker's knowledge of a small part of the world."[31] It can also be seen as the scene or situation or expectation that is evoked in the listener's mind by the joke-teller's statement.

"A text can be characterized as a...joke-carrying text," Raskin concludes, "if both of the following conditions...are satisfied. (i) The text is compatible, fully or in part, with two different scripts. (ii) The two scripts with which the text is compatible are

opposite."[32] The set-up line in a joke has to be compatible with both scripts, and the punch line shifts the listener's awareness from the expected script to an unexpected one. These two conditions, Raskin asserts, are all that are necessary and sufficient conditions for a text to be funny. One of these scripts—the surprising and thus comic one revealed by the punch line—must violate what we already know or generally accept about the world. It has to go against reason or experience—juxtaposing *real* with *unreal* situations—or it may be based on judgmental dichotomies—reversing accepted notions of *good* and *bad*.

Raskin's model is a refinement of the incongruity theory of humor. Kant was one of the first to put forth this theory in suggesting that "laughter is an affection arising from the sudden transformation of a strained expectation into nothing."[33] An eighteenth-century writer James Beattie articulated this view when he observed that "laughter arises from the view of two or more inconsistent, unsuitable, or incongruous parts or circumstances, considered as united in one complex object or assemblage."[34] Schopenhauer stated that "the cause of laughter in every case is simply the sudden perception of the incongruity between a concept and the real objects which have been thought through it in some relation, and laughter itself is just the expression of this incongruity."[35] In the twentieth century, Arthur Koestler coined the term "bisociation" to explain reasons for laughter. He observed that in the act of perceiving a joke, there is a sudden mental leap from one context to another. "The pattern underlying all varieties of humour is 'bisociative'—perceiving a situation or event in two habitually incompatible, associative contexts."[36] Elliott Oring emphasized that it is not enough for something to be incongruous to be funny. In order for an incongruity to be humorous, it must be an *appropriate* incongruity. "Jokes establish a primary meaning that is disestablished by some secondary, yet appropriate, interpretation."[37] Unless the listener is able to see the "incongruity and the appropriate connections between the incongruous words, behavior or ideas...there is no humor."[38]

Those theorizing about humor are generally trying to discover an overarching model for what makes people laugh. They are largely concerned with developing an explanation of what is both necessary and sufficient for humor, excluding those explanations that do not fulfill every instance. While this is certainly a valuable undertaking, the issue of what is necessary and sufficient for laughter is not of primary concern to those who are trying to *produce* humor. Those involved in the creation of humor, whether as writers or performers, approach this problem the other way around. Rather than reaching for an overarching model for what makes people laugh, then using it to generate funny remarks or funny scenarios, comics absorb their ideas piecemeal, building up a repertoire of humor techniques that work for them. They master certain formulas by which they can generate laughs, keeping those that work and discarding those that do not. They are able to use these formulas—either consciously or unconsciously—to create new jokes or witticisms.

Most books on joke-writing provide examples of humor formulas. There is no standard listing, and individual comics create their own labels for these jokes. In grouping jokes together, they tend to fall into three categories: misunderstanding, reversal, and exaggeration/distortion. Gag-writer Robert Orben distinguishes three types of jokes: "(1) Those that create a ludicrous impression for the reader. (2) Jokes

that establish a line of thought and then suddenly break it off. (3) Jokes that revolve around a comic misunderstanding or a play on words."[39]

Art Henley, who wrote an instruction manual on writing comedy for radio, breaks jokes down into the same three categories, which he labels misunderstanding, about-face, and satire. Although the terms are different, the categories are the same as Orben's (but listed in reverse order). *Misunderstanding* occurs when "one sound, phrase, word or word combination can be interpreted in two ways for a ludicrous result."[40] Such humor is based on the fact that a particular word or phrase is ambiguous and may have more than one meaning. This is often the basis of puns and plays on words. There is an *about-face* when "an opposite word or phrase reverses the direction of thought so that the punchline becomes a ludicrous contradiction of the straight-line."[41] About-face or reversal jokes usually revolve around a pair of antonyms (black/white, up/down, high/low, back/front). *Satire* occurs when "anyone or anything is held up to ridicule through exaggeration of their outstanding weakness."[42] This is based on distortion, and corresponds to Orben's category of jokes that create a ludicrous impression for the reader.

All of these formulas fit quite easily within Raskin's linguistic model of humor. Each of these forms contains two scripts or stories. In verbal humor two scripts can be linked through a misunderstanding or play on words, because a word or a phrase is ambiguous and can have two different meanings. The punch line shifts the listener's attention from the first script (normally an innocent one) to the second (which often contains a hostile or obscene message).[43] Henley gives an example: "I named my yacht The Girdle because it takes a lot of little tugs to get her out of her slip." The about-face or reversal joke leads the listener along one particular line of thought, and then suddenly wrecks it by contradicting it in some way. This can be done, Henley argues, either by negating it or by adding another idea that contradicts the first. One example he cites is: "Literature is going to the dogs. If Shakespeare were alive...he'd turn over in his grave."[44] The satire formula creates a ludicrous impression for the reader by contrasting a normal or expected image of an object, person, or situation with a distorted "exaggeration of its outstanding weakness."[45] "When I took my girl home to 2nd Street, I got a big hug. Then she moved and I had to take her home to 48th Street and I got a kiss. Gee, I can hardly wait till next week...she's moving to 195th Street."[46]

Raskin recognizes the first two of these categories—which he labels ambiguity and contradiction.[47] The third category (which Henley calls "satire" and Orben calls "the ludicrous") is based on *distortion*. It is less connected with word choice, and more concerned with creating an impossible picture in the mind of the audience, either through words or visual representation.[48] What Orben identifies as "jokes that create a ludicrous impression for the reader" are likewise jokes that distort our mental image of the object of the joke. Orben provided a brief checklist of techniques for creating a ludicrous impression, all of which involve some kind of distortion. A joke may—

- exaggerate its characteristics
- minimize its characteristics
- imbue it with ridiculously foreign qualities
- discuss it in comically alien terms
- reverse the situation[49]

Bob Bassindale urges people interested in producing humor to study the structures of jokes, and identifies basic verbal structures for puns (inaudible puns, sound alike puns, inexact sound alikes, forced or interpreted puns, telescoped puns, and split puns); for contradiction jokes, which he calls "pulling the rug out" (the series, contrast, qualification, opposite, pompous); and for distortion jokes, which he classifies as "advanced humor techniques." By looking at jokes, identifying the verbal structures that underlie them, and absorbing them, comics learn to come up with jokes on their own. The ability to produce original humor only comes with practice. "To actually sharpen and improve your own [sense of humor]," Bassindale urges, "to develop the ability to generate and express original funny ideas in the form of effective gags, quips, jokes, and stories, you need more than understanding. You need practice—effective, productive, meaningful practice. And the easiest, most practical way to practice is to work with humor formulas."[50] This approach may seem overly methodical, but the ability to generate creative expressions in any medium only comes from mastering the technique of that art. Comedy is like any other art form in that respect.

CREATING COMIC SITUATIONS

People create comic situations in much the same way, utilizing similar models. A scene or bit of comic business can be "switched" just as easily as a joke. The variations we find in burlesque scenes show evidence of this kind of switching. There has simply not been the same kind of examination of comic situations and bits as there has in jokes. A comic situation, like a joke, has two different scripts and something triggers the awareness from one script to the second. If there is only one script jump, it is only at the very end, and it is a blackout. However, many scenes set up these two scripts (or two realities) and keep the characters (or just the audience) moving back and forth between them. "Who's on First" is a case in point. Lou Costello believes that when Abbott uses the words "who," "what," and "I don't know," he is posing a question. Bud Abbott understands that "Who," "What," and "I Don't Know" are the nicknames of the infield players on the baseball team. Both maintain their perspectives until the very end of the scene. The audience is aware of both perspectives, and goes back and forth between the two scripts during the course of the scene. The delight of the scene for the audience is the way the two comics maintain the opposing scripts as they go round and round the baseball diamond. The two characters in the scene, however, are wedded to their perspective.

Art Henley suggests that the same formulas that apply to jokes are the basis of comic situations. In scenes based on *misunderstanding*, Henley states that there is a "confusion of viewpoints about a single action, or two or more combined actions, resulting in conflict that appears ludicrous to the audience which is aware of all sides of the action."[51] This confusion of viewpoints can be brought about by a misunderstanding as to the meaning of a word or statement, but it can also be built around mistaking some other aspect of a situation—the identity of a person or an object, or the purpose of an action. "Who's On First" is only one example of a burlesque scene built around a misunderstanding. A number of scenes in burlesque are built around an extended double entendre. In "Golf," for example, the Straightman tries

to explain the game of golf to the Comic, who misunderstands the references to "bags and balls" and to "grasping his putter" as referring to the male anatomy. From this misunderstanding, the scene creates wilder, more improbable images in the Comic's mind. In "Ice Cream," the Comic mistakes the smell of limburger cheese for an odor emanating from a rich and arrogant customer, prompting many disgusted remarks from the Comic.

A *reversal*, or about-face situation, involves a "reversal of circumstances at the climax, with the earlier action resulting in conflict that appears ludicrous to the audience which is aware of the impending reversal."[52] There are two directions the reversal can go—from defeat to triumph or from triumph to defeat. "A positive action brings about a comic reversal from defeat to triumph for a gleeful relationship between the initial and final circumstances," Henley writes. "A negative action brings about a comic reversal from triumph to defeat for a woeful relationship between the initial and final circumstances."[53] Scenes that rely primarily on an about-face set up clear-cut parameters for winning and losing. Typically the Comic wants something—if it is a scene played with a woman, it is sex that is on his mind; if it is a scene with another man, it is usually money he is after. As in most folktales, it is based on some kind of lack that must be liquidated or a wrong that must be revenged. Burlesque, like most folktales, sets up unambiguous motives, based on basic human needs and drives.

A common way to set up this comic reversal is a bet. The bet provides a clear basis of winning and losing, as the comic is lured into betting on what seems to be a sure thing, only to be tricked into losing. In "You're Not Here," the Straightman bets the Comic that he is not here, then proves it with an absurd bit of logic. In the "Upside Down Beer Bit" performed by Lou Ascol, the audience is led to believe that this is an impossible bet, but Ascol proves he can win it, to the delight and applause of the audience. A similar win-lose scenario is provided by "flirtation scenes," in which the Comic tries (usually unsuccessfully) to pick up a Girl, despite the Straightman's assurances that he has a surefire technique.

While in the scenes built around misunderstanding, both the comic and straightman must maintain their own perspectives on the situation, in scenes based on about-face, the comic often steps outside of the action to comment on what is going on. We see this in Lou Ascol's performance of "Upside-Down Beer Bit." Ascol constantly makes side comments to the audience. Each of these conceptual shifts keeps the audience going back and forth between different realities, and underscores the game-like quality.

In the scenes Henley classifies as satire, but I prefer to label *burlesque* (for obvious reasons), there is much less stress on winning and losing, and the pleasure lies in disrupting and distorting a situation. The humor in this situation, according to Henley, takes place when "there is ridicule of a familiar line of action through a comic exaggeration of the outstanding weakness of the original circumstances." Henley notes that these situations may either be a "parody of a specific action, or a farcical treatment of a typical situation."[54] This formula is the most common type of scene in burlesque, and accounts for most of the large-cast "body scenes." Here, there is a familiar or expected line of action, based on the well-established schema or script. Something or someone distorts, exaggerates, or disrupts that line of action, and it is the comparison between what is happening onstage with what *should* be happening

in that context that sets up the humor. The most clear-cut type of satire would be parody or theatrical burlesque, where a serious scene from Shakespeare, for example, would be acted out in a ludicrous way. This happens in "Fanny" where, to improve their love life, the Comic enacts the balcony scene from *Romeo and Juliet*, with his wife, Fanny. Our appreciation of the scene comes from our knowledge of how this is really supposed to go, and without the knowledge of the Shakespeare play, the scene would be much less appealing.

While a stage play is the most familiar source of a satire, there are many scripts or scenarios that can be distorted. As previously noted, people have scripts for all kinds of everyday activities, and these internalized scripts can also be satirized, exaggerated, or made fun of in some way. A "restaurant" script is made ludicrous when the waiter behaves differently from the way that we expect a waiter to act. If he insults the customers, refuses to take the order properly, it shatters the script we have in our heads, and given the right context, can give us a great deal of pleasure. Likewise, if the customer coming into the restaurant begins acting up and insulting other customers in an elegant bistro, it breaks the script. Most body scenes—those taking place in courtrooms, doctors' offices, schoolrooms, and so on rely on the fact that we have scenarios in our heads of how people are supposed to behave in what are normally serious circumstances. Once the comic enters the scene, the script goes off in unexpected directions.

Few burlesque scenes employ one of these strategies exclusively. Most scenes will combine sources of humor. Many flirtation scenes can include misunderstanding jokes, when, for example, the Comic is trying to pick up a Girl in a foreign country. It quickly turns into a scene based on misunderstanding and double entendre. Likewise, a scene based on misunderstanding will incorporate elements of satire or distortion; for example, in "Golf," when the Straightman tells the Comic to swing his putter over his shoulder, the Comic is visualizing trying to do that with his penis. Scenes based on satire or distortion will incorporate all the others. The chapters that follow look at each of these formulas in more detail.

8. Double Entendre Humor ✌

Figure 8.1 Cleopatra's asp was a regular subject for double entendre. Harry Arnie doesn't quite know how to react to this unidentified showgirl's asp. (From the author's collection.)

Burlesque, of course, will always be identified with sexually-oriented humor. Not all was sexual, as any look at the work of Abbott & Costello shows. Comics were free to introduce suggestive or obscene comments into any scene they were in. While some comics worked relatively clean, others introduced a lot of "kack," hoping to get a rise out of the audience. As Irving Zeidman observed, "Burlesque comics have no particular aversion to clean jokes. All is grist to their mill. Even if burlesque were not a sexually based entertainment, the comedians would have to resort to suggestive dialogue and bits, because a whole new world of humor is thus open to them."[1]

The sexual humor we find in burlesque is actually quite tame by today's standards. It relies much more on implication and innuendo than on explicit references or four-letter words. Burlesque humor was suggestive rather than obscene, a far cry from the frank discussions of sexuality that stand-up comedians are free to engage in at today's comedy clubs. Burlesque comics, of course, played by (and with) the rules of the day, pushing the limits of what was permissible onstage.

Victor Raskin asserts that sexual humor "is characterized by a standard opposition of a non-sex-related script with a sex-related script."[2] The punch line shifts the focus of the listener from a nonsexual meaning of the words to a sexual one. Double entendre is relatively simple to produce. Nearly any word, particularly a long or unfamiliar one, could be given a suggestive double-meaning with the right inflection or a shocked reaction. Burlesque performers made most use out of words that sounded like words that were forbidden onstage. Irving Zeidman noted that "in all burlesque shows, the following words were always sexually suspect: personality, scrutinize, Chevrolet, Queen's Box, machacha, Cleopatra's asp, tomb, mantilla, gondola, credentials, India, peace, cognomen, etc., etc., as well as practically all other words of more than two syllables."[3] A favorite was "scrutinizing," which the performers would draw out suggestively. Rowland Barber puts it in the mouths of the Soubrette and Ingenue. "Now we gotta change our approach," the experienced Soubrette tells her partner, "We gotta play hard to get." "But aren't we going to vamp 'em?" the Ingenue wonders. "No, first we let 'em scrutinize us, and then we vamp 'em." "*That's* playing hard to get?" the Ingenue wonders in wide-eyed innocence.[4]

Here, the misunderstanding sets up a single laugh on a simple play on words, but more often, the double entendre was used to set up a picture that goes beyond all sense, juxtaposing normal and average genitalia with gigantic or impossibly exaggerated dimensions, or normal sexual prowess with impossibly athletic prowess. In "Scrutinizing Scene" (Jess Mack Collection), the Straightman hires the Comic as an escort to help him handle the three hundred women who send him letters each week.

Str: When a woman comes in, I'll be sitting over there. (*Points to settee.*) And you stand her over there so I can scrutinize her.

Com: So you can what?

Str: So I can scrutinize her.

Com: How the hell can you reach her from over there? It can't be done.

Str: Why I can scrutinize a woman from here clear across the street.

Com: It's different with me. I can't scrutinize them even when I get them right up against me.

Str: You ought to see my father! He can scrutinize them around the corner.

Com: Now that's what I call a man!

Str: But you ought to see my uncle.

Com: The hell with your uncle, your old man is good enough for me.

The humor of these bits relies not just on wordplay, but on the impossible picture it creates in the Comic's mind of a man who copulates with women across the street and around corners.

In "Renting a Room" (Ralph Allen Collection), the Comic suspects that the Soubrette wants to rent a room in his home for immoral purposes, and his worst fears seem confirmed when she tells him the kind of work she does.

Sou: You see I am a public stenographer and I generally use my room as my office. You see I do business with men.

Com: That's what I thought. What kind of business?

Sou: I take dictations.

Com: You take dictations? In what hand?

Sou: Sometimes in both hands.

Com: Who the hell is coming up here, King Kong?

Sou: Sometimes I take dictations from five or six men in one night. In fact, you may hear my machine going all hours of the night.

It is not only the male member that gets exaggerated beyond all proportion. In "Cleopatra's Asp" (Ralph Allen Collection), the Straightman explains the tale of Cleopatra to the Comic.

Str: Now in those days the women had many pets and Cleo's pet was her asp.

Com: I beg your pardon.

Str: I said asp. Now everywhere that Cleo went her asp would go behind her.

Com: Did you ever see one go in front of any one?

Str: Oh yes, they had them. Cleo used to carry hers on her shoulder.

Com: Get out of here. Go way. What was she, a contortionist?

Str: No, sometimes she would walk down the street and leave her asp behind.

Com: What? Do you mean she would walk away from her asp?

In "Bullfight Scene" (Ralph Allen Collection), the Comic is about to play the matador, and the Straightman instructs the Comic in the proper behavior in the bullring. The Comic misunderstands the reference to the Queen's box as a reference to her anatomy, creating a ludicrous picture of the Queen.

Str: You bow to the King and throw a kiss at the Queen's box.

Com: Hey what does the King say?

Str: Oh the King throws kisses to the Queen's box also.

Com: Well what the hell the King's broadminded.

Str: Then you look closely and you will see all the Queen's attendants walking in and out of her box.

Com: What a queen!

EXTENDED DOUBLE ENTENDRES

A misunderstanding creating double entendres could also form the basis of more complicated scenes. In "Golf Scene" (Jess Mack Collection), the Straightman tries to explain the game of golf to the Comic. The Comic misunderstands the references to bags and balls and putters in a sexual way—setting up an elaborate double entendre. While the scene reflects the male concern about penis size, the humor doesn't come out of the bragging rights, but out of the Comic's admission of the feeble size of his own "putter." From start to finish, the scene is filled with unpleasantries, increasing from embarrassment and exposure to the imagined pain of "whacking your ball" with a club. All of that humiliation and pain, however, is based on a misunderstanding, and the humor comes from the audience's awareness of both the real and the imagined scripts, and listening to the Comic's thought processes. The performers themselves—particularly the Straightman—are completely committed to their understanding of what is going on.

Golf Scene

The Straightman chastises the Comic for not getting enough exercise, and suggests that he take up golf. The Comic knows nothing about the game, so the Straightman offers to teach him.

Str: Now in order to play golf, you have to have the proper equipment.

Com: And what does that consist of?

Str: That consists of your bag and your balls.

Com: Well I have that. I should be able to play a little bit.

Str: Besides your bag and your balls, you need a putter.

Com: What's a putter?

Str: It's a long thing, with a knob on the end of it. *(Gestures.)*

Com: No! How about a short thing with a wart on the end of it?

Str: No! It's got to be at least 26 inches long, including the knob. *(Gestures again.)*

Com: How about 3½ inches long, including the wart?

Str: Of course you know what the knob is for?

Com: Any fool knows what the knob is for.

Str: Yeah, well what's it for?

Com: That's to keep your hand from slipping off the end—I think.

Str: No, no, the knob is to whack your ball with.

The Straightman pantomimes whacking a golf ball with a club. The Comic reacts with alarm.

Com: Oh! This is a dangerous game.

The Straightman takes him on an imaginary trip to the golf course. There are other people lined up to tee off, so they have to wait their turn.

Str: Now, while you're waiting, so it shouldn't be a total loss, you reach in your bag and you pull out one of your balls.

Com: That's quite an operation, isn't it? *(Gestures.)*

Str: No...you have a zipper on your bag.

Com: To hell I have...I have the old-fashioned kind...

Str: Then you must have a little puckering string on it?

Com: Is that what they call that little thing?

The Straightman describes how he takes his ball, spits on it, polishes it, and then writes his name on it. This is so that he can identify his ball. The Comic insists that he has no trouble telling his ball from anybody else's. But the Straightman is firm—

Str: You see (Comic), you could be standing there and a ball could come whizzing by *(Gestures past Comic.)* 400 miles an hour...You wouldn't know whose ball that is.

Com: No, but whoever owns it will be close behind. At least an arm's length away I'd say.

It is now the Comic's turn to tee off. The Straightman explains that he steps forward, bows to all the pretty girls.

Str: Then you squat and you make a little pile.

Com: Get the hell out of here...In front of all those pretty girls?

Str: Why of course. There could be hundreds of people, all making little piles on the golf course at the same time.

Com: They are? This is the dirtiest darn golf course I ever heard tell of. But I'm game. I'm game.

Str: Now the next thing you do, is you reach in your bag and you pull out your putter and you hold it in your hands like this.

He pantomimes holding a golf club in both hands, as if to putt. The Comic is amazed.

Com: *(Skulls.)* Both hands?

Str: Both hands.

Com: Well one of them is going to be awful damned empty.

Str: Why? How do you hold yours?

Com: *(Gestures.)* The hard way.

The Comic holds it in one hand, straight out from the body.

Str: You can't hold it like that.

Com: To hell I can't. I've been doing it for years.

Str: No, you have to hold it like this. *(Gestures.)* In here.

Com: Why?

Str: Because you can't swing it out there.

Com: No, but I can dangle it a little bit.

Str: You have to hold it in here. Then you swing it over your shoulder. *(Gestures.)*

Com: Shoulder? I can't even get it past my belt buckle. Whatta you, crazy or something?

Str: And then you whack your ball.

The Straightman whacks the ball with his imaginary golf club. The Comic does a piece of business of walking in a circle, imagining the pain.

Str: And it soars and soars and soars.

Com: If I whack it like that, it will be sore for 11 months.

There is some discussion of how the caddy carries around the Comic's bag and balls.

Str: Now the next thing you do, is take your putter and you knock your ball into the hole. *(Gesture of hitting ball softly.)*

Com: I always thought the putter went in the hole and the ball dingled on the outside! No wonder I've stunted my growth.

Str: Of course not... The hole is too small for the putter to fit in.

Com: Not the one's we've seen. The ones we've seen you can put putter, bag, balls and all in. *(Hesitates.)* And sometimes the caddy and even the cart.

Str: Now the object of the game is to make 18 holes in the least amount of strokes in one day, and you win.

Com: I've got to make 18 holes in one day?

Str: That's right.

Com: I ain't never going to learn how to play this darned game.

Str: And why not?

Com: Because right now it takes me 18 days to make one hole.

<div align="center">BLACKOUT</div>

An alternate version can be found in Dundes and Pagter's collection of Xeroxlore, *Urban Folklore from the Paperwork Empire*. Although they write that such extended double entendres were rarely committed to memory, professional comedians did, in fact, have the routine memorized.[5]

The use of sports and games as an extended sexual metaphor is fairly common. "Baseball" (Ken Murray Collection) utilizes much the same formula, as the Straightman tries to explain the game of baseball to the Comic.

Str: While you're standing there a man from the opposing team comes to the plate and he stands there with his bat in his hand.

Com: Well, if he's willing to stand there with his bat in his hands, I'm willing to stand out there with my ball in my hand.

Str: Now he takes his bat and he swings it over his shoulder.

Com: Over his shoulder? You're a better man than I am, Gunga Din.

Str: While he is standing there with his bat on his shoulder you take your ball—

Com: That I have in my hand.

Str: And you wind up. Start to wind up about three or four times and you throw it towards the catcher.

Com: I think you better get yourself another boy.

"Beetlepuss" Lewis and George Rose perform the routine in the burlesque film *A Night at the Moulin Rouge*.

FOREIGN WORDPLAY

Foreign words and expressions lent themselves especially well for sexual innuendo. In a scene from a 1952 burlesque feature *Burlesque in Hawaii*, Comic Harry Vine tries to pick up a French Girl. She coyly responds, "You like to kiss me, yes?" The Comic reacts and asks her to repeat what she said. She replies "You like to kiss me, yes?" Certain that she is inviting him to "kiss my ass," he seeks confirmation from his buddy. "In my country, it's a great honor to kiss me, yes," the Girl insists. "Well in our country we have a different outlook on the matter," the Comic replies. Nowhere, in the scene does anyone actually say the forbidden words, but through his reactions and the repetition of key lines, the audience gets his drift.

When the Comic finds himself in a foreign country, there are all kinds of opportunities for suggestive misunderstandings. In "Bird of Paradise" (Chuck Callahan Collection), the Hawaiian King Kahuna offers his daughter to the Comic.

Kah: You must give her something or she will throw herself into the burning volcano [...] And if she likes you she will give you a lei.

Com: Where will she give it to me?

Kah: She will put it around your neck.

Com: I'll be damned if she will.

Kah: If you are the man of her dreams she will give you a lei for every day of the week. And now my boy you shall meet the princess [...] *(Looking off stage.)* Enter princess Wicky Wicky.

Com: Is she the girl that's going to give me a lay?

Kah: If she likes you she will give you many many leis.

Com: If this is a dream I wish some one would shoot me before I wake up.

The most involved scene of this sort is "Bull Fight," which exists in some form in nearly every collection, under various titles. The setting is a Latin country where the Straightman tries to recruit the Comic as a bullfighter. He paints an elaborate picture of the bullfight for the Comic, who takes everything in a sexual way. The following is one of two versions in the Chuck Callahan Collection.

Bull Fight (Machacha)

The Comic and Straightman enter as the band plays the Toreador song, ending on a discordant note. The Straightman explains to the Comic that they are in the wonderful land of Spain, and that he has a job for the Comic—fighting bulls. The Comic's reaction is immediate:

Com: The hell with that. The bull never did anything to me. And if he did I forgive him. *(Starts away.)*

Str: Don't be afraid Chuck. This bull is deaf, dumb and blind.

Com: Well he can still smell and I ain't so sanitary.

Str: Well another thing. He can't bite you. He has no teeth.

Com: I know, but he can gum hell out of me.

The Comic tries to leave again, but the Straightman stops him, and begins to paint a verbal picture of a bullfight.

Str: Why you have never seen a bullfight? Let me explain it to you. First you enter the arena. The arena is 600 feet in circumference.

Com: 600 feet in circumference?

Str: All around the arena are seats and boxes. And in the boxes are the beautiful señoritas. They are wild with excitement. They want to see the toreador. They want to see the bull slain. They want to see blood.

Com: Why don't they go to a slaughter house?

The Straightman ignores the Comic's remarks and continues to describe the ritual of the bullfight.

Str: Now, the gates of the arena swing open for the first time and in come the matadors, the picadors, and the toreadors.

Com: The cuspidors and the spittoons.

Then as the band strikes a chord, the Straightman paints a grim picture of what is in store for the Comic—

Str: The gates of the arena swing open for the second time. In dashes the infuriated bull.

Com: A fumigated bull?

Str: The bull is mad. The smoke is coming out of his nostrils.

Com: Ah, Bull Durham.

Str: He is pawing the ground. His tail is swinging wildly. Now the matadors stick their bandarillas into the bull. Then they wave red flags in front of the bull. He grows more and more ferocious. He craves action. He is wild. He wants to tear someone limb from limb. Just when the bull reaches the highest point of ferociousness, the band strikes another loud chord. *(Band strikes chord.)* The gates of the arena swing open again for the third time and you enter the arena.

Com: *(Bus. with Str.)* You mean that when—

The Comic repeats what the Straightman just said, adding—

Com: —then I come in?

Str: That's right.

Com: You're crazy as hell.

Str: Now you turn and face the bull.

Com: Who faces what bull? Charlie that bull is going to see the soles of my feet so often he'll think I'm laying down.

Str: Now you remove your hat. You bow to the right. You bow to the left. Now you see the King and Queen sitting in the royal box. What do you do? You sink to your knees and throw kisses at the Queen's box.

Com: *(Bus.)* What's the matter with the King?

Str: Oh he don't mind, he's used to it.

Com: Oh, I guess it's an old Spanish custom.

The Straightman explains that just as the bull is about to charge.

Str: Now you reach down and pull out your machacha. *(Bus.)*

Com: In front of the bull?

Str: Certainly.

Com: *(Starts away.)* The hell with that.

Str: What's the matter?

Com: He ain't going to gum hell out of my machacha.

Str: *(Bus.)* Now you stand there and pose with your machacha in your hand.

The Straightman takes a pose, holding an imaginary sword out in front of him, his hand roughly chest high. The Comic, who assumes through the rest of the routine that he is talking about the male member, pulls the Straightman's hand down to the groin area.

Str: The señoritas are looking at your machacha, and they are wild.

Com: Huh? That's enough to make them wild?

Str: Why they are throwing kisses at your machacha.

Com: *(Muggs.)* Hey Charlie do you think I can stand it?

Str: Why certainly. You have a beautiful machacha.

Com: How the hell do you know?

Str: Why every toreador in Spain has a machacha that long. *(Bus.)*

Com: *(Bus.)* Well that's Spanish. I'm Irish. *(Bus.)*

Str: Now you take your machacha and you wave it around your head.

Com: *(Bus.)* You better get another boy.

Str: But remember your machacha is very valuable. Don't drop it in the mud.

Com: Oh Charlie, you flatter me.

Str: Again you turn and face the bull.

Com: Charlie, I bet that bull is sick of looking at me.

Str: The bull is charging straight toward you. What do you do? As he charges, you lightly step aside. And as the bull passes you, you stick your machacha in the bull.

This is too much for the Comic, who turns and starts to walk offstage.

Str: What's the matter?

Com: I ain't going to ruin my machacha on you or any bull.

<div align="center">BLACKOUT</div>

A second version in the Callahan Collection titled "The Bull Fight" appears in Brooks McNamara's *American Popular Entertainments.* Jess Mack's version is titled "Bull Fighters" and the Ken Murray version is titled "Easy Bull Fighters." The Gypsy Rose Lee Collection has three versions, all titled "Bull Fight," and there are two in the Ralph Allen Collection, "Spanish Bullfight Scene" and "Spanish Bullfight (Balerio)." Comic Harry Rose performs the scene with straightman Bob Carney in *Naughty New Orleans.*

MISTAKEN IDENTITY

Although wordplay is the usual basis for double entendre based on misunderstanding, some other aspect of the situation can be misinterpreted or misperceived. In a number of scenes it is a case of mistaken identity that leads to the confusion. In "Doctor Plummer," the Comic is a plumber who happens to arrive shortly after a doctor has been called. The piece was a favorite of Billy "Cheese and Crackers" Hagan, Ralph Allen reported.

> Tools in hand, he has come to repair a leaky valve in the bathroom. Instead, he is invited to scrutinize a beautiful, nearly naked patient to see if she has a leaky heart. "What a break for a plumber," he says, masking his delight from the straight man but letting the rest of us share it. I shall never forget Billy's high squeaky voice when he said that line and the little smile that hinted at profound delights.[6]

Ken Murray had a version titled "The Plumber" that differed somewhat different from the Billy Hagan version.

<div align="center"><u>The Plumber</u></div>

The Straightman is on the phone summoning a plumber to come and fix leaky pipes. As he exits, the Ingenue and Prima Donna, as the wife and her sister, enter. The Ingenue has a swollen knee that is giving her a lot of pain, so the Prima Donna phones for a doctor to make a house call.

The Comic arrives, as the plumber, and asks the Prima Donna what is wrong. Mistaking him for the doctor, she replies that her joint is broken. This sets up a series of comic misunderstandings in which the Comic talks about fixing the pipes, which the Prima Donna understands to be about her sister's physical condition.

Com: Tell me has she been leaking any water?

Prim: I haven't noticed any.

Com: Maybe there's something needs plugging up.

Prim: Do you really think so?

Com: Well, I'll find out after I swab her out.

Prim: Swab her out?

Com: Sure...you see she may be a little rusty.

Prim: Rusty???

The Prima Donna sends him offstage to look at the patient. While he's gone, the Straightman returns, wondering where the plumber is. The Prima Donna tells him that the doctor is there to look at his wife's sprained knee. The Comic reenters, wiping his hands on a towel.

Str: Well, what's wrong?

Com: To start with her circulation was poor. That's what caused her bottom to get hot, and it warped.

Str: Oh, that's terrible, what did you do about it.

Com: Well, I opened up her pet cock, and boy...she blew steam like a locomotive.

Str: Blew off steam.

Com: Yes, but when she cooled off a little I swabbed her insides all out nice and clean. Then I took my big wrench which I use on all cases like that and tightened up her nuts and bolts.

The Straightman wants to know how her knee is now, and the Comic reveals he's not the doctor at all, but the plumber.

<div align="center">BLACKOUT</div>

The same basic premise is used in a pair of scenes in the Callahan Collection—"Filling Station Scene" and "Lizzie Scene"—in which the Comic thinks that the Straightman, who talks about a broken-down car, is referring to a girlfriend named Lizzie. The Gypsy Rose Lee Collection includes a scene titled "Three Jennies" in which a similar confusion takes place.

SPLIT SCENES

Another common technique for creating comic misunderstandings is to hide some element of the scene from one or more characters. A number of scenes set up a split scene onstage, with the Comic on the far side of a door listening to the conversation going on in the next room. The conversation is entirely innocent, but the words are such that the Comic believes that some incredible sex is going on. These scenes could be built around different objects. In "Dresser Drawers" (Chuck Callahan Collection), the Straightman and Soubrette are trying to remove a comb from a dresser drawer, but the Comic, overhearing the conversation, believes something much more erotic is taking place.

<div align="center">Dresser Drawers</div>

The Comic has just checked into a hotel room.

Com: *(Enter R.)* Well this room is small, but I guess I will get some sleep. If the people who have the next room are not too noisy.

The Straightman and Soubrette enter the adjoining room.

Str: Well, dear, here we are. Now I guess we had better prepare to retire, as I must be up early in the morning.

Sou: That's right, dear, but see if you can find my comb for me. I think it is in my drawers.

Com: *(Hears this.)* In her drawers?

Str: All right, dear. I'll look.

Com: I'd like to look myself.

Str: *(Tries to open drawer.)* I can't get them open.

Com: That never stopped me.

Sou: Maybe if you twisted the knob?

Com: Careful son, careful.

Str: I think it's coming.

Com: Take your time, take your time.

Str: There I have it open a little bit.

Com: That's all you need to start with.

Str: Why it's split.

Com: How the hell did you think it was?

Str: There. Now it's open.

Com: Now it will soon be over.

Sou: Can you put your hand in?

Com: What the h—

Str: I have my hand in and feel something soft.

Com: I wish you would shut up.

Str: Oh look at the pretty curls.

Sou: I've had those since I was a little girl.

Com: He knows that.

Sou: All the boys at school played with it.

Com: I'd like to play with it myself.

Str: When I think that this is yours I could kiss it.

Com: What kind of a man is he?

Sou: *(Hands straight her hat.)* Here, put it in. *(Points to drawer.)*

Com: Now you're talking sense.

Str: I can't get it in.

Com: I have the same trouble.

Sou: Be careful and don't hurt it.

Str: I won't but it's too big.

Com: Don't kid yourself. There ain't no such animals.

Str: Maybe if I shoved a little harder.

Com: You are making it damn hard for me...to sleep.

Sou: There...now it's all the way in.

Com: *(Has been getting more excited all the way through scene.)* Now I've got to go
out and spend two bucks. *(Or.)* I got to go out.

BLACKOUT

Steve Mills performed a similar scene in *This Was Burlesque*, titled "Packing the
Trunk," which was filmed for an HBO special. A newlywed couple takes refuge in
a farmhouse on their wedding night. The farm couple, played by Steve Mills and
his wife Susan, are listening in at the keyhole, when the Straightman presents the
Ingenue with a fur piece.

SCATOLOGICAL DOUBLE ENTENDRES

Not all misunderstanding involved a sexual double entendre. In "Ice Cream" (Jess
Mack Collection), the Comic mistakes the smell of limburger cheese for a foul
odor emanating from a rich and arrogant customer, prompting many disgusted
remarks.

<u>Ice Cream</u>

*Comic enters pushing an ice cream cart. A Bit Man asks the price, and orders six bricks
of ice cream. But when it comes time to pay, he's forgotten his money in his other pants.
The Comic takes back the ice cream and chases him offstage.*

*While the Comic is offstage, the Ingenue enters, steals the bell off the ice cream cart.
The Comic spots her and pursues her offstage. The Bit Man returns with a brick of
Limburger cheese which he secretly plants in the cart. The Comic returns, and the
Straightman enters. They greet each other as old friends, although the Straightman
speaks in an affected style throughout.*

Str: Well upon my soul. If it isn't my old friend (so and so). How are you?

Com: So help me, look who's here. Well, you are certainly looking well and
prosperous, I must say. Where have you been?

Str: I've been out west. I'm a wealthy man, now. I struck oil. Lots of money
and nothing to do. Time hangs heavy on my hand.

*He explains that he's retired and lives in a penthouse apartment nearby. He is having
a party that evening and is on his way to pick up some ice cream.*

Com: That's a coincidence. I'm in the ice cream business.

Str: That's fine. I would as leave give you the business as anyone.

*The Comic opens his ice cream cart, and pulls out the brick of Limburger. He immedi-
ately reacts to the smell, assuming that it is the Straightman who is the source of it.*

Com: Will you get the hell out of here. Go on, move. Move.

The Straightman takes affront.

Str: I don't have to. This is a public place. I can do anything I want.

Com: You did. *(Ad-lib more stink.)* Will you please go home?

Str: I don't want to, I just came out for a little air.

Com: You need a lot of air! Don't you feel good?

Str: No, I feel punk.

Com: You smell punk. Go on and scram.

Straight protests that he can't be treated that way—he's rich after all.

Com: Rich hell, you're ripe. *(Ad-lib Big man etc.)* Go on, get the hell away from me.

Str: I don't have to.

Com: You should have left an hour ago. Rich man...struck oil...big man.

Str: You bet I'm a big man.

Com: You do big things.

Str: Yes and don't forget I struck oil.

Com: Oil hell? You struck gas.

The script indicates some business by the Straightman with legs—stirring it up.

Com: Don't stir it up. Go on, you're drawing flies. What's wrong with you?

Str: I think I have goose pimples.

Com: You think you have? Go on home.

Str: I don't want to. What will my wife say?

Com: She'll tell you to get a gas mask.

Str: I'll go, but give me my ice cream.

Com: You don't want ice cream.

Str: No?

Com: Here's what you want. *(Hands him a roll of toilet paper.)*

BLACKOUT

Note that the Straightman is the butt of the joke, not the Comic. And he is specifically set up as a rich man, who speaks in an affected accent even though he comes from the same background as the Comic. The juxtaposition of wealth and pretense with the disgusting smells emanating from his vicinity is key to the enjoyment of the scene, and reverses the disgust with which it is assumed the well-to-do view the poor. George "Beetlepuss" Lewis performed the scene with Leon de Voe and George Rose in the 1949 burlesque feature *Midnight Frolics*. Abbott & Costello performed the scene on the *Colgate Comedy Hour*, with guest stars Charles Laughton and Isabel Bigley.[7]

In all of these, the audience sees what the Comic does not. They are able to go back and forth between the two scripts, to see the innocent version of what is happening, as well as the sexual or scatological misinterpretation of it.

9. Flirtations ✌

Figure 9.1 Comic Harry Conley learns the delicate art of picking up girls from straightman Dexter Maitland in a flirtation scene from *This Was Burlesque*. (From the author's collection.)

Comedy tends to deal with the negative aspects of life. This holds true even when the subject is sex. While the show celebrated heterosexuality with the display of scantily clad women for a mostly male audience, the comedy tended to dwell on failure, inadequacy, and frustration. The comic rarely succeeds with women and when a woman seems to be interested in him, you can be pretty sure she is after his money. This has led some scholars to suggest that the audience is supposed to identify with the success of the straightman against the failure of the comedian, but this is a limited reading of the superiority theory of humor. The audience for traditional burlesque was most likely to be middle-aged working-class men—hardly a group that would consider themselves successful with women, and therefore more likely to identify with the difficulties of the comic.

There is a basic comedic principle at work here. As Max Eastman noted in *Enjoyment of Laughter*,

> *The first law* of humor is that things can be funny only when we are in fun. There may be a serious thought or motive lurking underneath our humor. We may be only "half in fun" and still funny. But when we are not in fun at all, when we are "in dead earnest," humor is the thing that is dead. *The second law* is that when we are in fun, a peculiar shift of values takes place. Pleasant things are still pleasant, but disagreeable things, so long as they are not disagreeable enough to "spoil the fun," tend to acquire a pleasant emotional flavor and provoke a laugh.[1]

The comic has only one thing on his mind when it comes to the opposite sex. But his single-mindedness invites rejection. Fortunately, the straightman is happy to share his techniques for picking up women. What works for the straightman, however, more often than not backfires on the comic. There are quite a number of scenes that involve picking up women, which are generally referred to as "flirtation scenes."

KISSING BIT

On his own, the comic is pretty much a failure with the opposite sex. Whenever he tries to approach a woman, the worst possible misfortunes befall him. Not only must he deal with rejection, she is likely to call the cops while relieving him of his bankroll. The classic scene of this type is the "Kissing Bit" from the Ken Murray Collection. Here, the Comic encounters an attractive young lady who offers him a kiss, only to charge him for it when he takes her up on it. When he protests, she calls the cops on him, and he quickly finds himself with deeper problems.

Kissing

The scene is meant to be played in one, and as the 1st Comic encounters the Soubrette, he begins flirting with her.

1st: Hello there, do you live around here?

Sou: No, I just work around here.

1st: Say, do you know I could just fall in love with a girl like you. Are you married?

Sou: No, and I could fall in love with a great big strong handsome man like you too.

1st: Would you mind giving me a little kiss?

Sou: Not at all, you can have a dozen of them if you wish.

1st: A dozen? My, but you are generous. I'll take one and if it is all right, I'll take another one. *(They kiss.)* Gee that was good.

Sou: That kiss will cost you a hundred dollars.

1st: Cost me a hundred dollars? You're crazy. It won't cost me a cent.

Sou: Well, you give me a hundred dollars or I will call a policeman.

1st: G'wan, call the whole station house, who cares?

The Soubrette begins screaming for the police, walking up and down the stage. The Comic pleads with her to stop, but when she refuses, the Comic relents.

1st: Shut up. First thing you know you will wake up a policeman. Cut out that soup call, here's the hundred dollars, you female highway Jessie Jimmie.

He hands her the money, which she puts in her stocking. Then, seeing the 2nd Comic approaching, he decides to set his friend up. They greet each other, and the 1st Comic says—

1st: Do you see that girl over there?

2nd: Sure.

1st: She's stuck on you.

2nd: Well can you blame her?

1st: Not at all and she's dying to kiss you. Go over and ask her for a slobber.

2nd: Do you think she'll let me kiss her?

1st: Sure she will.

The 2nd Comic crosses to the Soubrette and inquires about a kiss, which the Soubrette is more than happy to give. The scene plays itself out as it did with the 1st Comic. When he gives her a kiss, she tells him—

Sou: That will cost you two hundred dollars.

2nd: What for?

Sou: For the kiss you just had. Two hundred dollars please.

She holds out her hand for the money, which the 2nd Comic naturally refuses to pay. She screams for the police until he, too, gives her the money she demands.

The two Comics commiserate with each other until the Straightman enters. Both Comics make a dive for him.

1st: Say, you are just the man I'm looking for.

2nd: Do you want to kiss a swell looking chick?

Str: What are you fellows driving at?

1st: That beautiful lady, she's just dying to kiss you, that's all.

Str: She wants to kiss me. Well, she shall have her wish.

The Straightman brushes off his coat, slicks his hair back, and crosses over to the Soubrette and tips his hat.

Str: Pardon me, but were you asking about me?

Sou: Yes, I wanted to meet you, and now that I've met you I'm charmed.

Str: *(To Comics.)* You see that? Already she's charmed.

1st: Yes and in a minute you'll be charmed.

2nd: He won't have enough money left to get himself a hot dog with.

Str: *(To Soubrette.)* How about giving me a little kiss.

Sou: Certainly, you can have a dozen if you like.

Str: *(To Comics.)* Did you hear that? I can have a dozen if I want them.

Sou: Yes and it will cost you twelve hundred dollars, too.

The Straight gives the Soubrette a long lingering kiss. The two Comics watch them and mugg. The Straight and Soubrette stop, sigh, then kiss again. Both Comics react. After the Straight kisses her for the third time, the Soubrette takes out a roll of bills and hands it to the Straight.

Sou: Here is a hundred dollars for you.

1st: There goes my hundred dollars.

They kiss again and the Soubrette takes out the other roll of bills and hands it to the Straight.

Sou: Here dearest is two hundred dollars for you.

2nd: There goes my money.

The Straight crosses toward the Comics. He takes a look at the Comics, laughs, and exits. The two Comics look at each other, then the 1st Comic kisses the 2nd Comic on the forehead. The 2nd Comic kisses the 1st Comic on the forehead. The 1st Comic hands the 2nd Comic money, which the 1st Comic ceremoniously hands back, then stoops over. The 1st Comic kicks the 2nd Comic, then stoops over to let the 2nd Comic kick him. Then, as the Orchestra plays a funeral march, the two Comics lock arms and walk offstage.

BLACKOUT

There are a number of variants of this scene in which it is evident that the Straightman is in on the racket, as in the following excerpt from a scene in the Ken Murray Collection, "Mick". The Soubrette manages to extort fifty dollars from both the Juvenile and the Comic by threatening to call the police. The two men leave, and the Straightman comes onstage.

Str: What's the big idea of making me walk down here pounding these bricks looking for you. How's business?

Sou: Rotten.

Str: How much money have you?

Sou: Only a hundred dollars.

Str: What, been out three hours and only a hundred dollars?

He takes her pocketbook, digs through it, and pulls out a wad of bills.

Str: What the hell you doing? Holding out on me? A measly hundred and seventy dollars. Why I ought to tear it up. No on second thought I'll throw it away.

He throws the money to the ground. The Comic, who has been reacting to what has been going on, throws his hat over the money. The Straightman looks at him and the Comic muggs and backs away to the Juvenile.

Str: *(To Soubrette.)* Say, who is the weasel here?

Sou: Oh he's just a gink.

Str: Listen, get yourself together and dig out and get me more and don't wake me up when you get home. Just slip it under the door. Say, I think I'll hit this monkey in the jaw. See if there's any cops around.

Sou: *(Looks around.)* No, the coast is clear.

The Straightman gets set to punch the Comic in the jaw, but the Soubrette tells him never to hit a guy there. She indicates another location, which is not indicated but is probably the groin.

Str: Well if I hit him there, how do you expect me to knock his eye out? Now straighten up.

There is physical business with the Comic, who is slumped in the Straightman's arms. The Straightman encourages the Soubrette to get out of the way so she won't have blood splashing all over her. The Soubrette is in a red dress, and replies that she doesn't care, her dress was white when she met him today.

Str: Now straighten up—one—two—three.

Com: *(Fainting.)* Wait a minute. I feel something dripping.

Quite by accident, the Comic takes a swing at the Straightman, who gets frightened and starts to back away. Seeing this, the Comic suddenly gets brave.

Str: Oh this guy thinks he's tough. *(Takes off coat.)* I'll get our money back. So you think you're tough.

The Straightman keeps backing away, as the Comic takes a swing at him. The Straightman turns to the Soubrette, declaring that he doesn't want to hit the Comic. The Comic dares the Straightman to hit him, so the Straightman takes a swing at the Comic's hat. The Comic does a pratfall. The Straightman takes the opportunity to leave with the Soubrette. A moment later, the Comic is back up again, full of fight.

Com: Where is he? Where is he?

Unseen by the Comic, the Straightman reenters.

Com: Do you think I'm afraid of him? You know what I would do? I would come back here. I would take my fist and double it up and—

He turns and sees the Straightman.

Str: Well, what would you do?

Com: I would run like hell.

Comic and Juvenile exit running.

<div align="center">BLACKOUT</div>

KISSING SYSTEM

In the difficulties that he has with the opposite sex, the comic usually has the straightman on his side, offering him guidance. In "System Kiss Bit," the Straightman informs the Second Comic he has a surefire system for kissing women. The system relies on acting refined and genteel, and he proceeds to demonstrate it for the Comic, gently flattering a Girl who is passing by. He gets a long, lingering kiss from her. When the Second Comic reports this to the First Comic, the First Comic bets that he can kiss a woman without a system and proceeds to demonstrate. The scene is found in three of collections: in the Gypsy Rose Lee Collection as "Kissing System," in the Chuck Callahan Collection as "System Kiss," and the following one from the Ralph Allen Collection.

<div align="center">System Kiss Bit</div>

The 2nd Comic is onstage, complaining about how dead the town is. He cannot even find a guy with a red tie (a gay reference). A Girl enters. As she passes the Comic, he says,

2nd: Hello baby, slip me a little kiss will ya?

She smacks him on the jaw and he takes a fall. As the Girl exits, the Straightman comes on. The Comic explains what happened.

Str: Well I don't blame her. You were too abrupt. You should be more refined, more genteel.

2nd: What, I should give up me religion? I should say not!

Str: No, what I mean by that is in order to kiss a girl nowadays you must have a system.

The Straightman offers to show the 2nd Comic his system on the first girl that passes by. The Girl reenters and crosses the stage. The Comic warns him that she's the one who just walloped him, but the Straightman goes over and greets her.

Str: How do you do?

Girl: How do you do?

Str: You know, I've been admiring you for the last week or so and I must say that you are adorable. You have such wonderful auburn hair.

Girl: Well after all the nice things you've said about me, I just can't help giving you a kiss.

The Straightman takes the Girl in his arms and bends her backward so that his back is to the audience. They hold it while the Comic makes side comments.

2nd: Hey! Come up for air. What do you think that is, an all day sucker? Hey, if you ain't out by Friday I'll throw you a rope. Hey Charlie, you're covering up the waterfront. Boy she must come from (local neighborhood).

The couple break and both give a long sigh. The Straightman makes a date with her for eight o'clock that night.

Girl: And don't forget to bring along your system.

Once the Girl has left, the 1st Comic enters. There is some humorous by-play and the 1st Comic asks what they're arguing about.

2nd: Well a girl came along here and I asked her for a kiss and she smacked me in the kisser.

1st: I don't blame her. I'd slap you myself if I was a woman. What the hell do you want the woman to do—get the mange? Go 'way you draw flies.

Str: You see (Comic), he didn't have a system.

1st: What do you mean system?

Str: Well you see nowadays you must have a system in order to kiss a girl.

1st: That's a lot of horse shoe nails—I kiss any girl I want to and I don't need a system.

The Straightman bets him ten dollars that he's got a system. And the two of them put their money down on the floor.

1st: Now you let any girl come pass here and I'll show you.

A 2nd Girl enters and walks quickly across the stage. As she gets in front of the 1st Comic, he grabs her and kisses her on the cheek. When she walks away, he kicks her in the butt. He grabs the money from the floor and starts to run offstage. As he gets to the wings, the Straightman and 2nd Comic holler after him.

Both: Hey is that your system?

1st: System, hell, that's my wife.

BLACKOUT

Another scene in which the straightman has a surefire system for picking up women generally goes by the title "Sweating Like Hell." Again, the Straightman offers to coach the Comic through the process. As the Comic tries to follow along, the Straightman offers flowery words of advice, which the Comic takes literally. He tries to keep up with instructions the Straightman fires at him, but messes up more and more. The title refers to the closing tagline. The bit appears in a number of collections, including the Steve Mills, Gypsy Rose Lee, and Ken Murray Collections. The following is drawn from "Adam and Eve Scene" in the Jess Mack Collection.

<u>Adam and Eve Scene</u>

The Comic and the Straightman (as the Devil) are looking in on Adam and Eve, played by the Juvenile and Ingenue. The Comic flirts with Eve, causing Adam to leave in a jealous huff. The Straightman tells the Comic that he's the one that Eve really loves. The Comic protests that he does not know how to make love to a woman.

Str: Well, I'll give you a lesson right now. Remember this. Now is the time, now or never, swim in while the tears are wet, go over and console her, speak to her gently with fervor in your voice, then get way up close and buzz, buzz like a bee. Then you look into her eyes and she looks into your eyes, then look into her eyes, then slobber, then squeeze, then loosen. *(Bus.)* Advance slowly, yet with determination.

Com: Come on, let's me and you go to hell.

Str: Don't let her get away from you, but don't crush her ribs, then little by little you throw out your chest, then you will sigh, then moan, then groan, then you wither like a wilted rose, flame up like a torch, get hot in the face but *don't sweat.*

The Comic gets excited and begins responding to the Straightman, who pushes him away. The Ingenue enters, crying.

Str: Now is your chance. Swim in while the tears are wet.

Stage directions indicate only business, but it suggests pantomiming swimming.

Str: What are you doing?

Com: Swimming in. But don't ask me to tread water.

Str: Get away up close and buzz around her like a bee.

The Comic starts buzzing and running around the Ingenue.

Com: I'll sting her in a moment. *(Bumps.)*

Str: Now look into her eyes.

He does so.

Str: She looks into your eyes.

The Ingenue grabs the Comic's ears and pulls his face towards her.

Com: Let go my ears.

Str: Then you look into her ears.

Comic pulls at Ingenue's ears and looks into them.

Com: They're dirty as hell.

Str: Now slobber.

Com: Huh?

Str: Kiss her.

Comic starts cooing and kissing the Ingenue, but very roughly.

Str: *(Very quickly.)* Now you squeeze. Now loosen, now squeeze again, now loosen. Now snuggle up. Don't let her go from you. Yet don't crush her ribs.

Comic grabs her and lets her go several times as fast as possible. Finally—

Com: Wait a minute, wait a minute, I can't get it all in.

Str: Now take her in your arms. Now little by little you throw out your chest.

Comic sticks out stomach.

Str: What are you doing?

Com: Throwing out my chest.

Str: Is that your chest?

Com: It slipped down.

Str: Well, slip it up again. *(Slaps Comic's stomach.)* You see, that's your chest. That's your tummy...that's you chest...and that's your tummy. *(Effeminately.)*

Com: *(Throwing arms around Straight's neck.)* Kiss me.

Str: Then you sigh, then moan, then groan, then wilt like a withered rose, flare up like a torch.

Comic follows each of the instructions, at the end jumping up into the woman's arms.

Str: What are you doing?

Com: I'm not doing a thing, but that guy there *(pointing to audience)* is sweating like hell.

<div align="center">BLACKOUT</div>

MAGICAL FORMULAS

While the straightman may have a technique for picking up women, more often his success is explained by the fact that he has possession of an elixir or magical object that makes women powerless to resist him. The most common version is the "Poppy Scene." In this version from the Gypsy Rose Lee Collection, the Straightman has a vial that contains essence of poppy. Just a bit of it, sprinkled on a handkerchief and waved under the nose of a Girl, will put her under a man's power.

<div align="center">Poppy</div>

As the scene opens, the Comic complains to the Straightman that he hasn't been able to get anywhere with women. The Straightman suggests that he simply walk up and say hello. The Comic protests that he'll just get walloped. A Woman enters. With the Straightman's encouragement, the Comic goes over and tries to talk. She bawls him out, slaps him in the face, and leaves. The Straightman produces a vial from his pocket, and pours some onto a handkerchief.

Str: Do you see this vial? It contains the essence of poppy. Do you know what poppy is?

Com: A small dog.

Str: Certainly not, you idiot…Poppy is a perfume from the flower of California. A few drops sprinkled on the handkerchief and gently waved before a lady's nose will make her give you anything you desire.

Com: Anything?

Str: Yes, anything.

Com: *(Grabs handkerchief.)* Give me that handkerchief.

Str: *(Takes it back again.)* I'll show you how it works.

A 2nd Woman enters and walks across the stage. The Straightman waves his handkerchief in front of her nose. She stops, smiles at him, and takes him into her arms, for a long, lingering kiss. They make a date for that evening, and the Woman exits.

Com: You know her?

Str: Never saw her before in all my life. Did you like it?

Com: It sounded good to me. Let me have the handkerchief.

He takes the handkerchief. A 3rd Woman enters, crosses the stage quickly in front of the Comic. The Comic tries to wave the handkerchief in front of her. He misses and she exits.

Com: Hell, she's too fast for me.

The 1st Woman returns and stands at right. Comic starts after her with the handkerchief, then sees who it is and runs back to the Straightman.

Com: Here, you try it. She'll beat hell out of me.

The Woman crosses in front of the men, and the Straightman waves the handkerchief under her nose. She stops, puts her arms around the Straightman, and gives him a long kiss. When they break, she reaches into her purse and hands him a wad of bills, then exits. The Straightman hands the handkerchief back to the Comic, encouraging him to try it. A 4th Woman enters, crosses in front of the Comic. He waves the handkerchief in front of her. She stops, but doesn't respond.

Com: Lady, you got a cold?

Str: Why did you ask her that?

Com: I wanted to be sure she'd smell it.

He waves it again. She smiles, turns toward the men with her arms outstretched. The Comic is under the impression that she is looking at him, but she walks right past his outstretched arms into the arms of the Straightman. After an embrace, the two exit the stage together.

The Comic remains, muggs, reaches into his pocket, and pulls out a stuffed club. A 5th Woman enters and crosses in front of her. He hits her over the head, catches her in his arms, and carries her offstage.

BLACKOUT

Comic Hermie Rose works the bit with straightman Don Mathers in *Striptease Girl*. The same footage appears in *B-Girl Rhapsody*. Joe E. Ross performs the scene with Dave Star and Holly Dorsen in *Teaserama*. Their version offered a slightly

different payoff to the scene. Instead of hitting her over the head with a blackjack, Ross takes off his shoe, holds it under the Girl's nose, and she passes out. He slings her over his shoulder and walks offstage. "Poppy Scene with Restaurant" (Gypsy Rose Lee Collection) uses this as a set up to a restaurant scene, where the Comic arrives with the girl still slung over his shoulder.

Variants to this routine use the magical properties of different objects. Several scenes with names such as "Tweet Tweet Scene" (Chuck Callahan Collection) and "Teasie Weasie" (Ralph Allen Collection) work off the suggestive properties of a phallic object or peanut. Steve Mills's version is titled "Tweeter Bit."

<u>Tweeter Bit</u>

The scene opens with the Straightman claiming to the Comic that he has what it takes to get women. It has been handed down his family. He pulls out a peanut, which is dangling from a piece of string. He claims it is an Egyptian love nut, which once belonged to old King Tut.

Str: I'll show you how it works. If a girl should walk by, you take this and waft it under her proboscis, and you say tweet-tweet, tweet-tweet.

A Girl enters, crosses in front of the two men and stops stage left. The Straightman goes over and flirts with the girl and makes a dinner date, then asks—

Str: How about a little kiss?

Girl: Kiss you, I should say not.

Str: If you won't kiss me, I'll have to tweet you.

Girl: You'll have to what?

Str: I said I'll have to tweet you.

Girl: I'd like to see you do it.

Str: Very well, here I go.

He swings the peanut in front of her, saying "tweet-tweet, tweet-tweet."

Girl: Kiss me, darling, kiss me.

They engage in a long, lingering kiss, and she leaves, promising to meet him at seven. Excited, the Comic insists that the next one is his. A 2nd Girl enters and crosses in front of both men and takes the same position.

Com: The hell with that one, she's from (local street).

Str: No, she's all right. Go on over and take it out.

Com: What?

Str: Your tweeter, and waft it.

Com: I'll strangle hell out of it.

The Comic goes over to the woman, introduces herself, and asks her out.

Com: Hey, when do I tweet her?

Str: Right now. Ask her for a kiss.

Com: How about a little kiss?

Girl: Kiss you, I should say not.

Com: She said no.

Str: Then tweet her, take it out and stroke, warm it up.

Com: Don't worry, it's all warmed up and ready for action.

Str: Then use it.

Com: *(To Girl.)* If you won't kiss me, I'll have to tweet you.

Girl: You'll have to what?

Com: I'll have to tweet you.

Girl: Listen big boy, it takes a man to tweet me.

Com: What the hell do I look like, a boy?

Str: Go on, give it to her.

Com: Tweet-twat. Tweet-twat.

Girl: What are you doing?

Com: Why I'm tweeting you.

Girl: What? With that little thing?

Com: Little thing, hell. Take a peep at this baby.

He pulls out a cucumber on a string for the...

<div align="center">BLACKOUT</div>

"The Tweet Tweet Scene" in the Callahan Collection uses the premise of the "Tweeter" scene, but combines it with a version of the kissing racket. After the Comic has kissed the girl, she demands five dollars or she will call the cops. The Comic tries to sell the tweeter to the Second Comic. The same thing happens to him. The Straightman returns to show them how it is really done. He works his magic on the women and they turn over the money that the Comics gave them to the Straightman. Other objects are sometimes substituted. In "Pickle Persuader," the peanut is replaced by a pickle, while in *Burlesque in Hawaii*, comics Harry Vine and Hermie Rose can be seen doing it with a pair of coconuts held on a string.

In "The Obtainer," which Jess Mack published in *Cavalcade of Burlesque*, it is a mutt that has a peculiar hold over women and it is the Comic, not the straightman, who owns this fabulous animal.

<div align="center">The Obtainer</div>

The Straightman and the Comic meet in the middle of the stage. The Comic has a dog on a leash.

Str: What do you use him for?

Com: He's my obtainer.

Str: Obtainer of what?

Com: Obtainer of women.

Str: Do you mean to tell me you can get a woman with that dog?

Com: Surest thing in the world. Watch me.

The 1st Girl enters.

Girl: My what a cute little dog.

Com: Yes, I'm its father.

Girl: Father?

Com: No, no, I mean I'm its owner.

She pets the dog.

Girl: I'd love to see him do some tricks.

Com: Will you be home this evening?

Girl: Yes—here's my card. *(She starts to exit.)* And don't forget, no doggie, no party.

Com: And you remember, no party, no doggie.

The 1st Girl exits. The Straightman still doesn't believe it. A 2nd Girl enters, crosses over to the men, and staring directly at the Comic says:

2nd G: My what a strange looking dog.

Com: Lady you're looking at the wrong dog—here's the dog down here.

2nd G: Does he do tricks?

Com: I'll say he does. Watch this.

He bends down and puts the dog between his legs. Talking to the dog, he says "Jump. Jump," adding—"Wouldn't it be funny if he did." There is more interchange between the two. Finally, the 2nd Girl reaches into her purse and takes out a card.

2nd G: I'm giving a party at my house tonight, and I'd like you to come up and bring the dog with you. Here's my card. *(Starts to exit.)* And remember, no doggie—no party.

The Straightman is impressed and wants to buy the dog from the Comic, but the Comic tells him it's no deal.

Str: He's only a mutt—what else can he catch besides women?

Com: He can catch rats.

Str: Don't kid me Jimmy—I was down in your cellar the other day looking for a drink—and there was that dog sitting there with fifty rats running all around him, and he didn't kill a one.

Com: Oh—those are our rats—but you let a strange rat come in the house and see what he does to 'em.

STRIP BITS

In some sketches, the date is replaced by a strip—which offered the audience the titillation of the girl removing various articles of clothing. One involves a special brand of bootleg liquor or a magical liquid that is supposed to make any woman the Comic's slave, as in this scene from the Ken Murray Collection.

<u>Strip Bit</u>

The Comic and Juvenile enter from opposite directions and greet one another. The Juvenile shows the Comic a flask—

Juv: I have a bottle of liquid here that is the greatest discovery of the age. One drop of this stuff will make any woman your slave.

He offers to sell it to the Comic for only fifty dollars and the Comic agrees. As the Juvenile leaves the stage, a Girl enters and pacing up and down the stage repeats the line,

Girl: Oh, I must have a drink. *(Repeat 3 times.)*

The Comic approaches her and tells her that he will sell her a drink. One drink, one dollar. She gives him a dollar and takes a long swig from the bottle, until the Comic takes the bottle away from her. She wants another drink. But it will cost her another dollar.

Girl: *(Bus. of looking for money.)* But I gave you my last dollar.

Com: Well, I gave you your last drink.

Girl: Wait a minute, I'll give you my hat for a drink.

She removes her hat and gives it to the Comic. Figuring that the hat is worth a dollar, he passes her the bottle. The Girl takes another long drink, until the Comic grabs the bottle.

The action continues, with the Girl asking for drinks and handing over articles of clothing until she is down to her slip. After the last drink, she faints in the Comic's arms. He wonders if he can collect for the last drink when the Girl wakes up. She entreats the Comic for another drink, but at that moment the Straightman enters.

Str: Stop. So there you are, you deceitful wife. After all these years of love and devotion I find you in the arms of another man. What have you to say for yourself.

Girl: Well, what of it. Did you ever show me any consideration? Did you ever give me any of the things that I wanted? Why you fool, you're nothing but a mill stone around my neck. With my youth and beauty I can get what I want and believe me, from now on, I'm going to get it.

The Comic throws the clothes at the Straightman and starts to escort the Girl offstage.

Str: Where are you going?

Com: I'm going to give her what she wants.

BLACKOUT

In "Generous Moonshine" (Gypsy Rose Lee Collection), the Comic has purchased a bottle of "generous whiskey" that makes people give you almost anything you want. The Straightman demonstrates it on the Soubrette, who is said to be the stingiest girl in town, and after a few drinks she hands the Straightman her bankroll. The Comic buys a bottle, tries it out on the Ingenue, who hands over her purse, her hat, and her coat in exchange for a swig. She is down to the last garment, and the Comic about to pour the final drink, when he discovers that he has run out of liquor. "No

more whiskey, no more presents," the Ingenue tells him and exits, leaving the Comic to curse his luck. The LoCicero and the Ralph Allen Collections contain scripts for "Vanishing" that involve an elixir that will make the Comic invisible. He uses it to watch two women change their clothes, but it wears off just before they get naked.

In some versions of the script, it is not a liquid at all, but a gun that the Comic uses to persuade the girl to take off various articles of clothing. In the "Disrobing Bit" (Gypsy Rose Lee Collection), the Comic tries to beg money off of the Straightman, who suggests that he can make better money by holding people up. When the Girl does not have any money to give him, he asks for articles of clothing instead, firing off a shot each time as a threat. However, he runs out of bullets just before she runs out of clothing.

MEET ME 'ROUND THE CORNER

Perhaps the best-known flirtation scene is "Meet Me 'Round the Corner." Ralph Allen included it in the script for *Sugar Babies*.[2] The scene usually involved three or four men and an equal number of women who come onstage, drop their pocketbooks, and when one man after another picks up the pocketbook and returns it to them are so grateful that "you can meet me 'round the corner in a half an hour." The line becomes a catchphrase as each man repeats the chant, "She's gonna meet me round the corner in a half an hour, meet me round the corner in a half an hour...meet me round the corner in a half an hour," executing a bump and grind on the last "half an hour."

The scene appears under the title "Women-Hater's Union" and "Mary Bit." In Mary Bit" (Gypsy Rose Lee Collection), the Straightman and two Comics each arrive onstage ready to meet their wives, each of whom turns out to be named Mary. They form a fraternity called the Mary Club to avoid temptation from other women. Whenever they feel tempted, they sing "Mary, Mary, long before the fashions came." Several women come on, dropping an article, and one by one, each of the men gives into temptation and exits after the girl. The last girl drops her pocketbook, which the 2nd Comic—trying hard to resist temptation—finally picks up. He reaches into the pocketbook and takes the money out of the pocketbook and gets chased off by the girl. In "Women Hater's Union," also in the Gypsy Rose Lee Collection, the men all agree to give up women, but quickly fall victim to their charms.

Women Hater's Union

Str:	I'm telling you boys, it's terrible the amount of money that you fellows are spending on the women, and I have a scheme whereby you fellows can save all that money.
Com:	Well I don't want to belong to the union.
Str:	Ah, but think of all the money you will save.
Com:	That's right. Well, I'll join the union.
Str:	Alright boys, now you know that every union must have a president, vice president, secretary and treasurer. So therefore we will have to elect officers. Now all those in favor of me being president say aye.

Boys: No.

Str: Thank you boys, I accept the nomination.

2nd: Now all those in favor of me being secretary, say aye.

Boys: No.

2nd: I accept the nomination.

Com: Ah what the he—...All those in favor of me being treasurer say aye.

Boys: No.

Com: Ah, gentlemen, I accept the nomination.

Str: Now boys, here is the by-laws for the union. So hold up your right hand and swear.

Com: Damn it.

Str: No. I mean swear that you will do as the bylaws say. I hereby swear never to look at a woman. *(Both repeat.)* I hereby swear never to speak to a woman. I hereby swear never to have anything whatsoever to do with a woman.

Com: I hereby swear never to have anything whatsoever to do with a what the hell—You mean I can't even hug a woman?

Str: No.

Com: I can't even kiss a woman?

Str: No.

Com: I can't even walk up to one and *(bus. with hands)* Oh man I can't join the union. *(Starts off.)*

Str: Ah, but think of all the money you will save.

Com: That's right, I'll stick.

Str: Now boys, this is the bylaws and constitution, so we must all sign the constitution. *(All sign.)* For without the constitution there would be no union. Now you being the treasurer, you will keep the constitution. But be very careful, for as I said before, without the constitution there is no union.

Com: Oh I'll take good care of the constitution. Because if I lose the constitution there wouldn't be any union.

Str: Now boys, the password for the union is we hate women. So let's rehearse. Now all together.

All: We hate women. We hate women. We hate women. *(Girl crosses, drops handkerchief. Straight picks it up.)*

Str: Pardon me just a moment, boys. I beg your pardon Miss, but didn't you drop your handkerchief?

Girl: Oh, thank you sir, and meet me around the corner in five minutes.

Str: I'm very sorry boys, but I'll have to leave you as I have a very pressing engagement around the corner in five minutes.

Com: Well don't press it too hard. *(Straight exits L.)* We'll still be the union.

Boys: We hate women. We hate women. *(Ing. crosses, drops handkerchief. 2nd Comic starts to pick it up.)*

Com: Don't weaken, boy. Remember the constitution. *(2nd Comic same business as Straight.)*

2nd: I'm sorry boy, but I'll see you later. Whoops over the river. *(Exits.)*

Com: Whoops flop in the sewer. I'll be the whole damn union by myself. I hate women. I hate women. I hate women. *(Soubrette crosses, drops handkerchief and flirts with Comic.)* I hate women. I hate women, I'm a damn liar. Lady go home while you're pure and innocent. Oh lady, go home while you're healthy. Oh, lady you're breaking up a damn good union. *(Comic tears up the constitution.)* Oh, the hell with constitution. *(Soubrette and Comic exit.)*

BLACKOUT

10. Trickery ✆

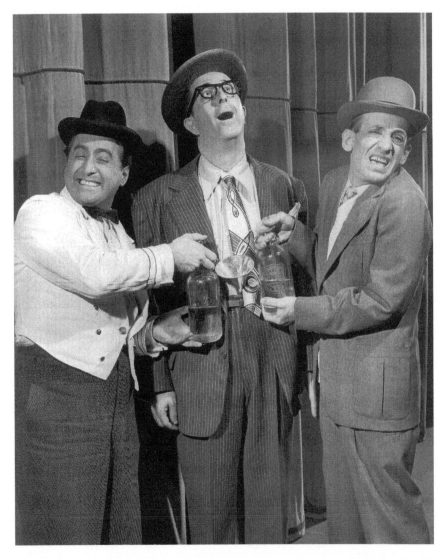

Figure 10.1 Joey Faye and Herbie Faye squirt seltzer down the pants of Phil Silvers in this still from the burlesque-inspired musical *Top Banana*. All three were veteran burlesque comics. (Courtesy of Photofest.)

The flirtation scenes we have just looked at transition us into the second formulaic structure for scenes—the reversal. Scenes involving a reversal or an about-face set up clear parameters for winning and losing. Typically the Comic wants something—if it is a scene played with a woman, as in the flirtation scenes just examined, it is sex that is on his mind; if it is a scene with another man, it is usually money he is after. Burlesque, like other oral forms, sets up unambiguous motives, based on basic human needs and drives.

Most of these scenes involve trickery. And again we are dealing with a narrative structure that is well represented in traditional tales. Reversal is the basis of many trickster tales, which can be found in cultures—tribal and modern—around the world. "A very large part of narrative literature deals with deceptions. The work of thieves and rascals, deceptive captures and escapes, seductions, adultery, disguises and illusions constitute one of the most extensive chapters in [the motif index]," folklorist Stith Thompson observes.[1]

SUCKER BETS

A common way to set up this reversal is a bet. The bet provides a clear basis of winning and losing as the Comic is lured into betting on what seems to be a sure thing, only to have the tables turned on him. Chuck Callahan preserved a number of these. In "Money Under the Hat Scene," the Straightman bets the Comic that he can get the money out from under the hat without picking it up. Certain that there is a gimmick, the Comic makes sure there is no hole in the floor. Satisfied, he takes the bet and the two men put their money down on the floor, covering it with the hat. "If I get the money without touching the hat, can I have the money?" the Straightman asks. Assured that he can, the Straightman makes a magician's pass over the hat, utters a ludicrous incantation, then proudly announces that the money is gone. Not believing any of this, the Comic lifts up the hat to check. The Straightman quickly snatches the money that is still underneath, announcing, "I won!" "How's that?" the Comic demands to know. "I didn't touch the hat," crows the Straightman as he leaves with his winnings.[2]

Most betting scenes involve a double reversal. The Comic, after having lost an unloseable bet, tries the scam on someone else, only to have the tables turned on him again. In "Grip Bit," also from the Callahan Collection, the Straightman bets the Comic he cannot carry a suitcase across the stage three times without ever setting it down. The Comic easily accomplishes this, but to collect his winnings, he sets the suitcase down, thereby losing the bet. The Comic tries it on the Second Comic, who wins the bet by crossing the stage three times, then hangs the suitcase on a nail. "Suitcase Bit," from the same collection, is similar, except that the Second Comic pretends to cramp up, handing the suitcase off to the First Comic before claiming his winnings.

A classic sucker bet is "You're Not Here." The Straightman offers the Comic what seems to be a sure bet—he will prove to the Comic that he's not here. The Comic quickly accepts the wager. Here's how the action takes shape in a scene Ralph Allen collected, titled "Vagabond Lovers."

You're Not Here

Str: There you are, you see you think you know everything, you see you're too sure of yourself. I'll bet you $10.00 you're not here.

Com: Say, are you crazy? Certainly I'm here.

Str: Well $10.00 says you're not.

Com: Charlie, you're alright—I'm crazy. You want to bet me $10.00 I ain't here?

Str: That's it exactly.

Both men place their wagers.

Str: Now, you're not in Washington are you?

Com: No.

Str: And you're not in Pittsburgh are you?

Com: No.

Str: Then if you're not in Washington and you're not in Pittsburgh, you must be somewhere else and if you're somewhere else you're not here.

With that, the Straightman picks up the money.

Com: Well I'm a son of a—well for Chri—well I'll be go—

Str: And remember my boy, Barnum was right—there's a sucker born every minute.

Com: Yes! I must have been born twice. Hey wait a minute, put that money down.

Str: What do you mean?

Com: Put it down before I break your arm.

Str: Well I done it didn't I?

Com: Not yet. Put it down. You know I been thinking this thing over.

Str: You've been thinking? With what?

Com: Say! I got brains I ain't even used yet. Now you say I'm not in Washington am I?

Str: No!

Com: And I'm not in Pittsburgh am I?

Str: And if I'm not in Washington and I'm not in Pittsburgh then I must be somewhere else. And if I'm somewhere else I'm not here, then if I'm not here then it ain't me who's got the money. So long, call me up sometime. *(Exits.)*

BLACKOUT

In many versions, the Comic tries it on another person, only to be snookered a second time. This is what happens in another sucker bet titled "Sausage." In Jess Mack's version, the Talking Woman bets the Comic that he cannot say the word "sausage" in answer to three questions. Figuring he can say sausage all day long, the Comic lays his money down.

<p style="text-align:center">Sausage</p>

Wom: Question number one: there's an old lady walking down the street, and on her arm she is carrying a basket of sausages. Coming down the street is an automobile and it hits the old lady knocking her down. Now which one would you pick up, the old lady or the sausage?

Com: I'd pick up the sausage.

Wom: That's one for you. Question number two: there's a fifteen story building on fire. Looking out the window on the fifteenth floor is a little boy with a sausage in his hand. You being a brave man, you climb up the ladder to the fifteenth floor. Now which would you save, the boy or the sausage?

Com: I'd save the sausage.

Wom: That's two for you. Question number three: if you win this bet, which would you rather have: the money or the sausage?

Com: I'd rather have the money.

Wom: You lose. *(Picks up money.)* You said money instead of sausage. See you later. Sucker.

Naturally, the Comic wants to recoup his money, and when he spots the Straightman, decides to try it on him, but when the Comic tries to set up the story, the Straightman keeps interrupting him.

Com: There's an old lady walking down...

Str: How old is this lady?

Com: She's walking...

Str: How old is the lady?

Com: She's...I'm not sure...but...

Str: Well you're telling the story, you should know. How old is she?

Com: She's past middle age.

Str: How far past middle age?

Com: She don't walk around the street with her birth certificate...she...

Str: I want to know how old she is. Later on in the story you may say she is a certain age, and I'll lose the bet. How old is she?

Com: Do you want to call the bet off?

Str: No...how old is the lady?

Com: I'm sorry I started with this guy...she's one hundred and six.

Str: O.K. Why didn't you say so? Continue with the story.

Com: She's walking down the street.

Str: What street?

Com: Any street...

The Straightman continues to hound him with inane and unnecessary questions. The Comic tries to call the bet off, but the Straightman refuses.

Str: What street is she on?

Com: She's up an alley.

Str: Oh, then she's not on a street?

Com: No, she's in an alley.

Str: How do you know?

Com: I was there too.

Str: What were you doing in this alley?

Com: I took a sh—ort cut. Never mind. She's on a street.

Str: But what street?

Com: It doesn't matter.

Str: Then it's im-material.

Com: Yes, she's on im-material street, okay? Nevertheless, she's walking down the street.

Str: What side of the street is she on?

Com: The left side.

Str: What's wrong with the right hand side?

Com: There's nothing wrong with the right hand side.

Str: Then why is she on the left side? Thousands of people walk down the street every day and they always keep to the right. What is she doing on the left side?

Com: Alright, she's on the right hand side, okay? Now she crosses the street and coming down the street is an automobile, and...

Str: What kind of an automobile?

Com: A 1937 Ford with a Studebaker rear end.

Str: Okay, continue.

Com: Now this automobile is coming down the street.

Str: How fast?

Com: Sixty miles and hour.

Str: How fast?

Com: Twenty miles an hour.

Str: How fast?

Com: It was backing up! Now the automobile knocks the lady down. Couldn't knock her any other way, she's an old lady. Now, which would you pick up—the old lady or the sausages?

Str: I'd pick up the sausages.

Com: You'd do anything for ten dollars

Str: I'd do anything for a buck.

Com: I'll see you later.

Str: Never mind. Continue.

Com: Well that's one question in your favor. Question number two: there's a fifteen story building on fire...and I didn't start the fire. On the fifteenth floor is a small boy sitting by the window waving his weenie in the breeze. I mean as pretty as you please.

Str: What?

Com: He's sitting there with his weenie in his hand.

Str: That's perfectly alright.

Com: Now you being a brave man, which would you save—the little boy or the sausage?

Str: The sausage.

Com: That's two for you. *(Reaches down and picks up money.)* Now if you were to win this bet, which would you rather have, the money or the sausage.

Str: The sausage.

Com: Well hot dam you. Here it is.

The Comic pulls a rubber frankfurter from his coat pocket, hands it to the Straightman and exits.

<div align="center">BLACKOUT</div>

Abbott & Costello used this technique in their "Jonah and the Whale" bit, which appeared in *One Night in the Tropics* and *Here Come the Co-eds*.

MATHEMATICAL CONS

A number of these scenes operate through the faulty or deceptive manipulation of numbers. In "3 × 3 Are Ten" (Chuck Callahan Collection), the Straightman comes onstage with three hats that he is taking to get cleaned. He bets the Comic that three times three is ten. The Comic accepts the wager and the Straightman demonstrates by laying down the hats and picking them up. On a count of 1, 2, and 3 he lays down each hat right to left. Starting from the right, he counts 4, picking up the other two hats on 5 and 6. He picks up the right hand one on 7, then lays them down on 8, 9, and 10. With that the Straightman picks up the money and leaves. The Comic is eager to try it on the Second Comic, betting that three times three is ten, but gets it all screwed up. He lays hats down 1, 2, and 3, right to left, counts 4 and 5 without picking up the hats, picks up the left hand one 6. He picks up the two on the right on 7 and 8, then lays them down on 9, 10, and 11. The Second Comic takes the money and leaves. Confused, the First Comic tries the routine again, but each time gets a higher and higher count. Finally, he says to hell with it and exits.

In "Paid in Full" (Jess Mack Collection), the Comic tries to collect his back wages—a year's worth. The Straightman agrees to pay him, but deducts for the hours he did not work until the Comic ends up with nothing. Abbott & Costello performed the routine in *One Night in the Tropics*. Versions of the scene appear in the Chuck Callahan Collection as "Deducting Scene" and as "Paid in Full" in the Jess Mack Collection.

<div align="center">Paid in Full</div>

The curtains rise on an office set. The Comic and Straightman are arguing. The Comic demands the money that the Straightman owes him.

Str: Well, how much do you think you have coming?

Com: Well, there are 365 days in the year and I get five dollars a day.

Str: In other words, you want five dollars for each day. That makes it 365 times five. I'll figure out just how much you have coming to you. How many hours a day did you work?

Com: Every day I worked eight hours.

Str: Well, there's twenty-four hours in each day, and you worked eight hours a day, which means you worked one-third of each day, which makes one-third of each year you've worked. In other words you worked one-third of 365 days. Now three goes into six twice—and three goes into five goes once. That means you have 121 days coming to you. Now you didn't work on Sundays did you?

Com: I should say not. I wouldn't work on Sundays.

Str: Well there are 52 Sundays in the year, so I will have to deduct 52 from 121. Which means that you have 69 days coming to you.

Com: Yes, I know but—

Str: Oh yes, I almost forgot something else. We close half a day on Saturdays, do we not?

Com: Sure we do, but—

Str: That makes 52 half days, or 26 whole days that we stayed closed. Now deducting 26 from 69 is, six from nine is three, and two from six is four. That makes it exactly 43 days you have coming to you.

Com: Say, wait a minute, you don't understand—

Str: Just a moment, you don't understand. Don't interrupt me, please. Now how long do you take off for lunch each day?

Com: One hour.

Str: That makes three hundred and sixty-five hours you took off to eat. Making it exactly 15 days you spent eating.

Com: What? I ate for 15 days?

Str: Yes, but not all at once. Just an hour at a time. Now I have to deduct 15 days from 43. Five from three leaves eight and one from three leaves two. That makes it exactly 28 days you have coming to you.

Com: Say, wait a minute—

Str: Now where do you go on your vacation?

Com: Atlantic City.

Str: How much vacation do you take each year?

Com: I always take two weeks' vacation.

Str: Two weeks is 14 days. Therefore I must deduct 14 from 28, which leaves 14 days you have coming to you.

Com: You don't realize that—

Str: Just a moment please. There are 13 legal holidays in the year. Now during these holidays we stay closed. Therefore, I must deduct 13 from 14, which leaves 1 day you have coming and here is your five dollars. *(Gives Comic a bill and starts to exit.)*

Com: Say wait a minute.

Str: What do you want?

Com: *(Hands bill back.)* You forgot Yom Kipper!

BLACKOUT

The most famous of the mathematical cons is "Seven Times Thirteen," which Abbott & Costello performed in two of their films—*In the Navy* and *Little Giant*—as well as on episodes of *The Abbott & Costello Show* and the *Colgate Comedy Hour*. In Jess Mack's version, the Comic is running an art institute. The Straightman wants to go to the school, but lacks the funds. He suggests that the Comic hire him, and he'll pay for his education out of his salary. The Comic offers him twenty-eight dollars a week, which the Straightman feels is not enough. "Seven days a week, thirteen dollars a day, seven times thirteen is twenty-eight, so you'll get twenty-eight dollars a week." The Straightman insists that seven times thirteen is more than twenty-eight dollars a week, so the Comic goes over to the blackboard, and shows through addition, multiplication, and division how it is possible. It is easiest to understand the logic of the trick by seeing the numbers written on the blackboard, as Richard Anobile shows in *Who's On First? Verbal and Visual Gems from the Films of Abbott & Costello*.

CADGING DRINKS

The prize is not always money, sometimes it's liquor. A number of confidence schemes involve ploys for hustling free drinks. Chuck Callahan saved several of these bits, which are apparently from a pre-Prohibition era, and most feature an Irish comic, Murphy, taking advantage of a Jewish comic, Cohen. In "Beer Bit," Murphy, who is carrying an empty pitcher to a saloon, meets Cohen, carrying a pitcher full of beer. Cohen tells him that the saloon is closed and he got the last pitcher. Murphy relates a story of how his foot was stepped on. Cohen, looking at the foot, lets half of his pitcher spill into Murphy's pitcher. "Did it hurt?" inquires Cohen. "You can see just where he stepped on it," Murphy replies. Cohen leans over again, letting the rest of the pitcher run out. Murphy leaves with a full pitcher of beer. Cohen lifts his pitcher and discovers his beer is gone.

In "Free Drink Bit," the Comic enters a bar with a bottle with a sponge in it. He goes to the bartender and asks for twenty-five cents' worth of whiskey. The Bartender fills the bottle then asks the Comic for the money. The Comic replies that he doesn't have any, so the Bartender takes the bottle and pours the whiskey out of it. The Comic takes the bottle back, breaks it, removes the sponge and squeezes it into a shot glass he has in his pocket and drinks.

These bits are often done in series. "Bar Bit," also from the Callahan Collection, is arranged as a series of challenges as an Irish and a Jewish Comic try to top each other by conning the bartender out of a free drink in increasingly ingenious ways. In *A Night at the Follies*, comics Harry Rose and Charlie Crafts try to cadge drinks off an unidentified bartender. *Dream Follies* (1954) featured a routine with Bob Carney and Harry Sperl as two drunks working with talking woman Jean Carol as the bartender.

Prohibition produced a number of scenes involving speakeasies and bootleg alcohol. "Port Wine Bit" (Ken Murray Collection) is based on the problem of poisoned alcohol.

Port Wine Bit

The Comic is about to drink from a flask of moonshine when the Straightman enters, wanting to know what he has. The Comic explains that it is port wine that his doctor prescribed him. The Straightman grabs the bottle out of his hands. When the Comic objects, the Straightman reprimands him.

Str: Don't you know this is prohibition and they sell you any old thing. You are likely to go blind.

Com: I don't care. I have seen everything.

Str: It's a lucky thing that you met me. *(Flashes the badge.)* You know I'm working for the government. I'm an official wine taster.

Com: All right, you, a little taste.

The Straightman takes a long drink.

Str: You know there's something funny about this.

Com: The bottle isn't big enough.

Str: Don't talk to me, you knock the taste out of my mouth.

He takes another swig.

Str: I don't like to say anything, but I think there is some dirty work going on around here.

He takes yet another swig.

Com: You think there is. I know damn well there is.

The Straightman finishes off the entire bottle.

Str: What did the doctor say it was?

Com: Port wine.

Str: He was right.

With that, the Straightman exits.

Com: I'm damn glad I found out. *(He pulls out a jug.)* Now I'll go and have a good time.

BLACKOUT

The piece survives under several different names. In "The Port Wine Tasters" (Ken Murray Collection), the responsibility of finishing off the bottle of port wine is taken by various characters, each of whom take a swig. In the end, they conclude that it *is* Port Wine. The Comic begs to differ. Turning the bottle upside down he says, "it *was* Port Wine." A variant of this scene also circulates as "Apple Bit" (Chuck Callahan Collection) in which the Comic has an apple he is about to bite into. Various characters enter and each take a bite out of the apple on the pretext

of determining what variety of apple it is, leaving the Comic with only the core at the end.

There is a variant of the classic "Slowly I Turned" built around drink. Here, the Straightman is a reformed alcoholic, who cautions the Comic on the evils of liquor and launches in on his story of why he never touches liquor, but manages to finish off the entire bottle. The scene is found under the title "First Drink" in the Steve Mills Collection and as "The Raid" in both the Ken Murray Collection and this one from the Ralph Allen Collection.

<div align="center">The Raid</div>

Two Comics run onstage. They have narrowly escaped getting caught in a raid on a speakeasy. The 1st Comic has managed to grab a bottle of whiskey. They uncork the bottle and start to drink when a Cop arrives. He frisks the two Comics, as they pass the bottle back and forth between them. When they are discovered, they offer some to the Cop.

Cop: What? You ask me to touch that filthy stuff after it ruined my life and robbed me of all that I once held dear. *(Very dramatic.)* Never. Would you and your friend care to hear the story?

Both Comics: No.

Cop: All right then, I'll tell it to you. Some years ago I was a happy married man living in a small town in Indiana with my two lovely children. I had everything to live for. I earned my daily bread by the sweat of my brow and made a good salary. Then one afternoon I came home from work quite early and I opened my front door and as I walked past the parlor I saw my wife in the arms of another man. 'Twas then I took my first drink.

At this moment, the Cop grabs the bottle from the 1st Comic and takes a long swig, then hands it back.

1st: You took a hell of a big drink for your first drink, partner.

Cop: Everything went red before my eyes. My fingers thirsted for blood. I went mad. I grabbed my wife's lover by the throat. *(Grabs 2nd Comic by throat.)* And I hurled him to the ground. *(Throws 2nd Comic to floor.)* 'Twas then I took...

1st: Another drink.

The 1st Comic hands the bottle to the Cop, who takes another drink.

1st: Say, you better make that story a serial. We won't have enough whiskey.

Cop: What did I do then?

Both Comics: What did you do...took another drink.

The Cop reaches for the bottle. Instead, both Comics take a quick drink.

Cop: No, I rushed over to where my wife was standing. *(Rushes over to 2nd Comic.)* I entwined my fingers around her throat. *(Does this to 2nd Comic.)* And I started to strangle her. *(Does this to 2nd Comic.)* My fingers grew tighter around her swan-like neck until her limp body slipped to the floor. *(After 2nd Comic falls to floor he gets up and rushes over to*

1st Comic's side, who has been watching and laughing. Cop still down on one knee as if beside wife's body. 2nd Comic feeling his throat.) And there she lay dead. *(Gets up.)* And boys do you know what I'm going to do? *(In rough voice.)*

1st: *(In rough voice.)* No. *(Catches self and then in mild voice.)* What are you going to do?

Cop: *(Starts to Nance off.)* I'm going to start another sit down strike.

<div align="center">BLACKOUT</div>

PRACTICAL JOKES

Trickery shows up in practical jokes, most of which involve dousing the comic or one of the other characters with water. The most widespread is "Buzzing the Bee" in which the Straightman persuades the Comic to play a game in which the worker bees collect the honey for the King Bee. The Girls playing the worker bees buzz offstage and come back with their mouths full of water. When the Comic says, "Give it to me," as he was instructed, they squirt water at him. The Comic is persuaded to try the trick on someone else, but gets squirted a second time, when he is tricked into saying "Give it to me" again. There are several filmed versions of the scene, including *Hollywood Burlesque* and *Strip, Strip Hooray*. Abbott & Costello performed the routine in a number of their films and television appearances including *In the Navy*.

Water plays a central role in several other scenes of this type. A notable one is "Niagara Falls Scene" (Chuck Callahan Collection), which Brooks McNamara included in his collection *American Popular Entertainments*.[3] The Straightman plays a practical joke on the Juvenile, telling him to hold a penny on his head so he can show him something. As the Juvenile does so, the Straight puts a funnel down his pants front and pours water down it. Angry at the dirty trick, the Juvenile is persuaded to try it on the Comic. But it does not faze the Comic—he has a hot water bottle in his pants. "I've heard that one before," he reveals.

Business with water is at the heart of "Water in Hat Bit" (Ken Murray Collection). The Straight has the Jewish Comic pose with a hat in his hand as he recites a poem that concludes, "Now I've finished speaking, I'll replace my Sunday hat." As the Comic is reciting, the Straightman pours water into his hat, so that water spills over him when he puts on his hat. The two of them connive to work the trick on the Irish Comic, but when he is finished with the recitation, he pulls a little pail out of his hat, then puts on his hat as he exits.

A somewhat more involved scene is the following, from the Ken Murray Collection, in which the Comic is doused with water; this takes place in a speakeasy, where the Comic hopes to get a glass of beer.

<div align="center">Louie the Bartender</div>

Str: I can get you all you want. Go up to that hole in the wall and say give it to me, and give it to me good—and you'll get all the beer you want.

1st: Is that all. *(Goes to hole.)* Louie the bartender, give it to me and give it to me good.

With that he gets a face full of seltzer. He starts to get angry, but the Straightman encourages him to try it on the next person who comes along.

The Ingenue enters, and greets everyone. The 1st Comic asks if she would like to have a glass of beer. When she replies yes, he tells her "the password." The Comic takes her over and positions her in front of the hole, then backs away. But when she gives the password, she gets handed a glass of beer. She thanks them, and leaves.

1st: What the hell. Maybe Louis is in a better mood. I'll try it again.

But when he does, of course, he gets seltzer in his face. The 1st Comic is frustrated, until the 2nd Comic arrives. The 1st Comic succeeds in getting the 2nd Comic to go over by the hole, and order the beer. As soon as he gives the password, the 2nd Comic ducks so that the 1st Comic gets squirted with the seltzer. Frustrated, the 1st Comic leaves. The scene concludes with the upside down glass of beer bit that was presented earlier.

<div align="center">BLACKOUT</div>

Versions of the scene are also found in the Ken Murray Collection as "Hee Haw," and in the Callahan Collection as "Telephone Bit." In "Hee Haw" the Comic is induced to walk over to a cabinet, put his hands on either side of the face and holler "Hee haw" a couple of times. When he does so, he gets a face full of seltzer. A Cop enters. It is his first night on the beat, and he is looking for a place to get a drink. The Straightman shows him what he showed the Comic. When the Cop tries it, a large glass of beer is handed to him. Ready to drink it, he holds the glass behind his back, while he asks the Straight to keep an eye on the entrance. While he does so, the two Comics pull out small rubber hoses, put them in the beer and drink it. The Cop finally turns around and discovers the beer is gone. He chases the two Comics offstage as they yell, "Hee haw, hee haw."

Most practical jokes involve dousing with Comic with water. In "Eight Day Match," however, the prank is to prevent the patsy from lighting a cigarette, tricking him to burn his fingers. In "Eight Day Match and Nickels" (Jess Mack Collection), the Straightman tries to make a date with a Woman, pulling out a cigarette and lighting a match. Each time he tries to light the cigarette, the woman pulls his arm down. He manages to burn his fingers on the match. The Straight decides it is a good trick, and tries it out on his buddy, the Comic. Straight talks about how dumb the Comic is as he pulls down the Comic's arm whenever the Comic attempts to light the cigarette. However, the Comic's match never burns down to his fingers. Finally, winded, the Straightman asks if the Comic has asbestos fingers. No, replies the Comic, he has an eight day match— revealing a taper that goes up his sleeve, he thumbs his nose at the Straightman. Versions of this scene appear in *Dream Follies* and in *Hollywood Revels*.

MORE COMPLICATED CON GAMES

There are scripts for more complicated confidence schemes as well. "The Dice Game" routine is familiar to Abbott & Costello fans. They used the routine in their first starring feature, *Buck Privates* (1941). The two men are on a troop train when Abbott entices Costello into joining an impromptu game of craps. Although

Costello reassures Abbott that he has never played the game before, he betrays a suspicious amount of knowledge of the game. The routine appears in several of the collections, and contains more than what appears in the Abbott & Costello version. Other filmed versions include one Abbott & Costello did on the *Colgate Comedy Hour* (Airdate November 18, 1951) as well as a version performed by Eddie Ennis and Jack Murray in *A Night at The Follies*.

In most of these confidence schemes, the Comic's misfortune is contrasted with the Straightman's good luck. "Ragged Coat" (Ralph Allen Collection), which also appears under the title "Torn Coat" (Jess Mack Collection) and "Napoleon's Coat" (Anthony LoCicero Collection), is a standard swindle scene in which the Comic gets taken by a Girl with a heart-rending story. In it, a Girl approaches the Comic with a sob story about her poor mother who will die unless she gets the medicine she needs. To raise money, the Girl must sell her brother's coat, which she has wrapped up in a package. Feeling sorry for her, the Comic buys the coat for five dollars, but when he opens the package he discovers that the coat is in shreds. The Straightman arrives and greets the Comic, and the Girl reenters, crying. She gives the Straightman the same story that she gave the Comic. The Comic tries to warn him off, but the Straightman, charmed by the girl, pays no attention. He pays the Girl five dollars. On opening the package she gives him, he discovers that it is a fine coat, worth much more than the five dollars he paid. He reaches into the pocket and discovers a wad of money.

In "The Wa-Hoo Scene" (Chuck Callahan Collection), the Straightman is running a scam with the Soubrette and Ingenue, in which they drop a handbag containing $500 in front of saps, then sell the bags for $200. The Comic and Luke buy a bag without money and find themselves wahooed; only the Straightman discovers he needs to buy the bag back because he has left his lottery ticket inside. The Prima Donna gets the bag for him, and he tells the comics they've been wahooed. They smile and explain they've already cashed his ticket in. Variants of the scene include "Three Suitcase Scene" (Ralph Allen Collection) where the suitcases contain bootleg liquor and "Three Bomb" (Gypsy Rose Lee Collection) in which anarchists have planted bombs in the suitcases, and there is a reward for the person who discovers them.

The Comic is almost always the fall guy for these confidence schemes. "Wise Guy" is one of the few in which he wins out in the end—or at least comes out even. The Comic in this scene is the wise guy, Jimmy Blink, who runs into a girl from his hometown, Jenny Brown. She has just moved into the city to find work. The Comic brags that you do not have to work for money in this town, showing off a diamond pin, a ring, a watch, and his wallet, with his initials J.B. on it to demonstrate that he can get all the money he wants. He shows her how to make some easy money, by standing on the street, crying, and telling passersby that she lost her purse and hasn't any money to get home to the farm. Several passersby rebuff her until the Straightman enters and inquires where she lost her purse. She replies that she was standing over by the Comic. "Is there any way to identify your purse?" asks the Straightman. "Yes," replies Jenny, "it has my initials on it. J.B." The Comic tries to hide the wallet in his sock, but the Straightman discovers the wallet with $500 in it. When asked if there was anything else she lost, Jenny lists each of the items he showed her and the Straightman returns them to her, advising her to watch out for people like the Comic.

After the Straightman leaves, the Comic admits to Jenny that he has been bested, and though the money was meant to go to his folks back home, she's entitled to take it back to her folks—just say that "Little Jimmy Blink sent it." As he delivers this melodramatic speech, he drops to one knee and grabs her hands in his. The bag, which was on her wrist, slips down onto his. As she leaves to catch her train, the bag is still on the Comic's wrist. He holds it up for the audience to see. "Hell, she ain't so wise after all," he says. Versions of the scene appear in the Ralph Allen Collection as "Wise Guy" and in the Gypsy Rose Lee Collection as "Wiseguy from (Local)" and "Initial Pocketbook and Watch."

The "Shell Game Bit" is Ken Murray's version of three-card monte or "the old shell game" using three coconut shells and lemons. Abbott & Costello performed it in several of their film and television appearances, most notably in their 1940 feature *In the Navy*. In the scene, the Straightman is operating a sidewalk confidence scheme and gets the Comic to place a bet that he knows which shell the lemon will wind up in. The Comic loses, but discovers the ruse that the audience sees from the very beginning: the lemons are dropping through a hole in the table into a wire mesh basket attached to the bottom of the table.

<center>Shell Game Bit</center>

The Straightman enters carrying a table, three coconut shells, and three lemons. The table has two round holes cut in the top for lemons to fall through. There is a wire basked attached under the table for the lemons to fall through.

An Irish and a Jewish comic enter ad-libbing a conversation.

Str:　　Here you are boys, the greatest chance in the world to win yourself a fortune. Here I have a little lemon and three little cups. I place the lemons under the cup, shuffle them around a few times. If you find the cup the lemon is hid under, I'll pay you ten dollars.

The Irish comic picks the right cup.

Irish:　There it is Mister, give me ten dollars.

Str:　　Just a moment boys, I forgot to explain that should you fail to find the lemon, you are to give me ten dollars.

Comics:　It's a skin game. It's a fake. I wouldn't play at all. Etc.

Str:　　Why boys it perfectly legitimate. Just watch me closely. *(Bus.)* Here we have the little lemon, here we have the cup, shuffle them around a few times, find the lemon and I'll give you ten dollars.

Comics:　I got it. I got it. Etc. Etc.

Str:　　How much are you going to bet?

Irish:　I'll bet fifteen cents.

Str:　　Get out of here, you piker, you cheapskate, bet fifteen cents. Why you've got to bet real money. Why I ought to give you a punch in the nose. Bet fives, tens, twenties, fifties. Do you get me Bozo?

Jew:　　*(To Irish.)* What's the idea, Bozo, you want to come down to a swell gambling place like this and bet fifteen cents? Why I'm ashamed of you.

Str: Well how much are you going to bet?

Jew: I'll bet a nickel.

Str: Get out of here, you are worse than he is.

Jew: Well, I'll bet ten dollars. *(Bus. places money on table.)*

The Straightman matches the bet. He shuffles the coconuts across the table top so that the lemon falls through the hole into the basket below. The Jew raises the shell, but nothing's there.

Irish: I knew it. That guy couldn't pick strawberries. I got the lemon right here. I'll bet ten dollars.

He places money on the table, which the Straightman covers, and raises the shell, finding nothing beneath.

Jew: We didn't even win once.

The Straightman tries to get them to double up, so the Jew places twenty down, losing again, and begins to argue with the Straightman.

Str: Well there is a sucker born every minute.

Jew: I must have been born a minute ago.

As the Comic argue with the Straightman about the game being crooked, the Soubrette enters.

Str: What are you guys beefing about? I want you to understand that this game is on the level.

Jew: Yes, only a little up—HILL.

The Soubrette asks if she can play. The Straightman explains the game to her, and she bets ten dollars. But when she picks up a shell, there's nothing underneath.

While the Soubrette is playing the game, the Comics discover how the lemons disappear. The Straightman walks over to the Soubrette for a moment, and when he does so, the Comics turn the table around, taking extra lemons from the basket.

Sou: Say Mister, won't you give me a little car fare?

Str: Certainly. *(Holds out a roll of bills.)* Help yourself. *(Soub. takes most of roll and exits.)* Say where do you live—in China? *(Turns to Comics.)* Well so long, boys. *(Takes table and is about to exit.)*

Comics: Just a minute. Don't go yet. We want some more money. *(Pulls out more money.)*

Str: Look at that bank roll. Alright boys, this is your last chance.

Jew: It's the last chance we want.

Straight goes through game routine again. Comics bet. Each Comic in turn calls Str. to one side while the other Comic is Bus. Ad-lib with lemons. Finally each Comic has two lemons under each shell. Straightman pulls string on secret trap. Comics lift shells. The lemons are gone without either audience or Comics seeing them.

General exit. Straightman takes table off stage with him.

BLACKOUT

11. Brutality ⌯

Figure 11.1 Lucille Ball was one of many comedians to perform "Niagara Falls (Slowly I Turned)" on film and television. Here she takes a pie wielded by Frank Scannell in an episode of *I Love Lucy*. (Courtesy of Photofest.)

If the comic is likely to be outsmarted by the characters he meets on the street, he is just as likely to be overpowered or physically abused. In one of the standard scenes, the comic encounters a stranger or strangers who, for no apparent reason, begin beating him up. These are sometimes referred to as "rave scenes." As Dick Poston explains, "a *Rave* is when a performer gets his teeth into a dramatic bit, tears up the scenery, rants and raves and explodes all over the stage in wild histrionic fervor and then *raves* himself or herself off stage and usually to thunderous applause."[1]

There are really two types of rave scenes. In the first, the comic encounters one or more characters who, for no reason, become enraged and start physically attacking

him. Despite his best efforts to extricate himself, he innocently brings on their wrath. This is the basis of the famous "Niagara Falls (Slowly I Turned)" in which a down-and-out stranger beats the Comic up whenever he hears the word "Niagara Falls." The venerable "Flugel Street" also fits into this category, as various passersby attack the Comic when he even mentions the Poskudyuck Hat Company. Often it is a policeman who is responsible for the brutality. In the other type of rave, the straightman or the talking woman plays an eccentric character who sees things that aren't there. Both "Pork Chops" and "Joe the Bartender" are in this category. Scenes involving physical abuse are some of the most familiar burlesque scenes, for there was no problem depicting scenes of such brutality on film and television.

SLOWLY I TURNED

"Slowly I Turned" is probably the most famous scene to be identified with burlesque. A host of comedians performed it over the years. Abbott & Costello did the routine in *Lost in a Harem* in 1944. Their version was released the same year as the Three Stooges' version in *Gents without Cents*. Lucille Ball performed the routine on an episode of *I Love Lucy* titled "The Ballet." Joey Faye did a guest spot on *Make Room for Daddy,* performing the routine with Danny Thomas. Imogene Coca and Sid Caesar did a variation of the routine on *Your Show of Shows.*

The routine has the Comic encountering a down-and-out character, played by the Straightman. It appears in the Chuck Callahan Collection as "You Ask Me Why I'm Sad."

You Ask Me Why I'm Sad

The Comic enters remarking on what a happy town it is. The Straightman enters, looking very dejected. Noticing him, the Comic asks why he is sad.

Str: My friend, it's a long story. Would you like to hear it?

Com: No.

Str: Well listen.

The Straightman launches into a melodramatic tale of how his Doctor ordered him out west for the sake of his health. He and his wife settled in a little cottage on the outskirts of Tulsa. A year later they were blessed with a "little bundle of pink and white," a baby. They were very happy until...

Str: One day we were sitting on the front porch, I was reading the daily paper, my wife was darning a pair of socks, when suddenly a stranger came riding by on horse back. Just as he got opposite the gate, the horse stumbled and fell and threw the rider to the ground. I rushed out, picked him up and carried him into the house.

Com: Who? The horse?

Str: Yes, the horse... *(Looks quickly at Comic.)*

Com: That's right. You couldn't get the horse through the door.

The Straightman explains that he nursed the stranger back to health. The man turned out to be an artist and he used to paint pictures of the family. They were all as happy living together, until...

Str: One day I received a telegram calling me to Omaha on important business. I knew if I went there and put over this deal, I'd make a lot of money. I kissed my wife and baby goodbye, shook hands with the stranger.

Com: What became of the horse?

Str: I took the horse to Oma...No, no I took the train to Omaha.

The deal in Omaha made him a fortune. He hurried home to tell his wife, only to discover that she and baby had gone away with the stranger.

Str: I swore I'd have revenge. I searched for him everywhere. State to state. City to city. I was about to give up in despair, when one day I saw him. He was standing there on the brink of Niagara Falls. *(Points off stage right.)* My first impulse was to sneak up on him from behind. *(Crosses to right. Comic follows him.)* Give him one push and send him down to be dashed to his death on the rocks below. But no. All the demons of Haiti within me rose, and said, "Make him suffer as he has made you suffer. So I slowly turned. *(Turns to Comic with outstretched arms. Comic muggs this up all the time.)* And I crept upon him, step by step...*(Advances on Comic who is backing away.)* Step by step, until I had him in my grasp. *(Grabs Comic by throat and chokes him.)* And I choked, and choked. *(Straight throws Comic to the floor, then helps him up.)* I'm sorry my friend.

The Comic accepts his apology, but the Straightman feels he must explain his behavior.

Str: You see I was merely overcome with emotion. That man had stolen my wife and baby, the only things in life I ever loved. And there he stood on the brink of Niagara Falls. *(Points right again.)* I wanted to sneak up behind him. *(Crosses to right. Comic follows again.)* Take out my knife and cut him from ear to ear. But no. That would be too good a death for him to die. Something within me seemed to say, "Make him suffer, as he made me suffer." So slowly I turned.

The Straightman repeats the choking business, as the Comic muggs. Catching himself, he apologizes profusely to the Comic. Again the Straightman tries to explain his behavior, leading him again to describe the scene on the brink of Niagara Falls. This time, when the Straightman utters "slowly I turned," the Comic crosses the stage and puts his neck into the Straightman's outstretched hands. They break up laughing on this.

Com: I got to where I like it now.

Str: I'm sorry friend.

Com: I even saved you a trip from coming over there.

Str: Ah forgive me. You see he was a wolf in sheep's clothing. And there he...

The Straightman suddenly turns, grabs the Comic by the throat and chokes him, slowly letting him sink to the floor limp. He cries "Revenge, revenge, revenge," laughs crazily and exits. The Comic slowly rises to a sitting position, and watches him leave.

At this moment, the Second Comic, Luke, enters.

Luke: Why the devil don't the city keep the streets clean? They leave the darnedest things lying around.

The Comic sees Luke, gets up quickly, takes off his coat and launches into a burlesque version of the Straightman's monologue.

Com: Seventy five years ago. *(Jumps at Luke, grabs him by the throat.)* Too soon. Some years ago my doctor ordered me away for my dandruff. So my wife and I moved out west to Elizabeth New Joisy. And there we settled down in a beautiful little igloo. One room and a sink. And there, one day, we were blessed with a little bundle of green, white, pink and yellow. A little baby. Little Adinois we called him. Ah, he was a beautiful child. He looked just like his father. He was so beautiful that thousands of people for miles around came to see him. They tried to figure it out, what the devil it was. We were happy then. We were happy then. We were as happy as three little cockroaches under the sink. One day we were sitting on the front verander. I was reading the Police Gazette, and my wife was vulcanizing a pair of socks. And the baby, ah the baby. He was cutting his teeth on a horseshoe. And then he came. He was a sign painter. I could smell the turpentine on his hair. And he ran away with my squaw and papoose. My blood became full of boils. I swore that I would find him. So I searched all over the United Snakes. Finally I found him. He was standing on the brink of the Mississloppy Ocean. I took out my knife and cut his ear, from throat to throat. Not content with that, you dirty bum, I grabbed him...

With that, the Comic grabs Luke. The orchestra picks up a waltz, and the Comic and Luke waltz offstage, mugging.

BLACKOUT

PORK CHOPS

A second type of rave scene has the straightman or the talking woman act out a scene in fantasy. The Comic plays along with the fantasy, and gets caught up in it. This is the basis of "Pork Chops" (Jess Mack Collection) in which a butcher boy is trying to sell some meat to an eccentric lady, who keeps addressing him as "Count," and involves him in a murder plot. Bert Lahr performed a version of the scene as "Lamb Chops" in the January 27, 1957, broadcast of *Omnibus* entitled "The Big Wheel."[2]

Pork Chops

The scene is played in one, with a minimum of scenery. The Straightman enters with a Girl to set up the premise.

Str: Now it's true that your sister was pronounced crazy, but she has spent three years in the rest home and I'm certain that she is O.K by now, so let her come home. She's harmless. However, should she become violent, just call me on the phone and I'll take care of her.

They exit, and the Comic enters dressed in a butcher's coat and carrying a basket with a pair of pork chops.

Com: Pork chops. Pork chops. Two for 35¢. Who wants pork chops? Anybody home? Pork chops. Two for 35¢.

A Woman enters. Addressing the Comic as "Count," she invites him to sit down on the chaise lounge. The Comic, looking around, sees only a bench. She insists that he sit and have a drink. The Comic protests that he just wants to sell the pork chops. Ignoring him, the Woman proceeds to play out a scene with imaginary people.

Wom: Oh Count. You must have a drink.

Com: Alright just one drink.

Wom: *(Calls off.)* Oh Marie.

Com: Who's Marie.

Wom: My maid. Oh there you are Marie. Marie I want you to meet the Count.

The Comic, of course, sees nothing. Following the Woman's lead, he shakes "Marie's" hand. The Woman orders a couple of highballs from Marie. This sets up a joke about where "highballs" come from—from giraffes, of course. The Woman takes a two glasses from the imaginary maid, and hands one to the Comic.

Com: What's that?

Wom: Your highball. *(Bus. with both hands.)* Be careful don't spill it.

At her urging, the Comic does a little toast—a comic recitation that isn't spelled out in the script. The Woman hands her glass back to Marie then asks for the Comic's glass. The Comic has forgotten about the glass, but comes up with one to satisfy the Woman. She dismisses Marie and turns to the Comic.

Wom: Oh Count, remember how you used to play the piano for me on the Riviera.

Com: Yeah, but that was a long time ago.

Wom: Count, you're kidding. Won't you play the piano for me?

Com: *(Looks around.)* You got a piano here?

Wom: *(X's to left.)* Why Count, don't you see this beautiful baby grand piano?

Com: That's a piano?

Wom: Yes.

Com: And that's Marie?

Wom: Yes.

Com: And I'm a Count?

Wom: Yes.

Com: Give me 35¢ and let me get the hell out of here.

The Woman is persistent. She crosses to the imaginary piano and pretends that she is winding a piano stool.

Com: What are you doing?

Wom: Adjusting the stool.

Com: *(Walks over.)* That's the piano and that's the stool?

Wom: Why can't you see it?

Com: No, that highball got me drunk.

The Comic touches the imaginary keyboard, and a note sounds. Surprised, he jumps away. The Woman insists that he play "Il Trovatore" from Faust. The Comic goes along with it, sitting at the piano and playing an arpeggio that takes him right past the end of the piano, so that he falls on the floor.

She insists that he play a jazz number. He plays "St. Louis Blues." The script indicates "Bus. of one hand…two hands…no hands."

The Woman interrupts, saying that there is someone at the door. She starts to walk through the piano, but the Comic shoves her back.

Com: What the hell are you walking over the piano for? Now she's got me seeing things. Look lady, please give me 35¢ and let me scram out of here.

At the door, the Woman acts out a scene with the people there, as the Comic reacts.

Wom: What do you want here? You've come for the piano? You can't take this piano. No, the Count here gave it to me, didn't you Count?

Com: I did what?

Wom: You gave me this piano.

Com: Sure I did and I'll give you a hundred more like that one.

Wom: Take your hands off the piano, I'm warning you. I've got a gun here and I'll use it. Oh you don't believe me. Very well then take that.

There is sound of a gun shot that does not quite correspond to the action onstage. The Comic starts to break up. The Woman, all involved in the reality of the situation, is immediately remorseful.

Wom: What have I done? Oh what have I done?

Com: You shooted him.

Wom: Blood, blood. The floor is covered with blood.

The Comic reacts by raising up his trouser cuffs.

Wom: What's that? A police whistle? *(Whistle off stage.)* The police are coming after me. Don't let them take me away. Oh please don't let them take me away.

She starts to maul the Comic. He declares that he will protect her and bawls out the imaginary police.

Com: Who the hell am I? Tell them lady who I am.

Wom: Why he's a Count.

Com: Yeah, I'm a count. You've heard of Monte Christo? Well I'm the Count of Monkey Crisco. Oh you wanna fight.

He engages in an imaginary fight, and hurts his finger. Once again he pleads with the woman to give him 35¢ and let him get out of there, but the Woman ignores him.

Wom: Now they're putting me in a cell, a dirty filthy cell. Look, rats. Rats. *(Scares Comic.)* Look cockroaches, millions of them. Now is my trial.

Why look, there's the Judge and look. *(Points.)* That little room with the red light.

Com: That's the men's room.

Wom: The door is slowly opening.

Com: Hey you damn fools, close the door, we can see you.

Wom: Look there's a seat in there, with a hole in the middle.

Com: What's the hole for?

Wom: To let the juice come through. Now look, the jury is coming out.

Com: That's some fellows who went down for relief.

Wom: What's that you say? I'm guilty of murder in the first degree? I must hang by the neck till I'm dead? But I don't want to die. I didn't mean to kill him, I tell you I didn't mean to kill him. Ah, I see it all now. *(Looks up.)* Some dirty stool pigeon squealed on me. And now look, there's the gallows. They're leading me up the 39 steps. I don't want to hang. I don't want to die…

She continues ranting as she exits. The spotlight which was on her goes up, over to the other side, and back to the top over the Comic. Each time the spotlight moves, the Comic follows. Exasperated, the Comic calls out that "I'm down here." When the spotlight finally lights on him, he enacts a burlesque of the scene.

Com: Count, won't you play the banana, piano. Alright just one more piece. That's all I have left. *(X over.)* That's the piano, that's the stool. *(Plays chop sticks with one finger.)* What's that, you come to take away the piano? You can't take that piano, it was given to me by the count. Count. 1,2,3,4. If you touch that piano, I'll pull me knife. Oh you'll pull yours too? I'll bet I can pull mine faster than you can. You don't think I'll do it? Alright, take that. *(Gun shot.)* I stabbed him with a knife. *(Or…I shot him with a knife.)* Look he's getting stiff. Blood. Blood. *(Looks up at spot…green spot.)* I'm getting mouldy. Blood, blood, red blood. *(Touch floor, taste it. Spits.)* Ketchup…or borscht. There's the police whistle. They've come to take me away. Now they're putting me in the police wagon. They're taking me to jail. They put me in a smell…cell. And now it's the trial. There's the fudge. Hello fudge, how the hell are you? And there's the little room with the red light. It's locked by order of the Board of Health. What's that you say, fudge, I'm guilty and should be hung. (You should see my father…two hung low) Now there's the gallups and the 39000 steps. I'm too tired to walk. They're putting the rope around my neck. I can't stand it. Must be Saturday night. But I don't want to die. I'm too old to die. I tell you I don't want to die…die…die… *(Dance off to drum beat.)* die…die…

BLACKOUT

The scene offers an alternate tag.

Com: I see it all now. *(Look up. Drummer hits wood block. Comic wipes eye.)* Some dirty pigeon stooled on me.

Another scene that is very closely related to "Pork Chops" is "Joe the Bartender," which Dick Poston included in *Burlesque Humor Revisited*.[3] The scene is played out

between the Comic and the Straightman, who takes the Comic into an imaginary bar. Giving the Comic a drink from a special glass, the Comic manages to drop the glass, shattering it. The imaginary bartender is enraged and the Straightman must pull out a gun and shoot the bartender. He too is taken into police custody, convicted of first degree murder, and executed. As in "Pork Chops," the Comic closes the scene with a parody version of the scene that the Straightman played out. The scene is featured in the burlesque feature *Everybody's Girl*, and there is a version in the Gypsy Rose Lee Collection titled "Joe Bit."

ENCOUNTERS WITH THE LAW

In encounters with criminals, the comic is usually outsmarted. In encounters with law enforcement, he is likely to be brutalized. The following scene from the Anthony LoCicero Collection is a good example of the often brutal knockabout comedy that was popular around the turn of the century. The scene is set up as an interrogation, as the Captain tries to extract a confession from the suspects that have been brought before him.

Police are Always Right

The police are under a lot of pressure to solve a jewel robbery. The Sergeant tells the Inspector they have rounded up four suspects, the Juvenile, the Character Man, and two Comics, who are brought onstage.

Ins: Now one of you four, if not all of you, had a hand in this robbery. Now, I'm going to find the guilty one if I have to send you all to the hospital.

He calls the Juvenile over and has him sit in the chair.

Insp: Now what do you know about this job that was pulled off last night?

Juv: Nothing.

Insp: It's a lie. *(Hits him with club.)* What's your name?

Juv: *(Gives name.)*

Insp: It's a lie. *(Hits him with club.)*

To every answer, the Inspector declares that it's a lie. When the Juvenile pleads that he does not know anything, the Inspector kicks him, shoves him to the floor and kicks him again.

The Sergeant returns and interrupts.

Sgt: Pardon me, Inspector?

Insp: Well, what is it?

Sgt: We've checked up the alibi of (Juvenile) and find it's okay.

The Inspector releases the Juvenile, who limps toward the door.

Insp: Hurry up, or I'll break the other leg.

The Juvenile exits and the Inspector turns his attention toward the other three men. The 1st Comic squeezes between the other two to avoid being seen. The Inspector spots the Character Man.

Insp: YOU! *(Character goes to Inspector and sits C.)* Sit down. What do you know about this robbery?

Char: I don't know nothing.

Insp: It's a lie.

The Inspector asks the same questions that he did of the Juvenile, and with each "wrong" answer, hits him with the club. He shoves the Character to the floor and proceeds to beat and kick him. The Sergeant returns and reports that his alibi, too, checked out. He was out of town that night. The Character man leaves, followed by the Sergeant. The Inspector turns to look at the two comics. The 1st Comic tries to sneak behind the 2nd Comic, who in turn tries to get behind the 1st Comic. The bit is repeated a couple of times, with the 2nd Comic winding up in front.

Insp: Now I know the guilty man is among you and I'm going to get him if I have to kill both of you. The police are always right. *(Calls.)* Bill Smith, Joe Doakes, Clark Gable.

The 2nd Comic brightens on the Clark Gable remark, so the Inspector calls him over. The 2nd Comic is played as a Nance. The business is repeated as before, with the Inspector shoving the 2nd Comic to the floor and beating him up. When the Sergeant returns to report that his alibi checked out, the Inspector is all solicitous.

Insp: Well (2nd Comic), I'm sorry I roughed you up that way and if there's anything I can do to make amends, I would be glad to do it.

2nd: Yes, Inspector, there is something you can do for me.

Insp: What is that?

2nd: Kiss me.

Insp: Get out of here!

The Inspector removes his coat, turns and looks at the 1st Comic and shouts, "Hey." The 1st Comic jumps out of his shoes. The Inspector picks them up, and tells him to come over and sit in the chair.

Insp: Of course, you don't know anything about this job, do you?

Before the Comic can answer, the Inspector yells "It's a lie" and hits him with the club.

Insp: Why don't you answer me? *(Bus.)* Shut up—say something—shut up— Oh, you won't talk.

He pushes the Comic to the floor and beats him some more. He is interrupted by the Sergeant who comes to report that the last alibi checked out.

Insp: I might have known he didn't have anything to do with it. He hasn't brains enough.

1st: The police are always right, eh?

Insp: Yes, the police are always right.

The Comic takes the jewels out of his pocket

1st: Well, here's the swag.

Insp: Grab him. Sergeant, bring him here. What do you mean the swag? You didn't steal those.

1st: I did.

Ins: You're a liar. The Police say NO, and the Police are always right.

1st: Honest, I stole them.

Insp: You stole them? Why you poor bum, you couldn't steal coal in Scranton. You couldn't steal pennies from a blind man. It takes brains to make a haul like that. Somebody gave you those pearls and you want to make out you're a clever crook. You stole them? Why, if a banana peddler came along and if he was blind and deaf and only had one arm, why you couldn't even steal one banana.

Inspector takes the watch from the 1st Comic's pocket.

Insp: I guess you think you're a clever crook. Nobody can put anything over on you, eh?

1st: No.

Insp: Oh, they can't, eh? Well, here's your watch.

1st: Thanks. *(Pulls out another watch.)* Here's yours.

<div align="center">BLACKOUT</div>

The scene appears in both the Ralph Allen Collection and the Gypsy Rose Lee Collection under the title "Third Degree" with some variations.

"Go Ahead and Sing" is another knockabout scene, featuring two comics and the straightman, as a policeman. The Second Comic urges the First Comic to ignore the Cop's warning not to sing on the street, enraging him more and more. Abbott & Costello performed this routine in *Buck Privates*, using a radio. On *The Colgate Comedy Hour* Lou brought an entire Mariachi band into the lobby of the hotel.[4] Bud urges Lou to keep up the music, telling him, "What do you care what the manager thinks?" Here is Chuck Callahan's version.

<div align="center">Go Ahead and Sing</div>

Luke and the Comic need some money, so Luke proposes that the Comic sing, while he passes the hat. They will split the money fifty-fifty.

Com: We'll split fifty-fifty?

Luke: Sure. You sing and I'll pass the hat and get the money.

Com: Don't do me no favors. If you get $4.80 in that hat, how much do I get?

Luke: You get eighty cents.

Com: Don't cheat yourself. You better give me fifteen cents.

Luke: Why fifteen cents?

Com: Then in case you don't pay me you won't owe me so much.

Luke: Go ahead and sing.

The Comic starts to sing "O Sole Mio," but is interrupted by the Straightman who enters as a cop, and pokes his billy club into the Comic's stomach.

Str: Now listen boys, I realize that you're out to have a good time and I don't want to spoil it for you, but you'll have to keep quiet, there might be

someone trying to sleep and you'll disturb them. Now go ahead and enjoy yourselves, but don't make any noise, you know, be nice and quiet. You know boys there's a hospital just two blocks down the street.

When the Cop exits, Luke tells the Comic to ignore his advice and to go ahead and sing. The Comic begins singing again. The Cop reenters, pokes the Comic in the stomach, and tells him to cut out the singing and keep quiet.

Str: You know boys, I don't make much money on this beat. *(Hits club in hand.)* And I'd hate to have to buy a new club.

The Cop exits, and Luke tells the Comic to go ahead and sing, assuring him that

Luke: That's alright. If he breaks that one I'll see that he gets a new one.

Com: Who's going to buy me a new head?

Luke: You won't need any. Go ahead and sing.

Com: You be sure and pass the hat. I don't think he'll come back anymore.

Luke: You ain't afraid of him are you?

Com: I should say not. *(Sings again very loud.)*

The Cop reenters and throws the Comic all around the stage. Luke, meantime, hides in a box. After roughing up the Comic, the Cop warns,

Str: Now if you sing any more, I'll quit being nice.

Safely hidden in the box, Luke says, "I'd like to see you do it." The Cop, thinking that it is the Comic wising off, proceeds to throw him around again. Finished, the Cop starts to exit, but the Comic grabs Luke and throws him over to the straight, saying "Go on you big stiff." So the Cop roughs up Luke.

After the Cop departs, Luke presses the Comic again.

Luke: Go ahead and sing.

Com: WHAT? You don't care what happens to us do you?

Luke: Go ahead, think of the money we'll get.

Com: Something tells me that I won't be able to spend it after we get it. But be sure and pass the hat.

The Comic sings again and the Cop enters with a stuffed club and beats them. The Comic and Luke stagger around the stage till Luke gets the Comic on his feet.

Luke: Are you alright now?

Com: Yes, I'm alright now.

Luke: Well go ahead and sing.

The Comic runs Luke off the stage.

BLACKOUT

DENTIST SHOP

Dentist scenes are the most obviously brutal of the doctor scenes, playing on the anxieties that most people have about visiting the dentist, and exaggerating the level

of violence. The dentist is played by the straightman, who beats up and brutalizes the comic in the course of giving him a treatment. While the comic is initially scared about visiting the dentist, he becomes less so as the action gets more violent. The more he has to react to, the less nervous he seems to become, commenting almost blithely on the action that is taking place, as in this version from the Ken Murray Collection.

<u>Dentist Shop</u>

The Doctor is working on a female patient, as the Comic enters. He finishes up and calls the Comic, who is scared of being hurt. The Doctor tries to reassure him, guiding him to the chair, then taking off his hat, very slowly and precisely.

Doc: Now you see I didn't hurt you, did I?

Com: Hell, you didn't do anything yet.

Doc: Now lay back and I will see if I can locate the seat of the trouble.

Com: No, Doctor, it ain't in the seat. It's in my tooth.

Doc: Well, I'll find it.

He feels around the Comic's face, and slaps him hard on one cheek. The Comic leaps out of the chair, yelling at the top of his lungs. The Doctor grabs him and puts him back in the chair, raises the chair, takes a sheet and puts it around the Comic.

Com: What's the idea of this sheet?

Str: I don't want your clothes to be covered with blood.

Com: *(Jumps up.)* Blood? Is there going to be blood?

Str: Perhaps. Some people die from the loss of blood, but you don't want to mind a little thing like that.

The phone rings and the Doctor goes to phone and answers it.

Str: It's you, Mr. Jones? What's that you say. I pulled three of the wrong teeth from your wife's mouth this morning? Well, you see, Mr. Jones, I couldn't find my glasses this morning and I couldn't see what I was doing. But tell Mrs. Jones not to worry because I'll find her tooth somewhere around the office.

Returning to the Comic, he picks up his tools—a saw and hammer.

Com: Doctor, are you sure that you'll get the right tooth?

Doc: I'll pull the right tooth, if I have to pull them all out to get it.

The Nurse interrupts, informing the Doctor that the previous patient just died and that he'll have to sign the death certificate.

Doc: My arm is getting tired from signing death certificates, so just use the rubber stamp.

Com: *(Exited, scared.)* So, they use a rubber stamp!

Nur: Doctor, what shall I do with the body?

Doc: How many patients have died today?

Nur: Eleven, Doctor.

Doc: Well, just leave it there. When another one dies that will make an even dozen and we'll send them all down to the morgue.

The Nurse exits, and the Comic jumps out of the chair, yelling. The Doctor grabs him, puts him back in the chair, and tries to quiet him. There are cries from the other room. The Comic reacts.

Com: Oh Doctor, the toothache is much better. I want to go home. In fact it's all better. Look! *(Slaps his own face.)*

Doc: Oh, that don't hurt?

Com: No.

Doc: Well, does that hurt?

The Doctor slaps him so hard in the face he falls out of the chair. The Doctor puts the Comic back in the chair and begins pulling tools out of a bag on the floor—a saw, hammer, knife. Taking a pair of forceps, he gropes around in the Comic's mouth, seizes hold of a red rubber balloon, and stretches it out of the Comic's mouth.

Doc: I got it. I got it.

Com: Got what?

Doc: I got your tooth.

Com: Tooth, hell. That was my tongue.

Doc: My mistake.

The Doctor climbs back on and straddles the Comic. The Nurse enters, begins to address the Doctor, notices and smiles knowingly, begs pardon, and leaves. The Comic jumps out of the chair.

Com: You're no Doctor.

Doc: No? What am I?

Com: Hell, you're a Naval Doctor.[5]

A man, all bandaged up, runs across the stage with a second man chasing him. "You're next. You're next," the man warns the Comic.

Com: Oh! *(Scared.)* Doctor, what was that?

Doc: That was my assistant. As I told you before, when I get through, he takes care of you.

Com: I'm going home and send my brother up. He ain't got no sense.

The Doctor announces he is going to extract that tooth, and takes a towel, which conceals a large tooth, and puts it by Comic's mouth, while pretending to extract the tooth. The Comic screams and the Doctor displays the tooth.

Com: Doctor, tell me please.

Doc: Tell you what?

Com: Was it a boy or a girl?

BLACKOUT

FLUGEL STREET

"Flugel Street" is most identified with Abbott & Costello, who performed it in the 1944 film *In Society*.[6] In the picture, Lou is attempting to return some straw hats to the Susquehana Hat Company, which is located on Beagle Street. He asks several passersby directions on how to get there. Hearing the name Susquehana Hat Company each becomes enraged, attacking Costello and destroying his hats. This scene, along with "Meet Me Round the Corner" and "Niagara Falls (Slowly I Turned)," is one of the most familiar scenes to come out of burlesque. The following was taken from the pages of *Cavalcade of Burlesque*.

Flugel Street

The scene opens with 1st Comic carrying large stock hat box. He meets a Policeman at center stage.

Com: I beg your pardon officer, can you tell me where Flugel Street is?

Str: Don't ask me buddy. Why don't you buy a street map? I'm only a traffic cop, and besides I'm a stranger in this town.

The Policeman exits as the Straightman enters. The Comic goes up to him.

Com: Say Mister, can you tell me where Flugel Street is?

Str: I beg your pardon.

Com: I say, do you know where Flugel Street is?

Str: Why certainly I know where Flugel Street is. What about it? What is it to you? Do I know where Flugel Street is?

Com: Well mister, don't keep it a secret, if you know where Flugel Street is, I wish you'd tell me. I got to...

Str: Sure you got to. I know what you've got. You should take care of it, too. People have been known to die with what you've got. Do I know where Flugel Street is? I was born on Flugel Street. I used to go to school on Flugel Street. I used to play ball on Flugel Street. I remember when I was a kid, me and my brother played ball on Flugel Street...and you ask me where Flugel Street is. Oh, so my brother is a bum...

Com: Who said anything about your brother?

Str: Oh, so he ain't good enough to be a bum...

Com: Now listen Mister—I don't want... *(Points finger at Straightman.)*

Str: Trying to jab out me eye, eh? *(Comic walks away.)* Going to get your gang?

Com: What's the matter with you? Who's got a gang?

Str: Let me tell you something—I love Flugel Street. What do you want with Flugel Street?

Com: Well, I'm looking for the Poskudyock Hat Company.

Str: I should have known that. I knew you were looking for the Poskudyock Company when I first laid eyes on you. Is that a Poskudyock hat you're wearing? *(Takes hat off Comic's head.)*

Com: Yes, that's a four dollar special.

Str: Why should I give you four dollars for that hat?

Com: Who said...Who asked you? Who knows you? Who wants to know you? Go away.

Str: Let me see. *(Pulls wire out of straw hat.)* Oh, so you put a wire in this hat so I should cut myself? You look like the kind of a guy that would do a thing like that. So this is a Poskudyock hat?

Com: Yes sir. Mr. John B. Poskudyock makes these hats.

Str: Mr. John B. Poskudyock makes them! Well, let me tell you, young man, Mr. Poskudyock never saw this hat. Little girls with curls make them. Child labor. They climb six flights of stairs every day to his factory and slave fourteen hours a day. So this is a Poskudyock hat? do you know what I think of a Poskudyock hat? I'll show you. *(Breaks hat.)* That's what I think of a Poskudyock hat. *(Hits comic with hat as he starts to exit.)* Ask me where Flugel Street is, a man that loves Flugel Street. I was born on Flugel Street, I played ball on Flugel Street.

The Straightman exits. The Comic reaches into his hat box, pulls out a new straw hat, and puts it on. A Girl enters.

Com: Pardon me, Mrs. Can you tell me where Flugel Street is?

Girl: Why do you call me Mrs.?

Com: Well, you look like a married lady.

Girl: Why should I marry you? I haven't even been introduced to you.

Com: I didn't propose to you, I just wanted...

Girl: You don't even know me. Why do you disturb me when I'm meditating? I like your nerve, to deliberately stop me, a total stranger. Why the idea is shocking to say the least. Do I know where what street is?

Com: Not What Street—Flugel Street.

Girl: Flugel Street? Do I know where Flugel Street is? I should say I do.

Com: Would you mind telling me where it is?

Girl: What do you want with Flugel Street?

Com: Well, I've got to get to the Poskudyock Hat Company.

Girl: *(Lets out a terrible shriek.)* Poskudyock Hat Factory. I should have known the minute I laid eyes on you that you wanted the Poskudyock Hat Company. Oh, if it wasn't for the Poskudyock Hat Factory my poor husband might have been alive today. It was on Flugel Street where he was killed. He was passing the Poskudyock Hat Company when it all happened. A truck driver took one look at the hat he was wearing and ran him down. If he was only wearing another hat. He happened to be wearing a Poskudyock hat. Is that a Poskudyock hat you have on?

Com: Yes, Mrs. This is a Poskudyock hat—it's a four dollar special.

Girl: Why should I give you four dollars for a hat like that?

Com: I'm not trying to sell the hat for four dollars. How do I get mixed up with people like this?

Girl: *(Takes his hat.)* So this is a Poskudyock hat? Well, this is what I think of a Poskudyock hat. *(Breaks it up, and hits him with it.)* Ask me where Flugel Street is? *(Exits.)*

Com: People in this neighborhood must be crazy.

He takes another hat from box and puts it on. The 2nd Comic enters and meets the 1st Comic. He stutters throughout his part.

Com: Pardon me, mister, can you tell me how to get to Flugel Street?

2nd: Oh, you want to get to Flugel Street? *(Stutters.)*

Com: Never mind, by the time you tell me, I'll have to pay rent here.

2nd: Do I know where Flugel Street is? Well, I'll tell you—you walk down Chestnut Street, then you go south, where the land of cotton is—then you cross the bridge and when you get there, you'll see an old man. Ask him how you get to Spring Garden Street, and when you get to...

Com: I beg your pardon mister, do you always stutter?

2nd: Only when I talk.

Com: What do you do for a living?

2nd: I work in a bird store. I teach parrots how to talk—but I'm going to get a new job as a radio announcer.

Com: I'm going to throw my radio out of the window. All I want to know is how do I get to Flugel Street?

2nd: You want to get to Flugel Street...you want to get to Flu-Flu...?

Com: Alright, alright, I want to get to Flug—Flu—now you got me talking that way. I want to get to Flugel Street.

2nd: What do you want on Flugel Street?

Com: Well, I want to get to the Poskudyock Hat Company.

2nd: Pos—Pos—Pos—Is that a Poskudyock hat? *(Points to 1st Comic's hat.)*

Com: Here we go again!! Yes, this is a four dollar hat.

2nd: Why should I pay you four dollars for that hat? Do you know how these hats are made? Little girls...

Com: Yes, I know—with curls. Little girls with curls make these hats. But how can I get the box to Flugel Street?

2nd: Here's what I think of a Poskudyock Hat. *(Breaks up hat. As he breaks first piece, he hands it back to 1st Comic.)* Here have a piece of Matzos. *(Continues to break hat.)* That's what I think of your Poskudyock hats. Little girls with golden curls make these hats. *(Exits.)*

Com: What a neighborhood. *(Gets another hat out of hat box.)* *(Straightman enters.)*

Str: Aha! What are you doing, reaching for another Poskudyock hat?

Com: Yes. *(He still has his hand in the box.)*

Str: GIVE IT TO ME.

Com: *(Pulls out chamber pot, gives it to Straightman, runs off stage.)*

<div align="center">BLACKOUT</div>

There are a number of filmed versions worth looking at. Abbott & Costello performed it on *The Colgate Comedy Hour* (October 14, 1951) and in an episode of the *Abbott & Costello Show* titled "Getting a Job." The scene is also the basis of a 1937 Vitagraph short *Hats and Dogs*, which starred Rags Ragland and featured Joey Faye and Jess Mack in supporting roles. Lindsay and Crouse used the scene in their play *Strip for Action*.

GHOST SKETCHES

It is not so much the violence in these scenes, as the *threat* of violence that makes them funny. The laughter in "Slowly I Turned" begins when the comic accidentally mentions "Niagara Falls" and the audience anticipates the pummeling that he is about to get. In that regard, we can include encounters with ghosts among these scenes of brutality.

An encounter with a ghost or some other kind of malevolent spirit shows up in several collections. These routines can be traced to the nineteenth century in such sketches as "Ghost in a Pawnshop" and "The Three O'Clock Train."[7] The premise was used in countless comedy shorts, with everyone from the Bowery Boys to the Three Stooges to Bugs Bunny encountering a ghost or some other monster. The most familiar of these bits is the "Moving Candle" scene, which Abbott & Costello used in *Abbott and Costello Meet Frankenstein*. A candle that the Comic is using to read the treasure map mysteriously moves across the table. Frightened, the Comic hollers for the Straightman, but in the meantime, the ghost has exited, and the Straightman refuses to believe the Comic's story, insisting there is a logical explanation. When the Straightman leaves, the ghost returns and begins tormenting the Comic again. The bit is repeated several times, with slight variations. Each time the Straightman is called, he arrives too late to see the ghost.

In the most common version of the ghost sketch, the comic and the straightman visit either a haunted house or a graveyard where the straightman insists there is a treasure waiting to be discovered. That is the premise of the following, from the Steve Mills Collection.

Oh Charlie

Charlie, the Straightman, persuades Henry, the 1st Comic, to go with him to the old house where an old miser hid all his money. He claims to have a map to the treasure, but the Comic is hesitant because the house is haunted. The Straight gives him the map and tells him to meet at the house in a half an hour. The 2nd Comic, Julius, proposes to Henry that they beat the Straightman there, dig up the treasure, and split the money.

The curtain comes up on the interior of a haunted house as the two Comics arrive. There is by-lay between the two characters. The 2nd Comic, playing on his partner's fear of ghosts, plays practical jokes on him, blowing out his candle, and letting out a scream.

A Skeleton appears behind them and slaps the 2nd Comic, who accuses his partner of hitting him. Then the 1st Comic is hit. They quarrel. Finally, the 2nd Comic discovers the Skeleton, screams, and runs offstage.

1st: There you go trying to scare me again. *(He finds that the 2nd Comic has left.)* That boy has gone and left me all alone. I'll sit here and read the document to keep my mind off the dark. "To whom it may concern…"

The Skeleton reappears. Candle moves back and forth. The skeleton puts it out and exits.

1st: Oh, Charlie. *(Three times.)*

The Straightman comes rushing on.

1st: Charlie, is that you?

Str: Yes.

1st: I'm glad you came. Julius and me was here just now. Julius left me. Someone came in and moved this *(pointing to candle)* from fro to too and too to fro, and flopped it out.

Str: Why that's merely an imagination.

1st: Maggie Mason nothing. I tell you I was sitting here and I saw it.

The Straightman lights candle.

Str: The window was open, the draught came in and blew the candle out. Now the window is shut.

1st: Well, then shut your mouth.

Str: I'm going outside and should you want me don't forget to call me.

1st: Don't forget to come.

Once the Straight leaves, the Skeleton returns and makes the candle go up and down again. The Straightman returns and insists that there is a logical explanation.

The Skeleton returns again and sits beside the Comic, tapping him on the shoulder.

1st: Julius is that you? Go on, Julius, I know that's you. Listen, Julius, if that's you this is not way to fool around. *(Ad-lib.)*

He touches the Skeleton's face.

1st: Oh, Charlie.
 (Touches Skeleton face again.)
 Oh, Charlie.
 (Turns around and finds it is the Skeleton.)
 Oh, Charlie, Charlie, Charlie
 (Skeleton chases Comic.)

The Skeleton exits. The 1st Comic runs up and down yelling "Charlie." The 2nd Comic runs out and grabs the 1st Comic.

Com: Come on, Charlie, I got him.

Charlie breaks through the door with the money.

Str: Look boys, I found the money.

2nd: All the time.

1st: You sursse scared hell out of me.

<div align="center">BLACKOUT</div>

There are a number of variants as the ghost plays tricks or practical jokes. In "Haunted House" (Ralph Allen Collection), the Ghost eats a banana the Comic is holding in his hand. In "King Poo Pah's Ghost" (Ken Murray Collection), the Ghost begins repeating whatever the Comic says, giving himself away by responding inappropriately, such as responding to the Comic's "Merry Chirstmas" with a "Happy New Year." Something similar is used in "Haunted House" (Ralph Allen Collection). The Straightman advises the Comic that "If you get scared, just dance. Ghosts are afraid of anybody that dances." When the Ghost returns, the Comic does a time step. The ghost responds with the appropriate break. Several ghost scenes have the Comic trying to ward off evil spirits by singing "The Old Jaw Bone," a mournful tune that goes back to the early years of minstrelsy. Published versions appear in Gilbert and McNamara.

12. Burlesques ✃

Figure 12.1 Comic Steve Mills protects Ann Corio from a spear wielded by Mac Dennison in the "White Cargo" sketch from "This Was Burlesque." (Courtesy of Photofest.)

The criticism is often made that the American burlesque show violated the spirit of real burlesque—that is, a parody or travesty of a well-known literary or dramatic work or genre. While the parodic element may not have been dominant in the twentieth-century burlesque show, it was certainly present—often in ways that are not apparent to modern audiences. Scenes such as "Slowly I Turned" spoofed the conventions and overwrought acting style in turn-of-the-century melodramas, while "First Drink" was a send-up of confessional temperance plays such as *The Drunkard* and *Ten Nights in a Barroom.*

A number of popular scenes did parody-specific dramatic works or theatrical genres. Edmund Wilson caught one at Minsky's National Winter Garden, which he described in a review for the *New Republic.*

> In the current version of *Antony and Cleopatra,* a perennial classic, Julius Caesar, in a tin helmet, smoking a big cigar, catches Antony (the Jewish comic) on a divan with Cleopatra (the principal strip-tease girl) and wallops him over the bottom with the flat of an enormous sword. "I'm dying! I'm dying" groans Antony, as he staggers around in a circle and Caesar and Cleopatra, the Roman soldiers and the Egyptian slave-girls break into a rousing shimmy to the refrain of "He's dying! He's dying!" "I hear de voices of de angels!" says Antony. "What do they say?" asks Caesar. "I don't know: I don't speak Polish..." "Bring me the wassup," says Cleopatra, and her slave-girl, kneeling, presents a box, from which Cleopatra takes a huge property phallus. (At some point in the development of the ancient act the word *asp* was evidently confused with *wasp.*)... Cleopatra falls prone on her lover's body, and Caesar, with pathetic reverence, places on her posterior a wreath, which he waters with a watering-pot... This curious piece of East Side folk-drama has been popular at Minsky's for years.[1]

The basis of comedic burlesque is an incongruity between style and subject, which juxtaposes high and low. There are two directions that a burlesque can take, John D. Jump points out in his study of literary and theatrical burlesque. There is *high burlesque,* in which "a relatively trifling subject is ludicrously elevated by the style of presentation," and *low burlesque,* in which "a relatively important subject is ludicrously degraded by the style of presentation."[2] Burlesque comedy on the American stage was concerned, almost entirely, with low burlesque, which was accomplished simply by introducing the comic into what would otherwise be a serious or formal occasion. A low burlesque may be of a particular work, Jump observes, or it may be of an entire class or genre of works. The most common form found on the American burlesque stage was *travesty,* "the low burlesque of a particular work achieved by treating the subject of that work in an aggressively familiar style" although some burlesques may also treat a genre more broadly.[3]

Burlesques call for a different attitude and approach on the part of the performer than scenes played "in one." Whereas the emphasis of scenes involving trickery, brutality, and flirtation is very much on winning and losing to create a series of comic reversals, in a pure burlesque, the comic is completely unconcerned with success or failure. The comedy derives from disrupting or distorting normally staid proceedings. It is the discrepancy between what is happening onstage and what *should* be happening that is the basis of comic pleasure. As Marie Dressler observed in a treatise on burlesque acting, the comic must stand outside of the action and "never

under any circumstances does he lose himself in the part." The successful burlesque performer is

> an actor with an eccentric point of view. Indeed, I think I may say that he is the only actor upon the stage whose artistic value is enhanced according to his capacity of standing apart from an interpretation and asserting his own individuality. His whole art consists in emphasizing his point of view and having it accepted by the front.[4]

SHAKESPEAREAN BURLESQUES

In order for a burlesque to work, the audience must be familiar with the original. As such, Shakespeare offered great opportunities for burlesque. There is a long tradition of Shakespearean travesties and burlesques in the American theatre. From the early nineteenth century until today, parodies of the Bard have been a staple of the popular stage. The powerful and poetic sentiments of Shakespearean drama offered great opportunities for burlesque and parody. There are burlesques of *Othello* and *Hamlet* to be found in the collections.[5] By far the most widespread of the Shakespeare burlesques are those of *Antony and Cleopatra* such as the following version from the Ken Murray Collection.

<u>Anthony and Cleopatra</u>

The scene opens as a Slave announces Anthony's arrival.

Slave: Ah Cleopatra, fair queen, Anthony awaits without.

Cleo: Without what?

Slave: Without pants.

Cleo: Bid him enter.

When Anthony arrives, Cleopatra inquires of the news from Rome. He replies, "Hast thou not heard? Brutus has foully murdered Caesar and bananas are ten cents a dozen."

Cleo: But Anthony, if you love me as you say you do, you must be prepared to give up your parties, picnics, festivals and beer.

Anth: Ah, Cleo, thou knowest not what thou dost ask. I can give up my parties, picnics and festivals but not my beer.

A bugle call interrupts them, and the Slave announces the arrival of Caesar. The band plays "Turkey in the Straw" and the 1st Comic climbs over the wall. He wears a grotesque Roman costume with tins for shield and breast plate and a wreath on his head. He is accompanied by the 2nd Comic, who wears a cuspidor on his head.

Anth: Octavius Caesar, what brings you here?

1st: (Local street car).

Anth: Well then take my jitney bus and be gone.

Cleo: No, Anthony, he has come to me.

Anth: What's this? Do you know that Cleo is my queen and has already promised to do my washing.

1st: That's nothing. She did mine yesterday.

This revelation is too much for Anthony. He draws his sword and challenges Caesar to a duel. Caesar is armed with a soup dipper, and they do battle, to the tune of "Yankee Doodle." The Comic stabs Anthony with the dipper.

1st: Ah blood. *(Drinks from dipper.)*

Anth: *(On floor.)* Ah, Cleo, he has soup-dippered me. *(Bum dying.)* Everything is turning black. I am dying, Egypt. Dying. I can hear the Angels calling me.

A chorus sings "How Dry I Am."

With Anthony dead, Cleopatra has nothing left to live for.

Cleo: What is the most poisonous thing in the world?

1st: Beef stew in (local) restaurant.

Cleopatra calls for her poisonous "wassip" and the 2nd Comic takes a toy frankfurter from his tunic, handling it as though it were a poisonous snake. She holds the frankfurter to her breast, then throws it back to the 2nd Comic. Her death sequence is a replay of Anthony's.

Cleo: Everything is turning rosy. *(Looks at balcony.)* I can see the beautiful angels.

1st: Angels, hell—that's the gang from the South side.

Cleo: Anthony. I come, I come.

Cleo falls face forward across the body of Anthony, so that her thighs are sticking upwards, and shivering.

1st: Ah Cleo, never let it be said that Octavius Caesar would forget you. I place this wreath I have upon your forehead just to keep your memory green. *(He places wreath on her back.)* Oh I shall soup dipper myself. *(Stabs self with dipper.)* Everything is turning red, white and blue. I can hear the cockroaches calling me, I guess I'm going to die.

He staggers around the stage and falls back with his feet up in the air. It's the 2nd Comic's turn.

2nd: There is nothing for me to live for. I guess I will kill myself. Where is my poison warship. *(Takes string of sausages from bosom.)* Sting me my warship and sting me good. *(Takes bite of it and throws it down by 1st Comic. 1st Comic picks it up, growls at it and then throws it at wreath on Cleo's back and 2nd Comic begins dying business.)* Everything is green. *(To 1st Comic.)* Nertz, they are calling me. They are calling me. Come. Come.

1st: *(Raising on elbow.)* Who is it?

2nd: Nothing Nertz. I am at the gates of Heaven and they won't let me in. What shall I do? What shall I do?

1st: Go to hell.

With that, a Slave crosses the stage, ringing a bell and announcing dinner. All the others get up and follow him.

BLACKOUT

Versions of the scene appear under such titles as "Cleopatra," "Cleopatra's Loves," and "Julius Sneezer and Cleo Potroast" (Steve Mills Collection). Ralph Allen published his version as "The Lost Asp of Cleopotroast."[6] A version also appears in Something Weird Video's compilation video, *Chicks and Chuckles*, with Harrie Arnie as the principal comic.

WHITE CARGO

Other scenes burlesqued contemporary plays, with those of Eugene O'Neill's being most common. There are burlesques of *Strange Interlude* and *The Hairy Ape* in the collections. The most frequently done burlesque of contemporary plays was of *White Cargo*, a 1923 potboiler that toured on the Columbia Wheel during the 1925–26 season. There is a concern here with the figure of the "vampire"—a woman who seduces men and drives them to destruction—made popular by the 1916 film featuring Theda Bara. By the 1920s, Bara's overwrought performance was widely ridiculed. The setting for the "White Cargo" burlesque is a tropical island, where the Comic has just arrived from England. He encounters the Character Man who warns him that it is not a paradise, but a damnable place, and cautions him about Tondelayo, a beautiful native girl who has the power to force men to love her. The following is the version belonging to Steve Mills, who claimed to have written the burlesque with straightman Raymond Paine, when both of them were working at Minsky's National Winter Garden.

<u>Tondelayo</u>

The stage is set on a tropical island, with a grass hut at left, two cases of beer, and a beer barrel. The Character Man complains about the conditions.

Char: Seven years I've been on this island, seven years of hell and three years more to go. Seven years of this intolerable heat, the damned dry rot that gets into your bones, nothing but natives to talk to, and the lousy native liquor to drink. *(At bottle.)* Well, if I'm going to endure it, I may as well stay drunk. *(Pours drink. Drinks.)*

The Comic enters, looking for the superintendent of the plantation. He's been sent from England to take charge.

Char: So you're the new overseer. Why didn't they send me a man?

Com: Well all the men... *(Catches himself.)* I'm a man, what do I look like? Besides, I think I can take care of myself while I'm here in the glorious tropics.

He enthuses about the woods, the flowers blooming in profusion, the birds singing in the trees. The Character Man is unimpressed.

Char: The morning that I landed here, like you, I was overwhelmed with its beauty. The beautiful flowers, the birds singing in the trees, the beautiful emerald sea, and the quiet of it all. But after being here seven long years with the tropical heat, the damned dry rot that eats into your bones and

seems to crush and smother the very life out of you, the lousy native liquor, and then there are other things.

Com: What do you mean the other things?

Char: Well for instance, there's Tondelayo.

The Character Man explains that she's a native girl known as the vampire of the island.

Char: Do you know what a vampire is?

Com: Sure, that's the guy that stands behind the catcher and hollers balls and strikes. That's the guy that's always wrong.

Char: No, a vampire is a woman that will take a man's heart in her hand and squeeze, and squeeze, until there is no more blood left in it.

Com: Could she do the same thing with a banana?

Char: *(Pushes Com.)* Jest all you will. But all the same, my fine feathered friend, after you've spent many weary days here and countless of sleepless nights, when the monotony of it all casts its spell over you, when the touch of a woman's hand, the sound of a woman's voice would mean all eternity to you, when you would sell your chances of ever getting to heaven, for the kiss from a woman's lips, it is then that Tondelayo will come into your life. Tondelayo, a half caste native, Tondelayo with her beautiful black hair, her dark piercing eyes, her ruby kissable lips, her beautiful bronze shoulders, her voluptuous busts, are you following me? *(Above is all indicated with hands.)*

Com: Hell, I'm on the Hoboken ferry already. *(Or local.)*

Char: Oh, you fool you. You won't be able to resist her, for Tondelayo will break you down. It is then you will fly into her arms. *(Over to Com., embrace, love bus.)* She will kiss you, caress you. *(Rubbing Comic's chest, etc.)* Etc....etc....

Com: *(Has been working this up.)* Oh, oh, oh, oh...

Char: What's the matter with you?

Com: I'm all right. That guy down there is sweating like hell. *(Points to aud.)*

The Comic insists that he cannot be seduced.

Com: I have a beautiful sweetheart waiting for me back home in England, and come what may I will remain true to her. Oh she's beautiful, she's got a... *(Indicating girl's shape with hands.)* She's a, well she looks like the foundation for somebody's garage, but I still love her.

That is what the other men said who fell under the spell of Tondelayo.

Char: But wait until you see Tondelayo, you'll fall, the tropical heat, the damn dry rot, the lousy native liquor, Tondelayo, and then it's mammy palaver, mammy palaver, mammy palaver...

He exits, raving.

Hawaiian music is heard. Tondelayo enters from the hut and dances around the Comic.

Com: Hello, who are you?

Tond: Me? Tondelayo.

The Comic tries to resist.

Tond: Tondelayo like Englishman.

She does a grind, and continues to dance around the Comic as he ad-libs, finally fall-ing into his arms.

Com: Go away from me, Tondelayo, go away. Stay away from me as close as pos-sible. Oh, oh, oh. *(At breasts.)* Oh those Jersey cantaloupes, go way.

Taking the Comic's hands, she drags him toward the hut. He keeps repeating that he doesn't want to go. The Character Man returns and sees the Comic disappear into the hut.

Char: Ha, ha, ha, oh no, he won't mammy palaver. *(To offstage R.)* Ungah, Ungah.

From offstage there is native gibberish. "Boo" enters, dressed in only a towel and carry-ing a spear. He talks gibberish to the Character Man, who replies in mock native talk, finishing with—

Char: Englishman, Tondelayo, hut.

Boo: *(More gibberish, finishes with Jewish.)* Mit my madla. *(Ad-lib.)*

The Comic re-enters, all disheveled. Boo starts for the Comic, but the Character Man steps between them.

Com: What did he say?

Char: He wants to know, did you go into the hut with Tondelayo?

Com: Yes.

The Character Man interprets to Boo, who replies in more gibberish and goes after the Comic again. The Character Man stops him.

Com: What did he say?

Char: He wants to know, did you kiss Tondelayo?

The Comic replies in the affirmative, and the Character translates to Boo, making a motion with his mouth like kissing as he says,

Char: Kissy, kissy.

Boo: Kissy, kiss, come into the woods, I give you banana.

Boo sticks his spear between the Character Man's legs. The script calls for business.

Com: What did he say now?

Char: He wants to know did you mammy palaver?

Com: Twelve times.

Char: *(With excitement.)* Twelve times. *(To Boo.)* Ungah, inger flinger, singer.

Boo: Inger flinger, singer, minka.

Boo bows to the Comic, runs and gets a loving cup and presents it to the Comic.

BLACKOUT

ONE WORD DRAMAS

Other burlesques satirized not a particular stage play, but an entire theatrical genre. Drawing-room dramas came under their share of ridicule. These generally dealt with the marital problems of the well-to-do. The dramatic moment often came when the husband arrived unexpectedly to discover his wife in the arms of his rival. The scene was such a theatrical cliché that very little exposition was required to explain the situation. A number of brief scenes play out that scenario one word at a time, under such titles as "Just a Word" (Chuck Callahan Collection), "Efficiency" (Gypsy Rose Lee Collection), and "One Word Drama" (Anthony LoCicero Collection).

<u>Just a Word</u>

He: Pardon.

She: Yes?

He: Yours?

She: Thanks.

He: Miss?

She: Clark.

He: Yes.

She: Yours?

He: Drake.

She: Stranger?

He: Rather.

She: Abroad.

He: India.

She: Long?

He: Years. *(Lighter bus.)*

She: That?

He: Lighter.

She: Work?

He: Seldom. *(Bus.)*

She: Oh.

He: Come.

She: Where?

He: Here.

She: Can't.

He: Tired?

She: Little.

He: Happy?

She: Rather.

He: Bored?

She: Hardly.

He: Smile.

She: Can't.

He: Try.

She: There. *(Smile.)*

He: Pretty

She: What?

He: Teeth.

She: Listen.

He: What?

She: Clock.

He: Twelve.

She: Going.

He: Wait.

She: Dangerous.

He: Married?

She: No.

He: Willing?

She: Perhaps.

He: Me?

She: Stop.

He: What?

She: Joking.

He: Honest.

She: Slush.

He: Truth.

She: Flattery.

He: Listen.

She: Clock.

He: Two.

She: Going. *(Starts.)*

He: Stop. *(Grabs her.)*

She: Ouch.

He: Sorry.

She: Brute.

He: There. *(Kiss.)*

She: Awkward.

He: Better?

She: Worse.

He: Please.

She:	What?
He:	Answer.
She:	Tomorrow.
He:	Morning.
She:	Evening.
He:	Impossible. *(Starts.)*
She:	Morning.
He:	Fine.
She:	Look. *(At spot.)*
He:	What?
She:	Moon.
He:	Green. *(Lights out.)*
She:	Oh.
He:	Lights.
She:	Out.
He:	Frightened?
Voice:	*(Offstage.)* Arabella.
He:	God.
She:	No.
He:	Who?
She:	Husband.
He:	Honest?
She:	Silly.
He:	Who?
She:	Pop.
He:	Listen.
She:	Clock.
He:	Three.
She:	Good.
He:	Night.

BLACKOUT

"Ah Scene," from the Gypsy Rose Lee Collection, does away with words entirely, as the characters communicate entirely in sighs.

Ah Scene

Bedroom set with door at center.

At the rise of the curtain, woman is discovered in bed reading. Phone rings. She answers saying AH three times, explaining in the three Ahs that he will be right up, she lays down again and reads.

Knock at the door. Man enters and says AH. Woman rising out of bed says AH. She is seated, he is standing, they kiss. Woman says AH as if relieved, man says AH, in same

register. They then hug, both together say AH, and sit on bed, man holds his hands to his heart, and says AH moaningly, she replies AH same register.

Enter Straight and discovers them in compromising position, and he says in mad tone AH. Woman screams AH. Man in frightened tone says AH, as he turns and sees him.

Straight pulls gun and says AH sarcastically, kills lover who dies saying AH faintly.

Whistle blows outside and Cop enters, saying AH proudly, asks woman AH, she says AH, frightenedly, Cop asks straight AH, did you do it, Straight says AH, guiltily.

Cop takes gun from Straight AH, freshly Straight AH, freshly. Cop points to door and says AH. Straight bowing head says AH, Cop says AH.

Woman says AH disgustedly on their exit, then she says three AHS, as if fainting and falls over the body of her lover.

Comic who has been under the bed during the entire scene, comes from underneath the covers and sticks his head out saying humorously, AH.

BLACKOUT

REHEARSAL SCENES

A commonly used approach to travesty is to set the dramatic situation up as a rehearsal. The humor comes out of juxtaposing the scene being acted out with goings-on during rehearsal. The technique goes back to the seventeenth- and eighteenth-century English burlesque notably George Villiers's *The Rehearsal* and Richard Brinsley Sheridan's *The Critic*. In the typical burlesque rehearsal scene, the Straightman is a director rehearsing a play or preparing to shoot a scene from a movie. Desperate to fill the role of the male lead, he offers the part to the Comic, who has difficulty suspending his disbelief and keeps trying to hop into bed with the leading lady. Here is how it is handled in a script from the Jess Mack Collection.

Good Bye Old Bed

The Straightman is directing the final scene of a movie in which the Comic is supposed to bid his wife goodbye.

Com:　Tell my wife good bye right now?

Str:　Yes right now.

Com:　What the hell, I just met the dame.

The Straightman insists, over the Comic's suggestions that he might do something more intimate. Finally accepting, the Comic turns and sees the camera.

Com:　What the hell is this?

Str:　That is the camera.

Com:　Camera? Looks like an old fashioned coffee grinder.

Str:　No that is the camera. You see, while you are bidding your wife goodbye, I shoot you from the rear.

Com: You do what?

Str: I focus you.

Com: With that?

Str: With that. You've been focused before?

Com: Not with anything like that.

The Straight explains that the Comic is to enter, see his wife, and embrace her. The Comic exits to await his cue, while the Ingenue takes her place at the foot of the bed. The Straightman calls for action.

Ing: Oh come to my arms my lover.

The Comic runs in, picks her up, and lays her on the bed. The Straightman rushes over, pulls him off the bed.

Str: Hey, what's the idea of throwing your wife on that bed?

Com: That was my own idea.

Str: Come here. *(Comic crosses.)* What were you going to do with your wife on that bed?

Com: The wife and I had some homework to do.

Str: There's no homework on this picture, and besides you're too rough.

The Straightman tells him he will show him what to do. He will play the husband and the Comic will be the wife.

Str: You walk up to her like this and you say, "Ah, my dear, my darling, my love, I shall always love you even though you go far away. I shall always dream about you. Hug me, squeeze me... *(Work this up.)* Kiss me."

Com: Pardon me but can you cook? *(Kisses Str. on forehead, does nance walk over to exit, turns.)* To hell with her, come with me baby, you'll do.

The Woman entreats the Comic to come into her arms. The Comic goes to her.

Str: Now repeat after me, "Oh my darling, you don't know how hard you make it for me."

Com: That's right.

Str: Now tell her that you love her and put some feeling in it.

Com: Oh baby I love you. *(Feels pratt of woman.)*

Str: Now what are you doing?

Com: Putting feeling in it.

Str: Not that line of feeling. Feeling of the voice.

Com: Oh in the voice?

Str: Yes, now repeat after me: "Ah my dear, ah my darling, I hate to go, but go I must and while I'm gone..."

The Comic and Ingenue work this scene up. Suddenly the Comic starts offstage, walking stiff-legged.

Str: Where are you going?

Com: I left my car parked by a fire plug.

Str: Come back here and embrace your wife. *(Comic does.)* Now squeeze her, now on the bed.

The Comic puts her on the bed, and joins her. But the Straightman yells at him.

Str: That's out.

Com: Huh?

Str: I say that's out.

Com: Again? *(Looks at fly.)*

Str: The hand business is out. Now this is a very sad moment.

Com: What's sad? It looks like happy days are here again.

Str: Look at your poor little wife—lying there, reminiscing on the bed.

Com: She is?

Str: Yes she is.

Com: Oh, the dirty thing. *(Shames her.)*

The Straightman orders him to pay attention to the furniture.

Str: Now say good bye to the table.

Com: *(To table carelessly.)* I'll be seeing you.

Str: No no, more like this. Good bye old table.

Com: Good bye old table.

Str: Many's the time I have rested my treasures on your bottom.

Com: Many times I have rested my bottom—

Str: No treasures. Now the chair.

Com: Oh the hell with it.

Str: No like this... Good bye old chair.

Com: *(Repeats.)*

Str: Now the hall tree.

Com: The what?

Str: The hall tree—that long thing standing up. *(Comic bus.)* Behind you, caress the hall tree. *(Comic pats it)* No, put more feeling in it. *(Comic shakes it.)* Now you're going to bid the bed good bye.

Com: Ah, now we're getting somewhere.

Str: This old bed means something to you.

Com: You bet your life it does.

Str: Alright, and give me a little action on the bed. *(Comic starts to mount her.)* No not that kind of action. Stroke the bed. *(Comic does.)* Now repeat after me. Good bye old bed—many's the time I've rested my carcass on your sheets.

Com: Many's the time—oh I better not say that.

Str: Why not?

Com: I'll get mixed up as sure as hell.

Str: Alright, we'll leave that out. Now here's the big moment of the picture. There's your little wife, she has been your pal, your companion for the past five years. Now, put all the feeling in your heart. With all the pent up emotions of your soul, you're about to tell her good bye. Now how would you tell her good bye?

Com: Get the hell over kid. *(Jumps into bed with her.)*

<div align="center">BLACKOUT</div>

Versions of the scene may be found in the Chuck Callahan Collection and the Anthony LoCicero Collection—the latter with the title "Bedroom Rehearsal." Abbott & Costello enacted a fragment of the scene as "Goodbye Old Fireplace" on the December 14, 1952, telecast of *The Colgate Comedy Hour*.

Closely related to the scene is "Gaston" (Jess Mack Collection) or "Gaston the Lover" (Steve Mills Collection). The scene is set in an upper-class drawing, where the Juvenile is departing for a business trip. The wife's paramour, Gaston, played by the Comic arrives for a tryst. The Straightman interrupts the scene from the audience, revealing it to be a theatrical rehearsal. He criticizes the actors and there is by-play between them. The scene becomes a series of frustrations as the Comic, especially, screws up his part, mugging, going into the audience, goosing the woman, and so on. Other scenes of this ilk include "Moving Picture Scene" (Jess Mack Collection; "Art Students Rehearsal Scene" (Chuck Callahan Collection); "Travesty Scene" (Ralph Allen Collection); and "Back Stage," "The Dramatic Instructor," "The Hat Rehearsal," "It's Up To The Public," "Oh, Archibald," "Rehearsal Scene," and "Stage Door John," all in the Gypsy Rose Lee Collection. Some of the scenes are written for a pair of comics, as in "Hollywood Happenings" and "Girl's Mustache or Nelly at the Pump" both in the Chuck Callahan Collection and "Under the Table" (Ralph Allen Collection).

MAGIC TRICKS

Other scenes introduce the comic into a different kind of stage act—a variety or vaudeville turn. In most of these bits, the straightman is a professional magician who needs a volunteer for the act. The volunteer turns out, of course, to be the comic, who manages to disrupt the act with his side comments and compound the problem through misunderstandings. In the final payoff, the comic usually reveals the trick. The scenes are fairly straightforward as magic acts, and the comedy comes from the comic's kibitzing and misunderstanding what he is supposed to be doing, and the complications that ensue. Many of these play off of the confusions made possible because of the flowery language of magicians, such terms of "prestidigitation" and "elucidation."

The most common of these scenes is "Egg in Hat," as in the following version from the Jess Mack Collection, in which the magician performs a trick in which he will break an egg into the Comic's hat, then makes the mess disappear. Naturally, there are problems.

Egg in Hat

The Straightman arrives onstage to introduce the next attraction, a great magician. He is interrupted by the Comic who has been told that he can do a recitation. The two converse and the Straightman lets him recite his poem about "Damon and Pythias." In the by-play, the Straightman admires the Comic's hat, wondering where he got it. The Comic replies that he found it under the bed, knocked the handle off and painted it black, referring to a chamber pot. The Straightman asks if he can borrow it for a trick.

Str: I promise not to harm it. I'll break an egg in your hat and make it disappear. *(Takes hat, breaks egg in it.)* Now hold the hat at an angle of 45 degrees and with a few words of magic the egg will disappear. *(Comic holds hat.)*

The Straightman breaks the egg into the hat. Both react to the smell of rotten eggs.

Com: Oh boy, the chicken that laid this egg was no lady. Hey, this damn stuff gets in your eyes.

Str: I'll have you understand that is a fresh country egg.

Com: Yes, but you didn't say from what country.

The Straightman makes a few passes over the hat and utters an incantation. When the Comic looks into the hat, the egg is still there. Both laugh uncomfortably.

Com: What the hell am I laughing at?

Str: I'll get the egg out of your hat. I'm not worried.

Com: You're not worried? The hell with you, I'm worried. Get this damn thing out of my hat.

Unfazed, the Straightman has the Comic hold the hat out again, telling him to smile for the audience, and utters the incantation again. Again the egg remains in the hat. The Straightman can't understand it, but tries once again, reminding the Comic to smile a big smile.

Com: It's still there.

Str: How do you know? You haven't looked.

Com: I don't have to look, I can smell the damn thing.

The Straightman assures the Comic that he has a script of the trick in the dressing room, and he'll go look at it, come back, and get the egg out of the hat. The Comic is left onstage, looking into the hat and mugging. After a few moments, the Straightman returns with bad news.

Str: I'm sorry, I can't find the script and I've lost the magic words to get the egg out of the hat, what will I do?

Com: Here, take it. *(Hands him hat.)*

Str: What will I do with it?

Com: Paint it white and put it back under the bed.

BLACKOUT

This bit was sometimes combined with other routines. In "General Pisano" (Jess Mack Collection) and "Egg in Hat" (Ralph Allen Collection), the magic trick is combined with a sharpshooting act, in which the Comic discovers that he's volunteered to have a cigarette shot out of his mouth. Here is the version from the Ralph Allen Collection.

<u>Sharpshooter</u>

The Straightman announces that he will demonstrate a few tricks of marksmanship, but will need the services of two young men to assist him. Two Comics walk on together. The Straightman hands the 2nd Comic a lighted candle, then crosses over to the opposite side of the stage.

1st: Hey, what are you gong to do?

Str: I'm going to shoot that candle out.

1st: I'll bet you a dime you can't do it.

Str: It's a bet.

The Straightman raises the gun and counts one…two…As the 1st Comic holds the candle up in the air, the 2nd Comic ducks behind a table. The Straightman shoots at the candle, but it remains lit.

1st: Wait a minute, I'll show you how to shoot that candle out.

He takes out a toy pop gun, loaded with a cork with a string attached. As he takes aim, the 2nd Comic holds the candle down to him, the 1st Comic shoots the candle out.

1st: And now ladies and gentlemen […], I will put the cigarette in the young man's mouth. *(Puts cigarette in 2nd Comic's mouth.)* and shoot the bullet through the cigarette and have the bullet stop right here. *(Denoting end near mouth.)*

The 2nd Comic stops him.

2nd: You're gonna tell me you're gonna shoot the bullet through the cigarette and have it stop right here?

1st: Sure.

2nd: Do you mind if I go home and get my brother. He's half witted, he don't care.

1st: What's the matter, ain't you got no confidence in me?

2nd: Sure I got confidence in you, but this don't sound so kosher to me.

1st: You can't get hurt. Now stand facing the audience like that.

He turns the 2nd Comic so that he is facing the audience, then crosses to the right about ten feet and takes aim with his pop gun. The gun shakes.

1st: Hey, Bill, are you still there? Hmmm, I can't see you, my eyes are a little hazy. Wait a minute, that's too easy.

He crosses over to the 2nd Comic, breaks the cigarette off close to the 2nd Comic's lip. The 2nd Comic does business of feeling if the cigarette is still there. Stage directions indicate that the 1st Comic paces off ten feet from the 2nd Comic. As the 2nd Comic holds his position, the 1st Comic carefully creeps toward him, getting the toy gun under the 2nd Comic's nose and shoots him in the nose. The 2nd Comic holds his nose as if hurt.

2nd: You damn fool, you shot me in the nose.

1st: Well, my aim was bad. And now ladies and gentlemen, I will now do my trick guess shot... my Wild Bill Hickok shot. *(He puts the toy gun under his coat and begins acting a scene out of a Western movie.)* Well stranger, I guess I'll turn in for the night... Who's a rat?

He shoots the 2nd Comic in the mouth. The cigarette flies out of the 2nd Comic's mouth. He holds his cheek as if hurt.

2nd: You dam fool, see what you did? Now you loosened my tooth.

1st: The tooth is loose? You know a dentist will charge you three bucks to pull that tooth out. I'll shoot it out for nothing.

2nd: You will?

1st: Sure.

He engages in business of pulling the toy gun through the 2nd Comic's lips and shooting the cork in the 2nd Comic's mouth. The cork has a string on and the 2nd Comic grabs string and pulls out the cork out.

At this point, the Straightman interrupts the pair and goes into the "Egg in Hat" bit.

BLACKOUT

13. Body Scenes ❧

Figure 13.1 The cast from the Silver Slipper in Las Vegas pose for a publicity shot for their "Schoolroom Sketch." The men include from left to right comics Mandy Kay, Hank Henry, Mac Dennison, and straightman Jimmy Cavanaugh. The showgirls cannot be identified. (From the author's collection.)

While a stage play or literary work is the basis of most burlesques, the source of this kind of comedy is not limited to works of fiction. People have scripts for all kinds of everyday activities and these internalized scripts can also be burlesqued in some way. In fact, there is no clear-cut difference between scripts that circulate onstage and those we utilize in everyday life. Few of us have direct experience of a courtroom trial, yet we are familiar with what takes place in a court of law. We acquire these scripts for a trial largely through film and

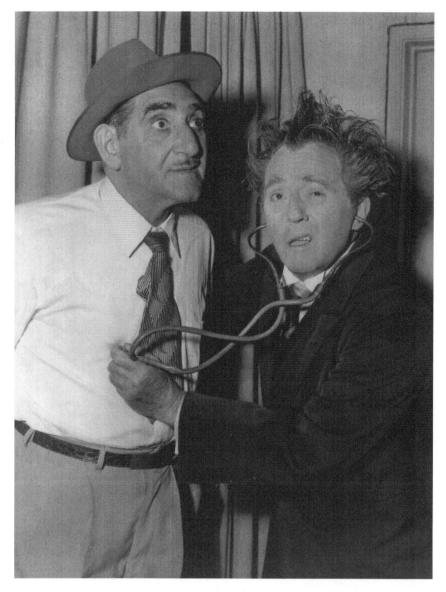

Figure 13.2 Joe Smith and Charlie Dale performed many incarnations of their "Dr. Kronkite" sketch. Chuck Callahan adapted classic burlesque doctor scenes for them. (From the author's collection.)

television. A schoolroom sketch is not just a send-up of what takes place in class-rooms across the country. It was also a burlesque of schoolroom scenes popular in vaudeville during the early part of the twentieth century.

This chapter examines several of the best-known "body scenes," scenes that require a large number of cast members. The scenes that are covered in this chapter are

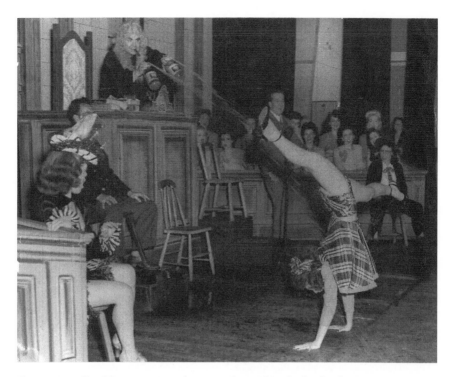

Figure 13.3 Ken Murray squirts seltzer at a showgirl in the finale of a Courtroom Scene. (From the author's collection.)

largely taken from everyday life. Unlike the scenes of trickery, brutality, and flirtation, which take place in a vaguely described public space and are usually played "in one," these body scenes are all set in an established environment, and required a full stage set. They take place in schoolrooms, restaurants, hotel lobbies, bedrooms, doctors' offices, and courtrooms. The set provides a cue for what is to happen, clearly differentiating the roles the characters will play and outlining a course of action familiar to audience members. The comedy comes about because one or more of the characters disrupts or distorts what is going on, without actually shattering the script. There is nearly always some kind of authority figure to play off of—a teacher, a doctor, a judge, a waitress—who is there to maintain order and decorum despite the departures from the expected line of action.

THE SCHOOLROOM SKETCH

The schoolroom sketch was one of the most familiar body scenes, and a number of versions circulated. These scenes pit the teacher against a wise-cracking student who comes up with snappy and risqué answers to the teacher's questions. School acts, which featured precocious child entertainers, were extremely popular on the vaudeville stage, and the burlesque versions are send-ups of the cute kids featured in

such acts as Gus Edwards's "School Days." The kids in the burlesque versions bear little resemblance to the cute and talented children featured in the typical vaudeville school act. Burlesque characters are clearly from the wrong side of the tracks, and the scenes play on the fact that these children are being played by adults. There are usually several chorus girls dressed in schoolgirl outfits or baby doll dresses. The remarks made by and to them are full of sly sexual references. The central character is the wise-cracking "bad boy" played by the Principal Comic, a figure that appears in jokes.[1]

The schoolroom sketch is organized around a series of "lessons" in spelling, history, and English, which allowed a series of unconnected jokes and recitations to be dropped into the scene. Each lesson is punctuated with by-play between the Comic and the Straightman who, in the Steve Mills version, desperately needs to go to the restroom.

School Daze

The Teacher is discovered behind her desk upstage center. Desks for the kids run from the center in both directions. As the orchestra plays "School Days," the kids enter, singing the lyrics to the Cobb and Edwards song, and take their seats. The Comic enters last.

Tea: I will now call the roll.

Com: I'll have coffee with mine.

Tea: (Comic), be quiet. Put out your hand.

He does so, and she promptly hits him on the head with a bladder. As the Teacher calls the students' names, each responds "here," until she gets to the Comic.

Tea: (Comic's name).

Com: I couldn't come today teacher.

Tea: Why not?

Com: I had to go to a funeral.

Tea: Oh, I'm sorry, who died?

Com: How the hell do I know, I just went for the ride.

She hits him with the bladder, and announces it is time for their singing lesson. The kids sing, "We love our teacher... we love our teacher," getting gradually softer, so that the Comic can be heard above them singing "Our teacher's lousy, our teacher stinks." He quickly switches to "She's beautiful, she's wonderful," but gets swatted with the bladder.

The Straightman raises his hand, with two fingers up, indicating he needs to go to the bathroom.

Com: Look teacher, he's goosing superman.

Tea: No Charlie, you can't go out.

Com: You'd better let him go out teacher.

Tea: No he can't go out.

Com: If he don't go out, we'll all have to go out in a minute.

The Teacher demands quiet and begins their spelling lesson.

Tea: *(To Girl.)* Mary, spell man.

Girl: M.A.N. Man.

Tea: Male or female?

Girl: Male.

Com: She's wrong.

Tea: She's right.

Com: Man is a male? That's right, the mailman.

Tea: *(To Juv.)* Willie. Spell girl.

Juv: Girl. G.I.R.L. Girl.

Tea: Male or female?

Juv: Female.

Tea: That's right. *(To Com.)* Spell cat.

Com: Aw what the hell, you always save the hard ones for me. Cat. C.A.T. Cat.

Tea: That's right. Male or female?

Com: Show me the cat.

There is more business as the Teacher goes after the Comic with the bladder. The Straightman raises his hand again, holding up one finger.

Tea: No Charlie, you can't go.

Com: Stay after school and fill the inkwells.

Ignoring the wisecrack, the Teacher announces that it is time for the history lesson. The Straightman replies that he knows all about history.

Tea: Well, then, tell me something about George Washington.

Str: George Washington was a great man. He was the father of our country.

Tea: Ya, who was the mother?

Com: Lydia Pinkham. *(All laugh it up on all jokes.)*

Tea: George Washington was our first man. He was first in war, first in peace, and first in the hearts of our countrymen. *(Kids do dance break.)* In fact, George Washington was first in everything.

Com: Oh no, he wasn't first in everything.

Str: Yes he was, he was first in everything.

Com: No he wasn't. He married a widow...

The Straightman again raises his hand again, but the Teacher ignores the Comic's pleadings that the Straightman be allowed to go, announcing that it is time for arithmetic.

Str: One and one is two, two and two is four.

Com: If the bed breaks down, finish on the floor.

The Teacher swats the Comic, demanding quiet. The Comic and Straightman simply go on talking among themselves.

Str: Hey, I heard you took your girl out fishing.

Com: Ya that's right.

Str: Did you catch anything?

Com: I hope not.

Str: What's the difference between mashed potatoes and pea soup.

Com: I don't know, what's the difference?

Str: Well anybody can mash potatoes.

The Teacher declares that it's time for poetry. A Girl gets up and recites a poem. The Comic gives her the raspberry. He takes stage and recites "Mary Had A Little Lamb" too fast to be understood.

Tea: That's no way to recite, you must be distinct.

Com: I stink enough now.

Tea: When you recite you must use gestures like this: *(She recites.)*
 Mary had a little lamb...hands in front *(She does so.)*
 Its fleece was white as snow...hands behind *(She does so.)*
 And everywhere that Mary went...hands in front. *(Hand bus.)*
 The lamb was sure to follow her...hands behind.
 Now go ahead and recite.

Com: Mary had a little lamb, in front.
 Its fleece was white as snow, behind.
 And everywhere that Mary went, in front.
 The lamb was sure to follow her behind *(Sits.)*

Str: *(Raises hand to go.)* Teacher I got to go. I got cramps.

Finally, she allows the Straightman to leave, taking a dunce cap and placing it on his head. He exits, trying to hold it in.

Com: Six to five he don't make it.

Tea: (Comic), you bad boy. I'd like to be your mother for about five minutes.

Com: I'll speak to my old man and see what I can do for you.

The Straightman returns.

Com: Hey Charlie, did everything come out okay? *(Bus.) (Talks to girl back of him.)*

Tea: Say, what's going on there?

Com: Teacher, can little girls have babies?

Tea: Why certainly not.

Com: *(To Girl.)* See, I told you we ain't got a damn thing to worry about.

Tea: Charlie, give me a sentence containing the word cloth.

Str: Cloth, cloth?

Tea: Yes cloth. What is your shirt made of?

Str: Me muddah's drawers.

Tea: *(To Com.)* Give me a sentence containing the word escort.

Com: Escort, escort. Last week I climbed over a barbed wire fence and got me escort.

The Teacher hits him with the bladder, then sits on her desk with her legs crossed. She drops her book. The Juvenile picks it up.

Juv: Oh teacher, I saw your leg.

Tea: Willie, you're a bad boy. Take your books and stay home for a week.

As the Juvenile exits, the Teacher drops the book again. The Straightman picks it up.

Str: Teacher, I saw your knee.

Tea: Charlie, you're a bad boy, too. You take your books home and stay there for a month.

She drops the book again, and the Comic goes over and takes a look. He works this up, kisses the Teacher on the cheek, whispers in her ear, and heads for the door.

Tea: Comic, where are you going?

Com: Teacher, my school days are over forever.

<div align="center">BLACKOUT</div>

Several versions of the schoolroom sketch are available. Dick Poston, Ralph Allen, and Brooks McNamara each included versions of the scene in their collections. Don Oliver included a version W. C. Fields performed in the 1928 edition of *Earl Carroll's Vanities* in *The Greatest Revue Sketches*. The scene was featured in an HBO filming of *This Was Burlesque*. A version appeared in the 1950 burlesque film, *Everybody's Girl*.

Most versions finish with the "My schooldays are over forever" gag. But there is an alternate tag that Poston uses in *Burlesque Humor Revisited* and that also appears in "School Days" (Ralph Allen Collection) and in "Futuristic School Room" (Ken Murray Collection). In the Ken Murray version, the First Comic, named Johnny, has taken out a hatpin and is trying to jab the other students with it. When the teacher asks one of the girls, Angy, to stand up, she says that she doesn't feel good—pointedly looking back at Johnny. The Teacher replies that it doesn't matter, she must stand up. Angy continues to protest, but the Teacher orders her to her feet.

Tea: *(To Angy.)* Now, what was the famous words that Eve said to Adam in the Garden of Eden?

Angy: Huh?

Tea: I said what was the famous words that Eve said to Adam in the Garden of Eden?

Angy: Eve said to Adam in the Garden of Eden—ah ah ah. *(Johnny is ready to stick her.)* Ah—Don't you stick that thing in me.

HOTEL SCENES

Hotel scenes were also popular, and might be set either in the lobby, where various people are checking in, or in one of the rooms. The most well-known and widely distributed of the lobby scenes is "Sleepwalker Scene," which also goes by the titles

"The Somnambulist" or "Three Door Scene." The stage is set with a registration desk and three functioning doors in the backdrop. Various characters check into their rooms, including a woman who walks in her sleep. The other guests try to lure her into their room, as in this version from the Steve Mills Collection.

Three Door Scene

The Straightman is discovered behind the registration desk. The Comic enters, and wants a room. After a short interchange, which is an opportunity for several jokes, he directs the Comic to the door at the left.

Str: Take the end room there. And by the way, if you need anything during the night, just call me.

The Comic goes into his room, as the Ingenue enters and requests a room. The Comic sticks his head out.

Com: There's plenty of room in here, that is if you want to...

Str: Hey get back in your room.

The Straightman insists there are no rooms available, but when the Ingenue pleads that it's raining terribly, the Straightman relents.

Str: I can give you the end room there. *(Door right.)*

Ing: Well is it a quiet room?

Str: Why do you ask?

Ing: Well, you see I walk in my sleep... and when I do, I always follow the sound of a bell.

Str: Well you'll have nothing to worry about in this hotel, as we have no bells here. And say... *(She starts in door)* If you want any little thing during the night, just send for me.

Ing: And what if I want any big things?

Com: *(Out of room.)* Send for me. *(Exits)*

The Ingenue enters her room. The Juvenile and Soubrette enter, as newlyweds.

Str: Newlyweds eh?

Juv: Uh huh

Str: First night?

Juv: Yes... [for] her.[2]

Com: *(Sticks head out.)* That's what you think. *(Exits.)*

The Straightman directs them to their room, then exits left as the couple heads for the middle door. Before going in, the Soubrette asks the Juvenile to get her a glass of water. He exits right. Once the Soubrette has entered the room, the Straightman returns.

Str: Well, I'd better keep score for these newlyweds.

He puts his eye to the keyhole and gets very aroused by what he sees. The Comic comes out of his room and catches him.

Str: Hmm, rather embarrassing situation for a hotel manager, eh what? (*Bus. rocking with Comic.*) You be a nice boy and I'll give you a tootsie roll. (*Straight exits left.*)

Com: Hmm. If I stick around here I might make a couple of bucks tonight. The very idea of a hotel manager looking into a hotel room. I wonder what the hell he was looking at? (*Peeps in center door.*) Ah, a bird's eye view of my old Kentucky home.

The Comic walks right in the center door. There is a woman's scream, which summons the Juvenile from offstage.

Juv: What's the trouble dear?

Sou: There's a man, I mean a mouse in my room.

The Comic comes running out of the room, and starts for his own room. The Juvenile draws a gun.

Juv: Mouse, hell. It's a rat. (*Shoots at Comic.*)

The Comic holds the seat of his pants where he's been shot. The Straightman has reentered.

Com: He got me.

Str: Where?

Com: Between the coffee pot and the buttered toast.

The Straightman orders the Comic back to his room, insisting that he turn out his light and get to sleep.

The lights go down and music plays, as the Ingenue emerges from her room in her nightgown, as if sleepwalking.

Str: She says when she walks in her sleep, she follows the sound of a bell. Well, I'll find out.

He takes the bell off his desk, rings it, and exits offstage right. The Ingenue starts to follow him. The Juvenile sticks his head through the center door, rings a little larger bell. The Ingenue turns and starts through the center door. The Comic comes out of his room, rings a large bell. The Ingenue comes to his door, and the Comic quickly grabs her and pulls her in. He reappears a moment later, placing a red lantern outside the door, and holds for the—

<div align="center">BLACKOUT</div>

Variants of the scene can be found in both the Gypsy Rose Lee Collection, titled "Four Door Bit" and "Chalk Line Bit," and in the Chuck Callahan Collection under the title "Sleep Walker Scene," which sets the action onto a cruise ship, and "Three Way Door Scene." In "Chalk Line Bit," the sleepwalking girl follows a chalk line that her husband draws between her room and his rather than the sound of a bell. The First Comic returns after they go to sleep, rubs out the husband's chalk line and puts a new one leading to his room, which the Second Comic replaces with one leading to his own. The sleepwalking girl walks into the Second Comic's room. Then a homely girl (or cross-dressed man) enters. The First Comic

sees her and is about to lure her into his own room, when the lights go up. Instead, he chases her offstage.

The sleepwalking motif is used somewhat differently in "The Somnambulist" (Ken Murray Collection). In it, the Straightman's wife walks in her sleep in search of a ruby. She imagines that whatever she lays her hands on is the ruby. The Straightman warns the two Comics that they should not wake her, for she is liable to drop dead. Even if she takes anything from them, they should not be concerned because she will bring it back when she is through with it. The Soubrette appears, walking in her sleep, and takes a letter from the First Comic, and leaves. She returns, takes the Second Comic's money and leaves. Both times, the Straightman tells them not to worry, she will bring it back when she is through with it. The Soubrette returns one last time, takes the Comic by the arm and starts to lead him off. The Straightman protests, "That's my wife." The Comic replies "Aw, that's alright, she'll bring me back when she gets through with me."

Other scenes are set in the hotel rooms themselves. Several use the premise found in "Newlyweds (A)" (Ken Murray Collection) that a newly married couple is given a room already occupied by the Comic. When the husband goes downstairs to get the key, the Comic takes advantage of being alone with the bride on her wedding night.

<div align="center">Newlyweds</div>

A Maid shows the Comic to a hotel room. They flirt, and the Maid gets him all excited, rubbing his chest and stomach, then bids him goodnight, and leaves.

Com: You're leaving me in a hell of a fix. Well I might as well go to bed. There's nothing else today. Good night.

He goes behind a screen, pulls off his clothes and reemerges in long red underwear. Crossing to the bed, he discovers bedbugs. The Comic gets a gun and shoots powder all over the bed and down his pants, then gets into bed and pulls the sheet up over him. At that, the Straightman enters followed by the Juvenile and Soubrette, as a newlywed couple.

Str: Should you need anything during the night, I'll bring it to you.

The Straightman leaves and as couple is about to get into bed, the Soubrette remembers that she forgot the key, asking the Juvenile to get it from the office while she gets undressed. The Juvenile leaves, and the Soubrette goes behind the screen.

The Comic climbs out of bed, takes the pillow from the head of the bed and puts it in the center of the bed, then he jumps back into bed and pulls the sheet over him. The Soubrette emerges in her nightie, goes over to the bed, pulls the sheet up, and screams.

Sou: It's a man.

Com: What did you think I was, a jackass?

Sou: Come on, get out of here. This is my room.

Com: You must be crazy. This is my room.

They are interrupted by the Juvenile, who is heard offstage.

Sou: My husband! Hide! Quickly!

The Comic runs around the stage, tries unsuccessfully to hide behind the hall tree and under the carpet. Finally he runs and jumps into bed while the Soubrette hides behind the screen. Entering, the Juvenile notices the lump in the bed, and concludes, wrongly:

Juv: My wife's already in bed. She's playing with me. I'll fix her. (*Tickles Comic.*) Come on, dear, I see you. (*Tickles again.*) Come and give Papa a nice little kiss.

He pulls the sheet off the Comic, who kisses him. He chases after the Comic, as the Soubrette emerges from behind the screen.

Juv: So you are trying to make my wife, eh?

Sou: Let me explain.

Juv: Explain! I've seen enough.

Sou: But you don't understand, dearie.

Juv: Shut up. I don't ever want to see you again. Send me down for the key so you could be with your lover.

He storms out of the room and the Soubrette begins to cry. The Comic tries to reassure her by explaining that he is better than the other guy, patting her leg sympathetically. She asks him not to. In response, the Comic pulls her over to the bed and climbs in next to her. The 2nd Comic pokes his head out from under the bed.

2nd: Hey, when you get through—send her under here.

BLACKOUT

The Ken Murray Collection contains alternate versions titled "Newlyweds (B)" and "Insane Bride." There is also a version in the Steve Mills Collection titled "Have This Filled, or Newlyweds in the Wrong Room." They are essentially the same up to the point where the husband leaves his wife alone with the Comic. In the tag to "Newlyweds (B)," Betty stares at Jack, who is dressed in his underwear with a hat held in front of him. Jack comments, "If you were a lady, you wouldn't look at me." Betty replies, "And if you were a gentleman, you'd tip your hat." The payoff of "Insane Bride" has a Guard arrive to take the Girl back to the insane asylum. The Comic wonders what to do. A Nance appears from behind a screen, waving a handkerchief and calling, "Yoo hoo." In "Have This Filled or Newlyweds in the Wrong Room," the husband, played by the Straightman, returns apologetic, and the misunderstanding is explained to him. He and the Soubrette leave. Afterward, the Comic discovers the Soubrette's undergarments, which she left behind. He calls down to the desk clerk to have them filled.

Other scenes treat the situation of two parties assigned the same room in quite different ways. "Room 202" (Ralph Allen Collection) opens with the Juvenile and Straightman fighting over a hotel room to which they've both been assigned. While they are arguing, two bums run into the room, get into bed, and throw the covers over themselves. They insult the Juvenile, who leaves in a huff, then cut cards with the Straightman to see who gets the room. The bums win when both draw aces. A girl enters with a bellboy carrying her dog. The bums think they are going to get to share the room with her, but it turns out she's only checking the dog there. They call her

on the phone to make a date with her. A Manicurist enters to give the First Comic a manicure, and the scene closes with patter between the Comic and the Manicurist.

"The Bath Between" (Chuck Callahan Collection) is set up as two hotel rooms with a connecting bathroom. The scene opens exactly like "Room 202" as the Juvenile and Character Man are assigned the same room, only to be driven out by two Comics who hop into bed and pull the covers over them. Once the Comics are alone, they begin arguing over which of them gets the bed. The First Comic discovers that the next room is occupied by an attractive woman and agrees to sleep in the bathtub. His partner locks the door behind him. The Woman's husband arrives, well armed, and heads to the bathroom to wash up. Desperate about being caught, the Comic claims he is the plumber sent to fix the plumbing and his assistant in the next room can vouch for this. Suspicious, the husband goes to the other room, rouses the Second Comic and demands to know the First Comic's occupation. The First Comic tries desperately to cue the Second Comic to say "plumber," but the Second Comic misunderstands. It culminates in a chase through the three rooms involving all four characters. In the end, the two Comics manage to lock both husband and wife in the bathroom, so that the two men each get a bed. Another version of the scene, also in the Callahan Collection and titled "Hotel Dilemmas," is specifically written for the comedy team of Smith and Dale. A version also appears in the Gypsy Rose Lee Collection titled "Bed Room Scene."

A script in the Gypsy Rose Lee Collection titled "Room 202" bears little resemblance to the Ralph Allen version, but is built around a bit that also appears in "Not Yet Henry Not Yet" (Jess Mack Collection). Two comics have checked into the hotel room. Various characters come and go through the room. The First Comic tells the Second Comic that he is expecting the Duchess. She arrives and the Comic offers her a chemise, which she goes offstage to try on. She returns, but has a cape over it. When they are finally alone, the Straightman enters, as the Duke. He pulls out a gun but instead of threatening the Comic, he announces that he has nothing to live for and will kill himself. The Comic asks him if before he does so, he will he tell his wife to take off her cape. He does so finally, and she removes her cape. Seeing that she only has a chemise on, the Straightman orders her to put on that cape. Pulling a big gun from his belt, the Comic says that if she does, he will kill her.

DOCTOR SCENES

Doctors have been a popular figure in folk dramas going back to medieval times and were popular in *commedia*. The humor of the doctor scenes revolves around the discrepancy between the proper (or accepted) behavior of doctors as healers and the self-centered behavior they exhibit in the scenes. In some cases, this is done by having the Comic masquerade as a doctor, or hired on as a doctor's assistant. Instead of behaving in a professional manner, the Comic is driven by libidinal impulses. Naturally, the patients make it worse, coming in with an overtly sexual or seductive attitude. The most famous of the doctor sketches was the version done by the comedy team of Smith and Dale. Their "Dr. Kronkite" routine was famous, and they became the model for Neil Simon's *The Sunshine Boys*, which contains a version of

their vaudeville routine. The title of their routine is also the title of a scene in the Jess Mack Collection.

Dr. Kronkite

The scene takes place in a bedroom where the Straightman is in bed, moaning. His wife accuses him of pretending to be sick so that he can go to the burlesque show. She phones the doctor. Immediately, there's a knock on the door, and the Comic enters, dressed in high hat and frock coat.

The Comic flirts with the Woman. He has a persistent cough.

Wom: You have t.b.

Com: So have you. *(Looking at her breasts.)*

Wom: What do you mean?

Com: Two beauts.

He tries to interest the Woman in his line of rubber goods—hot water bottles...rubber gloves...and so on. She's not interested.

Wom: My husband says he's sick.

Com: Is he helpless?

Wom: Yes.

Com: Good...I'm not. *(He puts his arm around her...coughs.)*

Wom: You have t.b.

Com: We told that joke before.

The Woman finally persuades the Comic to take a look at the patient.

Com: If your husband is very sick, it may be contagious...I advise you not to sleep with him tonight...here's my card...I keep open twenty-four hours a day...how 'bout you?...never mind.

There's comic business in examining the Straightman. The Straightman has a board under his shirt, so that it reverberates when the Comic taps his chest.

Com: You sound like you're wired for sound. Stick out your tongue. *(Str. does so.)* Further...further...further.

Str: I can't, it's hooked on back there.

The Doctor finally uncovers the source of the Straightman's weakened condition—the couple has twelve children.

Com: My advice to you, if you want to avoid having more children is this: before you go to bed with your wife, drink a tall glass of orange juice.

Str: Before or after?

Com: Instead.

After examining the patient, he concludes that the Straightman is suffering from...nothing. The Straightman gets out of bed. The Comic, still coughing, takes his place in bed.

Str: Can I do something for you?

Com: Yes.

Str: What?

Com: Call me a doctor. *(Coughs.)*

<div align="center">BLACKOUT</div>

The Callahan Collection contains a number of doctor sketches that appear to have been specifically written for Smith and Dale, including "Dr. Kronkite's Dental Parlor," "Dr. Kronkite's Sanitarium Scene," and "Dr. Kronkite's Rest Home." These were likely to have been adapted from preexisting scenes.[3]

<div align="center">Dr. Kronkite's Rest Home</div>

Joe Smith is working as Charlie Dale's assistant. Dale, as Dr. Kronkite, brags that he can cut Smith up into sixty pieces, put him back together again so that he will never notice the stitches. Smith doesn't want to work for anyone who will cut him up into sixty pieces.

Dale: You are not afraid are you?

Smith: No, I'm not afraid, but I'm careful.

Dale: You forget, I am the great "Dr. Kronkite."

Smith: Who cares?

Dale: Only last night I was called on a very important case. A lady was sick in bed. I opened her mouth, looked down her throat, and right then I knew she had been eating oysters.

Smith: How did you know she was eatin' oysters?

Dale: I saw the oyster shells under the bed.

Smith: That's nothing. My uncle is a great doctor too.

Dale: Yeh, yeh. Tell me about him.

Smith: My uncle was called on a case. A lady was sick in bed. And right there he knew she swallowed a trolley car.

Dale: How did he know she swallowed a trolley car?

Smith: He saw the conductor under the bed.

Dale shows Smith a book that identifies all the diseases and their cures in alphabetical order. All Smith has to do is look up the cure under the correct letter. Dale is called away, leaving Smith to study the book.

The Nurse enters.

Nurse: Hello. And who are you?

Smith: I'm the Doctor's sister.

Nurse: You mean Doctor's assistant.

Smith: Sister, 'sistant, I'm some relation to him.

She comments that he does not look like the man they were expecting.

Nurse: How old are you?

Smith: Well, first I want to know how old you are.

Nurse: Well to show you I'm a good sport, I'll tell you. I'm in the neighborhood of twenty.

Smith: How long ago did you move from the neighborhood?

Nurse: Come now, tell me: how old are you?

Smith: I am twenty six. I would have been twenty eight, but I was sick two years.

The Nurse persuades him to have a stomach massage. It won't cost him anything, so he agrees.

Nurse: Now the first thing you do is remove your coat, just like this. *(Bus. of taking off coat.)* Take it easy and don't get excited.

Smith: Well if you want to have a good time, go ahead.

Nurse: Now you see, I just want to explain this to you. This is your stomach. *(Bus.)* And this is the pit of your stomach.

Smith: When I got two stomachs, what kind of a guy am I?

Nurse: You place your hand here. *(Puts his hand on stomach.)* And massage it gently just like this. *(Bus. massaging.)* Do you like it?

Smith: I like it, but I can't afford it. Oh, nurse, do me a favor.

Nurse: What is it?

Smith: Let me do it to you. *(Bus. muggs.)*

They are interrupted by the Soubrette, who is looking for the doctor. The Nurse explains that Smith will take care of her until the Doctor comes. She leaves, telling Smith it is his chance to show what he can do.

The Soubrette speaks in French. Since he cannot understand her, Smith can't look up her disease. To one of his remarks, she replies, "kiss ki too," so Smith kisses her. She objects, in English, then explains that she hurt her foot while dancing, and asks Smith to take off her shoe, then her stockings. He tries, but the stocking is attached at the other end. Dale enters and tries to take over, but Soubrette will have nothing to do with him.

Sou: *(To Dale.)* This for you *(Snaps fingers.)* And this for you. *(Same bus.)* And this for your papa. *(Throws the back of dress to Joe.)*

Smith: Papa always gets the best of everything. *(Soub. exits right stage.)*

Dale is angry and tells Smith to stay away from his patients. Smith protests that Dale promised him a chance to practice. Dale replies that they just brought in a new patient, who fell off a scaffold and broke his leg.

Smith: Alright, I'll break the other one.

Dale: Nurse, bring in the patient. *(To Smith.)* And be very careful with your patient. Before you operate on him, give him an anesthetic.

Dale exits as the Nurse reenters, accompanying a patient who on crutches. Smith picks up a club to anesthetize him. The Nurse stops him. Smith goes to the patient, pulls his head back, and looks down his throat.

Smith: I know what's the matter with him.

Nurse: What's the matter with him?

Smith: He needs glasses.

BLACKOUT

Another common role for the doctor is as a mad scientist or eccentric inventor. Usually there is a sexual theme to these scenes. In "Cluck's Sanitarium Scene" (Callahan Collection), the Doctor makes a deal with Luke to pretend to be a cadaver that he brings to life, so he can impress and marry his nurse. Changing into pajamas like those the cadaver is wearing, he is brought to life and must pretend to have the body of a man, but the brain of a baby. Luke acts like an infant, speaking in baby talk. In response, the Nurse acts maternally towards him, taking him into another room, and changing her dress in front of the "baby." Doctor demands that she open the door. Luke sticks his head out and says "Goo goo, da da." The scene appears in Brooks McNamara's *American Popular Entertainments*.

In "Bust Developer" (Ken Murray Collection), the Comic and Straightman discover a satchel that belongs to the renowned Dr. Fingerfutz, the man who invented the famous Bust Developer and Hair Restorer, which instantly grow breasts or restore hair. The Straightman does a sales pitch and a Woman buys a bottle of bust developer. Noticing that the Comic is a bit thin on top, he suggests that the Comic try the hair restorer. The Doctor returns and the Woman angrily accosts him, showing him what his bust developer has done. She opens her coat and shows the hair on her chest. The Comic enters, exclaiming, "Look at what you've done to me!" He removes his hat, revealing two breasts on his head.

"Transformer" (Jess Mack Collection) utilizes the Doctor as an eccentric inventor. In the scene, the Doctor has invented a machine that will cure patients' ills, by transferring their symptoms into a dummy. The comedy takes place when the Comic has to take on the role of the dummy.

<u>Transformer</u>

The stage is dominated by a large electric board, featuring two cords with handles. Two chairs are set up nearby. The scene opens with the Doctor onstage.

Doc: At last, my marvelous invention is completed. Now as soon as the dummy arrives I will test the machine just to see that I haven't forgotten any of the details.

He calls his Nurse and describes his invention.

Doc: You see, Nurse, if any one comes in with any kind of an ailment, I place this cord in the dummy's hand, then I put this cord in the patient's hand. Then I throw on the switch, and the ailment automatically goes from the human body into the body of the dummy. If it works, I will be known all over the world. My name will go down in medical history. Nurse, didn't you see my glasses anywhere?

Nurse: Perhaps they are on your other desk, Doctor.

Doc: Very well, I'll go get them. I can't see a thing without them.

He exits left, and the Comic enters from the right. He embraces the Nurse and tries to persuade her to leave with him for a little "fuddle a duddle." She insists that she must stay, warning him that if the doctor catches him in the office, she will lose her job. Offstage, the Doctor is heard calling her.

Nurse: Oh there's the doctor now. Here, you sit in this chair and don't move. Don't even breathe.

The Comic sits in the chair, looks straight ahead, not moving. The Doctor, who still can't find his glasses, enters and sees the Comic in the chair.

Doc: Oh, I see the dummy has arrived. Now for my experiment. Remember, if anyone calls for a treatment, you call me at once.

He exits, as a doorbell rings offstage. The Nurse goes to answer it.

Nurse: Now remember, don't move. I'll see who this is.

The First Woman enters. She stutters. The Nurse calls the Doctor who returns.

Doc: Oh a patient. Now Miss, what can I do for you?

1st W: Well you see, Doc, I stutter. *(Done stuttering.)*

Doc: Yes, I notice that you do. Do you stutter often?

1st W: No, only when I talk.

Doc: I see, and what business are you in?

1st W: I work in a bird store.

Doc: A bird store. What could you do in a bird store?

1st W: I teach the parrots how to talk.

Doc: Oh yes, is that the only place you have worked?

1st W: No, I worked in a radio station.

Doc: What in the world did you do in a radio station?

1st W: I was an announcer. *(Still stuttering.)*

Doc: Well you sit down right here and I'll give you a treatment.

The Woman sits in the chair opposite the dummy. The Doctor puts one cord into her hand, another into the Comic's.

Doc: My, what a natural looking dummy this is. If it wasn't for the shape of his head, you would swear it was human. Well, here goes.

The Doctor turns on the switch and holds for a count of two, as the machine buzzes.

Doc: Now there we are. How do you feel?

1st W: Why doctor. Oh doctor, I can talk without stuttering. It's wonderful. How much do I owe you?

Doc: Nothing at all. Just tell your friends about my machine.

The Woman exits, thanking him profusely. The Doctor, pleased with his invention, also exits, reminding the Nurse to alert him if another patient arrives.

Com: What the he- he- *(starts stuttering.)* stu-, stu-…I'm going to get out of here.

The bell rings offstage.

Nurse: No, you can't leave now. Get back in that chair. Don't move.

She exits and returns with a Second Woman, who continually scratches herself. At the Woman's request, the Nurse calls the Doctor who reappears.

Doc: What can I do for you?

2nd W: Doctor, I've got the seven year itch and I got it in two days.

Doc: Very well, you sit right down in this chair and we will see what we can do.

The Woman sits in the chair opposite the dummy and the Doctor hooks them up to the machine and turns it on for a count of two.

Doc: Now, how's that? Feel better?

2nd W: Oh Doctor, I feel wonderful. The itch is all gone. How much do I owe you?

Doc: Nothing at all. Just tell your friends about my machine.

The Woman leaves, as does the Doctor. The Comic gets up out of the chair. He starts to stutter and scratch himself.

Com: That's all. I'm through. To hell with this dummy business.

Nurse: Now please don't let the Doctor know you are here. I'll get fired.

The bell rings again and the Nurse goes offstage, telling the Comic to remain in the chair. She returns, accompanied by the Nance.

Nurse: And what can I do for you?

Nance: Nothing you can do girlie. I'm in need of the Doctor.

The Nurse calls the Doctor and tells him there's a man to see him. The Doctor looks at the Nance, who flirts with him.

Doc: Did you say a man?

Nurse: Well he's got pants on.

Nance: Cat. *(Stomps foot.)*

Doc: Well, what can I possibly do for you?

Nance: Well Doctor, I seem to be so girlish. I want to be a big he-man. Every time I pass a pool room all the boys holler whoops, and for what, I don't know. I could scratch their eyes out. And if I were manly I could do it.

Doc: Well, I don't know whether I can do anything for you or not. However I'll try.

The Doctor directs the Nance to sit in the chair, holds out the end of one of the cord.

Nance: Oh Doctor, what a large instrument you have!!

Doc: Put it in your hand.

Nance: Oh Doctor must I?

Doc: Yes, you must. And when I turn the juice on, squeeze it.

Nance: Squeeze it. Oh, Doctor you're a dear. *(Takes cord.)*

Doc: Now I'll put the other one in the dummy's hand.

Nance: The other one? Oh Doctor, do you have two of them?

Doc: Why certainly

Nance: You're lucky, Doctor.

The Doctor tries to put it in the Comic's hand, but the Comic tightens the hand and the Doctor can't get it in.

Doc: Oh, Nurse, I can't seem to get it in. I've been having that trouble lately.

He finally gets it in, and turns on the machine. The Nance wiggles and squirms.

Nance: Oh Doctor. Oh Doctor.

Doc: Well, how do you feel now?

Nance: *(Changes character.)* Say Doc, I feel great. Why you've done wonders for me. I feel like a man. How much do I owe you?

Doc: Nothing at all. Just tell your friends about my famous machine.

Nance: Gee Doc, thanks. I'm going past that pool room and if those guys holler at me, I'll knock them for a row of shed houses.

The Nance exits, as does the Doctor. The Nurse tells the Comic that he can get up. Now stuttering and scratching and acting effeminately, he says:

Com: Listen you, I'm through with women. I wouldn't change places with any queen.

He is interrupted again by the doorbell, and the Nurse tells him to sit back down in the chair. She exits and returns with the Third Woman, who acts very frustrated. The Nurse calls the Doctor, who enters.

Doc: Well, what seems to be your trouble, little lady?

3rd W: Oh Doctor, I'm so worried. I don't know what I'm going to do.

Doc: Just take it easy now, calm yourself. Tell me what is your trouble?

3rd W: Doctor I'm going to have a baby.

The Comic jumps out of his chair.

Com: To hell with that!

Alternately the Comic can fall off the chair in a dead faint.

BLACKOUT

Versions of the transformer scene are also found in the LoCicero Collection, titled "Electric Box," and the Ken Murray Collection, titled "Electric Dummy." Filmed performances include a 1980 HBO special, *Burlesque U.S.A.,* and a 1953 burlesque feature *Peek-A-Boo.* "Electric Box" handles this situation quite differently. The Comic enters suffering from lumbago, which the Straightman cures by attaching the Comic to his electric box. Afterward, the Straightman hires the Comic to operate the machine and the two will split the proceeds. The First Girl enters suffering from spinal meningitis. The Comic gives her the treatment, making numerous sexual innuendoes over the way she takes the handle. He turns the machine on and she starts to shimmy. He continues turning the crank so that the guys in the audience can enjoy it, then forgets to charge her for the treatment. The Ingenue enters, shaking, suffering from St. Vitus' Dance and undergoes the same treatment, much to the delight of the Comic, who forgets to charge her as well. A Second Girl enters, suffering from a terrible toothache. She gets the same kind of treatment, exciting the Comic even more. When she exits, the Comic falls into the Straightman's arms. "How do you feel?" the Straightman asks. "I feel all right, but that guy down there feels like Hell."

COURTROOM SCENES

Another well-known burlesque scene was the courtroom sketch. Featuring a bladder-wielding judge, disrespectful lawyers, and a sexy defendant, it was useful for bringing on the entire cast. The Comic typically appeared as the judge, with the Straightman on hand as the prosecutor. Various other cast members would play defendants and witnesses. Ralph Allen counted some fifteen individual courtroom sketches, all of which, he suggests, derive from a minstrel show afterpiece called "Irish Justice."⁴ The term "Irish Justice" was used in burlesque and other amusements as a generic term for these courtroom scenes, rather than the title of any specific scene.

As Judge, the Comic misuses his authority by browbeating witnesses, attacking the attorneys with a bladder, chasing defendants out of the courtroom and leering at an attractive witness until his bench toppled over. The Cop executes a ridiculous and grotesque dance each time he leaves to bring on another prisoner or fell asleep while a young ruffian shoots up the courtroom. Most scenes featured a sexy witness who performed a cooch dance as she takes her place on the witness stand, letting her skirt ride up on her thigh when she crossed her legs. The action stops as all the men in the courtroom try to look up her skirt. "Modern Justice," from the Ken Murray Collection is illustrative.

<u>Modern Justice</u>

The scene features the 1st Comic as the Judge, the 2nd Comic as the Bailiff, the Straightman as the Prosecuting Attorney, and the Juvenile as the Defense Counsel. The Jury box on the extreme left of the stage is filled with chorus girls. As the curtain rises, the Straightman is discovered by the Judge's bench.

Str: Well, it looks like a busy day in court today, I hope the Judge is feeling good today, then I can handle him better.

Offstage, two gun shots go off. The 1st Comic enters as the Judge and goes behind the bench.

Str: Good morning, Judge, how do you feel this morning?

1st: I feel fine, I just had a couple of shots.

The 2nd Comic enters dressed as a comedy policeman, greets the Judge and sits in the chair downstage right.

1st: What's the first case on the socket?

Str: Docket your honor.

1st: I said socket.

Str: And I say docket.

1st: And I say socket! *(Bladder business.)*

The Straightman announces that the first case involves disorderly conduct. The 2nd Comic is sent out to bring on the Bit Man and a Woman, who gets into the witness chair.

1st: Now what is this case all about?

Str: Well, your honor, it was just like this. Last night this lady went into a theatre in our city to see a picture and relax for a couple of hours. Now as you know, your honor, during the filming of a motion picture the auditorium of a theatre is darkened. While the picture was being presented, this defendant came into the theatre and while there was plenty of empty seats elsewhere, he planted himself right down beside this lady who is the plaintiff. He had evil designs on her, your honor, for suddenly she felt his hand on her ankle.

1st: What, he put his hand on her uncle?

Str: Not uncle—ankle—then she felt his hand on her knee, then he put his hand on her thigh.

1st: Where the hell is that?

Str: Right here. *(Puts his hand away up high on his own thigh.)*

1st: What, way up there? Oh the dirty thing. Go on with the case.

Str: Then all at once he shoved his hand in her—

1st: Stop! Don't forget, you are in the courtroom—

Str: He shoved his hand in her stocking. Now your honor, I demand that you give this man the full extent of the law.

The Straightman crosses to the chair by the table and sits.

1st: Young lady, when you felt this man's hand on your thigh, why didn't you call the police?

Wom: Well, Judge, how did I know he was after my money?

1st: What? Get the hell out of here.

He chases the Woman and Bit Man offstage with his bladder.

1st: What's the next case on the socket?

Str: Docket, your honor.

1st: I said socket. *(He hits the Straightman with the bladder.)*

Str: The next case, your honor, is that of a boy accused of stealing a loaf of bread.

The 2nd Comic brings on the Soubrette dressed as a boy.

Str: Well your honor, this case should be brief, as the evidence is so clear that it is beyond contradiction. Last evening a bakery wagon was passing down the street when this boy before you, climbed into the back of the wagon and stole a loaf of bread. Think of it, your honor, if he steals a loaf of bread at eleven years of age, what will he steal when he is twenty-one?

1st: Doughnuts.

Str: The boy is a common thief. I demand his conviction. I now rest my case. *(Sits in chair slowly. Raspberry sound as before. All mug.)*

1st: *(To Straight.)* One more of those and you're going outside. Proceed with the case.

The Juvenile pleads that the boy stole the bread to keep his brothers and sisters from starving.

Str: Your honor, at home this poor unfortunate boy has nine starving brothers and eighteen starving sisters.

1st: What? Nine starving brothers?

Juv: Nine brothers, your honor.

1st: Why the hell don't they start a baseball team?

Juv: And eighteen starving sisters.

1st: Eighteen sisters. *(Pause.)* Well, they could start a golf course.

The case is dismissed.

An Indian, Chief Potawattomie, is brought on. He is accusing his wife of infidelity and demands a divorce. When asked why, the Chief responds:

Chief: When Indian plant corn, him want corn. When Indian plant rice, him want rice. But when Indian plants Indian and gets Chinaman—him want divorce.

The Comic grants him the divorce and the Chief exits.

The Straightman introduces the next case—that of a girl doing an indecent dance.

Ing: Oh you Judge. *(Grind and bump. She is L. with back to Straight.)*

1st: Some dancer.

Str: I'm surprised at her, your honor. *(Looks at Ingenue's rear.)* You can see that she has been well reared.

1st: What's that?

Str: I say, she is well reared.

1st: Yes, she looks pretty good in front, too. Go on with the case.

Str: Your honor it was in a night club. Everyone was enjoying themselves, when suddenly the orchestra struck up a weird strain, a most seductive melody. The lights went out and when the lights came up, there was this girl on the table in the middle of the stage and while she was doing a most immoral dance, she was arrested. That is the case, your honor.

1st: Well, how do I know it was an immoral dance? The only way I can handle this case is to see the dance. She will have to do the dance right here.

Juv: *(Jumps up.)* But, your honor, I object. That is against the law.

1st: The hell with the law. *(Hits Juvenile with bladder.)* Sit down. I'm the Judge here and I must see the dance.

Str: You are perfectly right, your honor.

2nd: You're dam right, he is.

1st: Young lady, do the dance you did at the night club.

Ing: Aw, go feather your nest.

2nd: You've got to do it.

Ing: Sez you!

The 1st Comic comes down from behind the bench, carrying a seltzer bottle, hidden behind him.

Str If you don't do the dance, it will be contempt of court.

Ing: *(To Straight—snapping fingers.)* Oh this for you. *(To 2nd.)* and that for you *(To 1st.)* and that for you!

She flips up her skirt and the 1st Comic squirts seltzer on her pratt.

BLACKOUT

The Jess Mack collection contains a number of courtroom blackouts that could be used in the scene to create variations. In "Nudist Courtroom," a man is brought in for indecent exposure. He isn't wearing any pants. The judge questions him and the man replies that he has been married for two years, and has nineteen kids. The judge dismisses the case.

Atty: But judge, you saw for yourself he wasn't wearing any pants.

Judge: Married two years and having nineteen kids, that guy never got a chance to put his pants on.

In "Disturbing the Peace," the Prosecuting Attorney announces—

Atty: While walking through the park yesterday, I came across a couple, stark naked, behind some bushes who were indulging in sexual intercourse.

Judge: What did you do? Join them?

Atty: No, I yelled and scared them away.

Judge: For that I now fine you twenty-five bucks.

Atty: For what?

Judge: For disturbing the piece.

In "Intercourse with a Ghost," the Judge is asked to rule about a case of a child born to an old maid who claims the child was conceived through intercourse with a ghost. He has never heard of such a thing, but asks the audience if there is anyone who has had intercourse with a ghost. A man in the audience responds, "Yes, me." He's brought up onstage and the judge asks, "Now tell me, did you ever have intercourse with a ghost?" "Oh, excuse me, your honor, I thought you said goat." The judge chases him offstage with a bladder.

In "Rust," the case on the docket is a man whose wife gave birth to a red-headed baby. He claims that he is not the father. Under questioning from the Judge, he reveals that no one in his family or his wife's family has red hair.

Judge: Let me ask you a personal question. How often do you make love to your wife?

Man: Twice.

Judge: Twice??

Man: Yes, once in the winter and once in the summer.

Judge: This man makes love to his wife twice a year. His baby doesn't have red hair!!!

Str: What is it?

Judge: That's rust.[5]

Other collections contain courtroom blackouts. In "Pleasure Farm" in the Ken Murray Collection, the Straightman is in court prosecuting the Second Comic and the Juvenile, who are both Nances, for trying to pick up sailors at the navy yard. The Judge declares them not guilty, in a very nancy voice. In "Naval Doctor" (LoCicero Collection), a girl who comes into court claims she visited a the doctor to have her tonsils removed, but he operated on her appendix. "He also took off all my clothing until I looked just like this," she says opening up her coat with her back to the audience. The Doctor replies that his excuse for operating on her stomach was that he's a naval doctor. Judge chases him off-stage, then observes that it's a good thing he wasn't a rear admiral.

LONGER COURTROOM BITS

"Westfall Murder Case" features a sexy defendant accused of killing her husband. It was featured in *Sugar Babies* in a somewhat truncated version. In the original script in the Allen Collection, various characters come into courtroom testifying in the case of a woman charged with shooting her husband. The first witness is Jimmy Muggs, a tough newsboy, who heard the shots. The Judge dismisses him, and Jimmy shoots up the courtroom as he leaves. Second witness is Mrs. Mariooch Guisseppi, who was selling fruit downstairs from the murder. The final witness is the defendant, Mrs. Westfall, a sexy woman who gets the eye from all the officers of the court. She testifies that her husband wanted her to get out of bed and make him some buttered toast and coffee. This led to an argument and a scuffle, during which she grabbed a revolver and shot him between the buttered toast and the coffee. A little lower, the Judge comments, and she would have hit him in the percolator. The scene is found under the title "Westfall Murder Case" (Ralph Allen Collection), "Shooting of Mr. Westfrall" (LoCicero Collection), and "Evidence Scene" (Callahan Collection).

"Wise Child Court," which according to "Pigmeat" Markham was the source of his renowned "Here Come The Judge," involves a case between two men, each claiming to be the father of the child.[6] Each testifies about a sexual encounter with the mother. The Judge decides to let the child pick the father. She picks out the Judge. Versions of the script are found in four of the collections under the titles "Wise Child Court" (Allen Collection), "Judge Scene" (Chuck Callahan and Gypsy Rose Lee Collections), and "Courtroom Scene Kid Case" (Steve Mills Collection).

In "42nd and Broadway" (Steve Mills Collection), the Comic is hired by an unscrupulous lawyer in a messy divorce case to testify that he was standing on the corner of Forty-Second and Broadway when he saw the woman hit his client. The Comic keeps jumping up at the wrong moment, getting himself entangled in the battle between the couple, and finally testifies that he saw the client shoot his wife, getting the Judge to try the client for murder. The action is interrupted by physical brawls and dancing. The scene also appears in the Gypsy Rose Lee Collection as "The Divorce" and in the

Anthony LoCicero Collection as "Souse Divorce." A performance of the scene can be seen in the 1957 burlesque feature *Kiss Me Baby*.

"One Man Court" is a tour-de-force for the Comic, who plays the roles of judge, defense, and prosecutor, when the latter two fail to show up in court. The case involves a woman accused of bigamy. A Nance Cop brings on the two men. One is dressed as a Naval Officer, the other as a tough. There is no attorney for the defense, or prosecutor, so the Judge fills in for all of them, switching from one to the other throughout the scene. He hears testimony from the Woman, who tells how her first husband went away to sea and she heard that he had been lost at sea, and that's when she met her second husband. But the first husband returned home and there was a fight. After hearing testimony, Judge acts as Defense Attorney and demands mercy, then switches over to act as Prosecutor. As Judge, he finds her guilty of bigamy and sentences her to jail. The Nance takes woman offstage, and there is a scream and a pistol shot. The Nance returns saying that the Woman killed herself. The Judge asks each man for money for her burial. When the Tough refuses to give, the Judge sentences him to a fine and jail. The Naval Officer is ready with the money, and Woman is brought onstage and reunited with him. The scene is found in both the Mills and Ken Murray Collections.

In "Corn Beef" (Anthony LoCicero Collection), a prisoner is brought on for murdering his wife. He claims to have a good reason. As he tells the story, lights go out except for a spotlight, and he begins to act out the scene. He arrives home after a long day, greets his wife. He's expected corn beef and cabbage. But she hasn't cooked it, and announces she never will. "You can kill me first," she says, so he shoots her. When the scene ends, the entire court is wiping away tears. All agree that he should be acquitted. The Judge acquits him, and promises to take him home for a meal of corn beef and cabbage. The Judge's wife jumps up and says "you'll get no corn beef and cabbage in my home," so the Judge shoots her and calls a local restaurant for corn beef. Two versions of the scene can be found in the Callahan Collection under the title "Bully Scene," in which the reason for killing his wife was that she refused to tie his dress tie for him. Closely related is "What No Beans" (Callahan Collection) and "No Beans" (Gypsy Rose Lee Collection), which takes place at the scene of a murder committed when a man's wife did not serve him beans.

"Women Court Room Scene" (Ralph Allen Collection) features an all-woman jury, as a Judge and attorneys have been assembled to hear the case of the Comic. The jury is ready to convict without even hearing the evidence. The Comic is brought on and the Prosecutor details the charges of how he murdered his aunt and grandmother, and burned down the orphanage. Before passing judgment on him, the Judge asks the Comic whether he has anything to say in his defense. He confesses to all the crimes, but adds that he is about to become a father, whereupon the jury proclaims that the Comic is not guilty and carries him off on their shoulders. The scene also appears in the Ken Murray Collection as "Fair Enough."

"Chambermaid Court" (Jess Mack Collection) features the Comic in a cross-dressed role as a hotel chambermaid who is testifying in court about a murder that she witnessed. The bit is built around misunderstanding the words. The Prosecutors keeps using big words, which the Comic regularly misunderstands in a sexual way. There are two versions of the scene in the Ralph Allen Collection as well, both bearing the title "Carrie Potts."

14. The Appeal of Burlesque Comedy ⟶

The primary focus of this study has been to show how these scenes worked in performance, how they supported a style of playing that relied not on written scripts, but on a remembered tradition. In that, we have focused largely on how these scenes served the needs of the performers. But these scenes and sketches survived and were passed on only to the extent that the material resonated with its audience. People went to the burlesque show for a variety of reasons, and few attended primarily to watch the comics. Most men went to be aroused sexually by the sight of scantily clad women moving seductively and invitingly. However, gay men were a presence at burlesque shows, and straight women also attended. The Minskys catered to slumming parties of well-to-do New Yorkers, tourists, and intellectuals—who were attracted as much by the audience and by the opportunity to engage in something naughty as by the show. During the Depression, a good many men attended simply to sleep or to get in out of the weather. But if the burlesque show attracted a wide range of people, it was primarily an entertainment for working-class men, promoted as the "poor man's musical comedy." It is in its relationship to class and male gender identity that burlesque comedy needs to be considered.

In his study of early twentieth-century film comedy, *What Made Pistachio Nuts?*, Henry Jenkins argues that humor is class-based and observes that there were two dominant comic aesthetics in the early decades of the twentieth century. The first was a tradition of "thoughtful" laughter, which stressed the propriety of humor, and came from the position that comedy serves a serious purpose. Such laughter is restrained and tied to a desire to come across as thoughtful, respectable, and refined. In this view, expressed by Henri Bergson among others, humor is meant as a social corrective, drawing attention to the imperfections of others.[1] Pitted against this was the "New Humor," which questioned the need for a higher purpose and considered audience response *the* tangible measure of the quality or effectiveness of a joke. This humor played on the audience's emotions more than the intellect, and the objective of the performer was "to manipulate the audience to the point that they suspended conscious thought and simply felt."[2]

These two forms, Jenkins argues, expressed something more than aesthetic preferences; they reflected particular class interests. Refined laughter was a source of social distinction. "High comedy demanded the experience of actual superiority and was therefore reserved for a higher class audience," Jenkins writes, while "low comedy offered only an illusion of superiority, the only type available to those of low intelligence and poor social position."[3] Sophisticated comedy reaffirmed the audience's intellectual

or social superiority, while low or vulgar comedy provided emotional and psychological release. This "New Humor" began to be commented on around the turn of the twentieth century.[4] Some pointed to the influx of Eastern European and Mediterranean immigrants during this period as the source of this more aggressive humor. Jenkins accurately observes that this aggressive style of humor goes back to the nineteenth century, where it was found in variety halls and saloon entertainments. "Materials previously restricted to the masculine culture of the saloons and the oral discourse of the ghetto were now gaining national prominence through the industrialization of amusement," he writes.[5]

While the immediate source for this more aggressive style of humor may be found in saloon entertainments, as Anthony Caputi has observed, low comedy, or what he calls "buffo," evolved "from an extended background of European folklore."[6] "Vulgar comedy has many origins," he writes. "There is a network of continuities and discontinuities leading from antiquity to the Renaissance, or more accurately, a series of emergences and re-emergences, births and rebirths, with the dramatic forms which crystallized in antiquity exerting now a major and now a minor influence."[7] This is closely tied to traditions of revelry and festival. These "revel backgrounds are crucial in explaining the frenzy, energy, violence, and ugliness of vulgar comedy," Caputi asserts.[8] Festival plays and entertainments exploit a principle of generating a high level of excitement. In such entertainments, "comic excitement is produced both by the use of the familiar formulas and by stimulating comic suspense repeatedly until excitement approaches frenzy," he asserts.[9]

This revel tradition connects the burlesque stage to the carnival world of the Middle Ages and to Mikhail Bakhtin's ideas on the carnivalesque. In *Rabelais and his World*, Bakhtin showed how the medieval peasantry drew upon an established "culture of folk humor" to resist the church-dominated official order by creating a world outside of officialdom. During carnival time, the peasantry was able to experience, at least temporarily, a "utopian realm of community, freedom, equality and abundance."[10] The rituals and protocols of carnival were based on laughter and were sharply distinct from official rituals, which were conducted with great seriousness and decorum. Carnival was, Bakhtin argued, "a second world, a second life outside officialdom," which was "to a certain extent a parody of the extracarnival life, a 'world inside out,'" during which "all hierarchical rank, privileges, norms and prohibitions" were suspended.[11] Bakhtin's ideas are not confined to the medieval carnival, but have meaning for a wide range of festive practices in many different cultures and historical periods. As Stallybrass and White point out, "the main importance of [Bakhtin's] study is its broad development of the carnivalesque into a potent, populist critical inversion of all official words and hierarchies in a way that has implications far beyond the specific realm of Rabelais studies."[12]

For those on the lower orders of society especially, festivity and revelry have an important function, providing them with an escape, a temporary liberation from the prevailing social order. An important feature of this carnival world is that people do not simply view it, they are a *part* of it—"carnival does not know footlights, in the sense that it does not acknowledge any distinction between actors and spectators," Bakhtin writes. "Carnival is not a spectacle seen by the people; they live in it, and everyone participates because its very idea embraces all the people."[13] Through participation in such festive rites, the people and the world itself are revived.

The experience Bakhtin describes corresponds to the phenomenon anthropologist Victor Turner labeled *communitas*. Communitas represents "the spontaneous, immediate, concrete as opposed to the norm-governed, institutionalized, abstract nature of social structure."[14] There is an existential quality associated with communitas that "involves the whole man in his relation to other whole men," meeting not in their social roles and the hierarchy that implies, but in what may be called a "free and easy" spirit of fellowship. Turner calls this phenomenon "anti-structure," for it emerges "where social structure is not."[15] It "breaks in through the interstices of structure, in liminality; at the edges, in marginality; and from beneath, in inferiority."[16]

THE BURLESQUE COMIC AS TRICKSTER

It is within the context of this working-class, festive environment that the burlesque comic needs to be understood. Clown figures have been associated with ritual and revel in a wide variety of cultures, where they are characteristically agents of "disorder."[17] Clowns typically express outlooks and attributes that are devalued or tabooed in the culture—representing the inverse of the most deeply held values and beliefs of a society. Thus clowns are stupid, deceitful, or cowardly; they engage in antisocial behavior; and they behave with little regard to the consequences of their actions. They live in a perennial "now" where they respond to immediate needs and desires, with little concern for propriety or awareness of possible repercussions. These are qualities frequently projected onto marginalized groups in a society, as Christie Davies has shown in his studies of ethnic joking.

Comedians in America utilized prevailing stereotypes of immigrants, rustics, and lower-class types to create their stage personas. While there is a tendency, today, to view such comic characterizations as inherently racist and demeaning, it is more complicated than that. As Paul Antonie Distler argued, "these burlesque characters possessed little, if any, of the censurious or punitive overtones that sometimes are found in satirical caricature or burlesque."[18] Something different takes place when a comedian *takes on* the role of the ludicrous outsider than when he makes jokes *about* them. The audience is asked to identify, in some way, with this marginal figure, this figure of disrepute. No longer is the audience simply making fun of "the other," they are identifying themselves with the low outsider. While the negative judgments adhere to the character, the comic also brings a certain sympathy and identification to the role. It is through the audience's identification with the outsider figure, Turner observes, that they are led to the experience of communitas. "In the closed or structured societies, it is the marginal or 'inferior' person or the 'outsider' who often comes to symbolize...the sentiment for humanity, which in its turn relates to the model we have termed 'communitas.' "[19] While the characters changed over time, the burlesque comic remained the embodiment of a lower-class point of view. He remained a marginal figure, decidedly, even aggressively, working class in his outlook. He remained unassimilated into the culture, defiantly so.

The burlesque comic can be understood as a classic trickster figure that appears prominently in comic tales in a wide range of cultures. It is suggested that tricksters exemplify that which is "between what is animal and what is human, what is natural and what is cultural...for at the center of his antinomian existence is the power

derived from his ability to live interstitially, to confuse and to escape the structures of society and the order of cultural things."[20] The trickster is a figure unassimilated into the society, who lives on the margins and who is in touch with the animal drives. The burlesque comic is a trickster that has been moved from a rural or small-scale society into an urban environment. The scenes reflected the lives and concerns of these working-class men, portraying life in the lower-class districts. They enacted the failures and frustrations low-status men encountered in their daily lives—confrontations with legal authority on the one hand, and exploitation by crooks and con men on the other. At the same time, the burlesque comic resisted assimilation, delighting in bringing down the social order. Even in those scenes where the comic takes on the role of judge or teacher or dramatic actor, he remains unassimilated.

THE COMIC'S TECHNIQUE

The comic's role is much more than simply telling funny stories and making wisecracks. He is more accurately a "master of the revels" who manipulates the performance situation itself. Although burlesque comics certainly employed jokes and witticisms, they were told within a broader setting, and as part of a larger arsenal of laughter-producing techniques.

Humor can be said to operate on three psychological dimensions—the cognitive, the affective, and the motivational. The cognitive dimension relates to our ability to perceive, create, and comprehend humor, and is addressed by the incongruity theory of humor. The emotional dimension connects humor to a happy, cheerful, and playful mood. Such a mood provides a low threshold for laughter. The motivational dimension relates to the sorts of things a person laughs at or finds amusing, and this usually has either a hostile or obscene intent. Where humor and laughter are concerned, these three phenomena are bipolar. The comedy or the spark that ignites laughter is the *shift* between the two poles.

We have discussed Victor Raskin's theory that a joke shifts between two scripts and that these scripts are opposite in some way. A similar shift takes place on the emotional level. Despite Henri Bergson's suggestion that "laughter has no greater foe than emotion," and that highly emotional souls have little in the way of a sense of humor, others have found the emotions play an important role in humor.[21] D. H. Monro observed that "we laugh whenever on contemplating an object or a situation, we find opposite emotions struggling within us for mastery."[22] It can be from a positive view of a situation to a negative view or, more often, from a negative emotion to a positive one. On the motivational dimension, expressed by the superiority theory of humor, laughter was a "sudden glory arising from some sudden conception of some eminency in ourselves; by comparison with the infirmity of others or with our own formerly."[23] It is similar to the emotional high that people experience in winning closely fought sports and games. In order to create this kind of high, a game must be closely contested, coming to "a sudden conclusion, resulting in a victory for the winner and a defeat for the loser."[24]

Different types of humor emphasize one of these processes more than the others. Jokes represent just one of the sources of humor, as Freud observed. Freud distinguished between three sources of comic pleasure that he labeled *wit, the comic,* and *humour.*

Like most humor theorists Freud concentrated on the laughter produced by jokes—what he called *wit*. Freud views *wit* as an indirect expression of repressed urges. It is related to basic human drives of aggression and sex, and the fact that people normally repress these impulses. Jokes allow us to exploit something ridiculous in our enemy, whether it be a person or an institution, to evade these restrictions.

Freud makes a clear distinction between jokes and what he terms *the comic*. Whereas jokes play with our thought processes, the *comic* is often based on nonverbal sources of pleasure. Devices for making people comic include "putting them in a comic situation, mimicry, disguise, unmasking, caricature, parody, travesty and so on."[25] Comic pleasure comes not through the expression of repressed hostility, but through a sudden release from restrictions. Individuals who enjoy this kind of humor are likely to be ones who are readily able to regress to a "childish" or less serious frame of mind, and to cast off the restrictive roles of adulthood.

In the body scenes, we see the aggressive and disruptive side. The comic creates chaos in the courtroom, the schoolroom, and other institutions. His hostility is not directed at other people, which might be too much of a threat to the audience, but against those figures above them in society—professional people, powerful institutions—where the hostility of the audience might be expected to be directed. In these scenes "the pleasure arises from the economized and transformed indignation."[26]

Humour is closely related to the *comic*, according to Freud.[27] It occurs in situations in which persons would normally experience emotions such as fear, sadness, anger, or pity, but an awareness of incongruous or ridiculous elements in the situations provides them with an altered perspective of the event that circumvents these negative feelings. He notes that

> humour is a means of obtaining pleasure in spite of the distressing affects that interfere with it…The conditions for its appearance are given if there is a situation in which, according to our usual habits, we should be tempted to release a distressing affect and if motives then operate upon us which suppress that affect.[28]

Humour largely depends on the audience being able to identify with the person in the predicament.

These correspond to the three dimensions—motivational, cognitive, and emotional—*wit* is primarily involved with drives and their inhibition, *the comic* plays on the discrepancy between perceptions and thought, and *humour* arises out of the conflict between positive and negative emotions. Although burlesque comics made use of jokes and witticisms, it is the sources of laughter in what Freud terms *humour* and *the comic* that has greater application and meaning for burlesque comedy. These sources of humor rely less on words and humorous expression, and more on the comic's ability to reframe what the audience *sees* and *feels*. These are not necessarily carried by the words on the page, but on the ability of the performer to convey his feelings and intent.

Humorous pleasure arises, Freud suggests, when we would be tempted to release a distressing affect, but other motives operate in such a way that suppress that affect. "The most favorable condition for the production of comic pleasure is a generally cheerful mood in which one is inclined to laugh," Freud writes, adding that "jokes,

the comic and all similar methods of getting pleasure from mental activity are no more than ways of regaining this cheerful mood—this euphoria."[29] Max Eastman also found a "close connection between funny and disagreeable."[30] Within the context of the play or revelry, "every untoward, unprepared for, unmanageable, inauspicious, ugly, disgusting, puzzling, startling, deceiving, shaking, blinding, jolting, deafening, banging, bumping, or otherwise shocking and disturbing thing, unless it be calamitous enough to force them out of the mood of play, is enjoyable as funny."[31]

In creating a mood of playful revelry, the comic was by no means alone. The music, the dance, the spectacle all contributed to a festive spirit, while the sexual nature of the burlesque show helped release the audience's inhibitions and permitted them to laugh at things they might not otherwise find funny. He was also helped by the audience's expectations of being amused. Simply visiting a burlesque house or having seen the comedian before could produce such an expectation. While wit produces laughter by momentarily evoking then eliminating the inhibitions against hostile or sexual feelings, the comic produces laughter by eliminating the cognition or forethought. Body scenes are close to what Freud identifies as *the comic*.

The situations presented in the "scenes in one" are about arousing then dispelling negative feelings, particularly those of failure, pain, and humiliation. In his social relations, the comic nearly always comes out on the losing end. Despite his sexual appetites, the comic is a notable failure with women. When he approaches one for a kiss, not only is he rejected, but she will call the police and, in the end, walk off with his bankroll. The results are an exaggeration of what would happen to the ordinary man on the street, but it does confront real issues facing low-status men in twentieth-century society. The comic's relations with other men are no more successful. He is regularly outsmarted by the straightman, played for a sucker in bets that seem to be a sure thing, and taken a second time when he tries to pull the same stunt on somebody else. Physically he is no match for men or women. Strangers on the street assault him for no apparent reason. Cops haul him off to jail, except when he is trying to get in there. Then he is ignored.

There is something in a comic performance that both arouses and dispels the negative feelings. One important reason those feelings are dispelled, Freud points out, is the attitude of the person involved. When the person directly involved does not take it seriously, "pity is inhibited because we understand that he, who is more closely concerned, makes nothing of the situation."[32] This "economy of pity," Freud observes, is one of the most common sources of humorous pleasure. Audiences in a burlesque show were not lulled into suspending their disbelief, for the comedians regularly broke the fourth wall to acknowledge the audience. Moreover, the Comic's exaggerated makeup and ill-fitting and outlandish costumes underscored the theatrical nature of the event.

Another way in which comics—in burlesque and in other entertainments—are able to reduce the pity that is felt is by treating the situation as a game. Many scenes are set up with a clear-cut winner and loser in the situation. In betting scenes, the comic does not seem to worry about losing everything, since he has a huge wad of stage money. This allows him to detach from the situation, to step outside of the game and comment on it either to the audience or to one of the other players. When he is trying to pick up the soubrette, the comic frequently makes side-comments to

the straightman, or asks him for advice in picking up the girl. The comic is able to shift from inside and outside the situation, thereby shifting the audience's perspective and provoking laughter.

Laughter, John Morreall points out, results from a pleasant psychological shift, from a negative to a positive view of a situation. This psychological shift can take place on one of three dimensions—the cognitive, the emotional, and the motivational. A joke naturally does this—shifting from one script in the set-up to a second script in the punch line. "Individuals with a strong sense of humor have the ability to rapidly shift their frame of reference or perspective on a situation," Rod Martin observes.[33] A joke shifts our perspective once; the set-up creates one expectation, which is shattered by the punch line. A blackout does essentially the same thing. In a longer scene, the comic takes us back and forth a number of times during the course of the scene. This is often done by setting up two different scenarios—it can be a scenario of winning and losing, one involving ambiguity or misunderstanding, or one based on exaggeration or burlesque.

In order for the negative emotions to be evoked however, the comic must have something at stake in the scene. In some cases, this is clearly set up in the situation. In scenes of adultery, for example, there is the comic's anticipation of climbing into bed with the woman. But he also confronts the threat of a husband walking in and extracting his revenge. This sets up a clear-cut life and death struggle.

The comic had to be able to create a sense of revelry and play. As Max Eastman observes, "things can be funny only when we are in fun," and notes that "'being in fun' is a condition most natural to childhood, and that children at play reveal the humorous laugh in its simplest and most omnivorous form."[34] Many comedians access the child within themselves, or project a childlike quality, to find that sense of exhilaration one finds in play activities. Onstage, the comic had to be able to project an innocent lightheartedness—often in the face of adversity.

A GENERATION OF COMIC PERFORMERS

Putting over a comedy scene is a complicated process, and different scenes require different approaches. What works for one type of scene may not work for another. In scenes based on ambiguity or a misunderstanding, such as "Who's On First," the comic must maintain his view of the situation for the misunderstanding to work. He must shift his perspective in other ways. In others, such as those involving betting or trickery, he must be able to step outside of the situation, then step back in.

A comic discovers what to do in these situations largely through trial and error, copying what other people have done, but adapting it to his own personality. This, of course, takes time and experience in front of an audience, and different performers find that different scenes work best for them. This was the great strength of the burlesque stage, and why so many skilled comedians developed out of it. They had the opportunity to observe experienced comics perform these scenes, often working alongside them in smaller roles, and learned how a particular bit was to be put over. They were challenged to do these scenes again and again in front of a variety of audiences in a variety of circumstances. They developed a comic persona that they used not just in burlesque but in films, television, and legitimate shows. And they acquired

a large repertoire of comic bits and scenes that served them in a variety of circumstances. By World War II, theatre critics and commentators were looking back on this generation of comic artists with a sense of nostalgia. *The New York Times Magazine* ran several articles during the 1940s commenting on the dearth of comedy talent. Bernard Sobel penned a piece called "The Lack of Comedians is No Joke," in which he complained that "the art of American stage comedy...is largely dependent on a handful of elderly men...There are few young comedians on their way up to carry on the traditions."[35] In "Lament for the Age of Clowns," Lewis Nichols wrote that "younger comedians for the most part are of radio, or they hope to be. They scorn the baggy pants, the glasses and the huge cigar; they rely alone on their voices and the stable of writers in the background. They are jokesters rather than jesters."[36]

The market for comedy had changed, as radio became the measure of success. Burlesque, now banned in New York City, no longer provided the opportunity to be seen by Broadway producers and casting agents. Young comics coming up worked the nightclubs—like those on Fifty-Second Street in New York City, where top-flight strippers such as Sherry Britton appeared nightly, since the ban on burlesque did not apply to nightclubs. In the clubs, a standup comedian could be just as risqué as in the burlesque shows, but nightclubs had a sheen and a high enough cover charge to make this material seem sophisticated, not crude.

The older generation of comedians were among those most saddened by the change taking place in the 1940s. Fred Allen told an interviewer, "I don't think a comedian can learn much in a night club. He faces the same type of audience every night. Most nightclub audiences react to risqué material and many of the night-club comedians find themselves and their material out of step before a theatre audience."[37] Bobby Clark concurred:

> It's a funny thing that the schooling of one branch doesn't avail in another. This is particularly so with the high-priced café entertainers. They mean plenty in the cafés and nothing on the stage. You'd think they could transfer their stuff to any field that is not too dissimilar. But of all the great café entertainers, the only one I know who could carry a Broadway show all by himself is Jimmy Durante. And that's because he's done it before.[38]

The dearth of stage comedians had a measurable effect on Broadway musical comedies. In the 1920s and 1930s, the comedian was often the star of the show.[39] But in the aftermath of World War II, it was the love story that would dominate, with the comedians relegated to supporting roles.

The difference was a stylistic one—but it was more than that. Ed Wynn put it succinctly when he said, "Comics say funny things. Comedians say things funny."[40] The first was a "gag" comedian, the other a "method" comedian. As Wynn told one interviewer,

> there are different kinds of humor as well as different kinds of comedians. You go to a show and some actor tells a bunch of stories and you howl your head off. Then you go home and tell your family the jokes and they roar with laughter. The chap who tells those stories is what I call a gag comedian. Then you go to another show and again you are amused. But when you repeat what the second actor said, everyone looks blank and

finally you say, "Oh, you have to go down and see that fellow yourself." The second actor is a method comedian. He does not depend upon his material as much as on the way he puts it over.[41]

Burlesque provided an environment where method comics could develop, and gave them the opportunity to hone their stage skills. It was not the only environment, for comics learned their craft in circuses, minstrel shows, tab and tent shows, and small-time vaudeville. They learned it by endeavoring to put over scenes that had been staged hundreds of times before. In order to make those scenes work, they needed something special—they had to develop a personality that connected with the audience. Burlesque provided an environment where young talent could try and fail and try again—an opportunity to appear night after night in front of a wide variety of audiences. It provided them with basic comic situations that had proven their effectiveness over time and, by working alongside more experienced comedians, the tools to put the scenes over. The style of humor in the burlesque houses meant a comic needed to be able to do more than memorize jokes or deliver funny lines. Burlesque forced them to learn the full techniques of the stage, to learn how to put a scene over through facial expressions and personality. It encouraged them to look for and collect comedy bits and jokes that they could make their own.

In a review of Bert Lahr's performance in the stage play *Burlesque*, *New York Times* theatre critic Brooks Atkinson mused,

> The comics who learned their trade in burlesque and vaudeville 25 or 30 years ago had a liberal education in the whole technique of the stage, and in varying degrees most of them can act parts as well as take pratfalls. Comedians of this heroic stature are never jokesmiths clinging desperately to the microphone, but dancers, singers, and acrobats, who can use the whole stage; not talkers, but actors, who know that what you do on the stage is more important than what you say.[42]

This is not to say that burlesque comics were necessarily all that good. As Phil Silvers pointed out, "Most of them were hokey, rigid and vulgar. That's why they stayed in burlesque. The ones who rose out of it were able to build creatively on the basics they learned."[43] Some burlesque comics remained formulaic, never moving beyond the basic routines. But comedians like Phil Silvers and Abbott & Costello show what people with talent and imagination could achieve within this genre.

Notes ❧

PREFACE

1. Allen, "Our Native Theatre," 280.

1 "WHO'S ON FIRST" AND THE TRADITION OF BURLESQUE COMEDY

1. See Anobile, *Who's On First?*
2. Finnegan, *Oral Traditions*, 7.
3. *New York Times* (May 30, 1956), 16.
4. *Billboard* (November 2, 1929), 35.
5. *Billboard* (November 16, 1929), 35.
6. Furmanek and Palumbo, *Abbott and Costello in Hollywood*, 18.
7. Costello and Strait, *Lou's On First*, 27.
8. See Cox and Lofflin, 146. Another comic who did the routine was Steve Mills. About the time Bud and Lou were breaking out of burlesque, Mills and straightman Brownie Sick were doing their version in Los Angeles in *Minsky's Goes to Hollywood*, according to Furmanek and Palumbo, *Abbott and Costello in Hollywood*, 19. A reviewer for the entertainment paper *Zit's Weekly* (August 1, 1936) described their "baseball balled up dialogue."
9. Furmanek and Palumbo, *Abbott and Costello in Hollywood*, 19.
10. Barber, *The Night They Raided Minsky's*, 205.
11. See idem; Fields and Fields, *From the Bowery to Broadway*, 23; Poston, *Burlesque Humor Revisited*, 21.
12. Fields and Fields, *From the Bowery to Broadway*, 22.
13. Poston, *Burlesque Humor Revisited*, 22–23.
14. For more on Irene Franklin, see Slide, *The Encyclopedia of Vaudeville*, 191–193.
15. Gilbert, *American Vaudeville*, 347.
16. McNamara, *American Popular Entertainments*, 92.
17. Susan Mills, personal communication. Rowland Barber refers to the routine as "Nuttin' for a Living" and attributes it to the comedy team of Shelton and Howard (205).
18. "Who and Die," Ken Murray Collection. The character name Yule probably refers to comic Joe Yule, the father of Mickey Rooney.
19. McNamara, *American Popular Entertainments*, 11.
20. Allen, "Our Native Theatre," 281.
21. Barber, *The Night They Raided Minsky's*, 202.
22. Allen, "Our Native Theatre," 276.
23. Furmanek and Palumbo, *Abbott and Costello in Hollywood*, 79.
24. Ibid., 114.
25. Ibid., 224.

26. Unidentified Clipping in Rags Ragland Clipping File, New York Public Library, Lincoln Center.
27. Furmanek and Palumbo, *Abbott and Costello in Hollywood*, 243.
28. Burlesque Conference, UCLA, 1993.
29. Furmanek and Palumbo, *Abbott and Costello in Hollywood*, 39.
30. Costello and Strait, *Lou's On First*, 28–29.
31. See "Over the River, Charlie" in McNamara, *American Popular Entertainments*, 120–124.
32. Ibid., 19.
33. Rags Ragland Clipping File, New York Public Library, Lincoln Center.
34. Barber, *The Night They Raided Minsky's*, 203.
35. "The Baseball Rookie," *Steve Mills Collection*. "Baseball Scene," *Jess Mack Collection*. "Who's On First," *Ken Murray Collection*.
36. Outfielder positions vary from one script to another. The Jess Mack version has "Izzy/Is he" in right field. The Ken Murray version has him in left field. In both versions, the other outfielders are "Why" and "Because."
37. "Who's On First," *Ken Murray Collection*.
38. Robert Orben reports "When [Abbott & Costello] played the London Palladium in 1953, they were faced with the problem of British theatre-goers unfamiliar with out national sport. So they changed the whole routine from the names of a baseball team to the names of the musicians in the pit orchestra. Who became the leader, what the drummer, Tomorrow the piano player. And when Costello asked in utter confusion, 'Who's the leader?'—and Abbott shot back, 'That's right!'—the belly laughs were just as big as back home" (*If You Have to Be a Comic*, 48).
39. Silvers and Saffron, *This Laugh Is On Me*, 51.

2 THE ORAL TRADITION AND THE POPULAR STAGE

1. One widespread scene is "Buzzing the Bee," which Dario Fo describes in his book *The Tricks of the Trade*, 174–175. The same scene is included in Paul Harris, *The Pantomime Book*, 64–66. The scene was also used by medicine showmen in America and is performed in *Free Show Tonight*, a reenactment of a traditional medicine show by surviving members of the profession. It is also featured in two burlesque films—*Hollywood Burlesque* and *Strip Strip Hooray*.
2. Nicoll, *Masks, Mimes and Miracles*, 41.
3. Zeidman, *The American Burlesque Show*, 203.
4. Imhof, "Advanced Burlesque," 2.
5. See Moody, *Dramas of the American Theater*, cited by Allen, "Our Native Theatre," 276, 275; see also Gorer, *Hot Strip Tease,* 50; McLean, *American Vaudeville as Ritual*, 3.
6. Abrahams, "Folk Drama," 352.
7. Brunvand, *The Study of American Folklore*, 7.
8. Ibid., 9; italics in the original.
9. Ibid., 7.
10. Ibid., 8.
11. Ibid., 9.
12. Finnegan, *Oral Traditions*, 38.
13. Tolken, *The Dynamics of Folklore*, 39.
14. Ibid., 38.

15. Brunvand, *The Study of American Folklore*, 9.

16. Ibid., 7.

17. Ibid., 9.

18. Dorson, "Is There A Folk In The City?" 32–79.

19. Brunvand, *The Study of American Folklore*, 39. In the fourth edition he changed the words "nearly extinct" to "rather rare."

20. See Burson, "Model and Text in Folk Drama," 309–310.

21. Sobel, *Burleycue*, 162.

22. Allen, "At My Mother's Knee," 48.

23. Wilmeth, *The Language*, 96.

24. Page, *Writing for Vaudeville*, 28–29.

25. Gilbert, *American Vaudeville*, 47.

26. See Hixon and Hennessee, *Nineteenth-century American Drama*.

27. See Leavitt, *Who Died First?* On Bob Ferguson and Mary Murray, see *Cavalcade of Burlesque* (March 1954), 17. Both the Ralph Allen and Steve Mills Collections contain scripts of "Who Died First?"

28. Eddie Ware and Charley Crafts perform the routine with other cast members in the 1951 burlesque feature *Ding Dong* (or *A Night at the Moulin Rouge*). As "Razor Jim," the scene featured a razor-wielding black man who drives the auditioners from the theatrical manager's office. Eddie Ware chases them out with a broom. Interestingly, the character of Edwin Booth persists in the twentieth-century version. For more material on "Razor Jim," see Conner, *Steve Mills*, 118–119; Isman, *Weber and Fields*, 89; and Kahn, *The Merry Partners*, 120.

29. Laurie, *Vaudeville*, 469.

30. Ibid., 469–473.

31. Ibid., 472. The same ruse appears under slightly different circumstances in "The Divorce Scene (B)" in the Gypsy Rose Lee Collection. The ruse is identified in the Aarne-Thompson Tale Type Index as Type 1585 and as Motif K-1655 "The Lawyer's Mad Client."

32. Thompson, *The Folktale*, 10. See also 188–216. Emphasis in original.

33. Degh, "Folk Narrative," 70.

34. These humorous tales are found in the Aarne-Thompson Tale Type Index under "Jokes and Anecdotes," types number 1200–1299.

35. Gilbert, *American Vaudeville*, 47.

36. Allen, *The Best Burlesque Sketches*, 31.

37. Page, *Writing for Vaudeville*, 97.

38. Zeidman, *American Burlesque Show*, 204.

39. Corio and DiMona, *This Was Burlesque*, 133. Also "It's Ladies' Day."

40. *Variety* (January 8, 1930), 10.

41. Lesser, *Top Banana Joey Faye*, 155.

42. Minsky and Machlin, *Minsky's Burlesque*, 48.

43. Ibid., 59.

44. See Barber, *The Night They Raided Minsky's*, 205. Billy K. Wells is one of the few writers who actually wrote burlesque bits. He began as a burlesque comic in the 1910s and became a writer and producer for James E. "Blutch" Cooper on the Columbia Wheel. He later went on write scenes for George White's Scandals and other revues, and was a staff writer on Milton Berle's *Texaco Star Theater*.

45. Minsky and Machlin, *Minsky's Burlesque*, 138.

46. Barber, *The Night They Raided Minsky's*, 205. Emphasis in original.

47. *Billboard* (January 18, 1930), 34.

48. See Anobile, *Who's On First?*, 92–127.

49. "Shuberts," 34.
50. Bud Abbott also worked with Harry Steppe before partnering with Lou Costello.
51. Faye copyrighted it as an unpublished work on June 6, 1942 (D80434). The title is included in Eddie Welch's list of burlesque bits as an alternative title for "Union Bit" [*Billboard* (June 28, 1930), 29].
52. *Billboard* (March 15, 1919), 10.
53. Lahr, *Notes on a Cowardly Lion*, 363–367.
54. *Zit's Review* (September 15, 1934), 7.
55. Matlaw, *American Popular Entertainment*, 70.
56. Ibid., 71.
57. Lesser, *Top Banana Joey Faye*, 263.
58. Ibid., 266.
59. Levi-Strauss, *The Savage Mind*, 16.
60. Ong observes that "oral discourse has commonly been thought of even in oral milieus as weaving or stitching—rhapsoidein, to 'rhapsodize,' basically means in Greek 'to stitch songs together'" (*Orality and Literacy*, 13).
61. Silvers and Saffron, *This Laugh Is On Me*, 50–51.
62. Wilson, "Joey Faye, Skit Collector."
63. Minsky and Machlin, *Minsky's Burlesque*, 138. Elsewhere Minsky estimates there were two hundred basic burlesque bits (206).
64. "Eddie Welch," 29. Eddie Welch was a burlesque skit writer, producer, and performer and for a time produced shows at the National Winter Garden. He died at age fifty-eight on April 8, 1931. See *Variety Obituaries* (April 12, 1931).
65. See the Steve Mills version of "At Midnight." *Ghost in a Pawnshop* was published as a blackface sketch in 1874 by Charles White.
66. Brooks McNamara includes a version of "Over the River, Charlie" by medicine show performer Anna Mae Noell in his collection *American Popular Entertainments*, 120–124.
67. "Rags Ragland."
68. Lee, *Gypsy*, 182.
69. The scene was also performed in the 1962 burlesque feature *Naughty New Orleans* by Harry Rose, Bob Carney, and Jean Carroll and by Jack Diamond and Mandy Kay in the 1953 feature *Striporama*.
70. The play actually toured on the Columbia Circuit during the 1926 season. See also "Ladies Day."
71. See Poston, *Burlesque Humor Revisited*, 88–95.
72. Laurie, *Vaudeville*, 418.

3 THE PRESSURES OF STOCK BURLESQUE

1. Conner, *Steve Mills*, 246.
2. Allen, *Horrible Prettiness*, 3–21.
3. Ibid., 247.
4. Sobel, *Burleycue*, 72.
5. See Slout, *Theater in a Tent*.
6. Gilbert, *American Vaudeville*, 37.
7. Ibid., 50.
8. Allen, *Horrible Prettiness*, 247.
9. Zeidman, *American Burlesque Show*, 115.
10. Ibid., 110.

11. Corio and DiMona, *This Was Burlesque,* 72.
12. "Jazztime Review," 35.
13. Minsky and Machlin, *Minsky's Burlesque,* 33–34.
14. There is no evidence that a raid took place at Minsky's on April 20, 1925, as Barber's book suggests. Since there are many other fictional elements in Barber's account, this must be considered a piece of imagination as well.
15. Other important stock burlesque producers included Arthur Clamage, Avenue Theater, Detroit; Warren B. Irons, Haymarket Theater Chicago and Capitol Theatre, San Francisco; T.V. Dalton, Follies and Burbank Theaters, Los Angeles; Issy Hirst, Bijou, Philadelphia; Mansbach and Frolich, State-Congress, Chicago; Leo Stevens, Academy, Chicago; Jack Christophel, Liberty, St. Louis and Dewey Michaels, Palace Theater, Buffalo. (*Billboard*, January 10, 1931: 24).
16. Zeidman, *American Burlesque Show,* 129.
17. cummings, "Burlesque, I Love It," 292–295; Wilson, *Shores of Light,* 274–281.
18. Cited in Barber, *The Night They Raided Minsky's,* 213.
19. Zeidman, *American Burlesque Show,* 194.
20. Dressler, *Burlesque as a Cultural Phenomenon,* 125–126.
21. Gorer, *Hot Strip Tease,* 51–52.
22. *Variety* (February 3, 1937): 70.
23. *WPA Guide,* 267.
24. Ibid., 170.
25. "Barkers, Posters," 2.
26. Dressler, *Burlesque as a Cultural Phenomenon,* 63.
27. Ibid., 63.
28. Ibid., 62.
29. Minsky, "G-Strings & Top Bananas," 86.
30. "Business of Burlesque," 141.
31. Green, "The Audiences of the American Burlesque Show," 234.
32. Allen, *Sugar Babies,* 52. Several candy pitches have been preserved. See Sobel, *Burleycue,* 259–261; Barber, *The Night They Raided Minsky's,* 294–300; and Minsky and Machlin, *Minsky's Burlesque,* 308–310.
33. Allen, *Sugar Babies,* 53.
34. Dressler, *Burlesque as a Cultural Phenomenon,* 64. See also Sobel, *Burleycue,* 259–261, for another example of a magazine pitch. A magazine pitch has been captured on film and is available on a compilation reel from Something Weird Video, entitled *Chicks and Chuckles.*
35. "Barkers, Posters," 6.
36. "Business of Burlesque," 147.
37. Several examples of these production numbers are available from Something Weird Video.
38. Allen, *Sugar Babies,* 46.
39. Sobel, *Burleycue,* 264.
40. McNamara, *American Popular Entertainments,* 17.
41. Ibid., 17.
42. The program is in the collection of the Museum of the City of New York.
43. Corio and DiMona, *This Was Burlesque,* 165.
44. Zeidman, *American Burlesque Show,* 118–119.
45. She opened at Minsky's Republic Theater on March 30, 1931.
46. *Billboard* (January 30, 1932): 13. Review of January 21, 1932, show at the Republic Theatre.

47. Scrapbook, Steve Mills Collection, Boston Public Library. The contract was for four weeks, with an option for another four weeks, and clearly this option was exercised, for Mills appeared at the Gaiety for a total of nine weeks.
48. Herbie Faye is best remembered for his appearances as a regular on *The Phil Silvers Show*. Milt Bronson made a number of guest appearances on *The Abbott and Costello Show*.
49. Bigelow, "12 Best Strippers," 229.
50. For more on Margie Hart and Carrie Finnell, see Zeidman, *American Burlesque Show*, 151–157.
51. Johnny Kane is also the singer in the Republic Show of April 1, 1932.
52. There are scripts for all of these scenes in Steve Mills's collection.
53. Zeidman, *American Burlesque Show*, 163.
54. Green, "The Audiences of the American Burlesque Show," 229.
55. Dressler, *Burlesque as a Cultural Phenomenon*, 76.
56. Zeidman, *American Burlesque Show*, 177.
57. Wilson, *Shores of Light*, 280.
58. Alexander, *Strip Tease: The Vanished Art of Burlesque*, 69.
59. Ibid., 70–71.
60. Morreall, *Taking Laughter Seriously*, 114.
61. Conner, *Steve Mills and the Twentieth Century American Burlesque Show*, 332.
62. Dressler, *Burlesque as a Cultural Phenomenon*, 144.
63. Ibid., 161.
64. Morreall, *Taking Laughter Seriously*, 114.

4 THE CAST AND CHARACTERS

1. Wilson, "Acting of Comedy," 329.
2. Towsen, *Clowns*, 206.
3. Fools and Numskulls Motifs J1700–J2799; Deceptions Motifs K0–K2399 (Thompson, *The Folktale*, 494–497).
4. Davies, "Ethnic Jokes," 384.
5. Disher, *Clowns and Pantomimes*, 30–33.
6. Sobel, *Pictorial History of Burlesque*, 72–73.
7. Wilmeth, *American Popular Entertainment*, 266.
8. Lesser, *Top Banana Joey Faye*, 205–206. In *The Language of Popular Entertainment*, Don Wilmeth suggests that it may have referred to the banana shape of the bladder that comedians hit each other with.
9. Conner, *Steve Mills*, 259.
10. Silvers and Saffron, *This Laugh Is On Me*, 177.
11. Idem.
12. Idem.
13. Distler, *Racial Comics in American Vaudeville*, 68.
14. Hartt, "The Home of Burlesque," 77.
15. Distler, *Racial Comics in American Vaudeville*, 70.
16. I have found only one comic from the period, Lou Powers, still doing an Irish stereotype.
17. Hartt, *People at Play*, 34.
18. Distler, *Racial Comics in American Vaudeville*, 75.
19. Norris and Nendick, *Denison's Make-Up Guide*, 15.
20. Distler, *Racial Comics in American Vaudeville*, 76.

21. Idem.

22. Shows on the American wheel were strictly segregated. The Columbia wheel featured a number of black-and-tan revues, but segregated the casts. Typically, the white cast performed the first half of the show, while the generally more talented black cast performed after the intermission.

23. Green can be heard performing two comedy sketches from the 1929 production *Hot Chocolates* on the Smithsonian American Musical Theater Series recording *Souvenirs of Hot Chocolates* performing "Big Business" and "Sending a Wire."

24. Gilbert, *American Vaudeville*, 291–292, describes Ben Welch's character as a fast-talking Jewish pushcart type. His brother Joe always played a mirthless Jewish character, who stressed his misery and misfortune.

25. Distler, "Exit the Racial Comics," 247.

26. Drew, "Scripts and Scribes," 21.

27. Dressler, *Burlesque as a Cultural Phenomenon*, 120. At least 30 to 40 percent of the population in the neighborhoods surrounding Brooklyn burlesque houses were foreign-born in the mid-1930s. In Manhattan, the percentage of foreign-born was smaller, but were still heavily represented.

28. Sandberg, "An Interview with Steve Mills," 337.

29. Joe Laurie Jr. writes Harry G. Richmond was the first to do a "tramp" act in 1888 (*Vaudeville*, 322).

30. Gilbert, *American Vaudeville*, 269.

31. Allen, "Our Native Theatre," 282–283.

32. Slout, *Theater in a Tent*, 83–84.

33. MacDonald and Norris, *Dennison's Make-Up Guide*, 14.

34. From *Actors Talk about Acting*. Cited by Lahr. *Notes on a Cowardly Lion*, 47.

35. Lesser, *Top Banana Joey Faye*, 172.

36. See Wahls, "Footlights."

37. There is a misconception that the straightman was the higher-paid member of the team. In fact this does not appear to be the case. In *Billboard* (March 29, 1930, 54), the first comic is paid $125 a week to the straightman's $100. In *Fortune*, the two comics are paid $150 a week, while the straightman receives $50 ("Business of Burlesque")

38. Hugh S. Fullerton eulogized a dead straightman in the *New York Evening Mail*, reprinted in *Billboard* (December 31, 1921).

39. Dolan, "What, No Beans?" 39.

40. Barber, *The Night They Raided Minsky's*, 202.

41. Laurie, *Vaudeville*, 82.

42. Ibid., 83.

43. Dolan, "What, No Beans?" 39.

44. Thomas, *Bud & Lou*, 20.

45. Ibid., 37.

46. Gorer, *Hot Strip Tease*, 86.

47. Dressler, *Burlesque as a Cultural Phenomenon*, 161.

48. Personal communication.

49. Chauncey, *Gay New York*, 13.

50. Significantly, lesbianism is entirely absent from burlesque comedy, despite the fact that a significant percentage of striptease dancers were lesbian, according to studies done in the 1960s. (See McCaghy and Skipper, "Lesbian Behavior.")

51. Poston, *Burlesque Humor Revisited*, 9.

52. Dressler, *Burlesque as a Cultural Phenomenon*, 137.

53. Dolan, "What, No Beans?" 39.

54. Barber, *The Night They Raided Minsky's*, 201.
55. Ibid., 201.
56. Stevenson, "Profiles: Takes," 52.
57. Barber *The Night They Raided Minsky's*, 201.
58. Sandberg, "An Interview with Steve Mills," *Steve Mills*, 340.
59. Dolan, "What, No Beans?" 39.
60. Sandberg, "An Interview with Steve Mills," 340.
61. Dolan, "What, No Beans?" 39.
62. Scheub, "Translation of African Oral-Narrative-Performances to the Written Word." Cited by Finnegan, *Oral Traditions and the Verbal Arts*, 108.
63. Finnegan, "Literacy and Non-literacy," 118.
64. Wilson, *Shores of Light*, 329.
65. Ibid., 331.

5 LEARNING THE BUSINESS

1. Reeves, "Why I Like Burlesque," 39.
2. MacPherson, "Minsky's Gift to Hollywood."
3. Minsky and Machlin, *Minsky's Burlesque*, 222.
4. Orben, *Comedy Technique*, 47.
5. Other remarks about timing: "Timing: in performing and directing the selection of the precise moment for saying or doing something. Timing involves tempo, rhythm and pauses" (Trapido, ed., *International Dictionary*, 883).
6. Hodgson, *The Batsford Dictionary*, 401.
7. Freud, *Jokes and Their Relation*, 118.
8. Minsky and Machlin, *Minsky's Burlesque*, 221.
9. Fernald, *The Play Produced*, 121.
10. Stein, "Radio Today."
11. See Adler, *Jokes*.
12. Minsky and Machlin, *Minsky's Burlesque*, 221; emphasis in the original.
13. Wilmeth, *American Popular Entertainment*, 113; emphasis in the original.
14. Seigel, *Language of Show Biz*, 219.
15. Ibid., 277.
16. Orben, *To Be a Comic*, 49
17. Lahr, *Notes on a Cowardly Lion*, 45.
18. Gilbert, *American Vaudeville*, 272.
19. In the 1950s, Jess Mack was attempting to make sure that various comics on his circuit were not duplicating each other's material.
20. Adams and Tobias, *The Borscht Belt*, 62.
21. Markham and Levinson, *Here Come The Judge!*, chapter 9.
22. Lesser, *Top Banana Joey Faye*, 144.
23. "'Nice Girl' Epidemic," 4.
24. McNamara, "'For Laughing Purposes Only,'" 141–142.
25. Ibid., 142–143.
26. "Gags...Groans...And...Grunts for Ad-Libbing and Padding." Jess Mack Collection.
27. Zeidman, *American Burlesque Show*, 205.
28. Harland Dixon is among the performers featured in *Omnibus* "The Big Wheel."
29. Stearns and Stearns, *Jazz Dance*, 207.
30. Sobel, *Pictorial History of Burlesque*, 73.

31. Corio and DiMona, *This Was Burlesque*, 162. Steer bladder were also used.

32. Markham and Levinson, *Here Come The Judge!*, chapter 2.

33. Alexander, *Strip Tease*, 80.

34. Ibid., 81.

35. Ibid., 79.

36. Alcoholism seems to have been common in the business and is one of the reasons why a burlesque comic never moved out of the business.

37. Minsky and Machlin, *Minsky's Burlesque*, 222.

38. The bit is associated with the comedy team of Arthur Moss & Edward Frye who did a routine called "How High Is Up?" See Laurie, *Vaudeville*, 205. Also Barber, *The Night They Raided Minsky's*, 205 and Lyons, *The Mirth of a Nation*, 232–233.

39. "Handful of Nickels #3" (Jess Mack). The Jess Mack Collection contains several of these bits under the titles "Handful of Nickels" and "Dumb Bit." The lines cited are just a few of the impossible questions that the straightman could fire off at the comic.

40. Alexander, *Strip Tease*, 78.

41. Andrews, "Arte Dialogue," 147.

42. Lord, *The Singer of Tales*, 13.

43. Radlov 1885, xvi–xvii. (Quoted in Foley, *Theory of Oral Composition*, 11.)

44. Parry, *Making of Homeric Verse*, 13.

45. Lord, *The Singer of Tales*, 68.

46. Ong, *Orality and Literacy*, 57.

47. Ibid., 34.

48. Idem.

49. Lord, *The Singer of Tales*, 22.

50. Ong, *Orality and Literacy*, 60.

51. Ibid., 11.

52. Ibid., 25.

53. Ibid., 26.

54. Miller, "Formulaic Composition," 363.

55. Norrick, *Conversational Joking*, 5.

56. Ibid., 14–15.

57. Ibid., 27.

58. Ong, *Orality and Literacy*, 35.

59. For more on Sandy O'Hara and her husband, Dave Hanson, see Stencell, *Girl Show*, 219–220, 230–231.

60. *The Best of Burlesque* was released by Active Home Video (Los Angeles, CA) in 1986 as an Olympus Films International Production. It appears to be a filming of a live stage production, probably in Reno, Nevada.

61. Green, *Clowns of Broadway*, 100–101.

6 BITS AND BLACKOUTS

1. Fitzpatrick, *The Relationship of Oral and Literate Performance Processes*, 34.

2. Ibid., 37.

3. Andrews, *Scripts and Scenarios*, 176.

4. Ibid.

5. Ibid.

6. Ibid., 180–181.

7. Andrews, "Arte Dialogue," 147.

8. Andrews, *Scripts and Scenarios*, 181.

9. Henley, *Writing Radio Comedy* I, 9.

10. Orben, *Comedy Technique*, 23.

11. "Court." In *Gags A to M*, Jess Mack Collection.

12. Wright, *1001 One Minute Black-Outs*, 3.

13. *Playboy's*, 241.

14. Randolph, *Pissing in the Snow*, 29–30. See Ashliman, *A Guide to Folktales*, 292; Legman, *Rationale of the Dirty Joke*, 757.

15. Legman, *Rationale of the Dirty Joke*, 757–758.

16. "Burlesque Entrance Gags #2." Jess Mack Collection.

17. McNamara, *American Popular Entertainments*, 68.

18. Ibid., 25.

19. Kemper was Jess Mack's partner in the late 1930s.

20. Andrews, "Arte Dialogue," 149.

21. Jess Mack Collection contains two variants, "Café Scene" and "Restaurant (Zoop)." Ralph Allen's "Restaurant Scene" is identical to the one in the Jess Mack Collection, an indication that the script itself was being passed around. Other versions can be found in the Callahan Collection—"Restaurant Scene"—and the Ken Murray Collection, titled "Restaurant." Other scenes set in a restaurant include "Tongue and Cheese," "Cut Up and Bleeding," and "Pousse Café"

22. Fitzpatrick, *The Relationship of Oral and Literate Performance Processes*, 9.

23. Olrik, *Oral Narrative Research*, 43.

24. Allen, *Best Burlesque Sketches*, 151.

25. Normally the Girl waters the Comic with her watering can. Margins indicate "Cucumber gag" with no explanation.

26. Margin notes indicates possible blackout on this line.

27. Beaugrande and Dressler. Cited by Fitzpatrick, *The Relationship of Oral and Literate Performance Processes*, 71.

28. Orben, *To Be a Comic*, 8.

29. Reznick, *How to Write Jokes*, 15–16.

30. Bassindale, *How Speakers Make People Laugh*, 89.

31. "Burlesque Entrance Gags #1."

32. Idem.

33. Idem.

34. Wilde, *Great Comedy Writers*.

35. Bassindale, *How Speakers Make People Laugh*, 146.

7 SCENARIOS, SCRIPTS, AND SCHEMAS

1. *Billboard* (September 7, 1929): 44.

2. Foley, *Theory of Oral Composition*, 51–52.

3. Scheub, "Oral Narrative Performance," 347.

4. Van Munching, *How to Remember Jokes*, 5.

5. Ibid., 8.

6. Scheub, *Story*, 14.

7. Ibid., 415–416.

8. Ibid., 14–15.

9. Ibid., 14.

10. Ibid., 94.

11. Ibid., 95.
12. Scheub, "Oral Narrative Performance," 347.
13. Scheub, *Story*, 143.
14. Scheub, "Oral Narrative Performance," 346.
15. McNamara, *American Popular Entertainments*, 21.
16. Henke, *Performance and Literature*, 2; Andrews, *Scripts and Scenarios, 171.*
17. Nicoll, *Masks, Mimes and Miracles*, 27.
18. Ashcraft, *Human Memory*, 344; emphasis in the original.
19. Cohen, *Memory in the Real World*, 76–77.
20. Miller, "Formulaic Composition," 354.
21. Cohen, *Memory in the Real World*, 77.
22. Ibid., 139.
23. Miller, "Formulaic Composition," 377. Emphasis in original.
24. Ibid., 378.
25. Propp, *Morphology of the Folk Tale*, 92.
26. Jason, *Swindler Tales*, 7.
27. Ibid., 9.
28. Dundes, "Lithuanian Folk Tales," 165–174.
29. Dundes, "North American Indian Folktales," 208–209.
30. Other sexual taboos show up in burlesque comedy—homosexuality, necrophilia, and bestiality.
31. Raskin, *Semantic Mechanisms of Humor*, 81.
32. Ibid., 99.
33. Cited in Morreall, *Laughter and Humor*, 47.
34. Cited in Oring, *Jokes and Their Relations*, 3.
35. Morreall, *Laughter and Humor*, 52.
36. Koestler, *The Act of Creation*, 95.
37. Oring, *Jokes and Their Relations*, 3.
38. Ibid., 4.
39. Orben, *Comedy Technique*, 10–11.
40. Henley, *Writing Radio Comedy*, I:17.
41. Ibid., 22.
42. Ibid., 27.
43. See Freud, *Jokes and Their Relation*.
44. Henley, *Writing Radio Comedy*, I:26.
45. Ibid., 27.
46. Ibid., 31.
47. Raskin, *Semantic Mechanisms of Humor*, 114.
48. The distortion can also take place on the level of the verbal or vocal, but it is the words themselves that are distorted, either through mispronunciation, reversal of word order, combining words together in a ludicrous way, introducing hics and sneezes and other foreign sounds. This kind of distortion helps explain the popularity of dialect humor, and mocks the way that immigrants misuse or mispronounce the English language.
49. Orben, *Comedy Technique*, 11.
50. Bassindale, *Speakers Make People Laugh*, 110.
51. Henley, *Writing Radio Comedy*, II:17.
52. Ibid., 21.
53. Idem.
54. Ibid., 26.

8 DOUBLE ENTENDRE HUMOR

1. Zeidman, *American Burlesque Show*, 201.
2. Raskin, *Semantic Mechanisms of Humor*, 149.
3. Zeidman, *American Burlesque Show*, 207.
4. Barber, *The Night They Raided Minsky's*, 273.
5. Dundes and Pagter, *Urban Folklore from the Paperwork Empire*, 214–216.
6. Allen *Best Burlesque Sketches*, 86. The original version was printed in Matlaw, *American Popular Entertainment*, 273–295.
7. *Airdate*, April 6, 1952.

9 FLIRTATIONS

1. Eastman, *Enjoyment of Laughter*, 3. Emphasis in original.
2. Allen, *Sugar Babies*, 20–27.

10 TRICKERY

1. Thompson, *The Folktale*, 425.
2. "Money Under the Hat Scene," Chuck Callahan Collection.
3. McNamara, *American Popular Entertainments*, 89–90.

11 BRUTALITY

1. Poston, *Burlesque Humor Revisited*, 79; emphasis in the original.
2. Kinescopes of the program are available at both the UCLA Film and Television Archives and the Museum of Television and Radio.
3. Poston, *Burlesque Humor Revisited*, 88–95.
4. Airdate January 11, 1953.
5. A homosexual reference.
6. Anobile, *Who's On First?*, 186–218.
7. White, *Ghost in a Pawn Shop* and Coes, *3 O'Clock Train*.

12 BURLESQUES

1. Wilson, *Shores of Light*, 275.
2. Jump, *Burlesque*, 1.
3. Ibid., 2.
4. Dressler, "The Solemn Art of Burlesque," 43.
5. "Desdemona" (Gypsy Rose Lee Collection) and "Desdemonia" (LoCicero Collection). *Hamlet* is burlesqued in "Travestie on Hamlet" (Gypsy) and "Hamlet" (Murray).
6. Allen, *The Best Burlesque Sketches*, 161–171.
7. A variant by Billy K. Wells appears in Oliver, *Greatest Revue Sketches*, 33–34.

13 BODY SCENES

1. See Legman, *Rationale of the Dirty Joke*, 65–76.
2. Originally "with her."

3. "Dr. Kronkite's Sanitarium Scene" is identical to "Cluck's Sanitarium Routine," except that the characters are identified as Smith and Dale. "Cluck's Sanitarium Scene" is reproduced in McNamara, *American Popular Entertainments*, 124–128. "Dr. Kronkite's Dental Parlor" appears under the alternate title "Dentist Shop."
4. Allen, *Sugar Babies*, 47.
5. The script is written for Martha Raye as the Judge.
6. Markham and Levinson, *Here Come The Judge!*, chapter 9.

14 THE APPEAL OF BURLESQUE COMEDY

1. Bergson, "Laughter," 111.
2. Jenkins, *"What Made Pistachio Nuts?"* 37.
3. Ibid., 44.
4. See McLean, *American Vaudeville as Ritual*, 106–137; Jenkins, *"What Made Pistachio Nuts?"* 26–45.
5. Jenkins, *"What Made Pistachio Nuts?"* 38.
6. Caputi, *Buffo*, 19.
7. Ibid., 22.
8. Ibid., 93.
9. Ibid., 157.
10. Bakhtin, *Rabelais*, 9.
11. Ibid., 11, 10.
12. Stallybrass and White, *Poetics of Transgression*, 7.
13. Bakhtin, *Rabelais*, 7.
14. Turner, *Ritual Process*, 127.
15. Ibid., 126.
16. Ibid., 128.
17. Zucker, "The Clown as the Lord," 306–317.
18. Distler, "Exit the Racial Comics," 247.
19. Turner, *Ritual Process*, 111.
20. Babcock-Abrahams, "Margin of Mess," 148.
21. Bergson, "Laughter," 63.
22. Monro, *Argument of Laughter*, 210.
23. Morreall, *The Philosophy of Laughter and Humor*, 20.
24. Gruner, *The Game of Humor*, 153.
25. Freud, *Jokes and their Relation*, 234.
26. Ibid., 231.
27. The English spelling of "humour" is used to indicate Freud's use of the term, while the term humor is used in its more colloquial sense. Similarly *comic*, as defined by Freud, is set in italics to distinguish it from more general uses of the term.
28. Ibid., 284.
29. Ibid., 271.
30. Eastman, *Enjoyment of Laughter*, 19.
31. Ibid., 3.
32. Freud, *Jokes and their Relation*, 286.
33. Martin, "Sense of Humor," 42.
34. Eastman, *Enjoyment of Laughter*, 3.
35. Sobel, "The Lack of Comedians," 10.
36. Nichols, "Age of Clowns," 12.
37. Sobel, "The Lack of Comedians," 11.

38. Allison, "Bobby Clark Back with Cane."
39. See Green, "Audiences of the American Burlesque."
40. George Frazer, "Comics—Like Firms—Need Image," undated *Variety* clipping in "Actors, Comedians" clipping file, Billy Rose Collection, NYPL.
41. Woolf, "How to Hatch a Joke," 12.
42. Quoted in Sidney Fields, n.d.
43. Silvers and Saffron, *This Laugh Is On Me*, 49.

Bibliography ·❦·

PUBLISHED SOURCES

Aarne, Antti, and Stith Thompson. *The Types of the Folktale: A Classification and Bibliography*, 2nd Revision. (FF Communications, No 184) Helsinki: Academia Scientiarum Fennica, 1964.

Abrahams, Roger D. "Folk Drama." In *Folklore and Folklife*, edited by Richard M. Dorson, 351–362. Chicago: University of California Press, 1972.

Adams, Joey, and Henry Tobias. *The Borscht Belt*. New York: Bobbs-Merrill, 1966.

Adler, Bill. *Jokes, and How to Tell Them*. New York: Doubleday, 1963.

Alexander, H. M. *Strip Tease: The Vanished Art of Burlesque*. New York: Knight Publishers, 1938.

Allen, Ralph G. "At My Mother's Knee (and Other Low Joints)." In *American Popular Entertainment: Papers and Proceedings on the History of American Popular Entertainment*, edited by Myron Matlaw, 43–60. Westport, CT: Greenwood Press, 1979.

———. *The Best Burlesque Sketches*. New York: Applause, 1996.

———. "Our Native Theatre: Honky-Tonk, Minstrel Shows, Burlesque." In *The American Theatre: A Sum of its Parts*, edited by Henry B. Williams, 273–313. New York: Samuel French, 1971.

———. *Sugar Babies: The Burlesque Musical*. New York: Samuel French, 1977.

Allen, Robert C. *Horrible Prettiness: Burlesque and American Culture*. Chapel Hill: University of North Carolina Press, 1991.

Allison, Gordon. "Bobby Clark Back with Cane and Low Comedy is King." Unidentified clipping in Bobby Clark Clippings File. Billy Rose Collection, NYPL.

Andrews, Richard. "Arte Dialogue Structures in the Comedies of Moliere." In *The Commedia Dell'Arte From the Renaissance to Dario Fo*, edited by Christopher Cairns, 142–159. Papers of the Conference of the Society for Italian Studies, November 1988. Lewiston: The Edwin Mellen Press, 1989.

———. *Scripts and Scenarios: The Performance of Comedy in Renaissance Italy*. New York: Cambridge University Press, 1993.

Anobile, Richard J., ed. *Who's On First? Verbal and Visual Gems from the Films of Abbott & Costello*. New York: Darien House Inc., 1972.

Ashcraft, Mark. *Human Memory and Cognition*, 2nd edition. New York: Harper Collins, 1994

Ashliman, D. L. *A Guide to Folktales in the English Language*. Westport, CT: Greenwood Press, 1987.

Babcock, Barbara A., ed. *The Reversible World: Symbolic Inversion in Art and Society*. Ithaca: Cornell University Press, 1978.

Babcock-Abrahams, Barbara. "'A Tolerated Margin of Mess': The Trickster and his Tales Reconsidered." *Journal of the Folklore Institute* 11 (1975): 147–186.

Bakhtin, Mikhail. *Rabelais and his World*, translated by Helene Iswolsky. Bloomington: Indiana University Press, 1984.

Barber, Rowland. *The Night They Raided Minsky's: A Fanciful Expedition to the Lost Atlantis of Show Business*. New York: Simon & Schuster, 1960.

———. "The Sudden Raid That Ruined Real Burlesque." *Life* (May 2, 1960): 122–124.

"Barkers, Posters, Lure to Burlesque." *New York Daily Mirror* (August 27, 1932): 2.

Bassindale, Bob. *How Speakers Make People Laugh*. West Nyack, NY: Parker Publishing Co., 1976.

Bergson, Henry. "Laughter." In *Comedy*, edited by Wylie Sypher, 61–190. Baltimore, MD: The Johns Hopkins University Press, 1956.

Bigelow, Joe. "12 Best Strippers." *Variety* (January 6, 1937): 229.

Black Justice, or Half Hour in a Kentucky Court House. New York: Samuel French, n.d.

Brunvand, Jan Harold. *The Study of American Folklore: An Introduction*, 3rd edition. New York: W.W. Norton & Co., 1986.

Burson, Anne C. "Model and Text in Folk Drama." *Journal of American Folklore* 93 (1980): 305–316.

"The Business of Burlesque, A.D. 1935." *Fortune* (February 1935): 67–73, 141–153.

Caputi, Anthony. *Buffo: The Genius of Vulgar Comedy*. Detroit: Wayne State University Press, 1978.

Chauncey, George. *Gay New York: Gender, Urban Culture and the Making of the Gay Male World, 1890–1940*. New York: BasicBooks, 1994.

Coes, George H. *3 O'Clock Train, or the Haunted House*. N/A, 1894.

Cohen, Gillian. *Memory in the Real World*, 2nd edition. Hove, UK: Psychology Press, 1996.

Conner, Patricia Sandberg. *Steve Mills and the Twentieth Century American Burlesque Show. A Backstage History and a Perspective*. PhD dissertation, University of Illinois at Urbana-Champaign, 1979.

Corio, Ann, and Joseph DiMona. *This Was Burlesque*. New York: Castle Books, 1968.

Costello, Chris, and Raymond Strait. *Lou's On First: A Biography*. New York: St. Martin's, 1981.

Cox, Stephen, and John Lofflin. *The Official Abbott and Costello Scrapbook*. Chicago: Contemporary Books, 1990.

cummings, e.e. "Burlesque, I Love It." In *E.E. Cummings A Miscellany Revised*, edited by George J. Firmage, 292–295. New York: October House, 1965.

Davies, Christie. *Ethnic Humor around the World: A Comparative Analysis*. Bloomington: Indiana University Press, 1990.

———. "Ethnic Jokes, Moral Values and Social Boundaries," *The British Journal of Sociology* 33 (1982): 383–403.

Degh, Linda. "Folk Narrative." In *Folklore and Folklife: An Introduction*, edited by Richard M. Dorson, 53–83. Chicago: University of Chicago Press, 1972.

Disher, M. Willson. *Clowns and Pantomimes*. New York: Benjamin Blom, 1960 [1925].

Distler, Paul Antonie. "Exit the Racial Comics." *Educational Theatre Journal* 18 (1966): 247–254.

———. *The Rise and Fall of Racial Comics in American Vaudeville*. PhD dissertation, Tulane University, 1963.

Dolan, Jill. "'What, No Beans?' Images of Women and Sexuality in Burlesque Comedy." *Journal of Popular Culture* (Winter 1984): 37–47.

Dorson, Richard M. "Is There a Folk in the City?" *Journal of American Folklore* 83 (1970): 185–216.

Dressler, David. *Burlesque as a Cultural Phenomenon*. PhD dissertation, New York University, 1937.

Dressler, Marie. "The Solemn Art of Burlesque." *Broadway Magazine* (March 1905): 42–46.

Drew, Maurice. "Scripts and Scribes," *Billboard* (December 6, 1919): 21.

Dundes, Alan. "The Binary Structure of 'Unsuccessful Repetition' in Lithuanian Folk Tales." *Western Folklore* 21 (1962): 165–174.

———. "Structural Typology in North American Indian Folktales." In *The Study of Folklore*, 206–215. Englewood Cliffs, NJ: Prentice-Hall, 1965.

Dundes, Alan, and Carl R. Pagter. *Urban Folklore from the Paperwork Empire*. Austin, TX: American Folklore Society, 1975.

Eastman, Max. *Enjoyment of Laughter*. New York: Simon and Schuster, 1936.

"Eddie Welch Classifies Bits," *Billboard* (June 28, 1930): 29.

Fernald, John. *The Play Produced: An Introduction to the Technique of Producing Plays*. London: H.F.W. Deane & Sons, 1933.

Fields, Armond, and L. Marc Fields. *From the Bowery to Broadway: Lew Fields and the Roots of American Popular Theater*. New York: Oxford, 1993.

Fields, Sidney. "The Comedians Dilemma." In Actors: Comedians Clippings File, Billy Rose Collection, NYPL.

Finnegan, Ruth. "'Literacy and Non-literacy': The Great Divide?" In *Modes of Thought*, edited by Robin Horton and Ruth Finnegan, 112–144. New York: Faber and Faber, 1973.

———. *Literacy and Orality: Studies in the Technology of Communication*. Oxford: Basic Blackwell, 1988.

———. *Oral Traditions and the Verbal Arts: A Guide to Research Practices*. New York: Routledge, 1992.

Fitzpatrick, Tim. *The Relationship of Oral and Literate Performance Processes in the Commedia Dell'Arte: Beyond the Improvisation/Memorisation Divide*. Lewiston: Edwin Mellen Press, 1995.

Fo, Dario. *The Tricks of the Trade*. New York: Routledge, 1987.

Foley, John Miles. *The Theory of Oral Composition: History and Methodology*. Bloomington: Indiana University Press, 1988.

Freud, Sigmund. *Jokes and Their Relation to the Unconscious*, translated by James Strachey. New York: W.W. Norton, 1960.

Furmanek, Bob, and Ron Palumbo. *Abbott and Costello in Hollywood*. New York: Perigree Books, 1991.

Gehring, Wes. *W. C. Fields, a Bio-Bibliography*. Westport, CT: Greenwood Press, 1984.

Gilbert, Douglas. *American Vaudeville: Its Life and Times*. New York: Dover Publications Inc., 1940.

Gorer, Geoffrey. *Hot Strip Tease and Other Notes on American Culture*. London: The Gresset Press, 1937.

Green, Stanley. *The Great Clowns of Broadway*. New York: Oxford University Press, 1984.

Green, William. "The Audiences of the American Burlesque Show of the Minsky Era (CA. 1920–40)." *Das Theater Und Sein Publikum* (1977): 225–237.

Gruner, Charles R. *The Game of Humor: A Comprehensive Theory of Why We Laugh*. New Brunswick, NJ: Transaction Publishers, 1997.

Harris, Paul. *The Pantomime Book*. London: Peter Owen, 1996.

Hartt, Rollin Lynde. "The Home of Burlesque." *Atlantic Monthly* 101 (January 1908): 68–78.

———. *People at Play*. New York: Houghton-Mifflin, 1909.

Henke, Robert. *Performance and Literature in the Commedia dell'Arte*. New York: Cambridge University Press, 2002

Henley, Art. *Writing Radio Comedy: How to Write It, Including the Mathematics of Humor.* New York: Humor Business, 1948.

Hixon, Donald L., and Don A. Hennessee. *Nineteenth-century American Drama: A Finding Guide.* Metuchen, NJ: Scarecrow Press, 1977.

Hodgson, Terry. *The Batsford Dictionary of Drama.* London: B.T. Batsford, 1988.

Holbrook, Richard T., ed. *The Farce of Master Pierre Pathelin.* New York: Houghton Mifflin, 1905.

Imhof, Roger. "Advanced Burlesque." *Variety* (December 14, 2007): 2.

Isman, Felix. *Weber and Fields: Their Tribulations, Triumphs and Their Associates.* New York: Boni & Liveright, 1924.

"It's Ladies' Day at the Burleyque." *Life* (September 16, 1966): 128–140.

jason, Heda. *The Narrative Structure of Swindler Tales.* Santa Monica, CA: RAND Corporation, 1968.

"Jazztime Review." *Billboard* (September 22, 1928): 35.

Jenkins, Henry. *"What Made Pistachio Nuts?" Early Sound Comedy and the Vaudeville Aesthetic.* New York: Columbia University Press, 1992.

Jump, John D. *Burlesque.* London: Methuen, 1972.

Kahn, E. J. *The Merry Partners: The Age and Stage of Harrigan and Hart.* New York: Random House, 1955.

Koestler, Arthur. *The Act of Creation.* New York: Macmillan, 1964.

Lahr, John. *Notes on a Cowardly Lion.* New York: Limelight Books, 1984 [1969].

Laurie, Jr., Joe. *Vaudeville: From the Honky-tonks to the Palace.* New York: Henry Holt and Co., 1953.

Leavitt, A. J. *Who Died First? A Negro Sketch.* New York: DeWitt, 1874.

Lee, Gypsy Rose. *Gypsy: A Memoir.* New York: Harper, 1957.

Legman, Gershon. *Rationale of the Dirty Joke: An Analysis of Sexual Humor.* New York: Castle Books, 1968.

Lesser, Joseph L. *Top Banana Joey Faye: The Evolution of a Burlesque Comedian.* PhD dissertation, New York University, 1987.

Levine, Lawrence. *Highbrow/Lowbrow.* Cambridge: Harvard University Press, 1988.

Levi-Strauss, Claude. *The Savage Mind.* Chicago: University of Chicago Press, 1966.

Lord, Albert B. *The Singer of Tales.* Cambridge, MA: Harvard University Press, 1960.

Lott, Eric. *Love and Theft: Blackface Minstrelsy and the American Working Class.* New York: Oxford University Press, 1993.

Lyons, Jimmy. *The Mirth of a Nation.* New York: Vantage Press, 1953.

MacDonald, Ward, and Eben H. Norris. *Dennison's Make-Up Guide*, 1932 edition. Chicago: T.S. Denison & Co., 1932.

MacPherson, Virginia. "Minsky's Gift to Hollywood," *PM* (6/5/45). Rags Ragland File at the Motion Picture Arts and Sciences Library, Los Angeles.

Markham, Dewey "Pigmeat," and Bill Levinson. *Here Come the Judge!* New York: Popular Library, 1969.

Markow, Jack. *Cartoonist's and Gag Writer's Handbook.* Cincinnati: Writer's Digest, 1967.

Martin, Rod A. "Approaches to the Sense of Humor: A Historical Review." In *The Sense of Humor: Explorations of a Personality Characteristic*, edited by Willibald Ruch. New York: Mouton de Gruyter, 1998.

Matlaw, Myron, ed. *American Popular Entertainment: Papers and Proceedings on the History of American Popular Entertainment.* Westport, CT: Greenwood Press, 1977.

Maurice Drew. "Scripts and Scribes." *Billboard* (December 6, 1991): 21.

McCaghy, Charles H., and James K. Skipper, Jr. "Lesbian Behavior as an Adaptation to the Occupation of Stripping." *Social Problems* 17: 262–270.

McLean, Albert F., Jr. *American Vaudeville as Ritual*. Lexington: University of Kentucky Press, 1965.

McNamara, Brooks. *American Popular Entertainments: Jokes, Monologues, Bits, and Sketches*. New York: Performing Arts Journal Publications, 1983.

———. "'For Laughing Purposes Only': The Literature of American Popular Entertainment." In *The American Stage: Social and Economic Issues from the Colonial Period to the Present*, edited by Ron Engle and Tice Miller, 141–148. New York: Cambridge University Press, 1993.

Miller, D. Gary. "Towards a New Model of Formulaic Composition." In *Comparative Research on Oral Traditions: A Memorial for Milman Parry*, edited by John Miles Foley, 351–393. Columbus, Ohio: Slavica Publishers, 1985.

Minsky, Harold, as told to Richard Gehman. "G-Strings & Top Bananas." *Argosy* (June 1960): 48–53, 84–87.

Minsky, Morton, and Milt Machlin. *Minsky's Burlesque*. New York: Arbor House, 1986.

Monro, D. H. *Argument of Laughter*. South Bend, IN: Notre Dame University Press, 1963 [1951].

Morreall, John. *Taking Laughter Seriously*. Albany: State University of New York, 1983.

———, ed. *The Philosophy of Laughter and Humor*. Albany: State University of New York Press, 1987.

Morris, D. L. *Dutch Justice: A Very Laughable Sketch*. Chicago: Dramatic Publishing Co., 1876.

Mullholland, Jim. *The Abbott and Costello Book*. New York: Popular Library, 1975.

Nathan, George Jean. "Burlesque and the Coffin." *The American Mercury* (July 1929): 377–378.

"'Nice Girl' Epidemic." *Billboard* (February 21, 1931): 4.

Nichols, Lewis. "Lament for the Age of Clowns." *New York Times Magazine* (February 1, 1948): 12–13.

Nicoll, Allardyce. *Masks, Mimes and Miracles: Studies in the Popular Theatre*. New York: Cooper Square Publishers, 1963.

Norrick, Neal. *Conversational Joking: Humor in Everyday Talk*. Bloomington: Indiana University Press, 1993.

Norris, Eben H., and Burckton Nendick. *Denison's Make-Up Guide*. Chicago: T.S. Dennison & Co. 1916.

Oliver, Donald, ed. *The Greatest Revue Sketches*. New York: Avon Books, 1982.

Olrik, Axel. *Principles for Oral Narrative Research*, translated by Kirsten Wolf and Jody Jensen. Bloomington: Indiana University Press, 1992 [1921].

Ong, Walter J. *Orality and Literacy: The Technologizing of the Word*. New York: Methuen, 1982.

Orben, Robert. *Comedy Technique*, 5th edition. New York: Lewis Tannen, 1951.

———. *If You Have to Be a Comic*. Baldwin Harbor, NY: Orben Publications, 1963.

Oreglia, Giacomo. *The Commedia dell'Arte*. New York: Hill and Wang 1968 [1964].

Oring, Elliott. *Jokes and Their Relations*. Lexington: University Press of Kentucky, 1992.

Page, Brett. *Writing for Vaudeville*. Springfield, MA: Home Correspondence School, 1915.

Parry, Milman. *The Making of Homeric Verse: The Collected Papers of Milman Parry*, edited by Adam Parry. Oxford: Clarendon Press, 1971.

Playboy's Complete Book of Party Jokes. New York: Castle Books, 1972

Poston, Dick. *Burlesque Humor Revisited*. New York: Samuel French, 1977.

Propp, Vladimir. *Morphology of the Folk Tale*. Austin: University of Texas Press, 1968.

"Rags Ragland, the Great." *New York Times* (November 17, 1940): 139.

Randolph, Vance. *Pissing in the Snow and Other Ozark Folktales*. New York: Avon Books, 1977.

Raskin, Victor. *Semantic Mechanisms of Humor.* Boston: D. Reidel Publishing, 1985.

Reeves, Al. B. "Why I Like Burlesque." *Variety* (December 12, 2008): 39.

Rémy, Tristan. *Clown Scenes,* translated by Bernard Sahlins. Chicago: Ivan R. Dee, 1997 [1962].

Reznick, Sidney. *How to Write Jokes.* New York: Townley Co, 1954.

Rosensweig, Roy. *Eight Hours for What We Will: Workers and Leisure in an Industrial City, 1870–1920.* New York: Cambridge University Press, 1983.

Rourke, Constance. *American Humor: A Study of the National Character.* New York: Harcourt Brace Jovanovich, 1931.

Sandberg, Patricia. "An Interview with Steve Mills." *Educational Theatre Journal* 27 (1975): 331–344.

Scala, Flaminio. *Scenarios of the Commedia Dell'arte: Flaminio Scala's Il Teatro delle favole rappresentative,* translated by Henry Salerno. New York: New York University Press, 1967.

Scheub, Harold. "Body and Image in Oral Narrative Performance." *New Literary History* 8 (1977): 345–367.

———. *Story.* Madison: University of Wisconsin Press, 1998.

Scott, David A. *Behind the G-String: An Exploration of the Stripper's Image, Her Person and Her Meaning.* Jefferson, NC: McFarland & Co., 1996.

Seigel, Sherman Louis, ed. *The Language of Show Biz: A Dictionary.* Chicago: Dramatic Publishing Co., 1983.

"Shuberts Censor Burlesque Show. *Billboard* (April 17, 1926): 34.

Silvers, Phil, with Robert Saffron. *This Laugh Is On Me: The Phil Silvers Story.* Englewood Cliffs, NJ: Prentice-Hall, Inc., 1973.

Slide, Anthony. *The Encyclopedia of Vaudeville.* Westport, CT: Greenwood Press, 1994.

Slout, William. *Theater in a Tent: The Development of a Provincial Entertainment.* Bowling Green, OH: Bowling Green University Press, 1972.

Snyder, Robert W. *The Voice of the City: Vaudeville and Popular Culture in New York.* New York: Oxford University Press, 1989.

Sobel, Bernard. *Burleycue: An Underground History of Burlesque Days.* New York: Farrar & Rinehart, 1931.

———. "The Lack of Comedians Is No Joke." *New York Times Magazine* (August 8, 1943): 10–11.

———. *A Pictorial History of Burlesque.* New York: Bonanza Books, 1956.

Stallybrass, Peter, and Allon White. *The Politics and Poetics of Transgression.* Ithaca, NY: Cornell University Press, 1986.

Staples, Shirley. *Male-Female Comedy Teams in American Vaudeville, 1865–1932.* Ann Arbor, MI: UMI Research Press, 1984.

Stearns, Marshall, and Jean Stearns. *Jazz Dance: The Story of American Vernacular Dance.* New York: Da Capo Press, 1994 [1968].

Stein, Charles W., ed. *American Vaudeville as Seen by its Contemporaries.* New York: Da Capo Press, 1984.

Stencell, A. W. *Girl Show: Into the Canvas World of Bump and Grind.* Toronto: ECW Press, 1999.

Stevenson, James. "Profiles: Takes." *The New Yorker* (August 31, 1981): 42.

Thomas, Bob. *Bud & Lou, The Abbott and Costello Story.* New York: J.B. Lippincott Co., 1977.

Thompson, Stith. *The Folktale.* New York: Holt, Rinehart and Winston, 1946.

———. *Motif-Index of Folk-Literature,* 6 vols. Revised and enlarged edition. Bloomington: Indiana University Press, 1955–1958.

Toelken, Barre. *The Dynamics of Folklore.* New York: Houghton Mifflin Co., 1979.

Towsen, John H. *Clowns*. New York: Hawthorn Books, 1976.

Trapido, Joel, ed. *International Dictionary of Theatre Language*. Westport, CT: Greenwood Press, 1985.

Turner, Victor. "Liminal to Liminoid in Play, Flow and Ritual: An Essay in Comparative Symbology." *Rice University Studies* 60 (1974): 53–92.

———. *The Ritual Process: Structure and Anti-Structure*. Ithaca, NY: Cornell University Press, 1969.

Van Munching, Philip. *How to Remember Jokes, and 101 Drop-Dead Jokes to Get You Started*. New York: Workman Publishing, 1997.

Wahls, Robert. "Footlights." Unidentified clipping in *This Was Burlesque* Clippings File, Billy Rose Collection, NYPL.

White, Charles. *Ghost in a Pawnshop: An Ethiopian Sketch in One Scene, by Mr. Mackey*. Chicago: Dramatic Publishing Co., 1875.

Wilde, Larry. *How the Great Comedy Writers Create Laughter*. Chicago: Nelson-Hall, 1976.

Wilmeth, Don. *The Language of American Popular Entertainment*. Westport, CT: Greenwood Press, 1981.

Wilson, Edmund. *Shores of Light: A Literary Chronicle of the Twenties and Thirties*. New York: Farrar, Straus and Young, 1952.

Wilson, Garff B. "Achievement in the Acting of Comedy." *Educational Theatre Journal* 5 (1953): 328–332.

Wilson, John S. "Joey Faye, Skit Collector." *P.M. New York* (July 1946). In Joey Faye Clippings File, Billy Rose Collection, NYPL.

Woolf, S. J. "How to Hatch a Joke." *New York Times Magazine* (July 5, 1942): 12.

The WPA Guide to New York City. New York: The New Press, 1992 [1939].

Wright, Charles F. *1001 One Minute Black-Outs*. Banner Play Bureau, Inc., 1934.

Wright, Milton. *What's Funny—and Why: An Outline of Humor*. New York: Harvest House, 1939.

Zeidman, Irving. *The American Burlesque Show*. New York: Hawthorn Books, 1967.

Zucker, Wolfgang M. "The Clown as the Lord of Disorder." In *Holy Laughter: Essays on Religion in the Comic Perspective*, edited by M. Conrad Hyers, 75–88. Seabury Press, 1969.

MANUSCRIPT SOURCES

Ralph Allen Collection: University of Pittsburgh

Chuck Callahan Collection: Hampden-Booth Library; The Players; New York

Gypsy Rose Lee Collection: New York Public Library at Lincoln Center

Anthony LoCicero Collection: University of Pittsburgh

Jess Mack Collection: James R. Dickinson Library; University of Nevada, Las Vegas

Steve Mills Collection: Boston Public Library

Ken Murray Collection: Magic Castle, Hollywood, California

BURLESQUE VIDEOS

Something Weird Video

B-Girl Rhapsody (1952)

Birthstone Girls/Rubber Balloons

Sharpshooter
Poppy
Bolshevik Scene

Burlesque In Hawaii (aka *Oriental Vanities*) (1952)

Garter Bit
We'll Split Her Fifty Fifty
Mindreader

Buxom Beautease (1956)

Interruption Scene
Dentist Scene
Paris Flirtation Scene
Three Times Three Is Ten

Can Can Follies (1954)

Restaurant Scene (Zupp)
Pawnbrokers (Comics help lady pawn her clothes)
Restaurant (Ordering Bit)
Hold Up Con

Chicks and Chuckles. (Compilation by Something Weird Video)

Cake with Nuts
Cleopatra Scene
Lemon Drop

Dream Follies (1954)

Bar Scene
Charity Worker
Eight Day Match
Sketch: Breaking Windows in the Whole Hotel

Everybody's Girl (1950)

Joe the Bartender
Reform
Schoolroom Sketch
International Cuisine (Sitting on her piazza)

French Follies (1951)

Transformer
Cut and Bleeding
Had a Smile on her Face and a $5 Gold piece

Crazy House
Generous Moonshine

Hollywood Burlesque (1948)

Buzzing the Bee
I Got Twenty, Too
Phone Call

Hollywood Revels (1946)

8 Day Match
German Spy

Honky Tonk Burlesque (1953)

Chicken Club
Baby Photographer

Hurly Burly (1951)

Cut Up and Bleeding/Hello Bill
You're Not Here
Drill Routine
Dressing and Undressing

International Burlesque (1950)

Hearing Aid Bit
Pushy Salesman Bit
Dishwasher Ad
Spot Remover
Frame story uses variant on "Niagara Falls (Slowly I Turn)"

Kiss Me Baby (1957)

A Lemon Bit
Stage Door Scene
French Scene
Traffic Cop
Courtroom Scene

Lili's Wedding Night (1952)

Celery Scene

Merry Maids of the Gay Way (1954)

No I Haven't
Seducing the Boyfriend

"3 × 3 is 10"
Telephone Scene and Drunk Scene

Midnite Frolics (1949)

Ice Cream
Specimen (Badly cut in the middle)
Violin Bit

Naughty New Orleans (1962)

Bullfight (Machacha)
Shipwrecked Sailor's Illusion Scene
Drunks at the Depot
Rendezvous

A Night at the Follies (1950)

Dice Game
Freshmen (Flirtation Scene)
Bar Bets—What's Yours?
Rendezvous
Pantomime Scene

Night at the Moulin Rouge (aka Ding Dong) (1951)

Talent Agent (Theatrical Office)
Baseball Scene (Double Entendre)
Ding Dong
We'll Strike!
Spiking the Punch

Peek-a-Boo (1953)

African Dodger
Electric Box
Palace of Passion
Passion Candy

Strip Strip Hooray (1950)

Buzzing the Bee
Have A Lemon
Bootlegger Scene
Dressing and Undressing

Striptease Girl (1952)

Poppy Juice

Holdup Scam/with Money Changing Bit
The Music Lesson

Teaserama (1955)

Magic Perfume
Going Past the Poolroom

Tia Juana after Midnight (1954)

Cut Up and Bleeding
Guitar Misunderstanding
Interruption Scene (Hammer)
Cut Up and Bleeding—Ordering Sequence
Spiking the Drink Pantomime Bit

Too Hot to Handle (1950)

Seven Times Thirteen
Sidewalk Conversation/Holdup
Desdemona and Othello
Sidewalk Conversation

BURLESQUE COMEDY ALBUMS

Burlesque with the Nuts Inside (Jubilee JFM 2065).
The Best of Burlesque (*MGM E* 3644)
Burlesque Uncensored (Cook 1071)
The Burlesque Show (Cameo C-2002)
Gypsy Rose Lee Remembers Burlesque (Sereo Oddities CG-1)
Sugar Babies (Broadway Entertainment Records 8302)
This Was Burlesque(Roulette SR 25185)
Also see various comedy albums by "Pigmeat" Markham.

Scenes Featured in the Volume ❧

Index ❧

Note: Page numbers in **bold** denote illustrations.

Printed and bound by CPI Group (UK) Ltd, Croydon, CR0 4YY